A YEAR
IN FASHION

A YEAR
IN FASHION

With Texts
by Pascal Morché

PRESTEL
MUNICH | BERLIN | LONDON | NEW YORK

In cooperation with
gettyimages

Day by Day—A Century in Fashion

Fashion is more than just a blend of fabrics and colors; it is more than cut and design, more than mere superficiality and attractive appearances. In fact, fashion responds to the vibrations emitted by the spirit of the times; it mirrors the state and the mood of society—in cuts, colors, patterns, and fabrics. It has become a topic for literary supplements, for scientific papers and university seminars. Fashion is a cultural phenomenon so wide-ranging and independent that it is impossible to capture it entirely. *A Year in Fashion* shows more than the fashions of the past 100 years—, it shows their various facets and endless variety.

Of course you will also find in this calendar the so-called "Shots of Style" of the great photographers, but in its pictures it also often reflects the everyday reality of the colorful, garish, glamorous, and sometimes even bizarre world of fashion.

The arc stretches across 365 double pages from the very beginnings of fashion, from Charles Worth, Paul Poiret, and Jeanne Paquin, from Jacques Fath, from the great Coco Chanel and Christian Dior, up to the important designers of our time. The psychedelic colors of the 1970s alternate with the purism of the 1990s; the Swinging Sixties confront the glamorous style of the 1980s. Corsets versus patent leather coats; pumps versus stout punk boots; and the elegant evening dress is replaced the next day by a tattered T-shirt of the grunge look. *A Year in Fashion* shows styles, designers, and models,—but what is especially fascinating is the way it

takes a look behind the scenes of the world of fashion and its protagonists. The result is a calendar presenting a selection of pictures that is as anarchic and arbitrary, as cheeky and independent, as fashion itself. *A Year in Fashion* accompanies the everyday routine rather than clinging rigidly to a succession of statuesque, totally artificial fashion shots.

The pictures are complemented by quotations, often by the designers themselves. And they are accompanied by short texts, aphorisms, and statements. They are often poetic, playful, not infrequently critical observations about the "fashion circus." They also alternate with biographical notes on couturiers or styles; they provide comments about a brand or a label and even explain some of the specialist terms used in fashion.

A Year in Fashion stands for contrast—day by day: couture and mass production; down-to-earth sneakers and audaciously high heels; seductive lingerie and glamorous evening dresses; style icons, stars and starlets of the fashion world; fashion and style; eccentricity and provocation, superficiality and profundity. And that is why *A Year in Fashion* provides exactly 365 exciting glimpses of a world that affects us all—after all, we too reach (at least) 365 times every year into our wardrobe.

Fashion itself guarantees that every single page of this calendar will be a surprise, a provocation, a shock, or a moment of pure joy. So turn the pages. Day by day.

Pascal Morché

© Prestel Verlag, Munich · Berlin · London · New York 2008

© for all images by Getty Images 2008
Photo credits see last page

Cover: Audrey Hepburn as Holly Golightly in *Breakfast at Tiffany's*, 1961.

**Audrey Hepburn™ Trademark and Likeness
Licensed by Sean Ferrer and Luca Dotti**

Prestel Verlag
Königinstraße 9, D-80539 Munich
Tel. +49 (0)89 24 29 08-300
Fax +49 (0)89 24 29 08-335

Prestel Publishing Ltd.
4, Bloomsbury Place, London WC1A 2QA
Tel. +44 (20) 73 23-50 04
Fax +44 (20) 76 36-80 04

Prestel Publishing
900 Broadway, Suite 603
New York, N.Y. 10003
Tel. +1 (212) 9 95-27 20
Fax +1 (212) 9 95-27 33
www.prestel.com

Library of Congress Control Number: 2008924896

British Library Cataloguing-in-Publication Data
A catalogue record for this book is available from the British Library.

The Deutsche Bibliothek holds a record for this publication in the
Deutsche Nationalbibliografie; detailed biographical data can be
found under: http://dnb.ddb.de

Prestel books are available worldwide. Please contact your nearest bookseller or
one of the above addresses for information concerning your local distributor.

Editorial direction by Claudia Stäuble
Copyedited by Jonathan Fox
Quotes compilation by Jon Frost and Claudia Hellmann
Cover and layout concept by LIQUID, Augsburg
Production by Astrid Wedemeyer
Typesetting by Vornehm, Munich
Origination by ReproLine Mediateam
Printing and binding by C&C Offset Printing, Hong Kong

Printed on acid-free paper

ISBN 978-3-7913-3946-7

Beauty is whatever anyone
thinks is beautiful.

Rei Kawakubo

My role is that of a seducer.

John Galliano

John Galliano, the icon of British fashion. His passion for romantic shapes, dramatic effects, and pure glamour made him famous at a time when minimalism still ruled the fashion world. Born in 1960 in Gibraltar, Galliano grew up in London. His creed: fashion must be "beautiful and sensuous"! In 1995 Galliano was summoned to the couture house of Givenchy. Two years later he reached the Olympus of the fashion world as the Creative Director of Dior. The House of Dior has been on a steep upward trajectory ever since.

A model presents a creation by British designer JOHN GALLIANO for CHRISTIAN DIOR during the Fall/Winter 2007/08 ready-to-wear collection show in Paris.

1 2 3 4 5 6 7 8 9 10 11 12 13 14 15 16 17 18 19 20 21 22 23 24 25 26 27 28 29 30 31

JANUARY

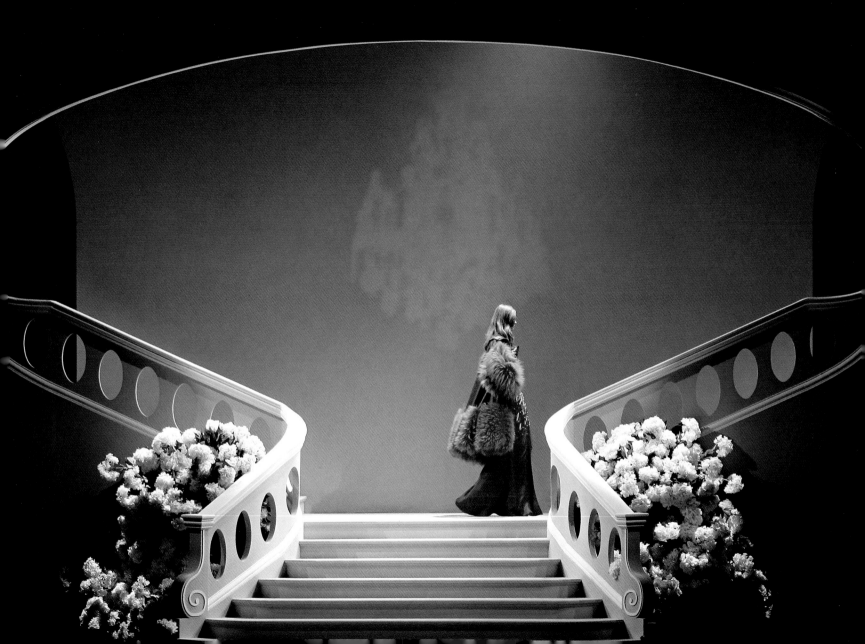

A dress is just a fantasy on a paper until it is sold.

Hardy Amies

By appointment to Her Majesty the Queen! Hardy Amies resides at house number 14 on venerable Savile Row. Here, surrounded by London's best tailors, shoemakers, and designers, Amies designs and tailors fashion (not only) for the British monarchy.

A sketch and fabric sample for an outfit made for the Queen by London designer HARDY AMIES, March 2005.

1 2 3 4 5 6 7 8 9 10 11 12 13 14 15 16 17 18 19 20 21 22 23 24 25 26 27 28 29 30 31

JANUARY

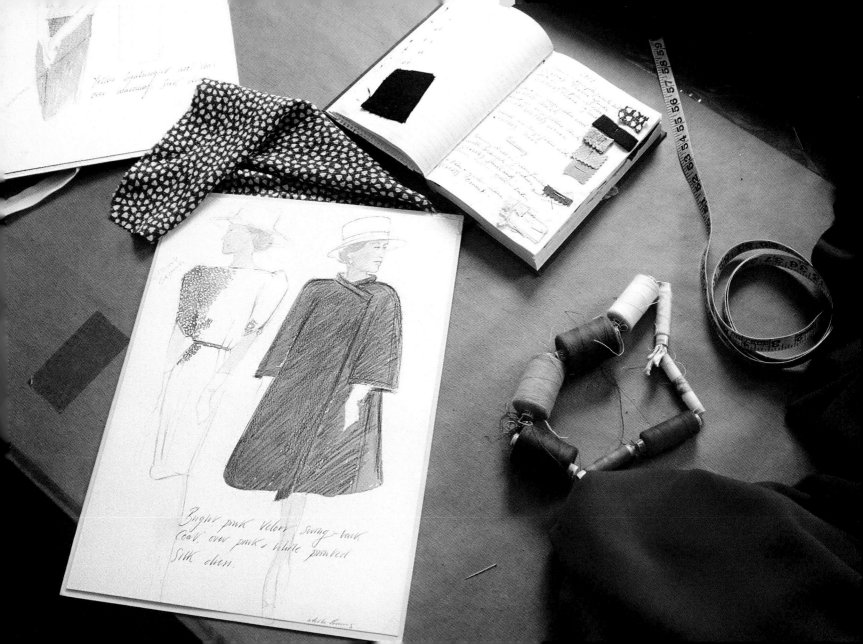

Never fear being vulgar, just boring.

Diana Vreeland

She is the Peggy Guggenheim of the fashion world—Diana Vreeland (1906–1989). Fashion columnist for *Harper's Bazaar*, Editor-in-Chief of American *Vogue*, and finally the consultant for the Costume Institute at the Metropolitan Museum of Art. All her life, the upper-class lady from New York—a friend of Andy Warhol—staged and stylized herself to perfection.

Portrait of fashion editor DIANA VREELAND in New York City, August 1974.

1 2 3 4 5 6 7 8 9 10 11 12 13 14 15 16 17 18 19 20 21 22 23 24 25 26 27 28 29 30 31

JANUARY

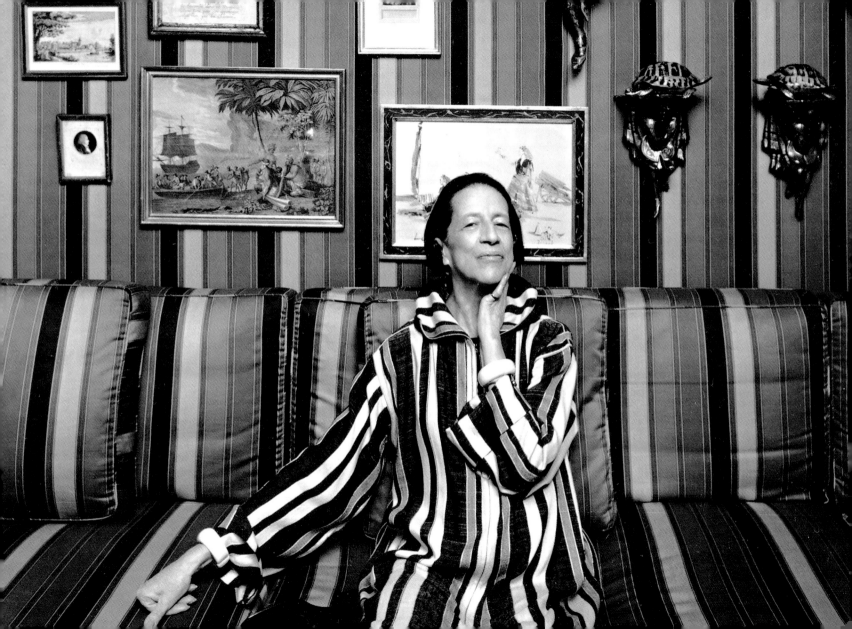

I use things that people want to hide in their heads. War, religion, sex: things we all think about but don't bring to the forefront. But I do and I force them to watch it.

Alexander McQueen

He has made it. He is commercially successful, and yet Alexander McQueen (b. 1969) is determined to live up to his bad-boy image as the "devil child anarchist of fashion" (*Face Magazine*). His catwalks appear to lead through hell—or perhaps out of it. Karl Lagerfeld called McQueen a "twin soul of shock artist Damien Hirst."

A model stands amid a ring of fire during British designer ALEXANDER MCQUEEN's Fall/Winter 1998/99 haute couture collection show as part of London Fashion Week.

1 2 3 4 5 6 7 8 9 10 11 12 13 14 15 16 17 18 19 20 21 22 23 24 25 26 27 28 29 30 31

JANUARY

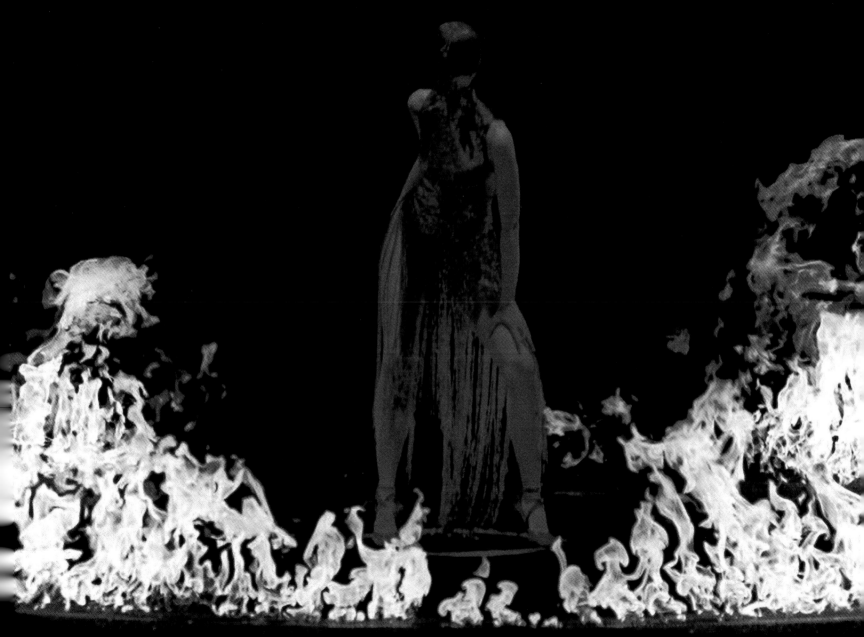

Fashion gave me the opportunity to always slip into different roles.

Veruschka

She was Germany's first top model—Vera Gottliebe Anna Gräfin von Lehndorff, alias Veruschka. She also worked as an actress (*Blow Up*), artist, and photographer. Seldom seen as relaxed as in this photo, Veruschka knew how to throw herself down in a theatrical pose.

Legendary German model Veruschka (b. 1939) in the film *Veruschka—Poesia di una donna*, 1970.

1 2 3 4 **5** 6 7 8 9 10 11 12 13 14 15 16 17 18 19 20 21 22 23 24 25 26 27 28 29 30 31

JANUARY

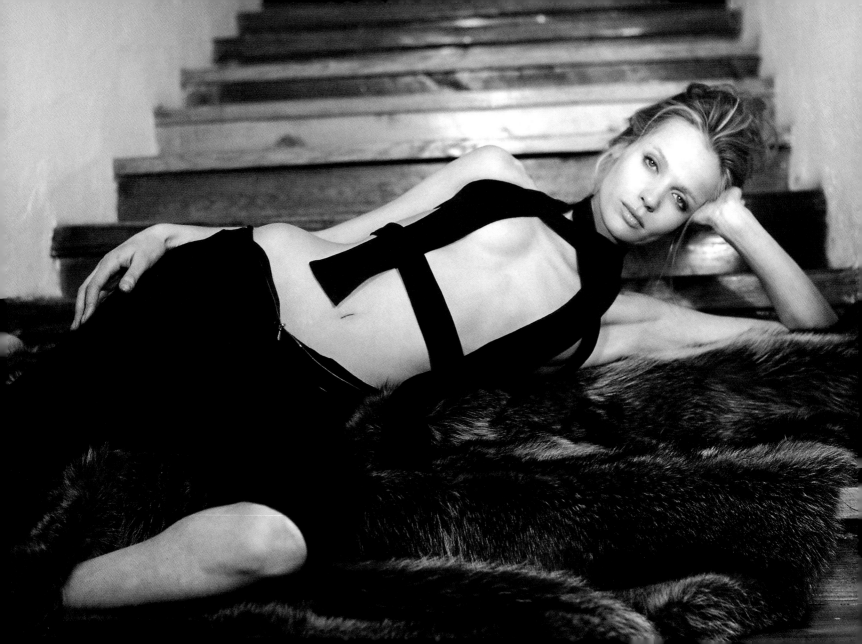

My inspiration comes from anthropology, genetic anthropology, migration, history, social prejudice, politics, displacement, science fiction, and, I guess, my own cultural background.

Hussein Chalayan

Heinrich von Kleist wrote of marionette theaters that natural beauty comes to the fore in the complete absence of consciousness. Does that only apply to puppets?

Models pose on the catwalk during the HUSSEIN CHALAYAN fashion show as part of Paris Fashion Week Fall/Winter 2007/08.

1 2 3 4 5 6 7 8 9 10 11 12 13 14 15 16 17 18 19 20 21 22 23 24 25 26 27 28 29 30 31

JANUARY

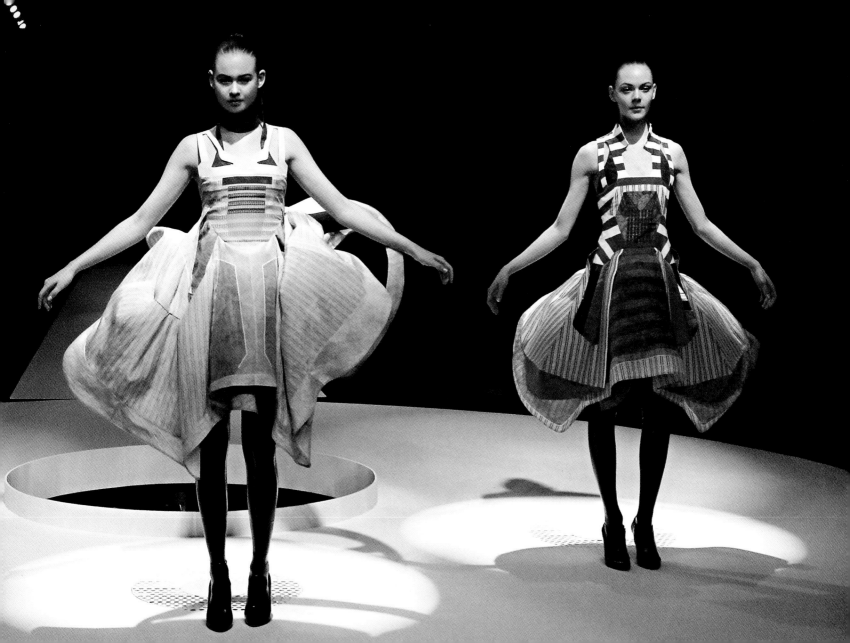

Fashion today has replaced the movie business in providing us with the fantasies and glamour that feed our dreams.

Terry Jones

"Fashion is an entertainment tax which is due at least twice a year" (Françoise Sagan). The people who sit in the front row at a fashion show are especially important, and very much like to be entertained.
Celebrities attend the DIOR 2008 Cruise Collection fashion show in New York.

1 2 3 4 5 6 7 8 9 10 11 12 13 14 15 16 17 18 19 20 21 22 23 24 25 26 27 28 29 30 31

JANUARY

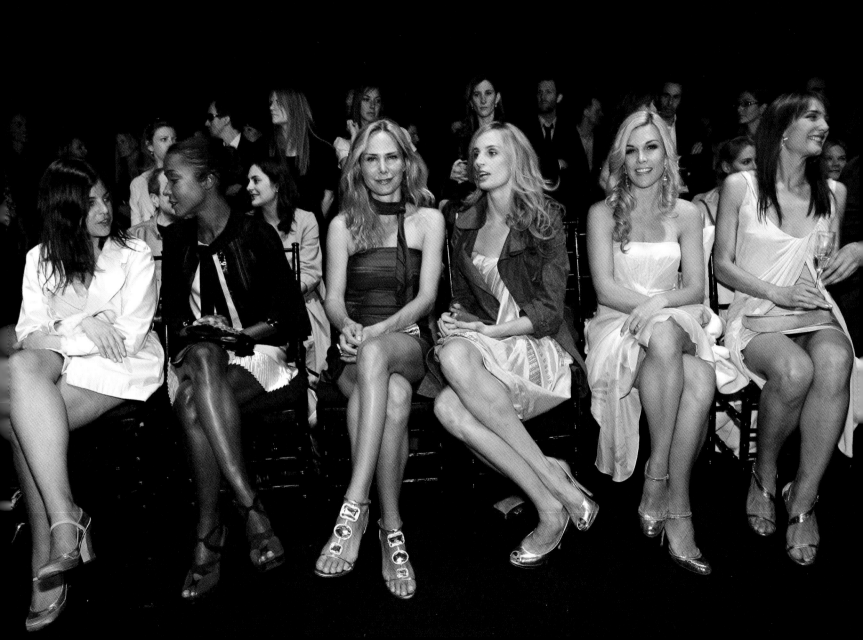

Don't take off your charm
with your cap.

Friedl Beutelrock

If only today's headscarf debate could be solved as aesthetically as
during the 1950s.
Model wearing nursemaid's kerchief, 1952.

1 2 3 4 5 6 7 **8** 9 10 11 12 13 14 15 16 17 18 19 20 21 22 23 24 25 26 27 28 29 30 31

JANUARY

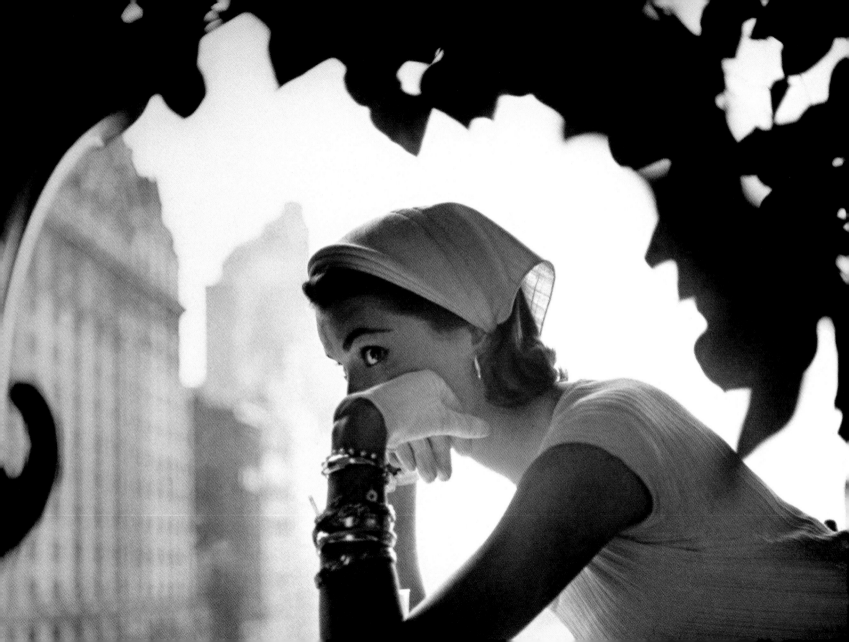

My only fashion school was what I saw
in the newspapers and on television.

Jean Paul Gaultier

**Is fashion childish? Childish clothes, childish mouths—and childlike gazes into
the future of fashion.**
Models walk down the catwalk at the HERMÈS Spring/Summer 2007 fashion show
during Paris Fashion Week.

1 2 3 4 5 6 7 8 9 10 11 12 13 14 15 16 17 18 19 20 21 22 23 24 25 26 27 28 29 30 31

JANUARY

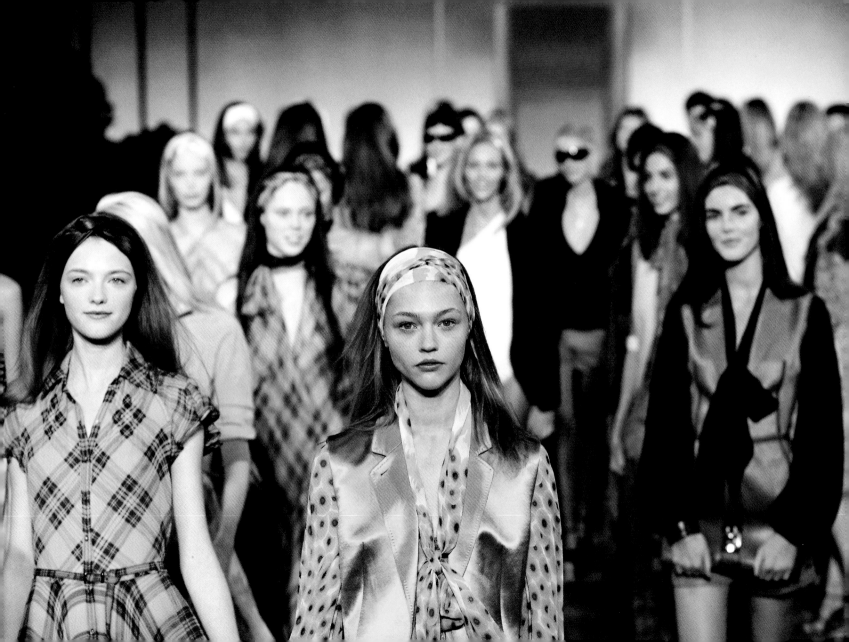

I want to achieve anti-fashion through fashion. That's why I'm always heading in my own direction. Because if you're not waking up what is asleep, you might as well just stay on the beaten path.

Yohji Yamamoto

Even a sketch by Japanese designer Yohji Yamamoto enchants with its intellectual brilliance, breathtaking romance, abstract silhouettes, and his perpetual loyalty to black. With Yamamoto's designs spread on the floor we can guess at the maestro's favorite shoes—Converse All Stars. A classic wears classics.

Drawings by Japanese fashion designer YOHJI YAMAMOTO displayed on the occasion of the exhibition "Juste des Vêtements" (Just clothes) at the Fashion and Textile Museum, Paris, April 2005.

1 2 3 4 5 6 7 8 9 **10** 11 12 13 14 15 16 17 18 19 20 21 22 23 24 25 26 27 28 29 30 31

JANUARY

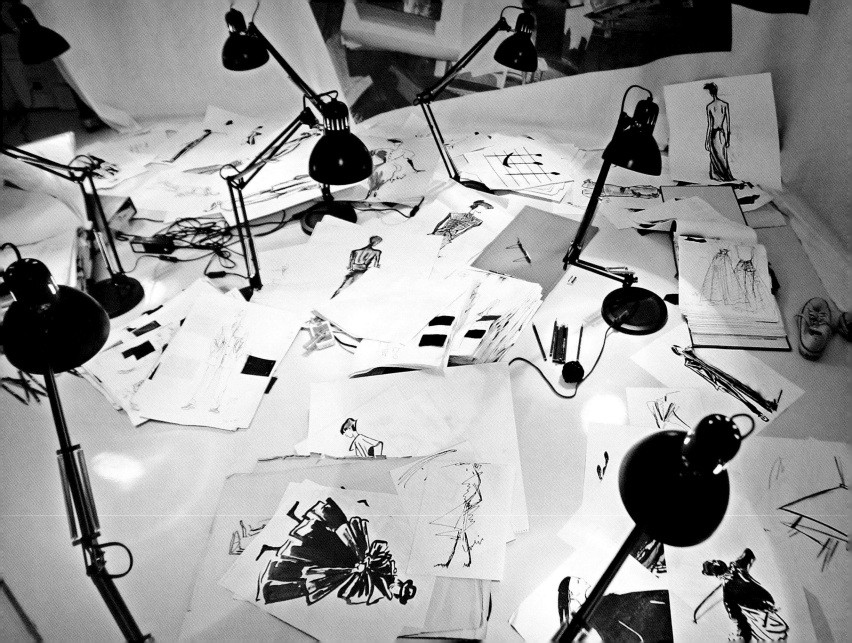

She (Coco Chanel) has, by a kind of miracle, worked in fashion according to rules that would seem to have value only for painters, musicians, and poets.

Jean Cocteau

There is scarcely a more fortunate and successful association in fashion than that between Karl Lagerfeld and the House of Chanel. The cosmopolitan German fashion designer and the famous Paris couture house seem to rush forward from one triumph to the next. And if one of the designs should happen to look a bit garish—every provocation is a calculation.

A model presents a creation by German designer KARL LAGERFELD for CHANEL during the Fall/Winter 2006/07 haute couture collections in Paris.

1 2 3 4 5 6 7 8 9 10 **11** 12 13 14 15 16 17 18 19 20 21 22 23 24 25 26 27 28 29 30 31

JANUARY

There is still a lot I want to achieve, my mind works very quickly and there isn't any room for complacency in this head!

Alexander McQueen

Fashion hides and fashion reveals. That is its charm, its erotic delight. A dress can often say more than a thousand looks.

A model peers through the gap in the high collar of this embroidered bodice from ALEXANDER MCQUEEN's Fall/Winter collection at London Fashion Week, 1996.

1 2 3 4 5 6 7 8 9 10 11 **12** 13 14 15 16 17 18 19 20 21 22 23 24 25 26 27 28 29 30 31

JANUARY

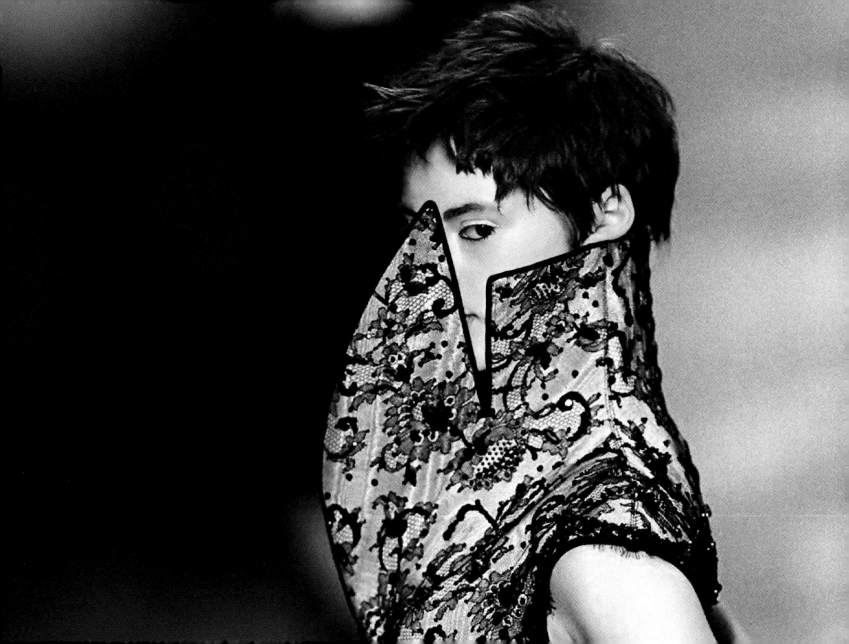

He for whom art is life, his life is a great work of art.

Johann Sebastian Bach

Sometimes an artist likes to stylize himself as a priest of his art. The appropriate robe was always an essential part of the image. Gustav Klimt's mistress Emilie Flöge designed new dresses without corsets. At the end of the nineteenth century they were appreciated by women's rights activists and were worn by the artists of the Vienna Secession.

GUSTAV KLIMT at Lake Atter in a frock designed by EMILIE FLÖGE, 1913.

1 2 3 4 5 6 7 8 9 10 11 12 **13** 14 15 16 17 18 19 20 21 22 23 24 25 26 27 28 29 30 31

JANUARY

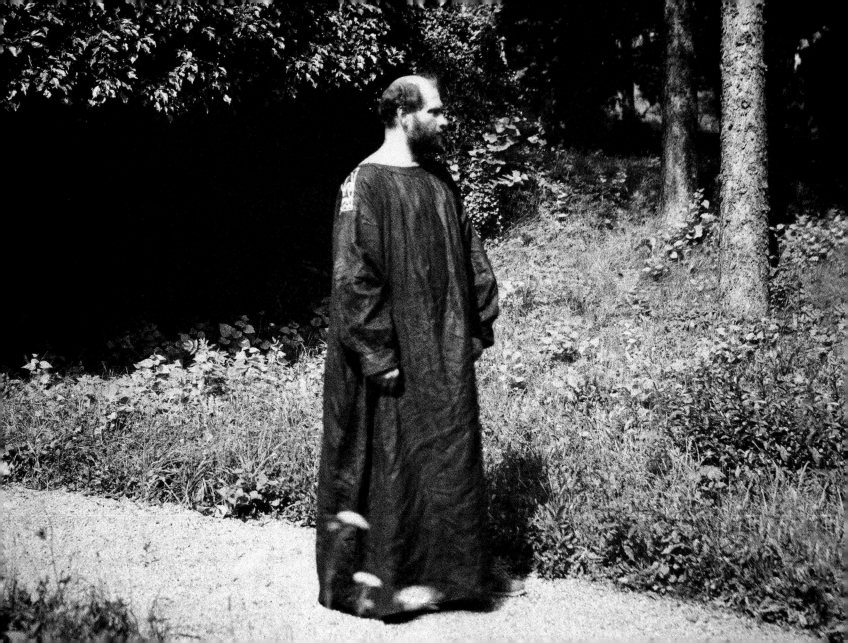

The sixties were a time when ordinary people could do extraordinary things…!

Twiggy

She was as skinny as a rake, made the miniskirt popular, and had the innocent look of a child—Twiggy was the "face" of the 1960s, the "Swinging Sixties." These days Twiggy sits on the jury of *America's Next Top Model* and helps to assess the potential of the next generation. The game must go on.

Legendary British model TWIGGY, originally Lesley Hornby (b. 1949), London, 1966.

1 2 3 4 5 6 7 8 9 10 11 12 13 **14** 15 16 17 18 19 20 21 22 23 24 25 26 27 28 29 30 31

JANUARY

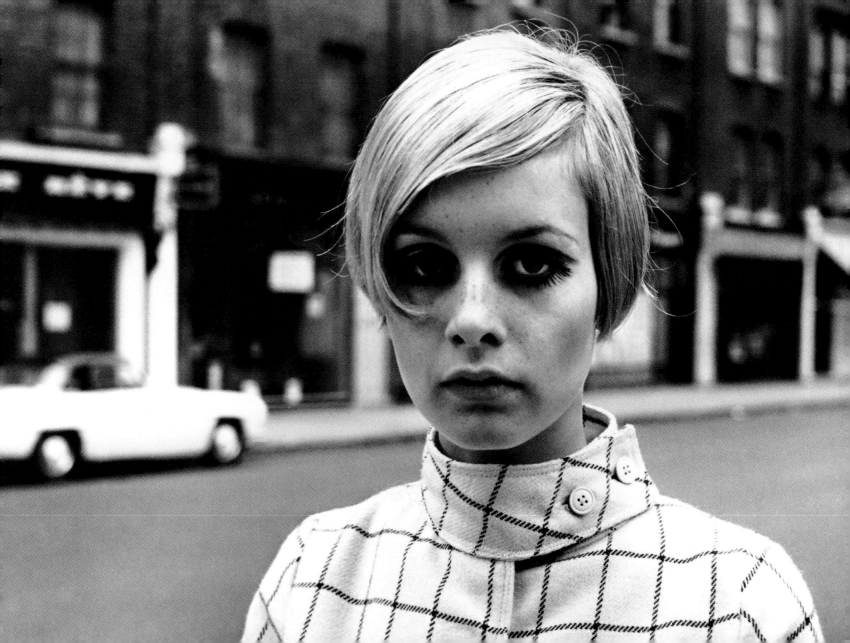

I'm writing my code for Givenchy without destroying its history. Givenchy was aristocratic because Mr. Givenchy always dressed aristocratic people—but it was aristocratic with craziness.

Riccardo Tisci

To be a bride; to be a princess. Haute couture plays up to woman's oldest longings.

A model shows off a design at the GIVENCHY show as part of the Fall/Winter 2006/07 haute couture collections in Paris.

1 2 3 4 5 6 7 8 9 10 11 12 13 14 **15** 16 17 18 19 20 21 22 23 24 25 26 27 28 29 30 31

JANUARY

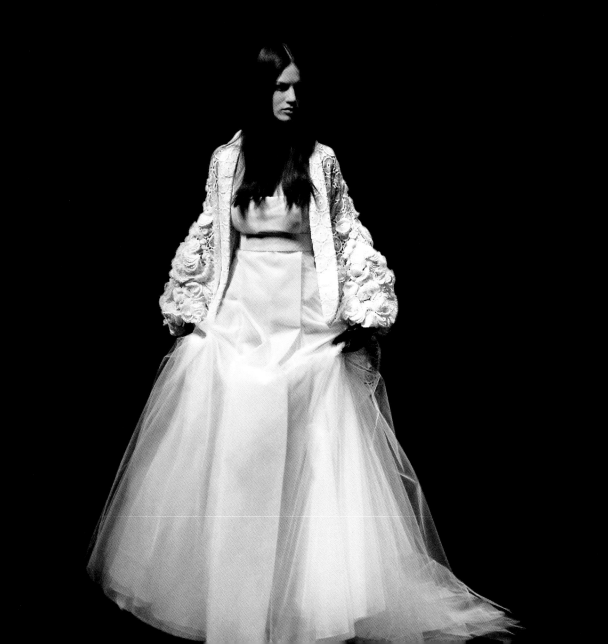

The functional must be the soul of a
dress, its composition, its interior rhythm…
aesthetics is the envelope.

André Courrèges

No designer combines flower power, emancipation, confidence in the future,
and the lightness of being as perfectly in his designs as André Courrèges during
the 1970s.
French designer ANDRÉ COURRÈGES poses among his models wearing part of his
1976 Spring/Summer haute couture collection.

1 2 3 4 5 6 7 8 9 10 11 12 13 14 15 **16** 17 18 19 20 21 22 23 24 25 26 27 28 29 30 31

JANUARY

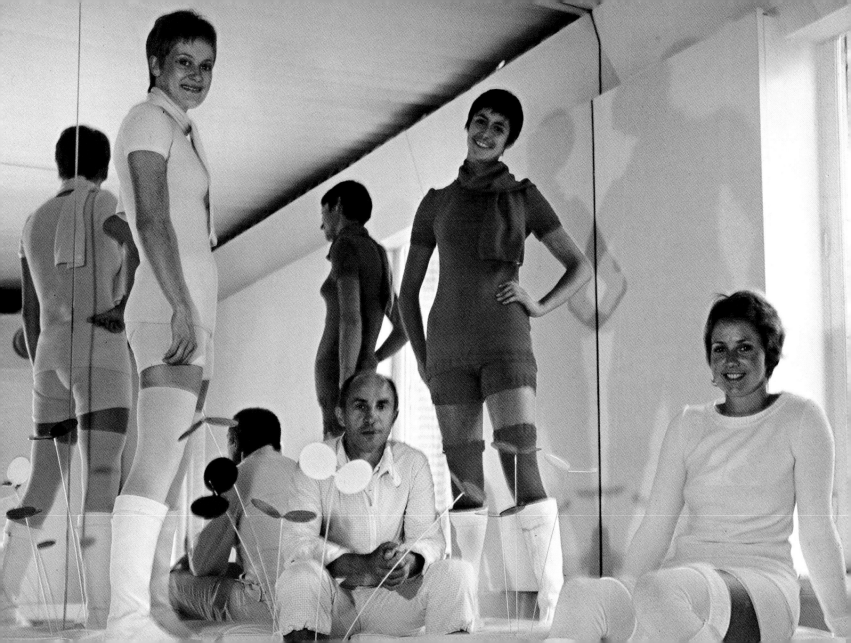

Fashion has become too sophisticated, too serious. Lighten up! You should enjoy it, like a good wine.

John Galliano

The end of the first decade of the twenty-first century is definitely romantic. Whoever doesn't believe that should take a look at John Galliano's designs.
A model displays an outfit created by JOHN GALLIANO during the Spring/Summer 2008 ready-to-wear collection show as part of Paris Fashion Week.

1 2 3 4 5 6 7 8 9 10 11 12 13 14 15 16 **17** 18 19 20 21 22 23 24 25 26 27 28 29 30 31

JANUARY

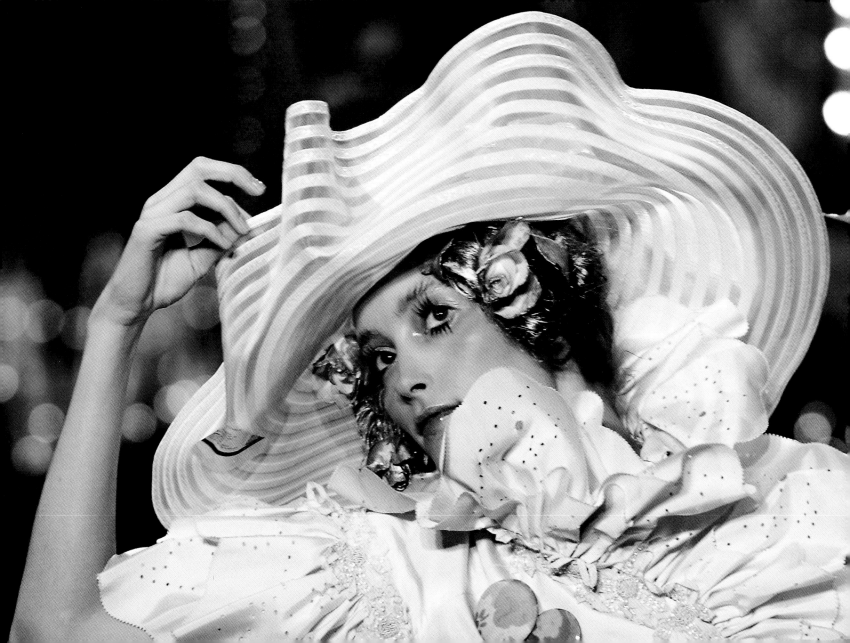

I don't do fashion, but clothes.

Véronique Nichanian

Always in line and perfectly in step. The strict choreography of a fashion show is serious business—not only at Hermès.

Models walk down the catwalk for French fashion house HERMÈS as part of the Fall/Winter 2007/08 men's ready-to-wear collections.

1 2 3 4 5 6 7 8 9 10 11 12 13 14 15 16 17 **18** 19 20 21 22 23 24 25 26 27 28 29 30 31

JANUARY

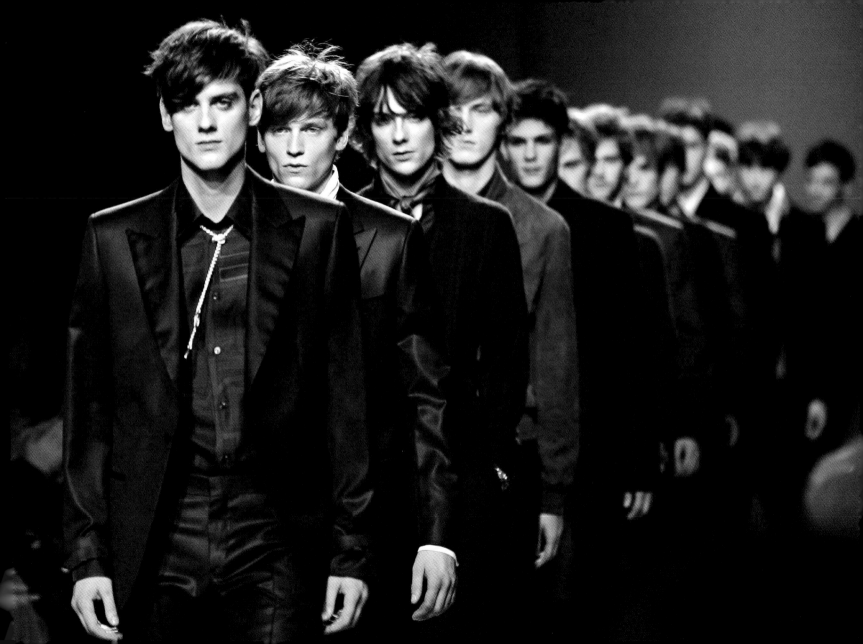

Accessories are what, in my opinion,
pull the whole look together and make
it unique.

Yves Saint Laurent

In fashion, it is always the little things, the details, which catch the eye.
Detail from the MICHAEL KORS Fall 2006 collection, Olympus Fashion Week,
New York.

1 2 3 4 5 6 7 8 9 10 11 12 13 14 15 16 17 18 19 20 21 22 23 24 25 26 27 28 29 30 31

JANUARY

I am married to fashion and I will
remain faithful.

Dirk Bikkembergs

Dirk Bikkembergs—born in 1959—is one of the great Belgian designers of the
"Antwerp Six" school. His fashion reflects power and energy; after all, the designer
has devoted himself to the spirit of sportswear. His trademark is the double seam.
In other words, twice as strong.
Models display outfits by DIRK BIKKEMBERGS during the Fall/Winter 2007/08 men's
collection at Milan Fashion Week.

1 2 3 4 5 6 7 8 9 10 11 12 13 14 15 16 17 18 19 20 21 22 23 24 25 26 27 28 29 30 31

JANUARY

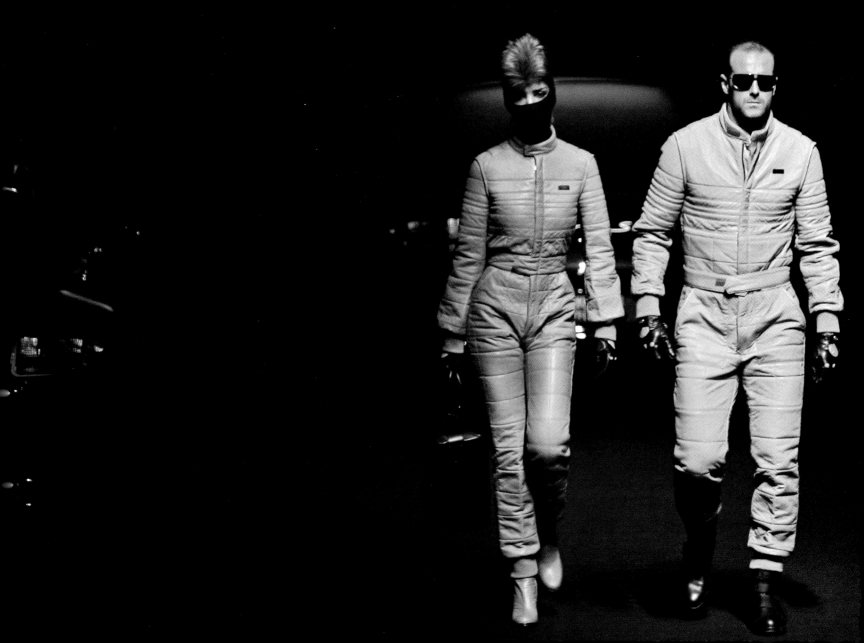

My work is about pushing the
boundaries of creation.

John Galliano

Placed in a sophisticated setting, lingerie is immediately transformed into a
surprising variation on "outerwear." Finding a new use for bodices is definitely
not for prudes—as Madonna has already proven.
A model presents a creation by British designer JOHN GALLIANO for CHRISTIAN DIOR
during the Spring/Summer 2004 ready-to-wear collections in Paris.

1 2 3 4 5 6 7 8 9 10 11 12 13 14 15 16 17 18 19 20 21 22 23 24 25 26 27 28 29 30 31

JANUARY

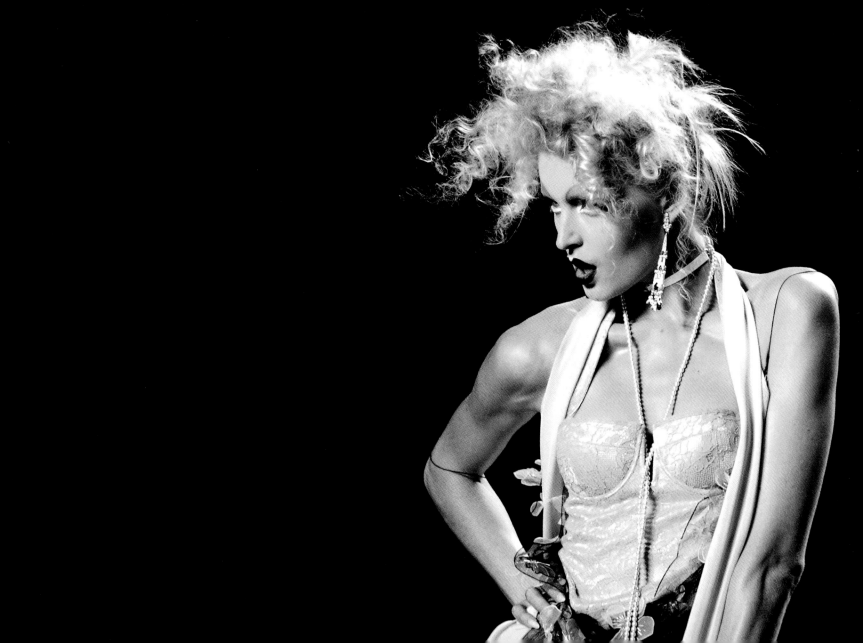

You can make political statements about
society by the clothes that you wear.
It's something I kept going on about for
the last twenty years.

Katharine Hamnett

Simple, reduced, and sexy, Katharine Hamnett's collections also reflect the
London designer's environmental and political awareness—without ever ending
up as an "ecological look."
Alluring—clothing created by British fashion designer KATHARINE HAMNETT, 1987.

1 2 3 4 5 6 7 8 9 10 11 12 13 14 15 16 17 18 19 20 21 22 23 24 25 26 27 28 29 30 31

JANUARY

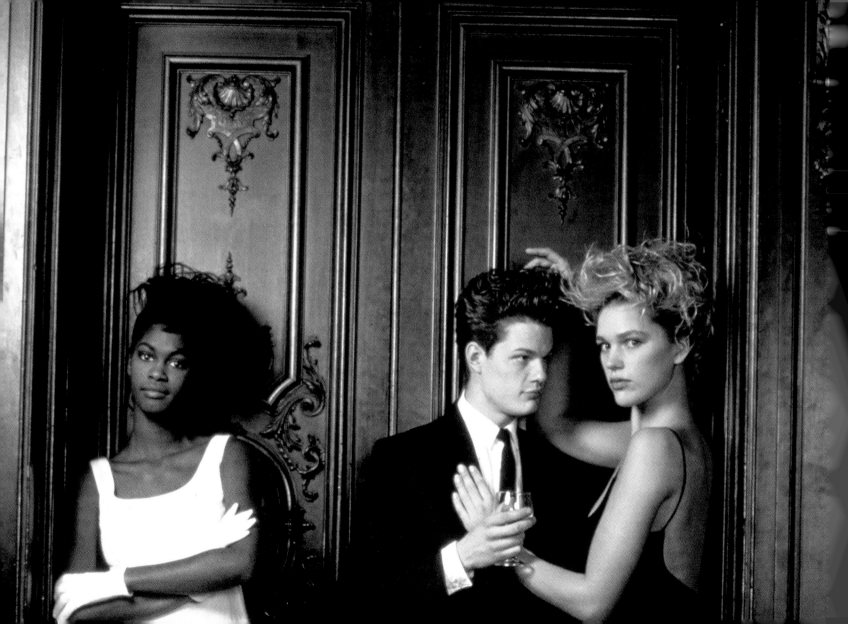

Her style looks absurdly simple—an effort-
less act of projection, a serpentine lasso
whereby her voice casually winds itself
around our most vulnerable fantasies.

Kenneth Tynan on Marlene Dietrich

Marlene Dietrich (1901–1992) was more than just a great German actress.
She was a star, a style icon, a symbol of non-conformism, of resistance—in fashion
as well. At a time when women had not yet thought of pants suits, she already
wore one. Even though she impudently claimed, "If you want to keep your
beautiful legs, you have to get them massaged by the admiring looks of men."
Well, the Diva's entire attitude seemed to invite that treatment. Which was why
"La Dietrich" kept not only her legs beautiful throughout her life.
German actress MARLENE DIETRICH in a purple pants suit, ca. 1950.

1 2 3 4 5 6 7 8 9 10 11 12 13 14 15 16 17 18 19 20 21 22 23 24 25 26 27 28 29 30 31

JANUARY

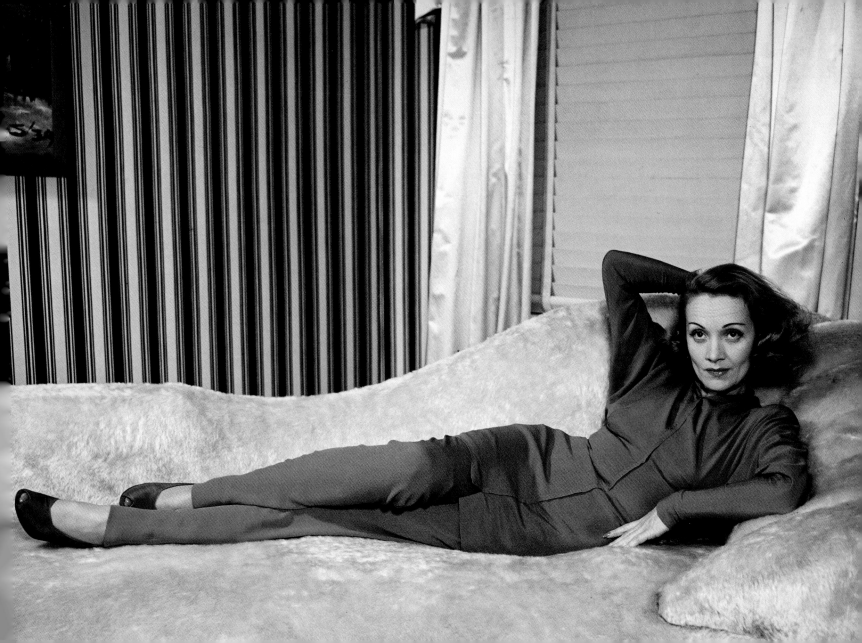

I am here to make people dream,
to seduce them into buying beautiful
clothes and to strive to make amazing
clothing to the best of my ability.
That is my duty.

John Galliano

A complexion like a china doll—extraterrestrial, otherworldly. The make-up worn by John Galliano's models leaves plenty of room for analogy.
Close-up of a model on the catwalk during the CHRISTIAN DIOR fashion show, Spring/Summer 2007 haute couture collections, Paris.

1 2 3 4 5 6 7 8 9 10 11 12 13 14 15 16 17 18 19 20 21 22 23 24 25 26 27 28 29 30 31

JANUARY

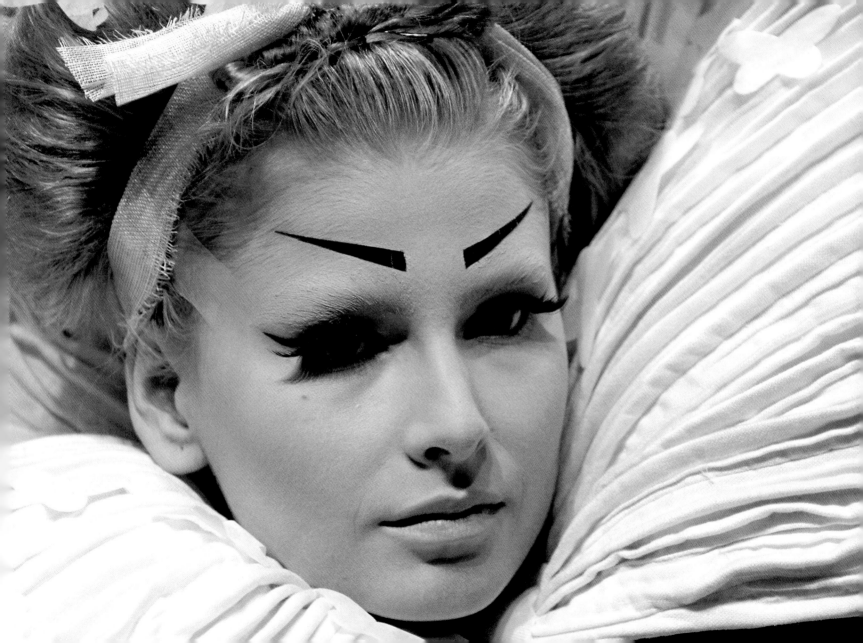

The life of a couturier is a magnificent
and continuous torture.

Jacques Heim

Is that Alfred Hitchcock choosing a film costume? No. When examining fabrics,
Jacques Heim's love of and attention to detail merely demonstrate the same
meticulous concentration. Control freaks leave nothing to chance.
French designer JACQUES HEIM examines a jacket and headscarf in his
workshop. 1965.

1 2 3 4 5 6 7 8 9 10 11 12 13 14 15 16 17 18 19 20 21 22 23 24 25 26 27 28 29 30 31

JANUARY

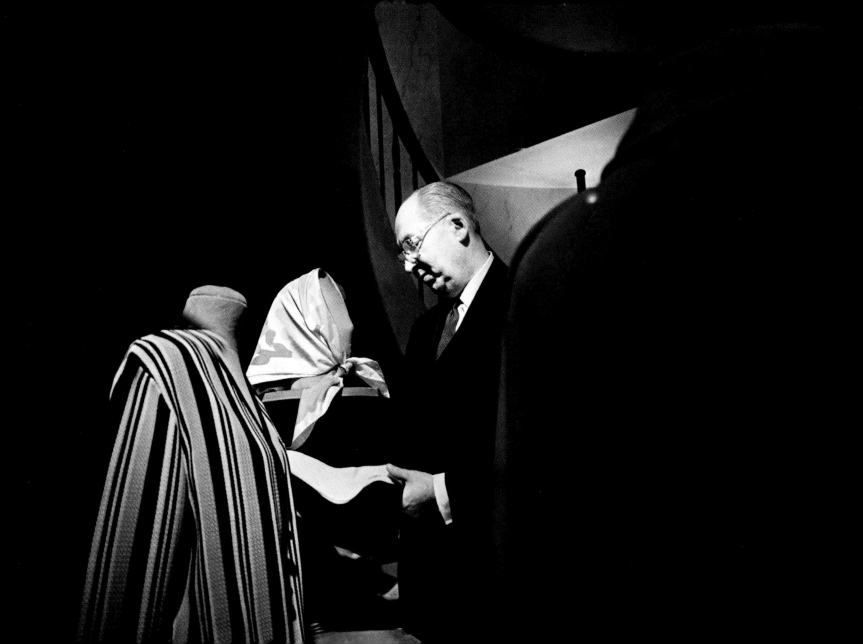

When a work appears to be ahead of
its time, it is only the time that is behind
the work.

Jean Cocteau

Will it make it from the catwalk to the street? At every fashion show, the critics
in the first row are as feared as they are respected.
Models walk down the runway during the HERMÈS Fall/Winter 2005/06 ready-to-
wear fashion show as part of the Paris Fashion Week.

1 2 3 4 5 6 7 8 9 10 11 12 13 14 15 16 17 18 19 20 21 22 23 24 25 26 27 28 29 30 31

JANUARY

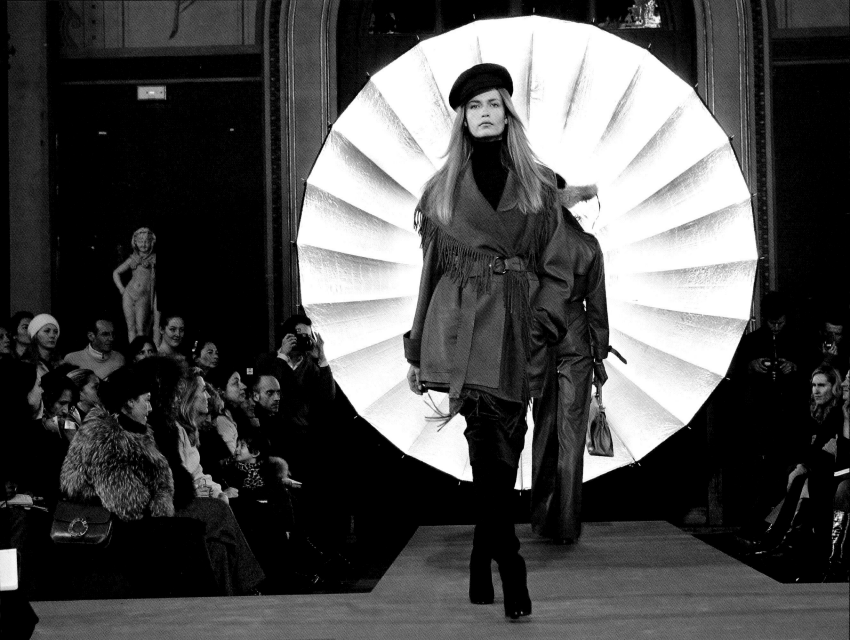

There is no fashion which women would not have the power to implement.

Peter Bamm

Well brought-up, well-dressed, and still cheeky! The emancipated woman of the Roaring Twenties was half Lolita, half vamp; she wore a flowered dress and a feather boa, cut her hair in a bob, and went out to enjoy herself—with or without a man.

Four women present outfits by LOUONDA for the racing season, 1928.

1 2 3 4 5 6 7 8 9 10 11 12 13 14 15 16 17 18 19 20 21 22 23 24 25 26 27 28 29 30 31

JANUARY

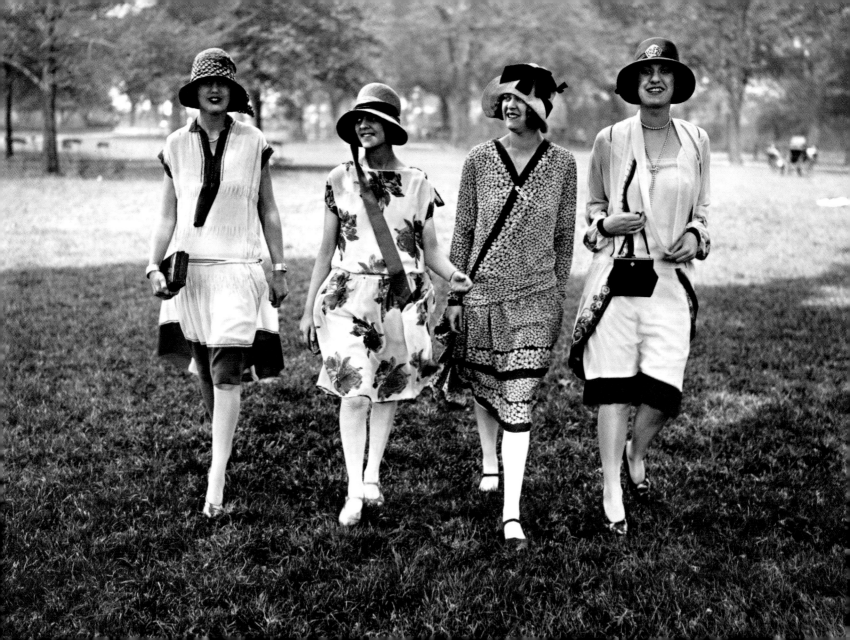

A sense of narrative inspires me,
it gives me a sense of richness.

John Galliano

Lavish! In daily life, fabric sometimes collapses like a soggy meringue.
A model presents a creation by DIOR during the Spring/Summer 2005 fashion
show collections at Paris Fashion Week.

1 2 3 4 5 6 7 8 9 10 11 12 13 14 15 16 17 18 19 20 21 22 23 24 25 26 27 28 29 30 31

JANUARY

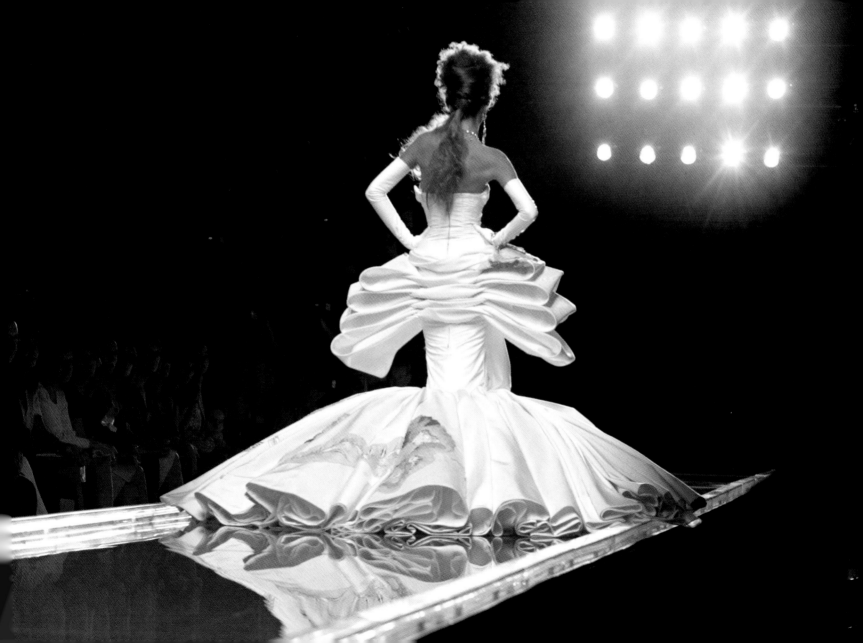

If you dress up it helps your personality
to emerge—if you choose well.

Vivienne Westwood

Vivienne Westwood is the most successful woman designer in the United
Kingdom. She has always followed her chosen route through punk and pomp.
And she has always been a lady with style, a proud, intelligent woman.
British fashion designer VIVIENNE WESTWOOD on the catwalk during the Spring/
Summer 2008 Paris Fashion Week.

1 2 3 4 5 6 7 8 9 10 11 12 13 14 15 16 17 18 19 20 21 22 23 24 25 26 27 28 29 30 31

JANUARY

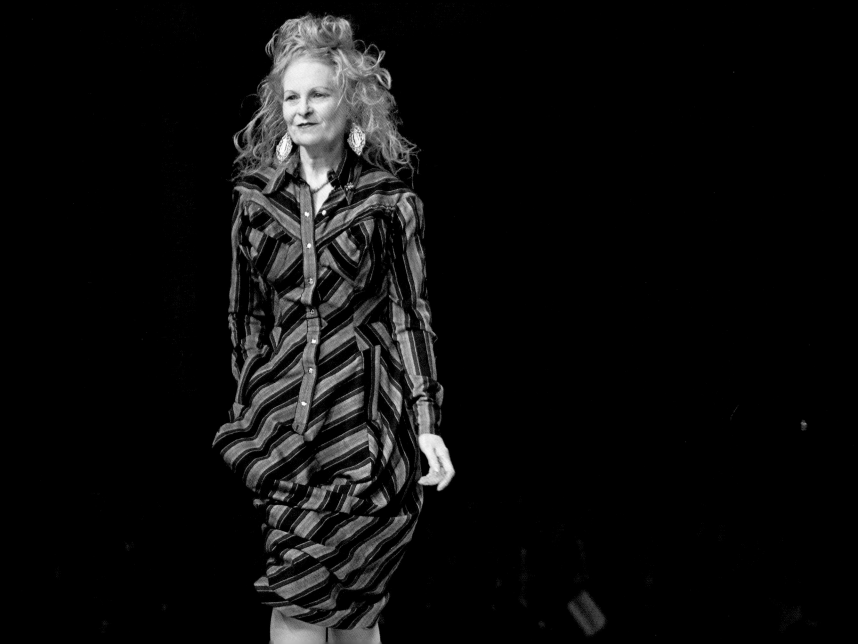

There's no point in design for designer's
sake. Everything I believe in is about
getting women dressed.

Michael Kors

Faster! Faster! Does fashion revolve around us? Or do we revolve around fashion?
A model walks the runway at the MICHAEL KORS Spring 2006 fashion show during
Olympus Fashion Week, New York.

1 2 3 4 5 6 7 8 9 10 11 12 13 14 15 16 17 18 19 20 21 22 23 24 25 26 27 28 29 30 31

JANUARY

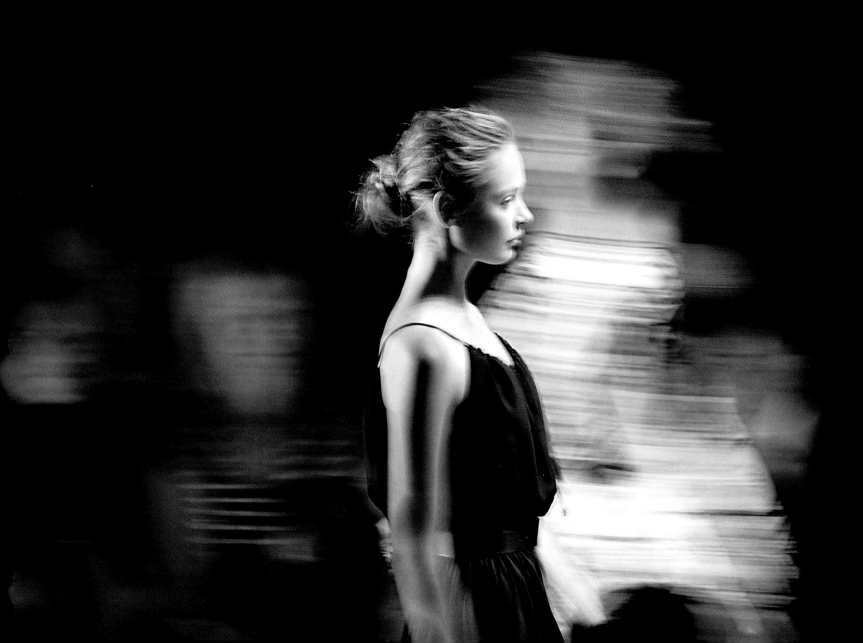

The dressing room is a picture of hell, whereas to the public it has to appear as a bouquet.

Christian Dior

A dream job? Keeping up appearances is hard work for models, often to the point of physical—sometimes even psychological—exhaustion.
An exhausted model sleeps backstage during the GIORGIO ARMANI Spring/Summer 2007 "One Night Only" fashion show, London.

1 2 3 4 5 6 7 8 9 10 11 12 13 14 15 16 17 18 19 20 21 22 23 24 25 26 27 28 29 30 31

JANUARY

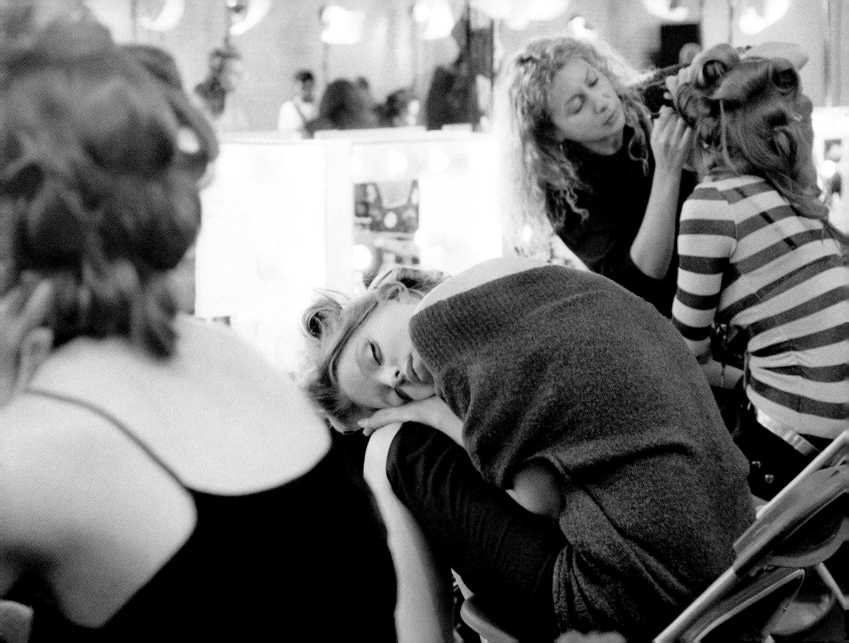

Intent is an actual focus of wishes given
to one who wears the clothes.

Fause Haten

All eyes are on her. The young woman is walking down the catwalk towards us.
But will she turn our heads when we pass her on the street in the same outfit?
That is the question. The answer is the great unknown of the fashion game.
A model presents a dress by FAUSE HATEN during São Paulo Fashion Week, 2008.

1 2 3 4 5 6 7 8 9 10 11 12 13 14 15 16 17 18 19 20 21 22 23 24 25 26 27 28

FEBRUARY

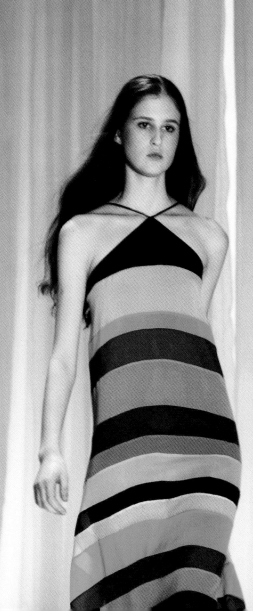

Kids repel the change and
Bring back the street
Shops filled by whole nations
Carnaby Street

The Jam, "Carnaby Street"

Platform shoes definitely satisfy our yearning for the monumental. At the end of the seventies, pop stars like Diana Ross, Stevie Nicks, and Elton John owned entire collections of shoes like these.

A stylish platform shoe with white stitching, from London's Carnaby Street, 1975.

1 2 3 4 5 6 7 8 9 10 11 12 13 14 15 16 17 18 19 20 21 22 23 24 25 26 27 28

FEBRUARY

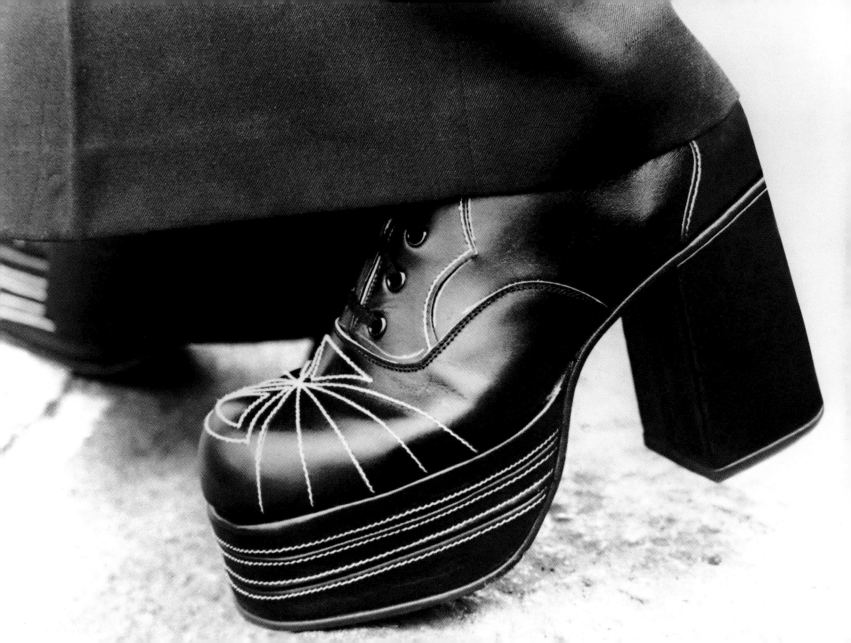

I made clothes because I was looking
for something that didn't exist.
I had to try to create my own world.

Thierry Mugler

The human fetish—Thierry Mugler's fashionable creations can be reduced precisely to this. Born in Strasbourg in 1948, he fascinates us with his theatrical designs. For years we laughed at them and treated them as fancy dress. A model wears a suit and futuristic sequined headwear for the THIERRY MUGLER Spring/Summer 2008 men's ready-to-wear collection, Paris.

1 2 3 4 5 6 7 8 9 10 11 12 13 14 15 16 17 18 19 20 21 22 23 24 25 26 27 28

FEBRUARY

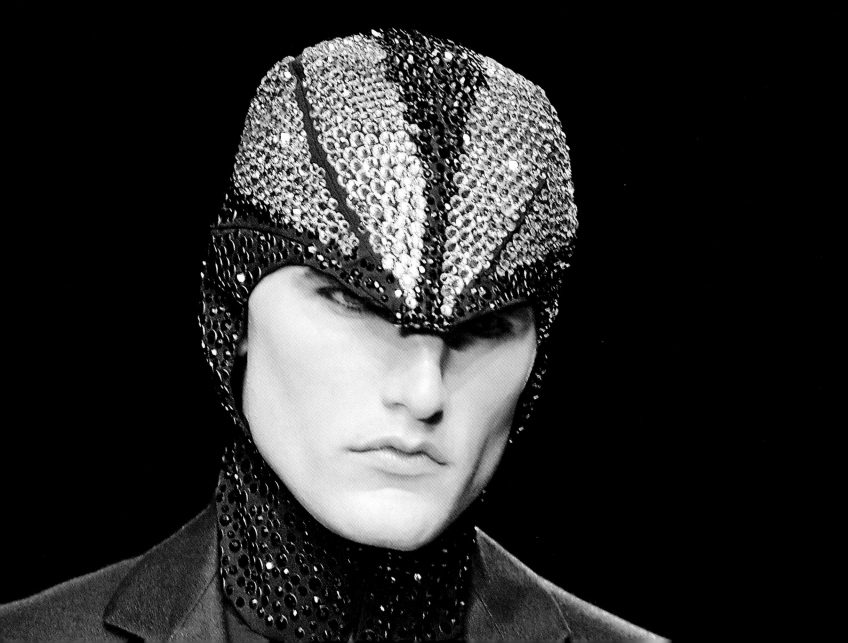

In a machine age, dressmaking is
one of the last refuges of the human,
the personal, the inimitable. In an
epoch as somber as ours, luxury must
be defended inch by inch.

Christian Dior

What do coat and model most fear? The disapproving look of the maestro, or
his merciless pointer? Fashion is unforgiving when it comes to swinging pleats.
French couturier CHRISTIAN DIOR inspects a design in his Paris studio, 1952.

1 2 3 4 5 6 7 8 9 10 11 12 13 14 15 16 17 18 19 20 21 22 23 24 25 26 27 28

FEBRUARY

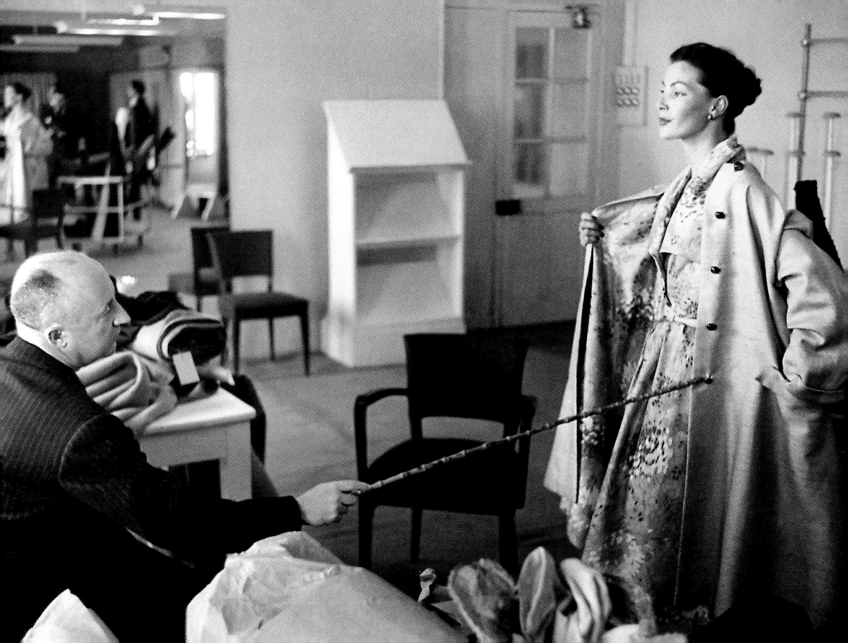

In fashion you are supposed to hate
what you have loved before. I cannot
do that.

Jean Paul Gaultier

Typical Gaultier. Each design is an act of homage to the endless variety of
women. Leather and tulle; rocker bride and ballerina. Jean Paul Gaultier was
predestined to become Madonna's favorite designer.
Agyness Deyn presents a creation by French designer JEAN PAUL GAULTIER during
the Spring/Summer 2007 ready-to-wear collections in Paris.

1 2 3 4 **5** 6 7 8 9 10 11 12 13 14 15 16 17 18 19 20 21 22 23 24 25 26 27 28

FEBRUARY

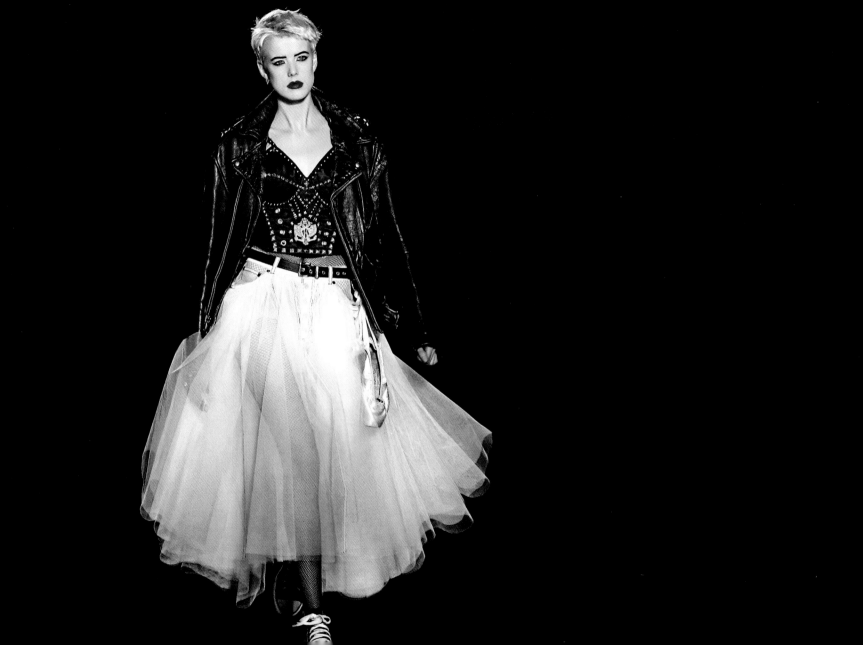

There are a lot of negative feelings
towards global businesses now. It is
time to do something more individual
and personal.

Miuccia Prada

True beauty always lies in the eye of the beholder.
Close-up of a model backstage at the PRADA Fall/Winter 2007/08 fashion show,
Milan.

1 2 3 4 5 **6** 7 8 9 10 11 12 13 14 15 16 17 18 19 20 21 22 23 24 25 26 27 28

FEBRUARY

A hat cannot actually give one golden curls if
the hair is mouse-colored and stringy; it cannot
lift a face, pay overdue bills, subtract ten years
from one's age, or transform a plain soul into
a reigning princess. But it can lend practically
any woman a temporary out-of-herself feeling.
For the right hat creates a desired mood, and
that isn't fiction or fancy, but fact, fact, fact.

John P. John

The high and mighty are always at their most fashionable when they are
accessorized. Thus hats and bags have always been especially important
in fashion.
A woman wearing a picture hat marvels at a hat fantasy by MR. JOHN in a
boutique window on 57th Street in New York, ca. 1950.

1 2 3 4 5 6 **7** 8 9 10 11 12 13 14 15 16 17 18 19 20 21 22 23 24 25 26 27 28

FEBRUARY

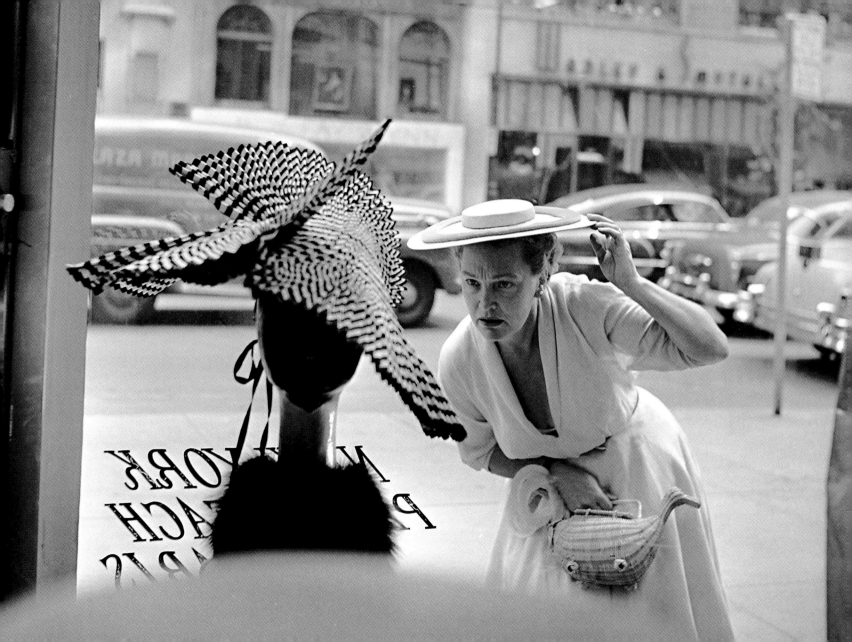

I'm past the stage of being rebellious.

Anna Sui

Heavy Metal, extra-light—with greetings from Paco Rabanne. Anna Sui, born in 1955 in Detroit, the daughter of Chinese immigrants, often harks back to the cuts and fabrics of the 1970s in her designs.
A model displays a shimmering outfit by U.S. fashion designer ANNA SUI during Mercedes-Benz Fashion Week in New York, September 2007.

1 2 3 4 5 6 7 **8** 9 10 11 12 13 14 15 16 17 18 19 20 21 22 23 24 25 26 27 28

FEBRUARY

I try to sketch the future by mixing past
and present, space and time.

Christian Lacroix

One girl. One outfit. One number. But who is Lily? What is Missy dreaming of?
Is Sara happy?
Numbered Polaroid pictures of models are displayed backstage during the
presentation of the Spring/Summer 2005 women's collection by French fashion
designer CHRISTIAN LACROIX for the Italian line PUCCI at Milan Fashion Week.

1 2 3 4 5 6 7 8 9 10 11 12 13 14 15 16 17 18 19 20 21 22 23 24 25 26 27 28

FEBRUARY

My philosophy is evolution,
not revolution.

Giorgio Armani

Time and again, fashion comes to life in its allusions. Remembrance of times past. Sometimes we even remember warm ears in convertibles, or bikers who used to be known as the Hell's Angels.
Models wear outfits from Italian designer GIORGIO ARMANI during the Fall/Winter 2002/03 ready-to-wear collection show.

1 2 3 4 5 6 7 8 9 **10** 11 12 13 14 15 16 17 18 19 20 21 22 23 24 25 26 27 28

FEBRUARY

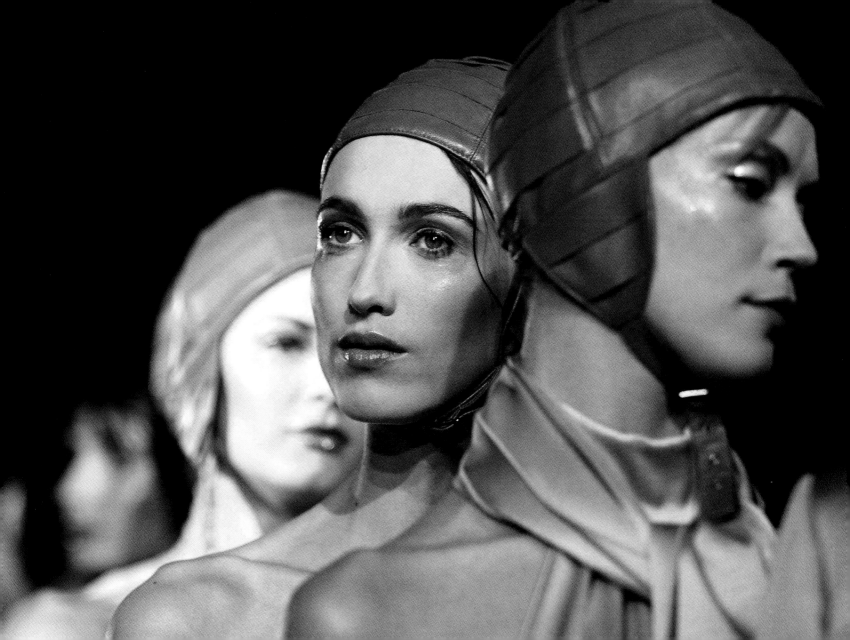

Design is never practical. In the beginning at least it is nothing for everyday use. Only after twenty, thirty years for example does fashion, which at first was art, become wearable. The proportions change.

Pierre Cardin

Sex and futurism, pure and simple. In the late 1960s, that was what the name of designer Pierre Cardin stood for. His formalist creations are as famous as his tightly fitting over-the-knee boots, as soft and supple as gloves.
Model Sin-May Zao poses in a short day dress and an evening dress by French innovator PIERRE CARDIN, 1968.

1 2 3 4 5 6 7 8 9 10 **11** 12 13 14 15 16 17 18 19 20 21 22 23 24 25 26 27 28

FEBRUARY

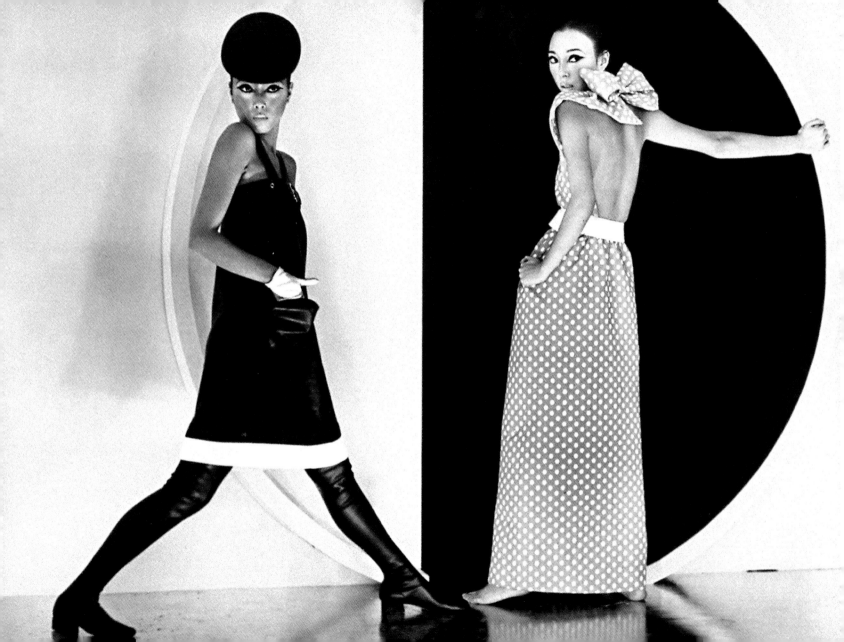

I don't want to be avant-garde.
I like beautiful clothes. I don't care
what people think about me.

Julien MacDonald

A completely new approach to lace—and typical MacDonald. The collections
and shows of the British designer, born in 1954, are shrill and loud, sexy and
glamorous. He has considerably increased the turnover of the haute couture
House of Givenchy in Paris.
A model wears an outfit created by JULIEN MACDONALD for French fashion house
GIVENCHY during their Spring/Summer 2003 haute couture collection in Paris.

1 2 3 4 5 6 7 8 9 10 11 **12** 13 14 15 16 17 18 19 20 21 22 23 24 25 26 27 28

FEBRUARY

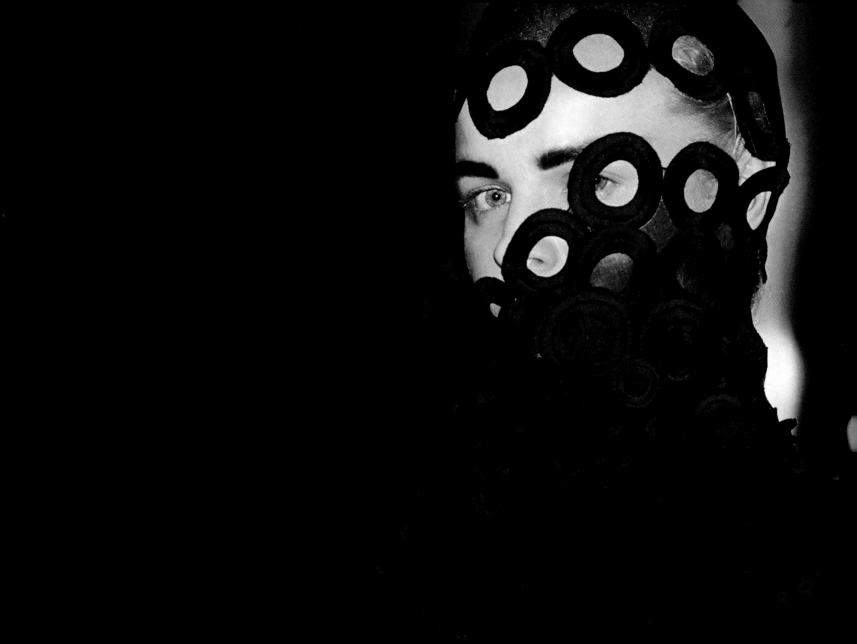

Style to me is about an attitude to dressing and a certain confidence in knowing what really suits you.

Matthew Williamson

The color orange is back! With his shapes and colors, Pucci shows that the 1970s are gone but not forgotten. Fashion designers have an excellent memory.
Models walk down the catwalk during the EMILIO PUCCI fashion show as part of the Fall/Winter 2007/08 Milan Fashion Week.

1 2 3 4 5 6 7 8 9 10 11 12 **13** 14 15 16 17 18 19 20 21 22 23 24 25 26 27 28

FEBRUARY

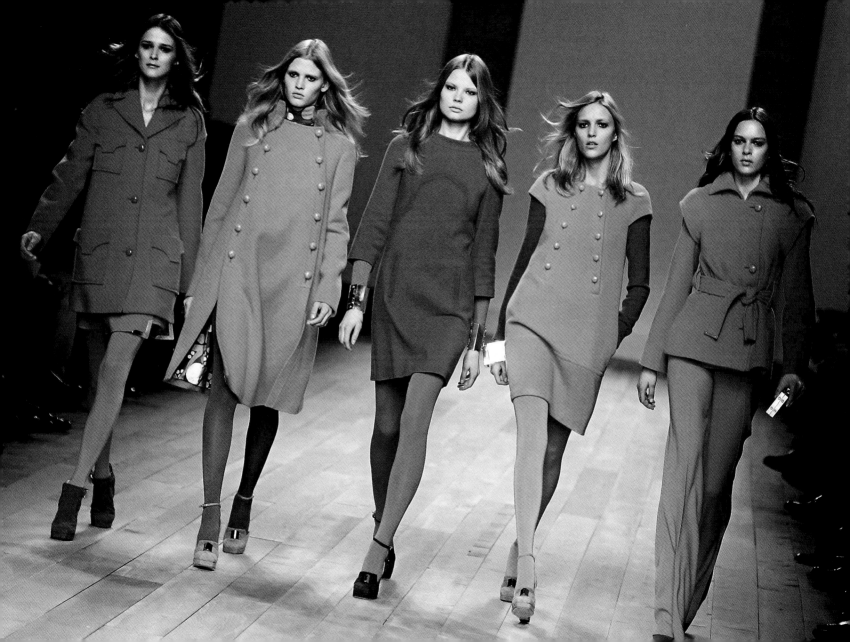

All memory is present.

Novalis

There are people who claim that a woman isn't really a woman until she owns a Hermès handbag. Whether it's the model Birkin or Bugatti, Kelly or Kleber—your prize possession must be purchased at 24, Rue du Faubourg Saint-Honoré in Paris. Where else?

An early HERMÈS handbag, Paris, 1937.

1 2 3 4 5 6 7 8 9 10 11 12 13 **14** 15 16 17 18 19 20 21 22 23 24 25 26 27 28

FEBRUARY

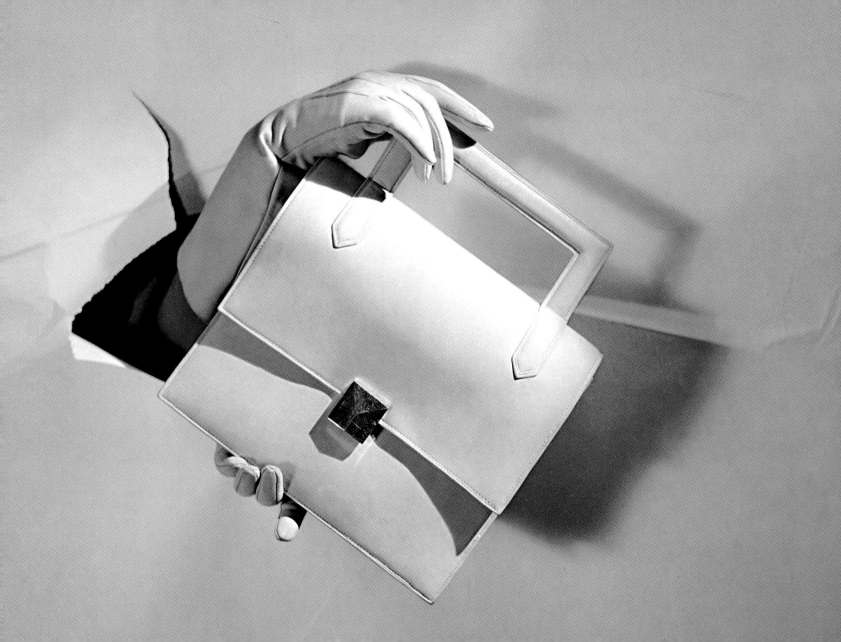

You used color to rebel; I used
monochrome to rebel.

Iman Abdulmajid

The idea of combining leather with diamonds must have been born of an
archaic desire. Maybe fashion designers are the true anthropologists of our time.
At the 55th Cannes Film Festival Somalian supermodel IMAN displays an aubergine
leather choker and bracelet, both studded with diamonds, 2002.

1 2 3 4 5 6 7 8 9 10 11 12 13 14 **15** 16 17 18 19 20 21 22 23 24 25 26 27 28

FEBRUARY

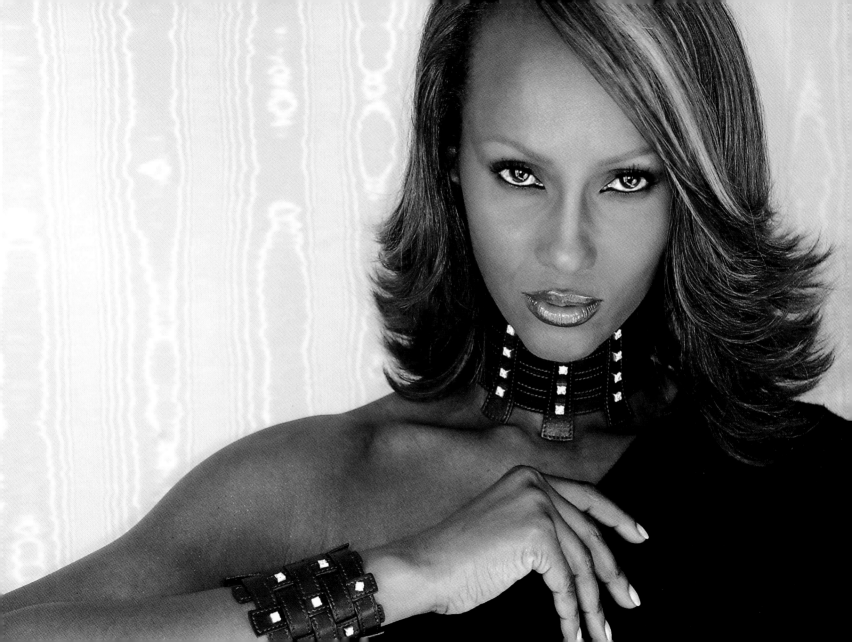

I'll be at charges for a looking-glass,
And entertain a score or two of tailors,
To study fashions to adorn my body:
Since I am crept in favour with myself,
I will maintain it with some little cost.

William Shakespeare, *The Tragedy of King Richard III*

Paul Poiret (1879–1944) is regarded as the "first designer" in the fashion world. Poiret had declared war on tight corsets, freeing women from "the slavery of their clothing." But then in 1910 a new form of slavery was introduced: Poiret invented the (in)famous "hobble skirt", which was so narrow at the hem that the wearer was forced to take little teetering steps like a geisha. The American patron of the arts, Peggy Guggenheim, had oriental robes made for her by Poiret; she was later photographed wearing them by Man Ray.

PAUL POIRET and his tailor during a fitting, 1925.

1 2 3 4 5 6 7 8 9 10 11 12 13 14 15 **16** 17 18 19 20 21 22 23 24 25 26 27 28

FEBRUARY

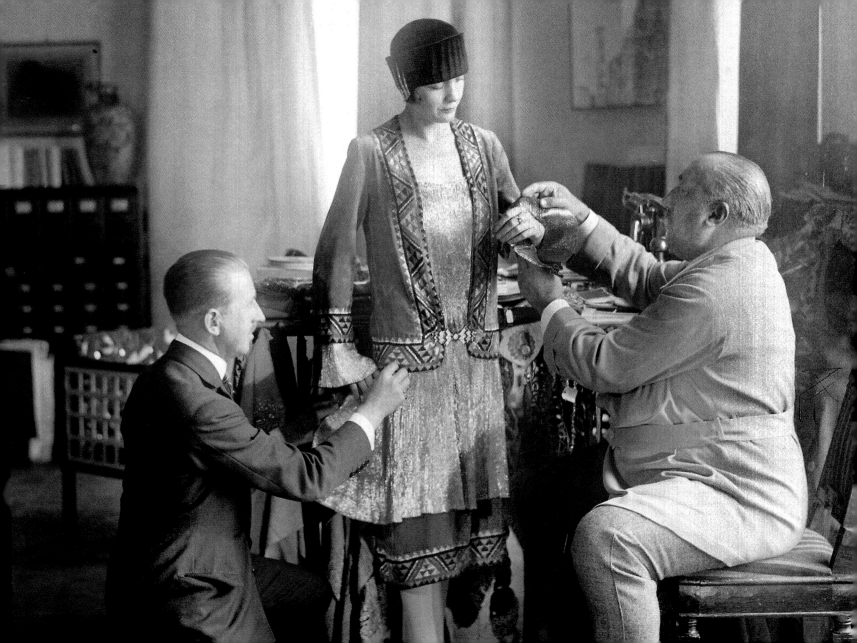

We need to learn to decipher and
translate the symbols, signals, and
hieroglyphs that tell us about the future.
Even if only to find them in ourselves.

Jil Sander

It's so simple, the fashion by German designer Jil Sander. The native of Hamburg
is happy to let her colleagues find the courage to come up with something shrill
and extravagant in form and color.
A model displays a creation by German designer JIL SANDER during the Spring/
Summer 2006 men's collections at Milan Fashion Week.

1 2 3 4 5 6 7 8 9 10 11 12 13 14 15 16 **17** 18 19 20 21 22 23 24 25 26 27 28

FEBRUARY

Never worry about the facts, just project
an image to the public.

Diana Vreeland

"Babe Paley had only one fault: she was perfect. Otherwise she was perfect,"
quipped Truman Capote.
American socialite BABE PALEY, wife of CBS founder WILLIAM PALEY (rear,
with camera), stands by the pool at their cottage in Round Hill, Jamaica.

1 2 3 4 5 6 7 8 9 10 11 12 13 14 15 16 17 **18** 19 20 21 22 23 24 25 26 27 28

FEBRUARY

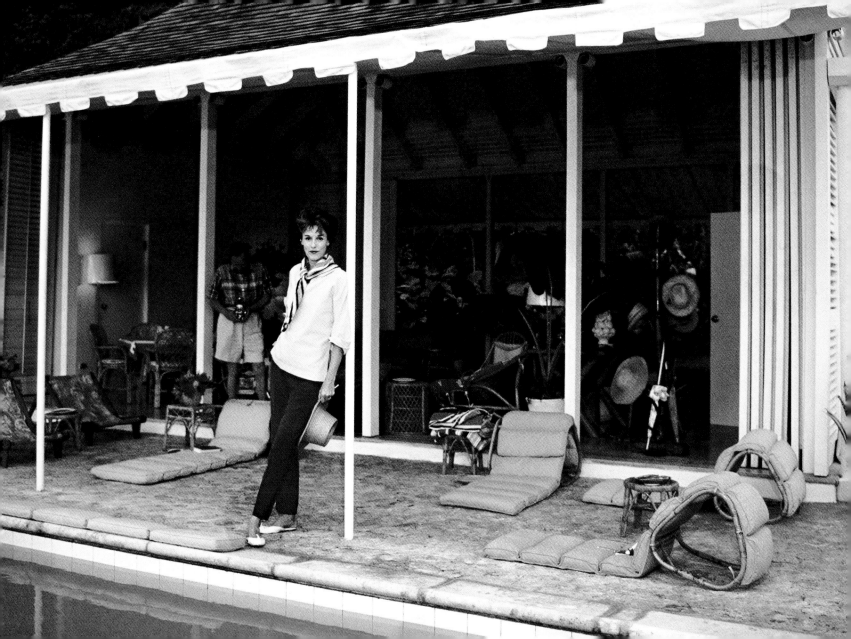

Fashion is a movie. Every morning when you get dressed, you direct yourself.

Thierry Mugler

A tweed jacket with a leather collar sends out a signal—its wearer is walking the tightrope between arrogance and extravagance.
Models present creations by THIERRY MUGLER during the Fall/Winter 2006/07 men's ready-to-wear collections in Paris.

1 2 3 4 5 6 7 8 9 10 11 12 13 14 15 16 17 18 19 20 21 22 23 24 25 26 27 28

FEBRUARY

I haven't yet made clothes that I have
been totally satisfied with, and maybe
I never will.

Rei Kawakubo

Child, or woman? Or both? Columbina from the commedia dell'arte still
entices us.
A model walks the catwalk during the COMME DES GARÇONS fashion show
as part of Paris Fashion Week Fall/Winter 2007/08.

1 2 3 4 5 6 7 8 9 10 11 12 13 14 15 16 17 18 19 20 21 22 23 24 25 26 27 28

FEBRUARY

As a fashion designer, I think I play
a role in reflecting society rather than
in changing society.

Giorgio Armani

The triumph of wearability! Giorgio Armani is the grand master of purism.
His unadorned, intelligent, and invariably highly elegant style revolutionized
fashion during the 1980s like no other.
Models walk down the runway at the GIORGIO ARMANI fashion show during Milan
Fashion Week Fall/Winter 2005/06 at the Armani Theater.

1 2 3 4 5 6 7 8 9 10 11 12 13 14 15 16 17 18 19 20 21 22 23 24 25 26 27 28

FEBRUARY

I think reinterpreting things with today's
influences, today's fabric technology,
is what it's all about.

John Galliano

Fashion is also theater. And as such it has much in common with the operetta.
That it pleases the audience is okay—as long as they buy it.
British designer JOHN GALLIANO walks down the catwalk, surrounded by his
models, during the CHRISTIAN DIOR fashion show as part of Paris Fashion Week
Fall/Winter 2007/08.

1 2 3 4 5 6 7 8 9 10 11 12 13 14 15 16 17 18 19 20 21 22 23 24 25 26 27 28

FEBRUARY

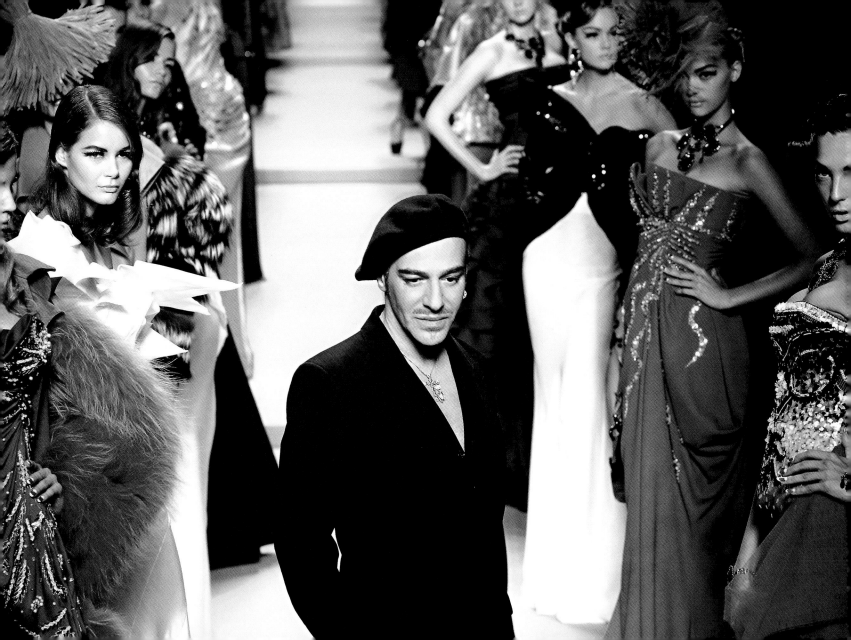

I felt certain that the movies would
become America's Paris. Consequently,
when women went to the movies,
they would look to film divas as fashion
role models.

Adrian

Style icon Greta Garbo had no need for fashion—but fashion needed
Greta Garbo. And so she became a mirror of her time.
Portrait of Swedish-born film actress GRETA GARBO, 1930.

1 2 3 4 5 6 7 8 9 10 11 12 13 14 15 16 17 18 19 20 21 22 23 24 25 26 27 28

FEBRUARY

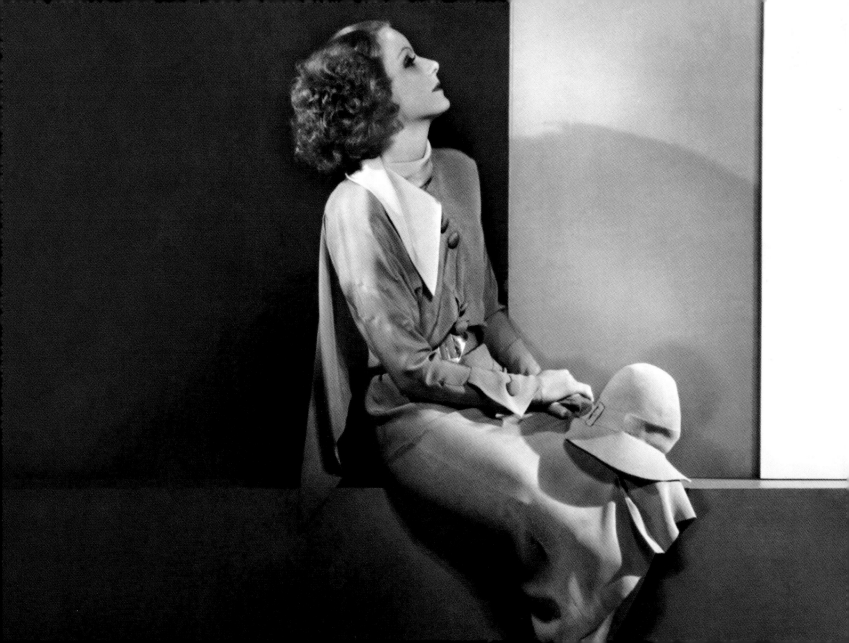

Domenico (Dolce) and Stefano
(Gabbana) are having a love affair
with the entire world.

Brooke Shields

The fetish look lives most intensely in shoe fashion, making high heels an object of desire. Behavioral scientists have interpreted the stretched leg in many species as a sign of the willingness to mate.
Shoes of a model walking down the catwalk during the DOLCE & GABBANA fashion show as part of the Fall/Winter 2007/08 women's ready-to-wear collections in Milan.

1 2 3 4 5 6 7 8 9 10 11 12 13 14 15 16 17 18 19 20 21 22 23 24 25 26 27 28

FEBRUARY

My ultimate goal: to offer haute couture pieces as an integral of the ready-to-wear collection.

Alexander McQueen

The body and its cover! In fashion, everything is possible—and everything is permitted. Even a glamorous encounter between the Renaissance and Ancient Egypt within a single design.
A model wears a creation by British designer ALEXANDER MCQUEEN during the presentation of the Fall/Winter 2004/05 collections at Paris Fashion Week.

1 2 3 4 5 6 7 8 9 10 11 12 13 14 15 16 17 18 19 20 21 22 23 24 25 26 27 28

FEBRUARY

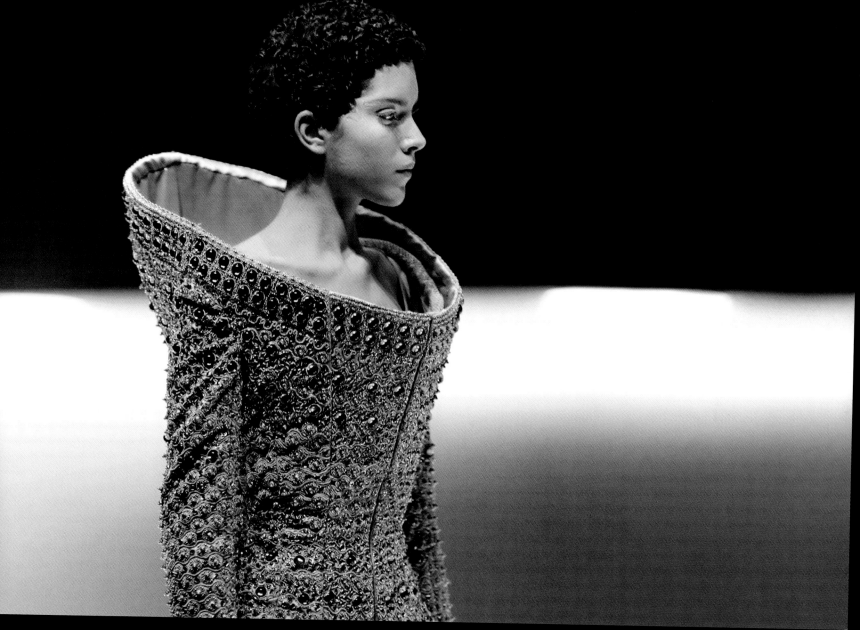

Sportswear is "dressing up" for leisure.

Birgit Richard

The aesthetic of sport has become the aesthetic of fashion. Sport, one of the top sources of inspiration for fashion designers after pop music and television, has found a niche for itself as "sportswear."
Football and rugby shirts and accessories by Adidas, Puma, Converse, and more, 1977.

1 2 3 4 5 6 7 8 9 10 11 12 13 14 15 16 17 18 19 20 21 22 23 24 25 26 27 28

FEBRUARY

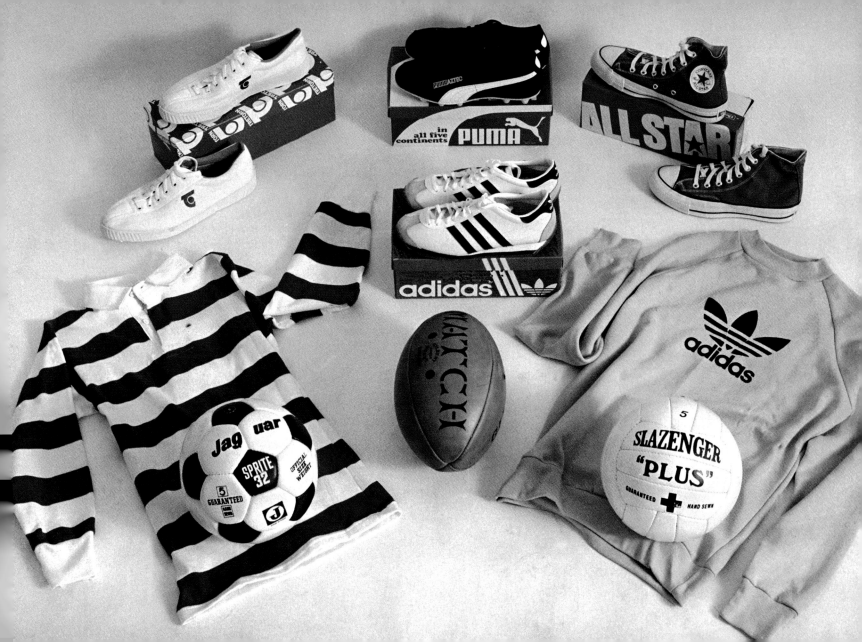

Over the last thirty-five years many of the biggest names in modeling and film have posed for the calendar, so it's an amazing feeling to now be included in that list.

Catherine McNeil

Since 1964, the Pirelli Calendar has been commissioned every year by the Italian tire manufacturer of the same name. It is regarded as the epitome of erotic photography—to be photographed as a model here is as much of an honor as it is to be chosen as one of the photographers. Fashion photographers like Peter Lindbergh, Herb Ritts, Mario Testino, and (in this case) Patrick Demarchelier gave the calendar a face—and show their viewers every year the bodies of the most beautiful women in the best possible light.

Australian model CATHERINE MCNEIL poses for photographs during the launch of the 2008 PIRELLI calendar in Sydney. Behind her is a photo of herself in the 35th edition of the calendar, shot by Patrick Demarchelier in Shanghai.

1 2 3 4 5 6 7 8 9 10 11 12 13 14 15 16 17 18 19 20 21 22 23 24 25 26 27 28

FEBRUARY

I like to think that the clothes could have
a life after the show is over. And that's
important, because everything we make
is some kind of fantasy; even if it's quite
practical, it's still a heightened reality.

Marc Jacobs

Born in 1960 in New York, Marc Jacobs is a star of the fashion scene. Since 1997 he has succeeded in bringing a wind of change into the formerly sleepy fashion house Louis Vuitton with a mix of mad ideas and bright colors. However, he refuses to be a captive of Vuitton, where he is responsible for all the fashion lines. Jacobs also brings out his own collections under his own name.
A model presents a creation by designer MARC JACOBS for LOUIS VUITTON during the Fall/Winter 2007/08 ready-to-wear collection show in Paris.

1 2 3 4 5 6 7 8 9 10 11 12 13 14 15 16 17 18 19 20 21 22 23 24 25 26 27 28/29

FEBRUARY

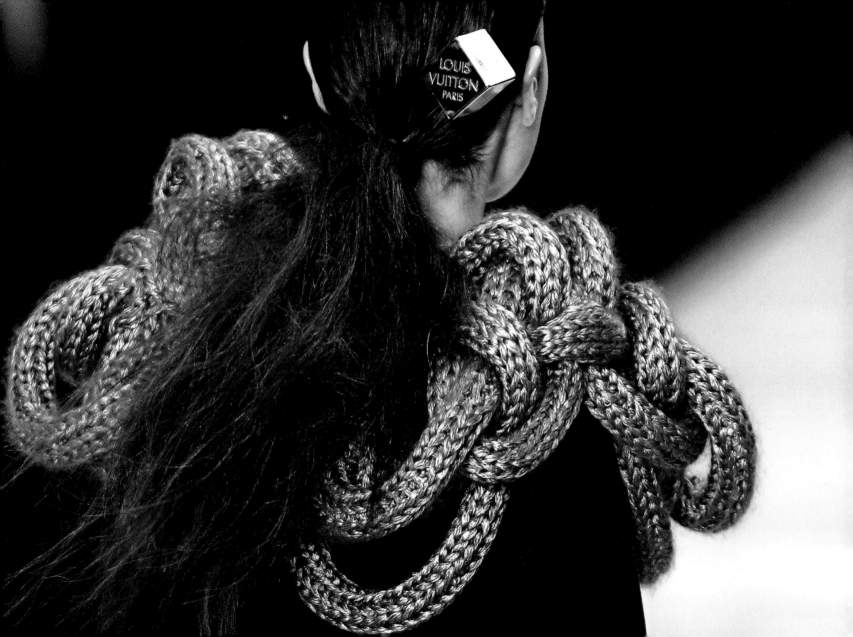

My work is my passion, where I am in life
is reflected in my vision and style.

Malene Birger

Man during the Holocene—the mannequin on the catwalk. Even during a
fashion show, things in Denmark are rather more casual than in Milan or Paris.
The spectators' shoes prove it!
Fashion show of the Danish designer MALENE BIRGER at Copenhagen
Fashion Week Spring/Summer 2008.

1 2 3 4 5 6 7 8 9 10 11 12 13 14 15 16 17 18 19 20 21 22 23 24 25 26 27 28 29 30 31

MARCH

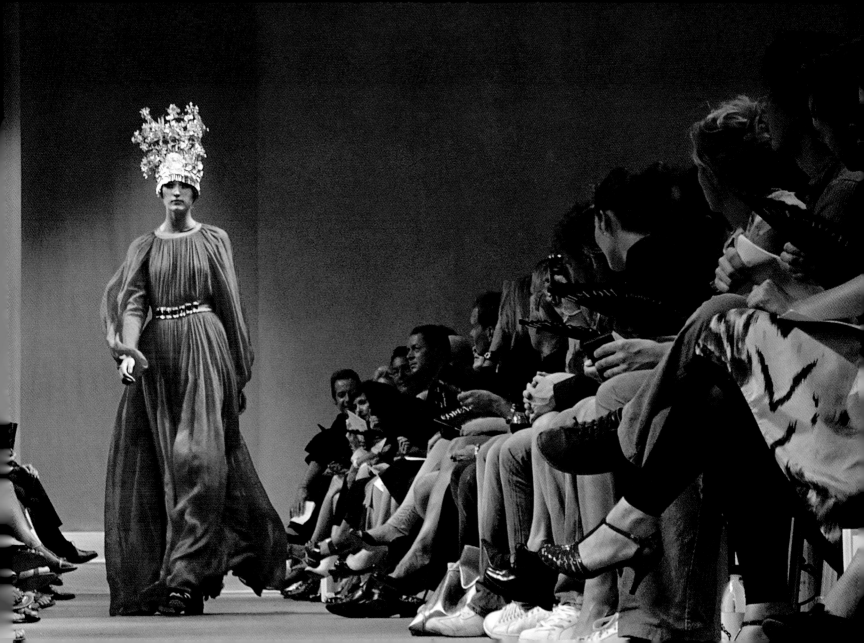

Nostalgia is a very complicated subject for me.
I'm attracted by nostalgia but I refuse it intel-
lectually. It interests me to be modern, and so
I refuse nostalgia, but still I have it. So you see,
contradictions and oppositions are maybe
what makes the work contemporary, because
nowadays we are all composed of opposites.

Miuccia Prada

She began as a twinkling starlet and has become one of the brightest stars in
the fashion firmament—Miuccia Prada (b. 1949) completed her doctoral studies
in political science, studied acting under Giorgio Strehler, and is now one of the
creative geniuses behind the successful global fashion concern Prada.
A creation by Italian designer MIUCCIA PRADA from the Spring/Summer 2008
collection.

1 2 3 4 5 6 7 8 9 10 11 12 13 14 15 16 17 18 19 20 21 22 23 24 25 26 27 28 29 30 31

MARCH

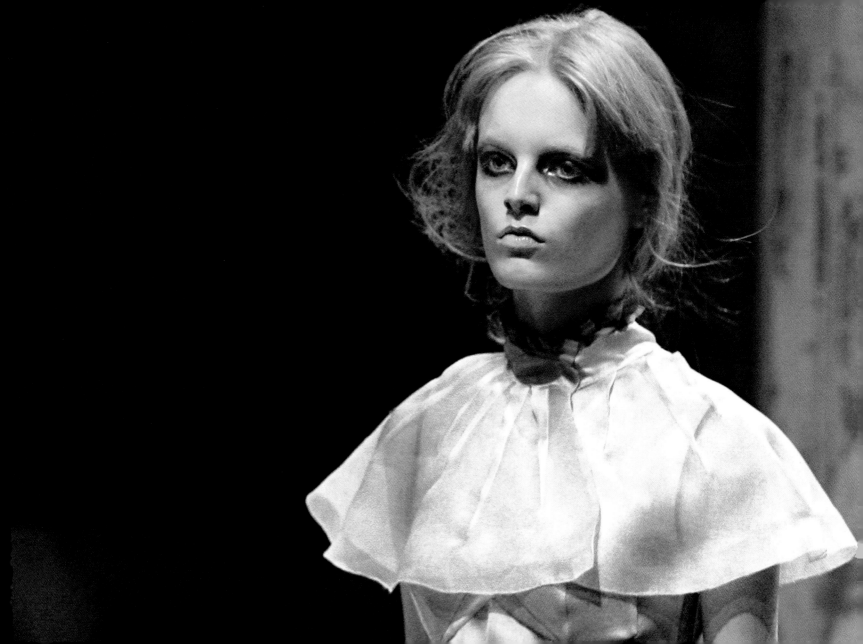

I've never been one to see women in ruffles. To me it's just silly.

Calvin Klein

Calvin Klein, a U.S. citizen with Hungarian-Jewish roots, established his fashion label in 1968. Spectacular advertising campaigns made the company famous. The CK label may not guarantee luxury, but it does represent status. That is why you will find it on countless licensed products like eyeglasses, perfumes, and watches. American designer CALVIN KLEIN surrounded by models and staff members in his New York design studio, early 1970s.

1 2 3 4 5 6 7 8 9 10 11 12 13 14 15 16 17 18 19 20 21 22 23 24 25 26 27 28 29 30 31

MARCH

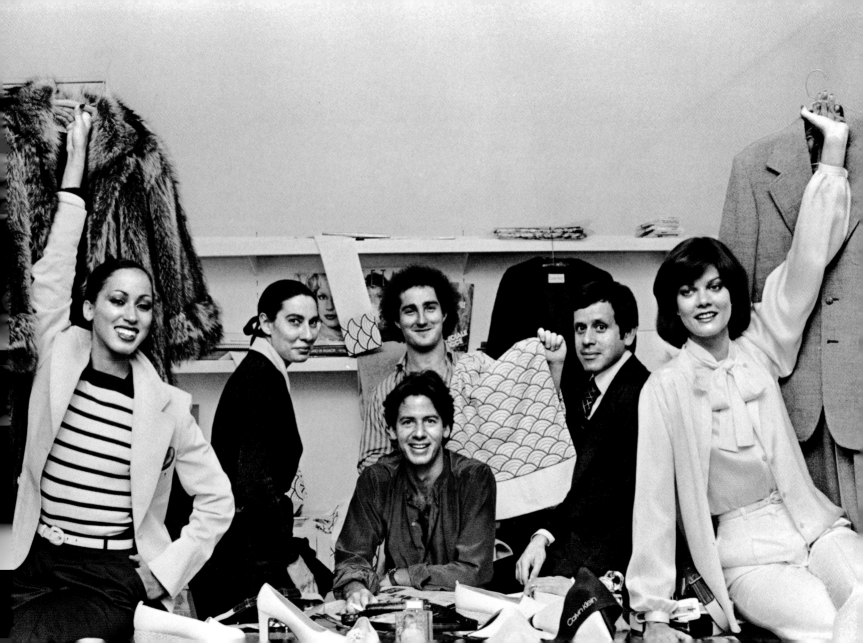

I think individuality is what inspires me.
I would like all women to be able to
wear my clothes, but women with
attitude especially. They know what
they are doing. They believe in what
they are doing. They're very conscious
of who they are.

Donatella Versace

Apart from the extravagant designs with their wealth of colors and patterns,
Versace has a second line that follows more purist lines. And yet, as in the designs
of Gianni, the founder of the company who was shot in 1997, sex appeal remains
in the foreground with his sister Donatella at the helm.
A model presents a creation by Italian designer DONATELLA VERSACE during the
Spring/Summer 2007 women's collections in Milan.

1 2 3 4 5 6 7 8 9 10 11 12 13 14 15 16 17 18 19 20 21 22 23 24 25 26 27 28 29 30 31

MARCH

Fashion is made to become
unfashionable.

Coco Chanel

A cloak provides a distant air. With this extravagant cape in the style of an extra-large collar, the fashion designer has taken into account a woman's *faiblesse* for narcissism.

A cocktail dress designed by JACQUES FATH with a collar-cape frill, 1956.

5

1 2 3 4 5 6 7 8 9 10 11 12 13 14 15 16 17 18 19 20 21 22 23 24 25 26 27 28 29 30 31

MARCH

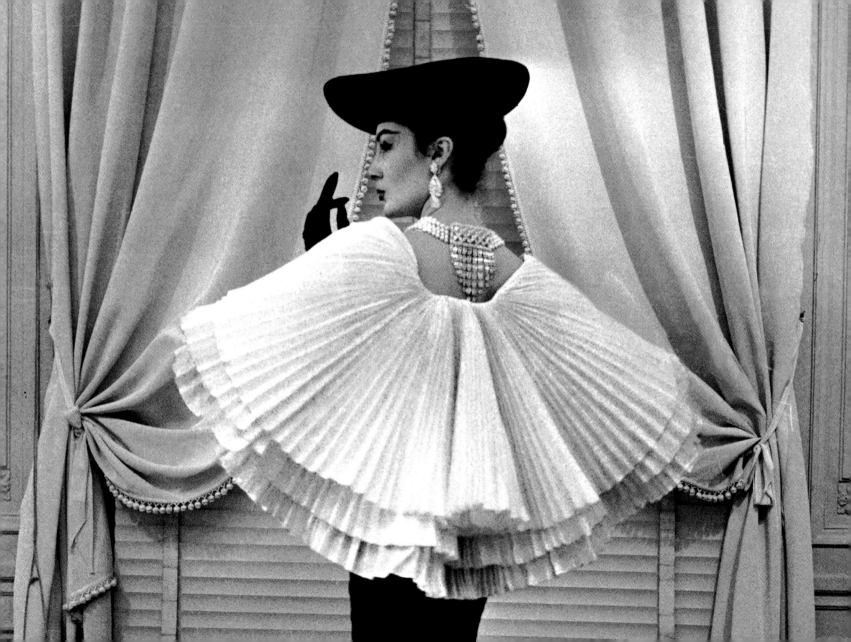

I'm sort of the original reluctant sex symbol.

Raquel Welch

From the flokati rug to the moon landing, the end of the 1960s was characterized by a boundless belief in the future. Fashion welcomed the theme of space euphoria and cut its designs out of plastic and acrylic. Jane Fonda and Raquel Welch became the desirable Amazon dominatrices of their time.
American actress RAQUEL WELCH in a futuristic outfit featuring a mini skirt and scarf in blue plastic, worn with a Plexiglas visor, ca. 1967.

1 2 3 4 5 **6** 7 8 9 10 11 12 13 14 15 16 17 18 19 20 21 22 23 24 25 26 27 28 29 30 31

MARCH

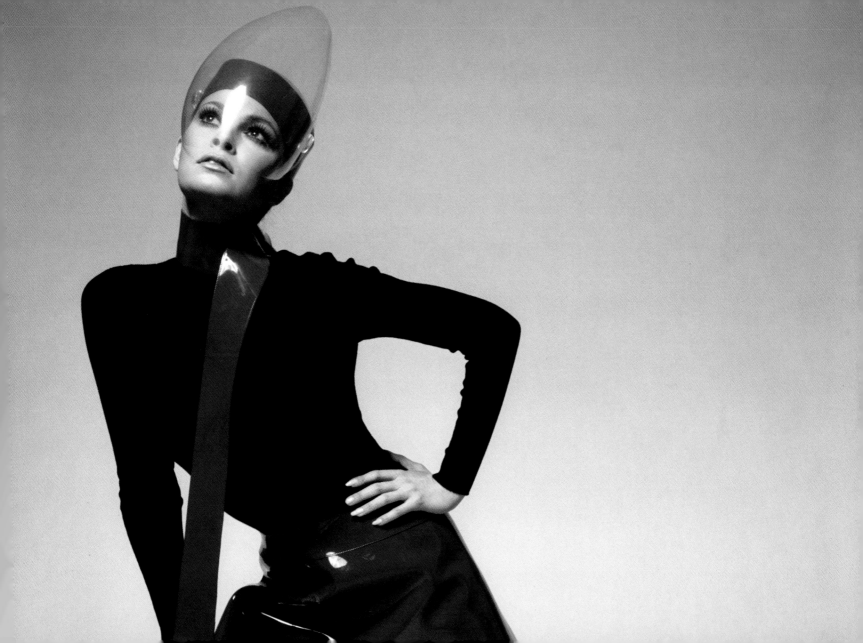

For the perfect dandy... enamored
as he is above all distinction, perfection
in dress consists in absolute simplicity,
which is, indeed, the best way of being
distinguished.

Charles Baudelaire

Perry Ellis died of AIDS in 1986 at the age of only 46. His label lives on to this day.
Ellis's fashion credo, that clothing must be timeless and wearable, has been
faithfully adopted by other designers.
Models walk the runway at the PERRY ELLIS Spring 2007 fashion show in New York.

1 2 3 4 5 6 **7** 8 9 10 11 12 13 14 15 16 17 18 19 20 21 22 23 24 25 26 27 28 29 30 31

MARCH

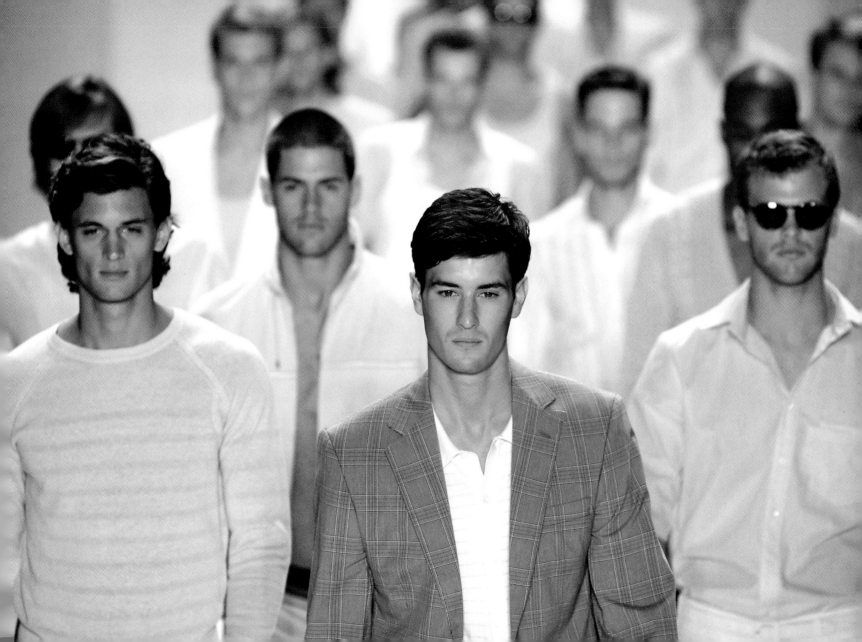

Modern clothing cannot renounce
romantic attributes.

Jeanne Lanvin

Imaginative little hats added a touch of whimsy to the often austere elegance
of the 1930s. Suit jackets were usually narrow-cut and severely styled.
An elegant outfit by French designer JEANNE LANVIN featuring a felt hat, gloves,
and a purse, 1935.

1 2 3 4 5 6 7 8 9 10 11 12 13 14 15 16 17 18 19 20 21 22 23 24 25 26 27 28 29 30 31

MARCH

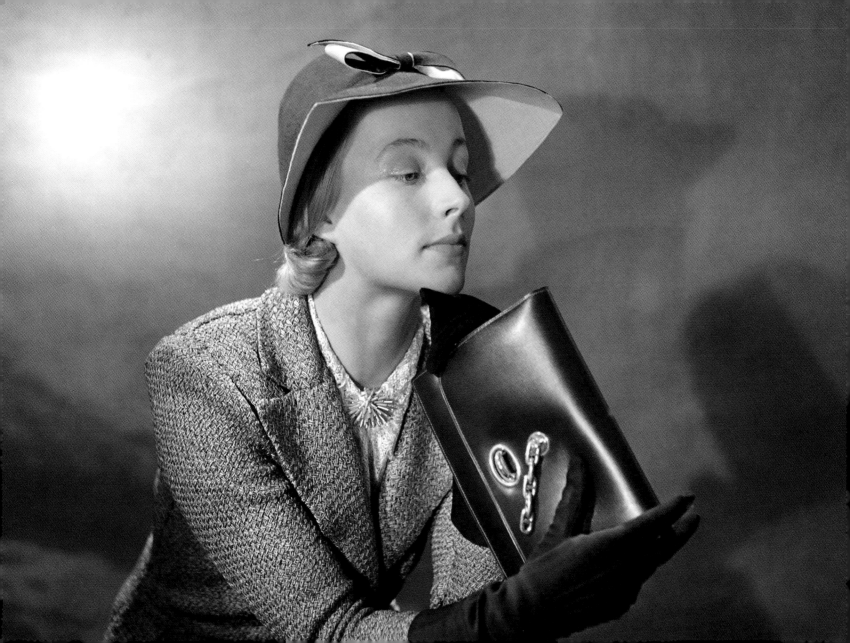

I find "timeless" classic terribly boring.
A classic is an excuse, because one is
too lazy to confront the spirit of the time.

Jil Sander

When Jil Sander (b. 1943) opened a boutique in Hamburg in 1967, it marked the beginning of her rapid ascent to the fashion summit. During the 1980s, she discovered the business suit with the obligatory white shirt for the modern career woman. Today the German designer is known as the "Queen of Less" because of her minimalist style.

JIL SANDER appears on the catwalk at the end of the presentation of her Spring/Summer 2005 women's collection at Milan Fashion Week.

1 2 3 4 5 6 7 8 **9** 10 11 12 13 14 15 16 17 18 19 20 21 22 23 24 25 26 27 28 29 30 31

MARCH

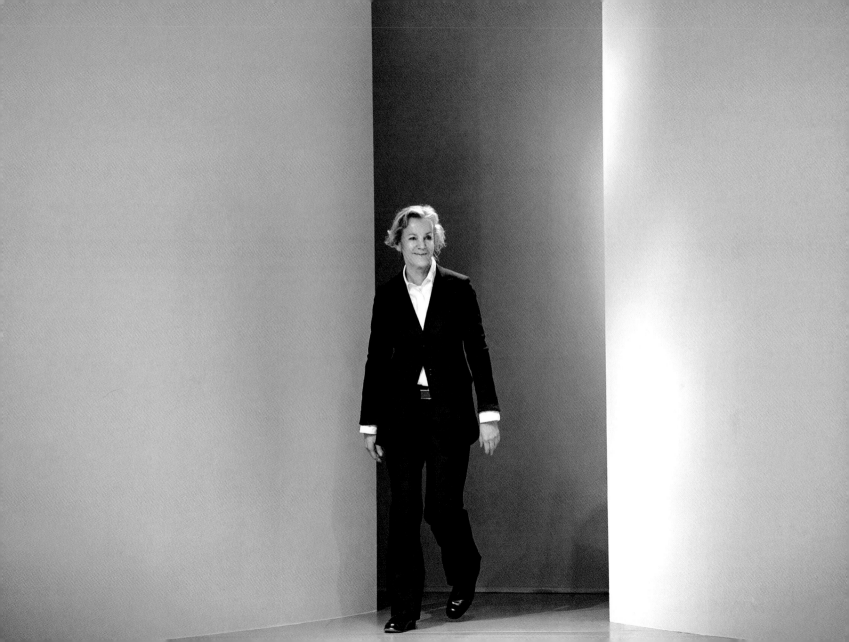

To call a fashion wearable is the kiss
of death. No new fashion worth its salt
is ever wearable.

Eugenia Sheppard

"Removing our hat shortens the body, making us smaller," observed man of letters
Georg Christoph Lichtenberg, famous for his aphorisms. Aren't we glad that
women refuse to make themselves smaller and keep their heads covered?
A jeweled headdress worthy of a pharaoh designed by JEANNE PAQUIN, 1924.

1 2 3 4 5 6 7 8 9 **10** 11 12 13 14 15 16 17 18 19 20 21 22 23 24 25 26 27 28 29 30 31

MARCH

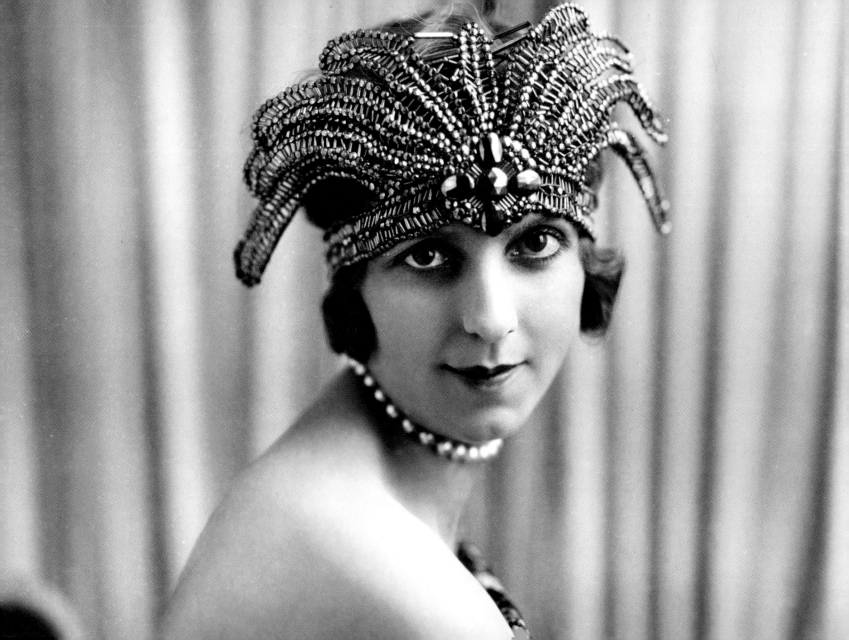

I have always been known to mix things.
I love the idea of fusion and now that
the world is so global, everybody is
traveling a lot more.

Ashley Isham

Vanished cultures and worlds live on in fashion. Designers' anthropological
quotations are very much in evidence today.
A model walks down the runway at the ASHLEY ISHAM fashion show as part of
London Fashion Week Fall/Winter 2006/07.

1 2 3 4 5 6 7 8 9 10 11 12 13 14 15 16 17 18 19 20 21 22 23 24 25 26 27 28 29 30 31

MARCH

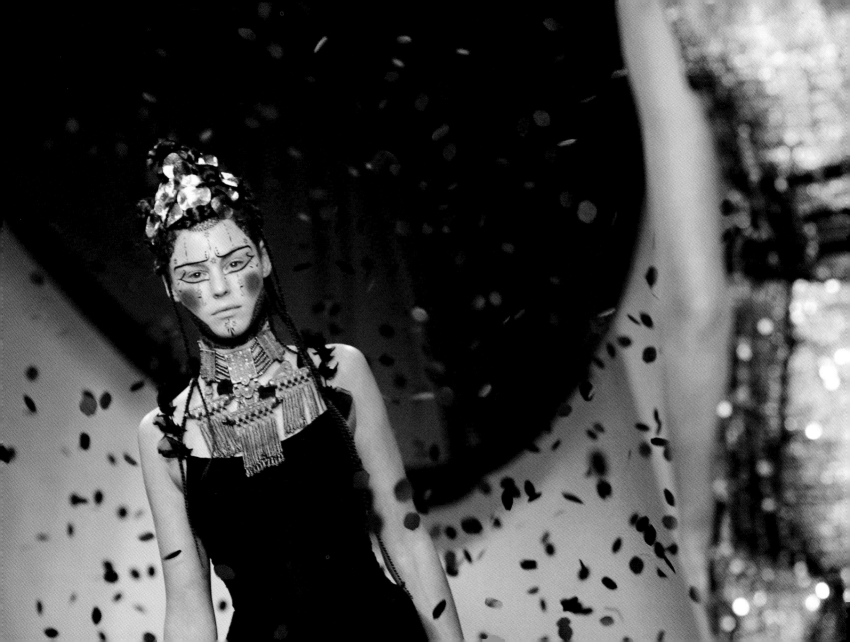

Nothing goes out of fashion sooner
than a long dress with a very low neck.

Coco Chanel

The shop window is probably the only window designed so that people can look
in rather than out. Glass reflects neither longings nor desires.
A shop window showing evening dresses offered in the winter sales, January 1950.

1 2 3 4 5 6 7 8 9 10 11 **12** 13 14 15 16 17 18 19 20 21 22 23 24 25 26 27 28 29 30 31

MARCH

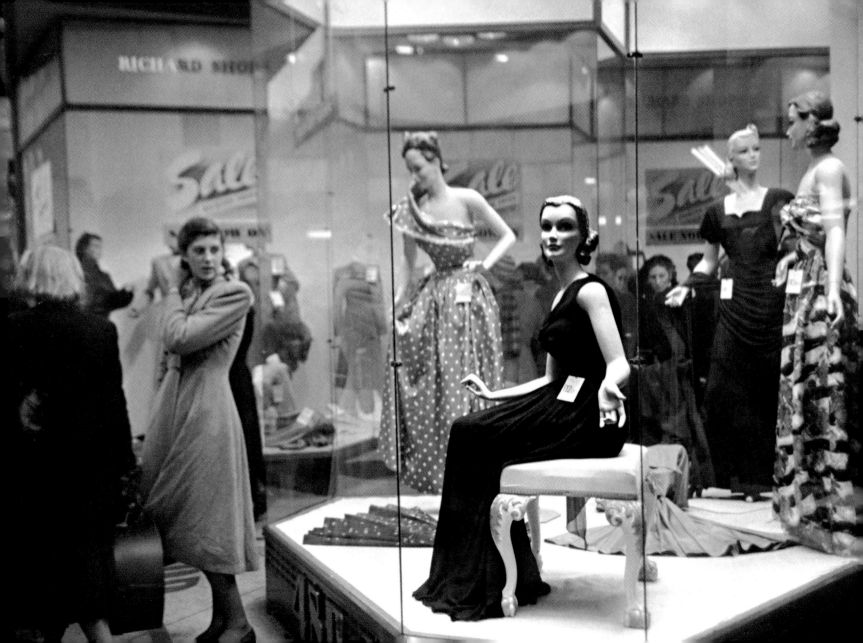

I find beauty in the grotesque, like
most artists. I have to force people
to look at things.

Alexander McQueen

Let us quickly dispense with the thought that so many roses on one's head
could in fact be a crown of thorns. "Smell me, pick me," says the young woman
to us—and does so with flowers.
A model presents a creation by ALEXANDER MCQUEEN during Paris Fashion Week
Spring/Summer 2007.

1 2 3 4 5 6 7 8 9 10 11 12 **13** 14 15 16 17 18 19 20 21 22 23 24 25 26 27 28 29 30 31

MARCH

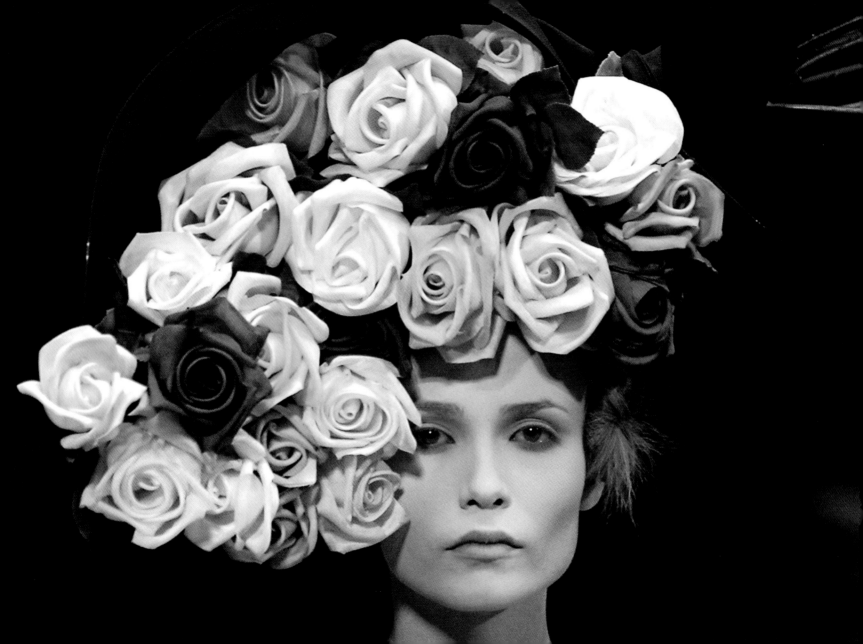

London is where the new ideas
get born.

Jasper Conran

Incredibly cool, or perhaps a designer is the only one who can still get away
with one of the worst fashion sins of all time—white socks. All the same, Conran's
most famous customer was Princess Diana.
JASPER CONRAN was the designer to Diana, Princess of Wales in the 1980s.

1 2 3 4 5 6 7 8 9 10 11 12 13 **14** 15 16 17 18 19 20 21 22 23 24 25 26 27 28 29 30 31

MARCH

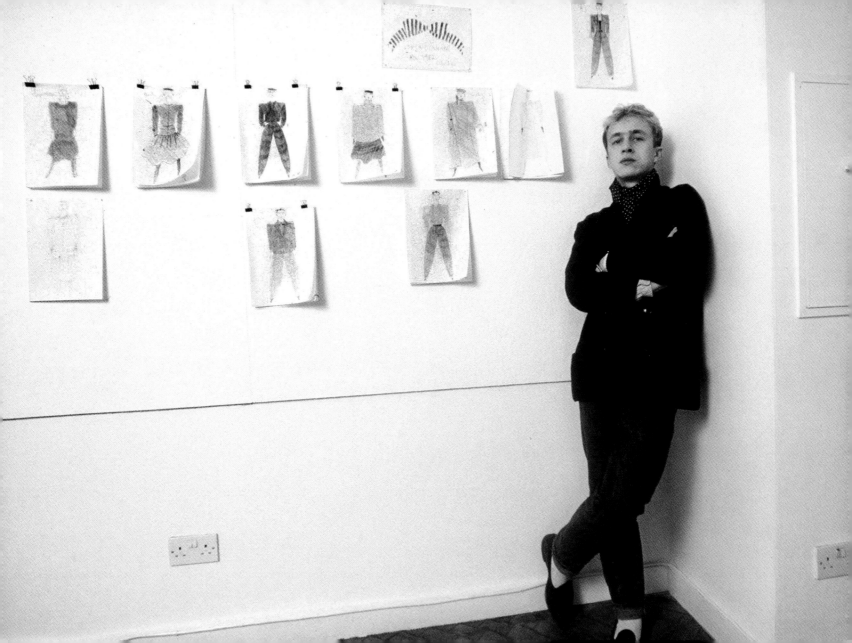

I am Christian Dior—every aspect
of my life is reflected in my dresses,
whether I like it or not.

Christian Dior

Traditionally, the end of each runway show is marked by the appearance of the
wedding dress. These are followed by the magnificent ball gowns for which Dior
famously expended enormous quantities of fabric—measured in weight, they are
spectacularly beautiful burdens for the models.
Parade of the brides—mannequins walk down the catwalk during the grand finale
of CHRISTIAN DIOR's spectacular 1955 fashion show at a ball in Gleneagles.

1 2 3 4 5 6 7 8 9 10 11 12 13 14 **15** 16 17 18 19 20 21 22 23 24 25 26 27 28 29 30 31

MARCH

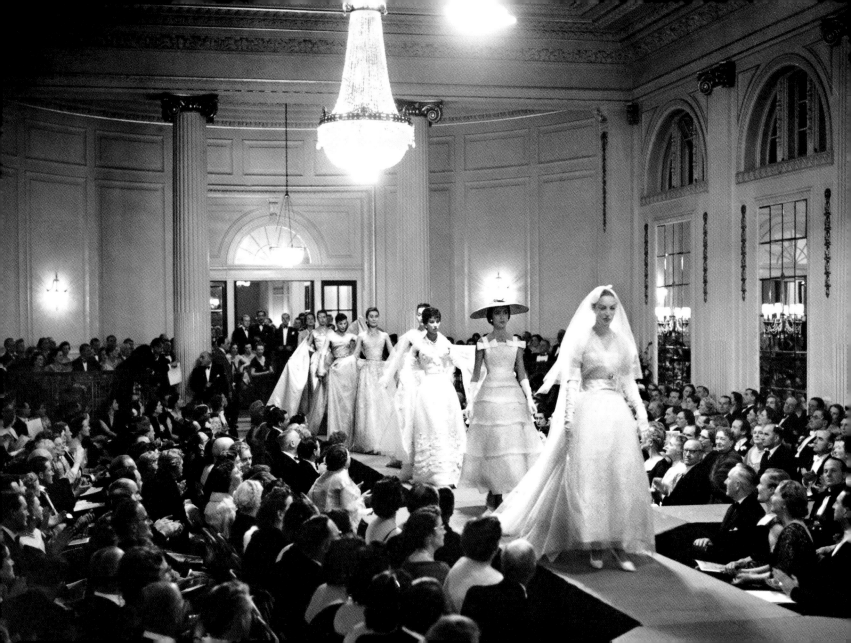

It's all about balance, about making
beautiful things for people to enjoy.

John Rocha

John Rocha's collections are highly regarded in London. They are intelligently cut,
always wearable, simply elegant—and radiate an aura of glamour.
A model shows a creation from the Fall/Winter 2006/07 collection of JOHN ROCHA
at London Fashion Week.

1 2 3 4 5 6 7 8 9 10 11 12 13 14 15 **16** 17 18 19 20 21 22 23 24 25 26 27 28 29 30 31

MARCH

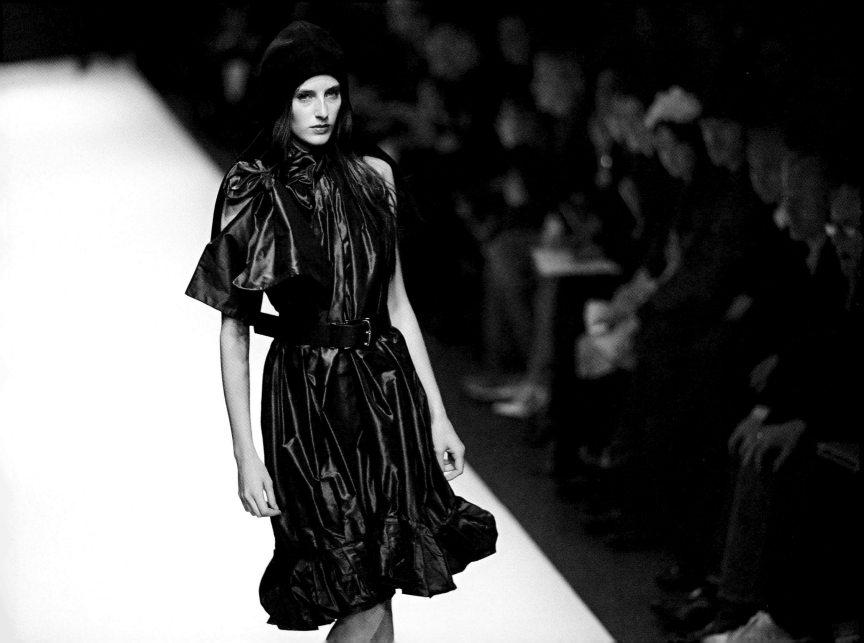

Elegance does not consist in putting
on a new dress.

Coco Chanel

Not Callas as Madame Butterfly, yet the same pose. Fashion is pure opera,
and always theatrical.
Delicate pleats grace the back of a model at Paris Fashion Week, 1962.

1 2 3 4 5 6 7 8 9 10 11 12 13 14 15 16 **17** 18 19 20 21 22 23 24 25 26 27 28 29 30 31

MARCH

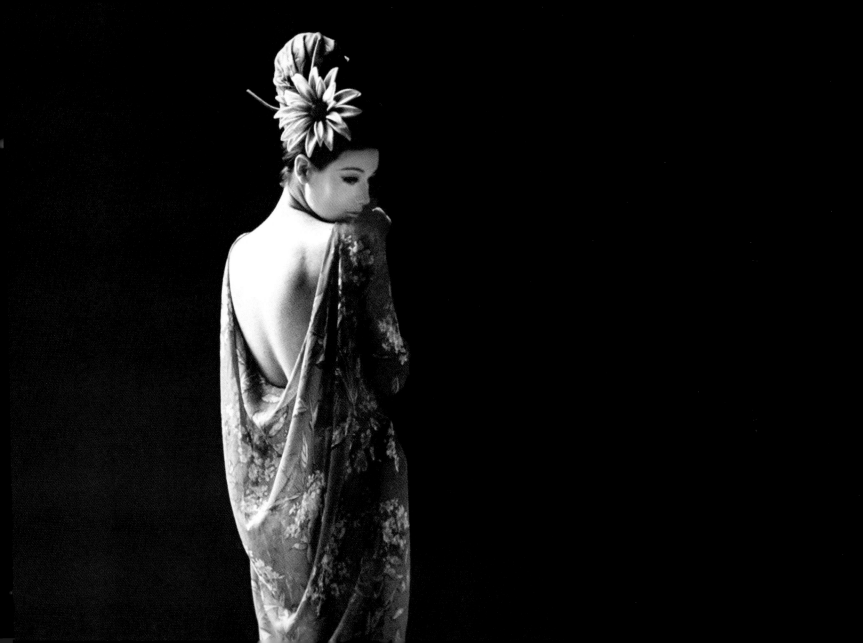

I try to translate what I sense from
the street.

Jean Paul Gaultier

Down with bodices! This feminist cry goes unheard when Jean Paul Gaultier—
the self-styled enfant terrible of the fashion world—sends his models down
the catwalk.
A Chinese model presents a creation by French designer JEAN PAUL GAULTIER
at the 2004 Shanghai Fashion Week.

1 2 3 4 5 6 7 8 9 10 11 12 13 14 15 16 17 **18** 19 20 21 22 23 24 25 26 27 28 29 30 31

MARCH

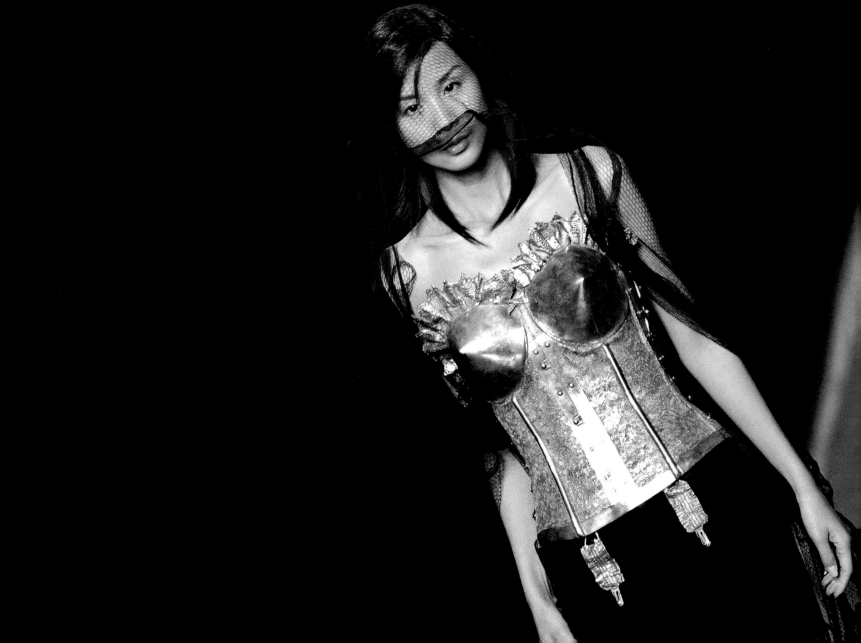

I think I intuitively know how a woman
feels when she's wearing clothes.
Clothes can give you confidence or
take your confidence away. I'm all
for giving confidence.

Jasper Conran

Black. White. Nude. These colors are often pure provocation.
A model in an outfit by designer JASPER CONRAN during the presentation of
his Spring/Summer 2005 collection at London Fashion Week.

1 2 3 4 5 6 7 8 9 10 11 12 13 14 15 16 17 18 19 20 21 22 23 24 25 26 27 28 29 30 31

MARCH

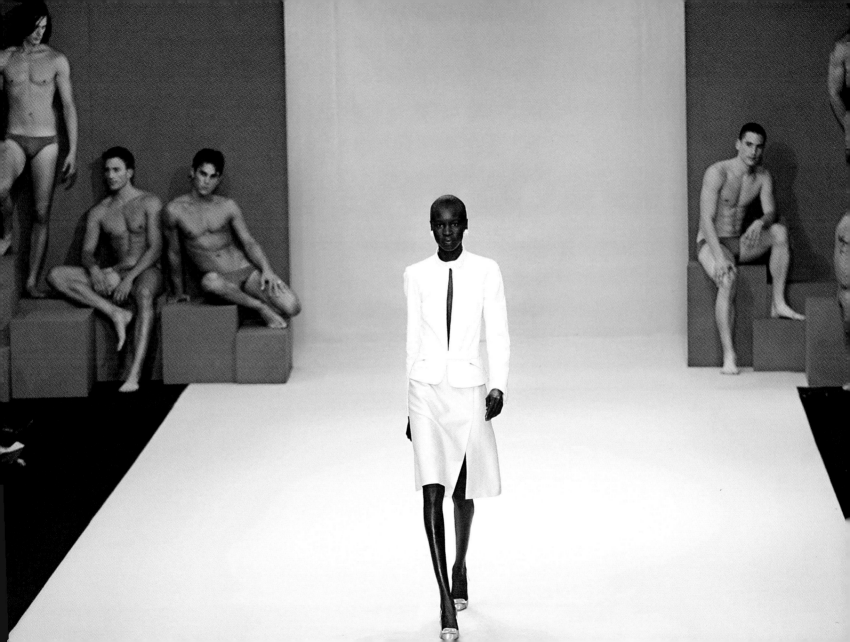

It's pretentious to be in awe of it (fashion).
Fashion is a craft and an expression of a
period of time, but it is not an art.

Bill Blass

The best encouragement to stay slim is a perfectly tied sash around the hips.
A creation by BILL BLASS at Olympus Fashion Week, Spring 2005, in New York.

1 2 3 4 5 6 7 8 9 10 11 12 13 14 15 16 17 18 19 20 21 22 23 24 25 26 27 28 29 30 31

MARCH

I am neither in the past, nor
avant-garde. My style follows life.

Coco Chanel

One reason why so many marriages end in divorce today is probably so that
we can buy wedding dresses more often. When a dress is as beautiful as this one
by Chanel, why should you only wear it once in a lifetime?
Model DEVON AOKI wears a wedding dress during the CHANEL Spring/Summer
2001 haute couture show in Paris.

1 2 3 4 5 6 7 8 9 10 11 12 13 14 15 16 17 18 19 20 21 22 23 24 25 26 27 28 29 30 31

MARCH

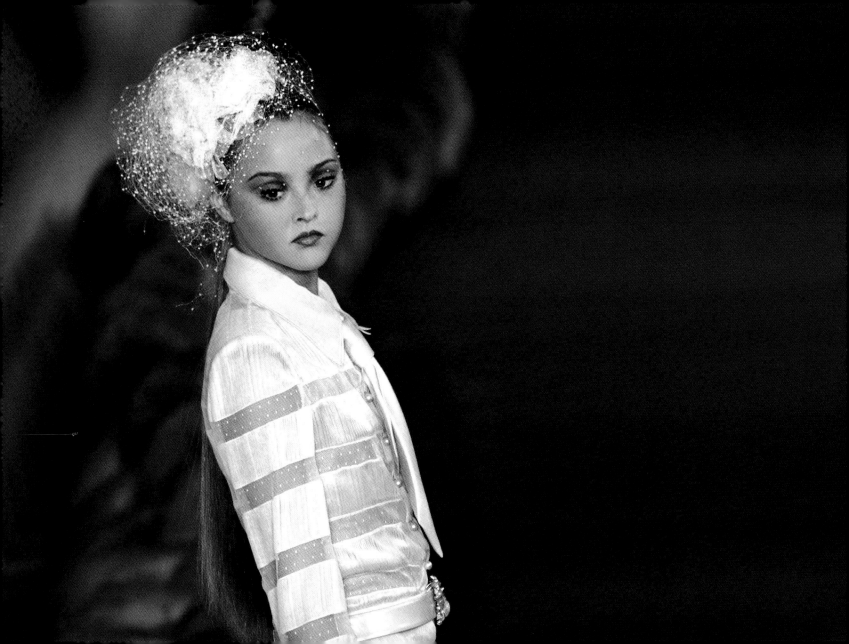

The hat is not for the street: it will never be democratized. But there are certain houses that one cannot enter without a hat. And one must always wear a hat when lunching with people whom one does not know well. One appears to one's best advantage.

Coco Chanel

Off we go—and it had better not rain! Fashion-conscious people have always had a *faiblesse* for uniformity—even interchangeability.
Three young women arrive at Buckingham Palace in London for a garden party, July 1919.

1 2 3 4 5 6 7 8 9 10 11 12 13 14 15 16 17 18 19 20 21 22 23 24 25 26 27 28 29 30 31

MARCH

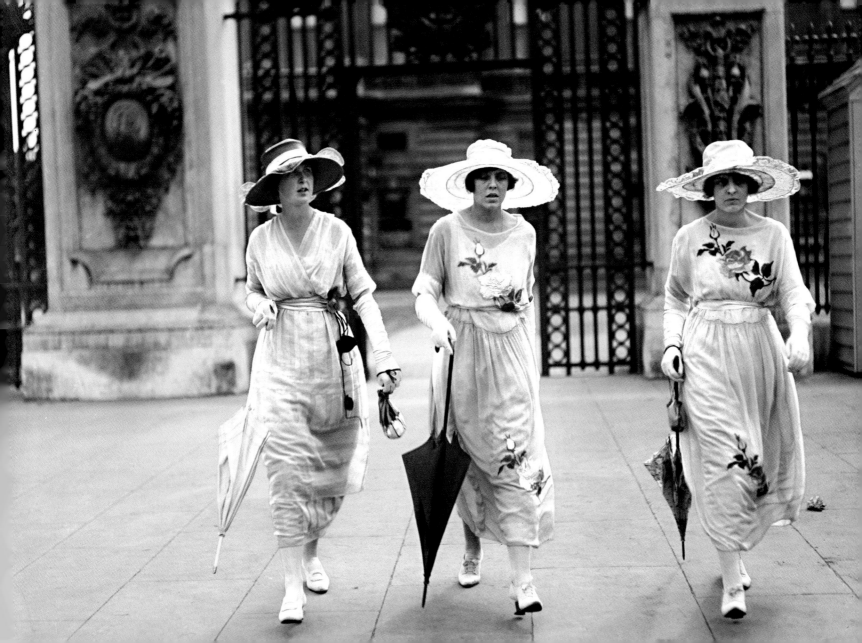

He (Emilio Pucci) loved a woman's body;
his inspiration was the architecture of a
woman's body.

Laudomia Pucci

The House of Pucci has long been famous for its psychedelic patterns. The colors and patterns often looking as if they were designed on an LSD high made Pucci one of the favorite designers among the rich hippies of the Swinging Sixties—and has inspired a current-day revival for the Italian label.
A model walks down the runway during EMILIO PUCCI's Fall/Winter 2006/07 women's ready-to-wear collections show at Milan Fashion Week.

1 2 3 4 5 6 7 8 9 10 11 12 13 14 15 16 17 18 19 20 21 22 **23** 24 25 26 27 28 29 30 31

MARCH

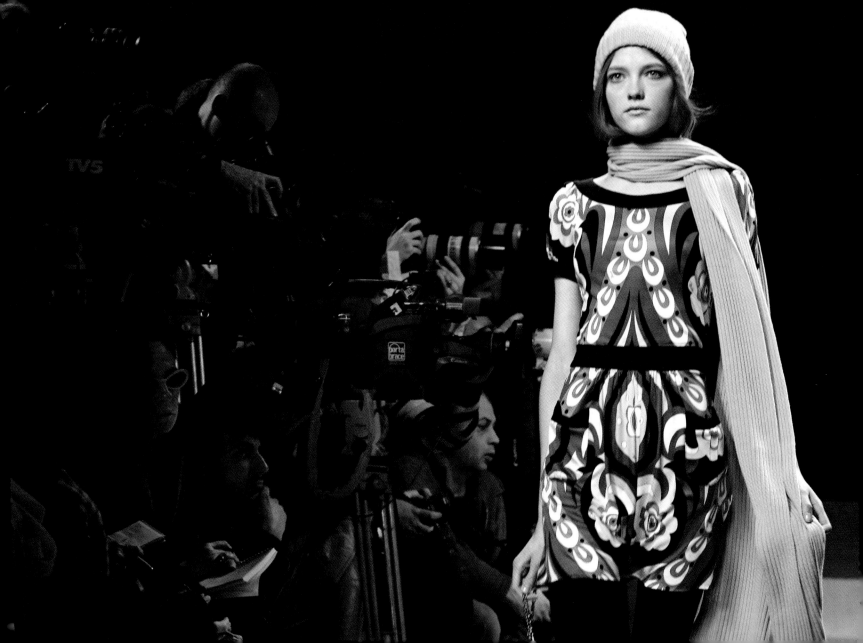

In the 60s there was a look. In the 70s there was a look, and in the 80s. Now, it's a free-for-all.

Betsey Johnson

Betsey Johnson was awarded the coveted fashion title "Timeless Talent" by fashion critics in 1999. She surprised her audience time and time again with timelessly crazy creations, including the "mirror dress" of 1966. Today her look is increasingly romantic. After every fashion show, Betsey traditionally does a cartwheel down the catwalk.
Model Elizabeth Jagger (left) at the BETSEY JOHNSON show during New York Fashion Week Spring 2005.

1 2 3 4 5 6 7 8 9 10 11 12 13 14 15 16 17 18 19 20 21 22 23 **24** 25 26 27 28 29 30 31

MARCH

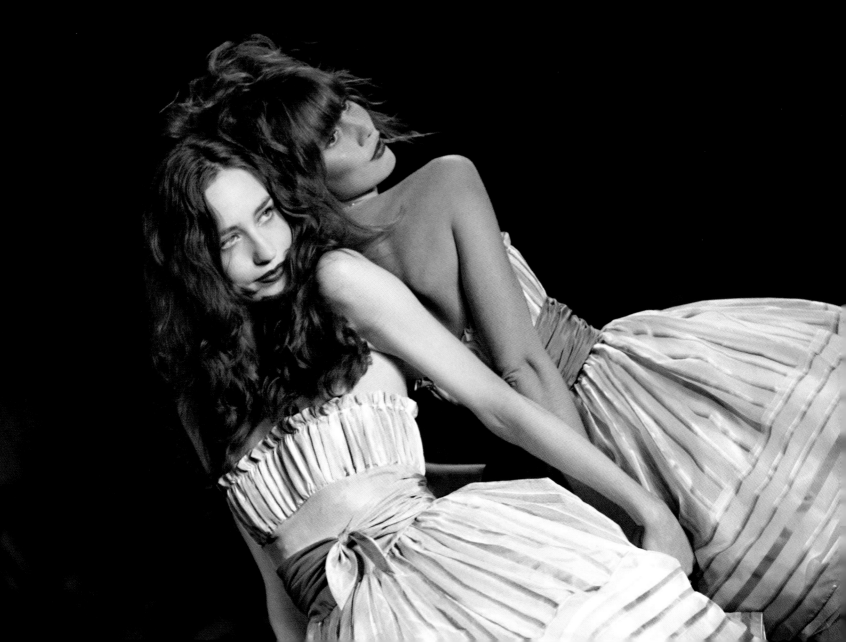

Fashion is a despot whom the wise
ridicule and obey.

Ambrose Bierce

During the 1950s, Paris was characterized by a spirit of optimism which was
inevitably reflected in the fashion of the times.
Designer GUY LAROCHE surrounded by several fashion models. 1957.

1 2 3 4 5 6 7 8 9 10 11 12 13 14 15 16 17 18 19 20 21 22 23 24 25 26 27 28 29 30 31

MARCH

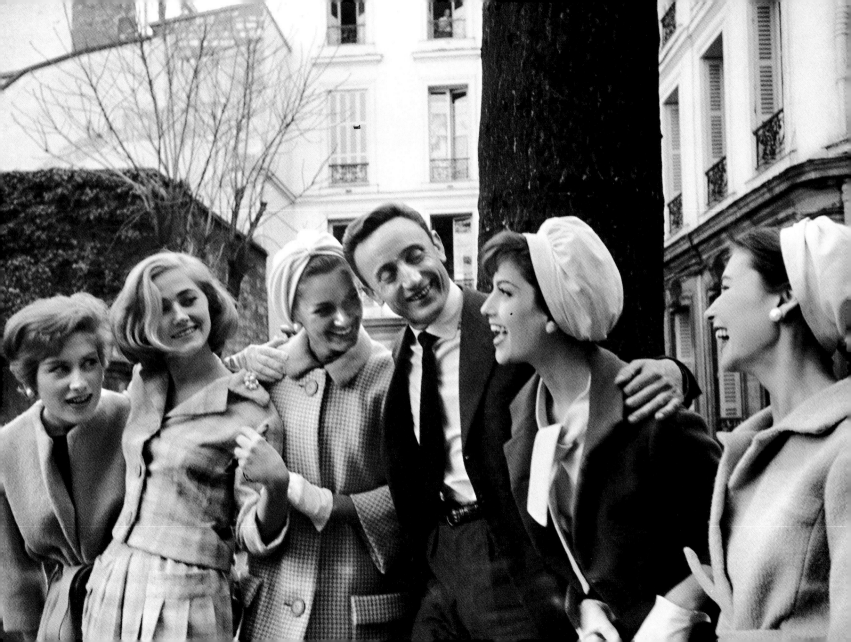

If from your first meeting with a woman
you remember her dress, it means
that it was an ugly dress; if you
remember the woman it means
she had a beautiful dress.

Coco Chanel

The designer Guglielmo Mariotto knows the precise sensuous effect radiated by
a perfect combination of cut, fabric, and color.
A model displays a creation by Italian designer GUGLIELMO MARIOTTO as part
of Gattinoni's Fall/Winter 2007/08 haute couture collection on Rome's Campidoglio
square during Fashion Week.

1 2 3 4 5 6 7 8 9 10 11 12 13 14 15 16 17 18 19 20 21 22 23 24 25 26 27 28 29 30 31

MARCH

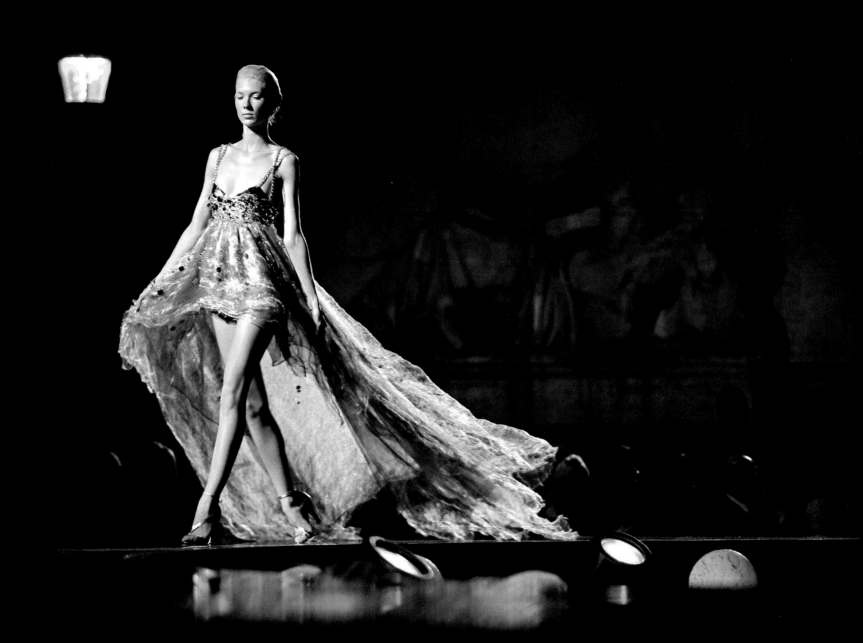

Designing for men is the creation
of reality. Designing for women is the
creation of fantasy.

Naoki Takizawa

Harlequin's collar—or whipped cream? Naoki Takizawa works for Issey Miyake, the
Japanese master of the pleat. It goes without saying that he will pay his respects
with refined pleating.
A model presents a creation for ISSEY MIYAKE by NAOKI TAKIZAWA during the
Spring/Summer 2007 ready-to-wear collections in Paris.

1 2 3 4 5 6 7 8 9 10 11 12 13 14 15 16 17 18 19 20 21 22 23 24 25 26 27 28 29 30 31

MARCH

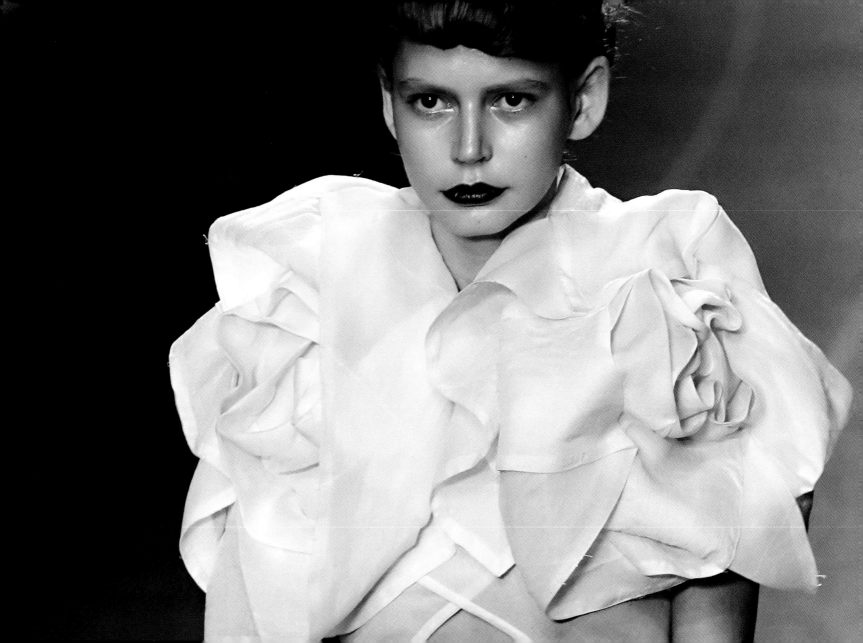

My work aims to give people the
means to remain themselves, as
close to their tastes as possible.

Dries van Noten

"Elegance is refusal," said Coco Chanel. But why do models refuse to eat?
A psychological and fashionable subject which will never be solved on the
catwalk.
A creation by Belgian designer DRIES VAN NOTEN, presented at the Spring/
Summer 2007 ready-to-wear collections in Paris.

1 2 3 4 5 6 7 8 9 10 11 12 13 14 15 16 17 18 19 20 21 22 23 24 25 26 27 28 29 30 31

MARCH

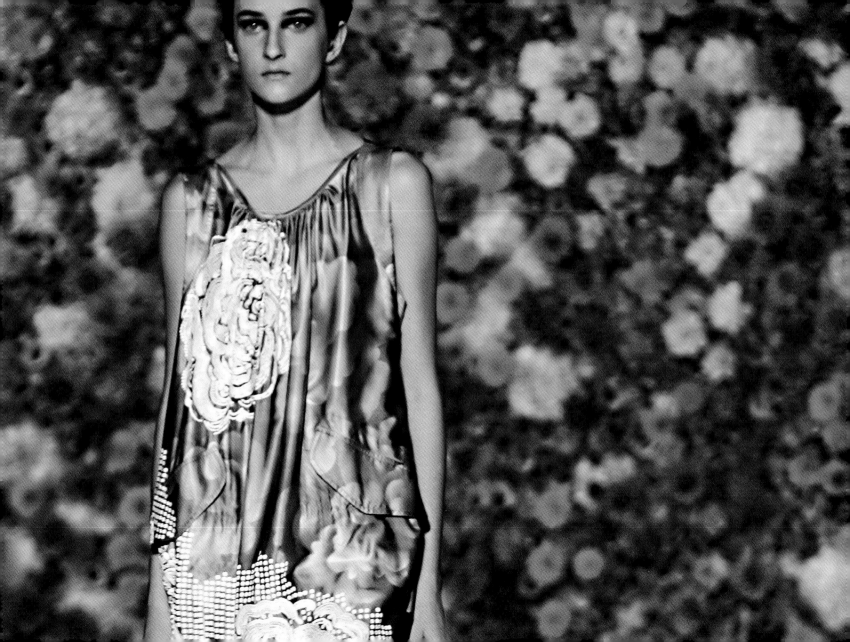

I've tried to find a new elegance.
It's not easy because people want
to be shocked. They want explosive
fashion. But explosions don't last, they
disappear immediately and leave
nothing but ashes.

Giorgio Armani

Simple, yet refined—Armani's style suits the *grande entrée* to perfection.
A model strides down the runway at the ARMANI fashion show as part of
Paris Fashion Week Haute Couture Spring/Summer 2006.

1 2 3 4 5 6 7 8 9 10 11 12 13 14 15 16 17 18 19 20 21 22 23 24 25 26 27 28 29 30 31

MARCH

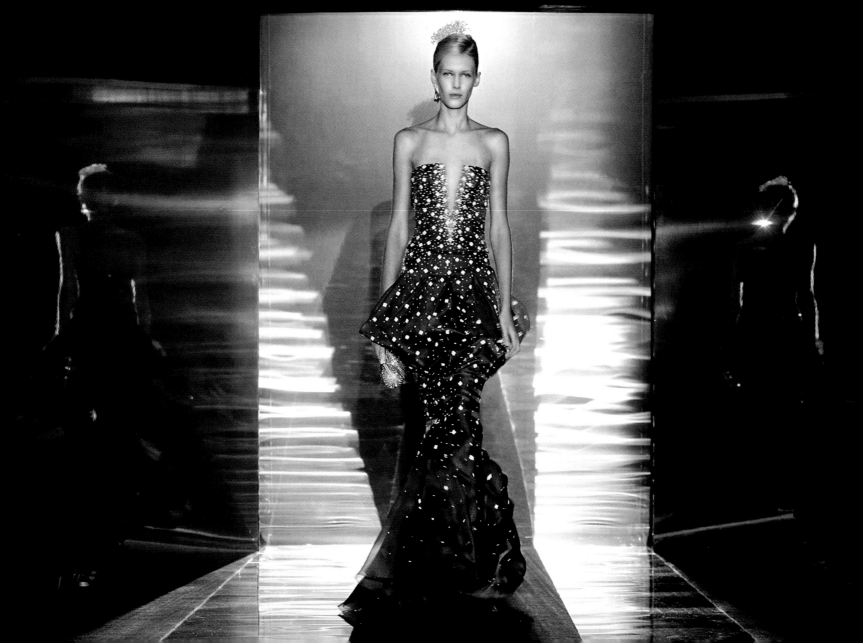

A style does not go out of style as long as it adapts itself to its period.

Coco Chanel

"Maxi is only attractive with as long a slit as possible, otherwise men will end up forgetting what a woman's leg looks like," observed Sophia Loren. She may be wrong: maxi is attractive when the design is by a master of fashion.
Model BARBARA GOALEN wears a knitted suit, tightly belted and worn with gauntlet gloves and a scarf tied at the neck. The outfit is completed with a small brimmed hat with a round crown, 1953.

1 2 3 4 5 6 7 8 9 10 11 12 13 14 15 16 17 18 19 20 21 22 23 24 25 26 27 28 29 **30** 31

MARCH

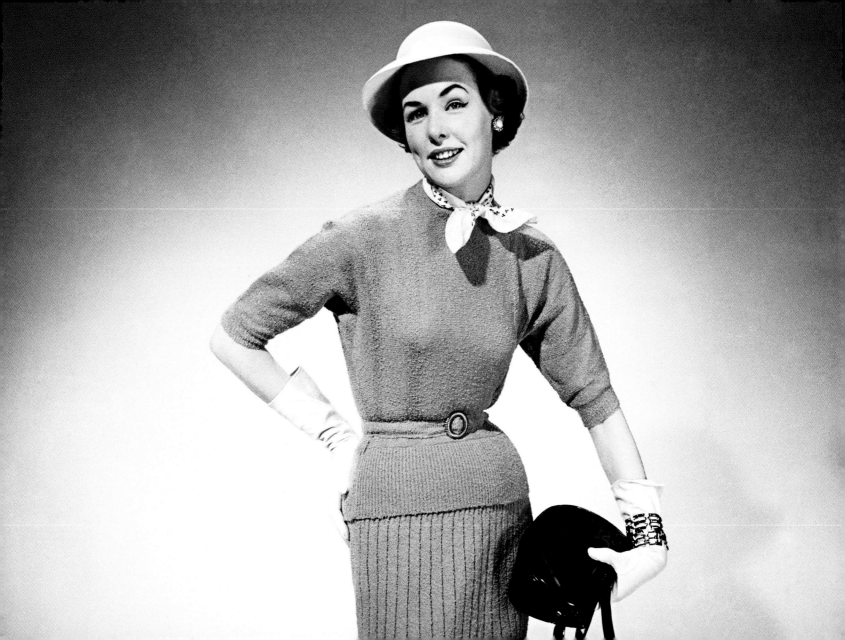

There should be as little philosophizing
as possible. The head, when used in
support of the heart and an informed
sense of good, will rarely lead astray.

Martin Margiela

Think pink! Margiela, born in Belgium in 1959, refuses to be photographed and
gives no interviews. His designs are often characterized by broad shoulders and
close-fitting lines. They have made the designer so famous that he can even
permit himself the luxury of doing without a logo on his garments.
A model presents a creation for MAISON MARTIN MARGIELA during the Fall/
Winter 2007/08 ready-to-wear collection show in Paris.

1 2 3 4 5 6 7 8 9 10 11 12 13 14 15 16 17 18 19 20 21 22 23 24 25 26 27 28 29 30 31

MARCH

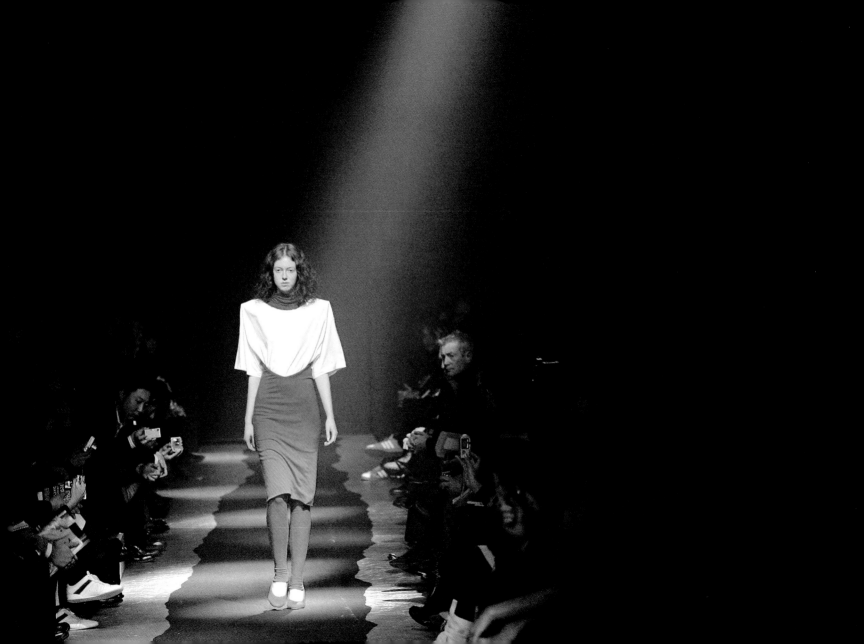

Fashion fades, only style remains
the same.

Coco Chanel

Jacques Fath (b. 1912) was regarded as a wunderkind of haute couture. The
"Fath style," radiating freshness but still extremely sophisticated, has left a lasting
impression on fashion history. Fath died in 1954 at the height of his fame.
A model in a white hat by JACQUES FATH, 1952.

1 2 3 4 5 6 7 8 9 10 11 12 13 14 15 16 17 18 19 20 21 22 23 24 25 26 27 28 29 30

APRIL

I see that the fashion wears out more
apparel than the man.

William Shakespeare, *Much Ado About Nothing*

Those who think of couturiers with only scissors, needle, and thread in their hand
forget that pencils, erasers, and wax crayons are equally important design tools.
Sketches and fabric of a dress designed for the Queen by JOHN ANDERSON, 1996.

1 2 3 4 5 6 7 8 9 10 11 12 13 14 15 16 17 18 19 20 21 22 23 24 25 26 27 28 29 30

APRIL

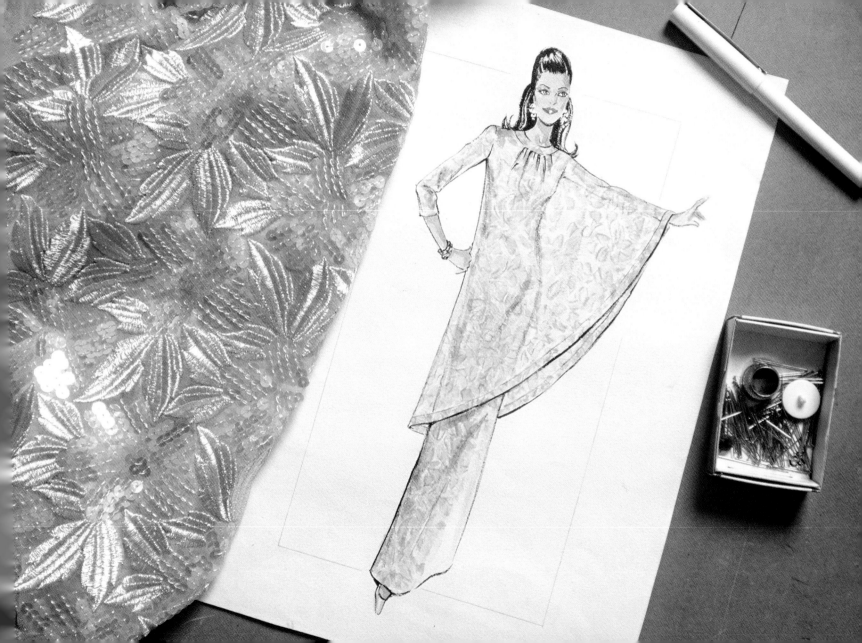

And people always say to me,
"Oh, you're not known for doing sexy."
So I wanted to think about that.

Marc Jacobs

This flowing design by Marc Jacobs is a perfect example: accessories like belts and bags are essential to complete the look.
A model displays a creation by MARC JACOBS during Mercedes-Benz Fashion Week in New York, 2007.

3

1 2 3 4 5 6 7 8 9 10 11 12 13 14 15 16 17 18 19 20 21 22 23 24 25 26 27 28 29 30

APRIL

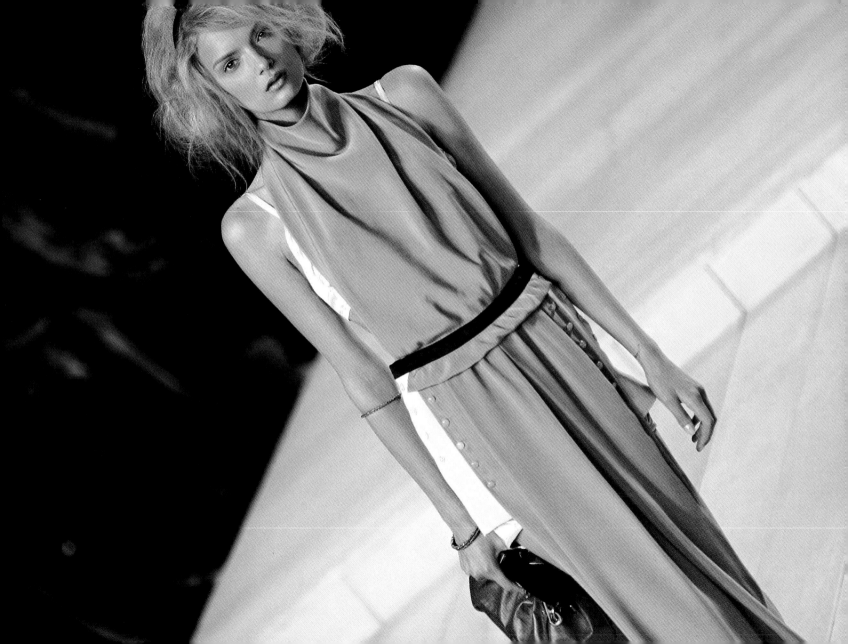

Fashion (is that) by which what is
really fantastic becomes for a moment
universal.

Oscar Wilde, *The Picture of Dorian Gray*

Woman—that bird of paradise. Fashion designers' love of peacock and ostrich feathers, especially for elegant evening dress, encourages the ornithological association.

A model wearing an ostrich feather evening gown by EDWARD MOLYNEUX stands in front of a large mirror in Molyneux's atelier, 1934.

1 2 3 4 5 6 7 8 9 10 11 12 13 14 15 16 17 18 19 20 21 22 23 24 25 26 27 28 29 30

APRIL

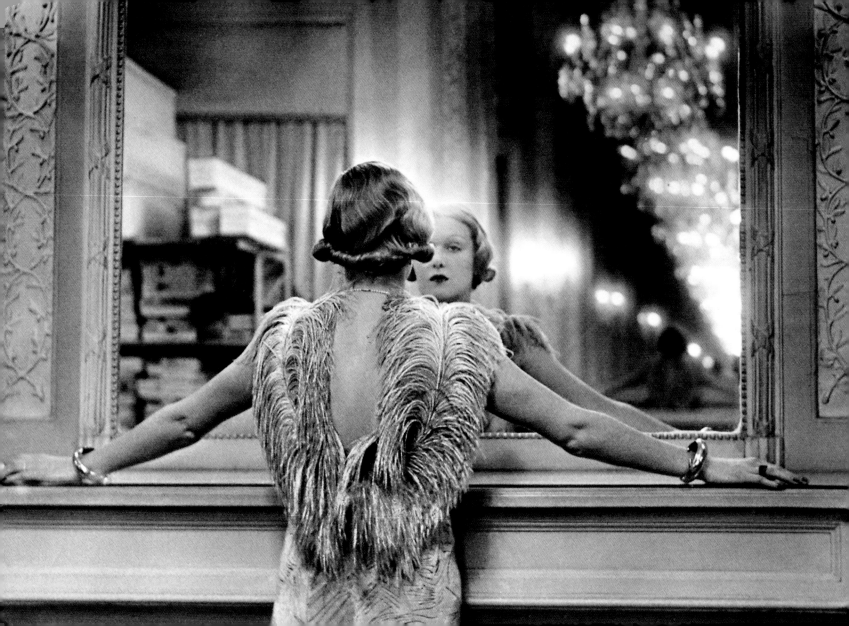

For me, the Rykiel woman is an intelligent woman.
She is impulsive, frivolous and likes to be artificial.
Because artificial is also art. She knows the way to
walk, the way to play with words and with herself.
She has two different sides to her character. She's
perverse, sweet. She is very sophisticated and
she is also very simple.

Sonia Rykiel

Sonia Rykiel (b.1930) is the queen of knitwear. Her luxurious creations are
invariably the very epitome of glamour. Her style emphasizes femininity.
A model presents a design by SONIA RYKIEL during the Fall/Winter 2006/07
ready-to-wear collections, Paris.

1 2 3 4 **5** 6 7 8 9 10 11 12 13 14 15 16 17 18 19 20 21 22 23 24 25 26 27 28 29 30

APRIL

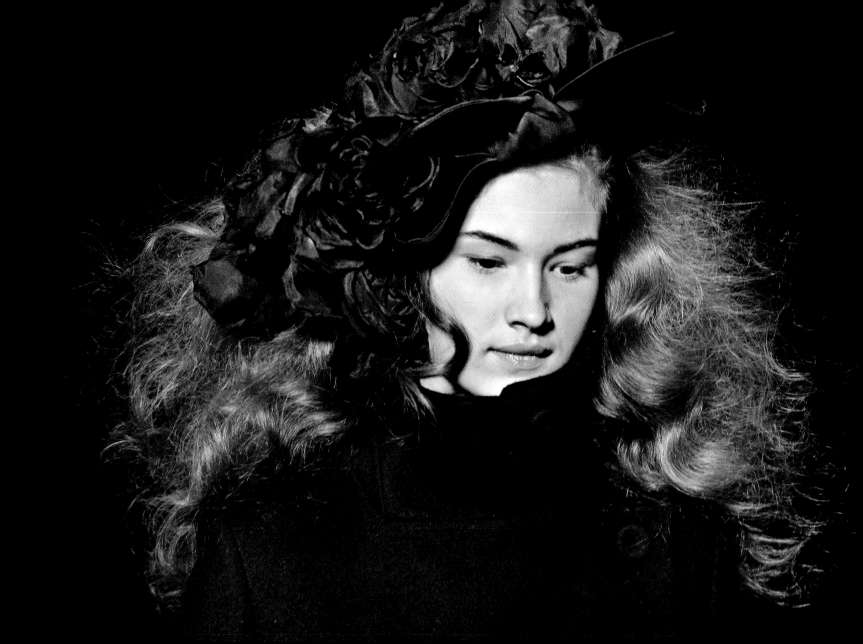

Everybody was wearing a narrow suit
at the end of the 1960s… so I just went
wild with the lapels and cut them as
wide as you possibly could—enormous—
and it was terribly flared at the jacket.
So that was my first look and it was
different from anybody else.

Tommy Nutter

In the 1960s, the "British style" in men's fashion showed a penchant for quoting the
gentleman's suit—only to produce a skillful exaggeration of the severe silhouette.
English tailor TOMMY NUTTER in his shop. 1969.

1 2 3 4 5 **6** 7 8 9 10 11 12 13 14 15 16 17 18 19 20 21 22 23 24 25 26 27 28 29 30

APRIL

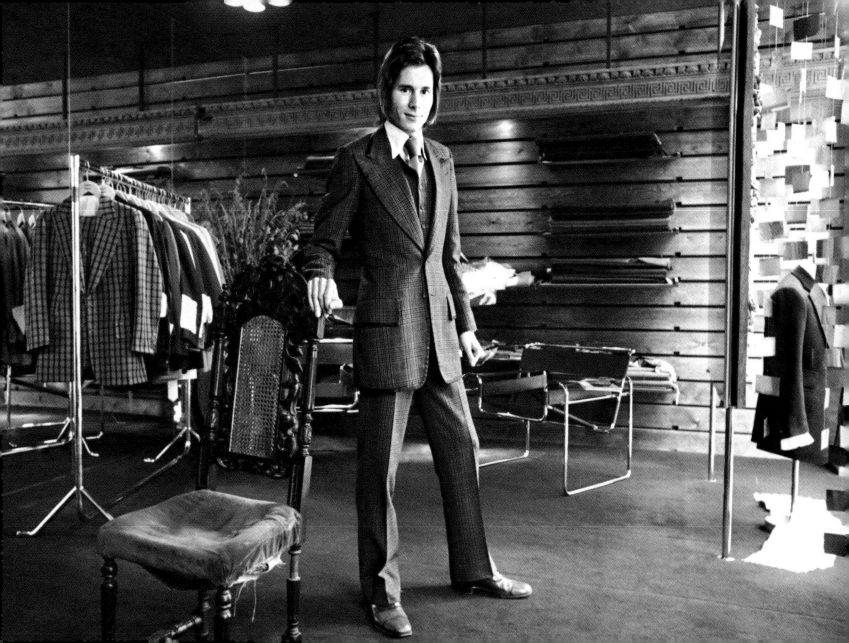

Fashion must do good, it must improve the attitude toward life. How often does a woman have the chance to feel perfect? Not often. Most people believe they should dress up really beautifully for a wedding and buy a luxurious dress. But why just for the wedding? The week afterward may be much more decisive!

Olivier Theyskens

"The big white gown" is as much a fashion staple as the "little black dress." Beginning in the art deco era, fanciful evening dresses have emphasized the train. Always regarded as a sign of rank and dignity, these days a train makes an appearance only when a woman wants to make that once-in-a-lifetime impression.

Model on the runway at the OLIVIER THEYSKENS Fall/Winter 2001/02 ready-to-wear fashion show, Paris.

1 2 3 4 5 6 **7** 8 9 10 11 12 13 14 15 16 17 18 19 20 21 22 23 24 25 26 27 28 29 30

APRIL

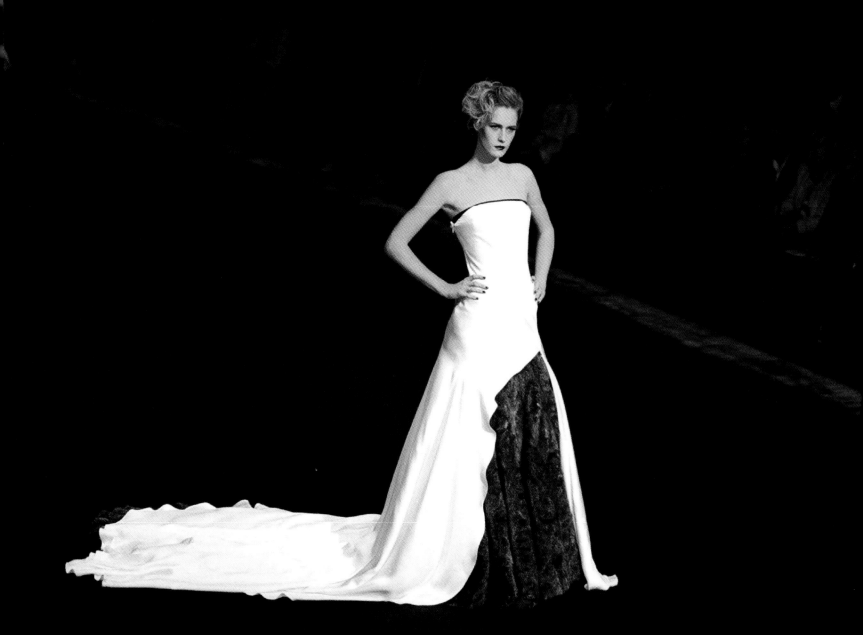

I try to express the contemporary
woman and do it through fashion
because that's my instrument.

Miuccia Prada

According to the book (and film)—*The Devil Wears Prada.* Is it he who reaches for
the coat hanger here? Is this where he buys his clothes? We shall never find out.
Interior shot of the new PRADA store on Rodeo Drive in Beverly Hills, Los Angeles,
2004.

1 2 3 4 5 6 7 **8** 9 10 11 12 13 14 15 16 17 18 19 20 21 22 23 24 25 26 27 28 29 30

APRIL

Most of the provocative things I've done were not done purposefully, but instead came quite naturally.

Jean Paul Gaultier

The portrayal of a confident, often aggressive sexuality dominates the fashion of Jean Paul Gaultier. Madonna's favorite designer sees women as strong, dominant, and mysterious.
LINDA EVANGELISTA presents a creation by JEAN PAUL GAULTIER for the Fall/Winter 2003/04 haute couture collections in Paris.

1 2 3 4 5 6 7 8 9 10 11 12 13 14 15 16 17 18 19 20 21 22 23 24 25 26 27 28 29 30

APRIL

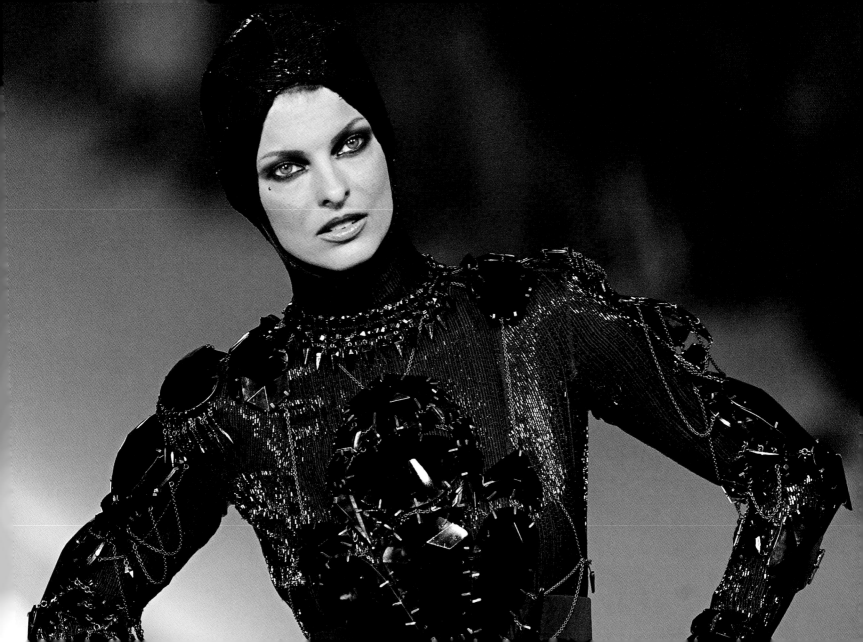

Fashion is a charming tyranny of short duration.

Zeno of Citium

Famous faces en masse. To attend an important fashion show is just as prestigious as an opera première in Milan, Salzburg, or Bayreuth.
WALLIS, DUCHESS OF WINDSOR, and her husband EDWARD, DUKE OF WINDSOR, visit an English fashion show in Paris, 1963.

1 2 3 4 5 6 7 8 9 **10** 11 12 13 14 15 16 17 18 19 20 21 22 23 24 25 26 27 28 29 30

APRIL

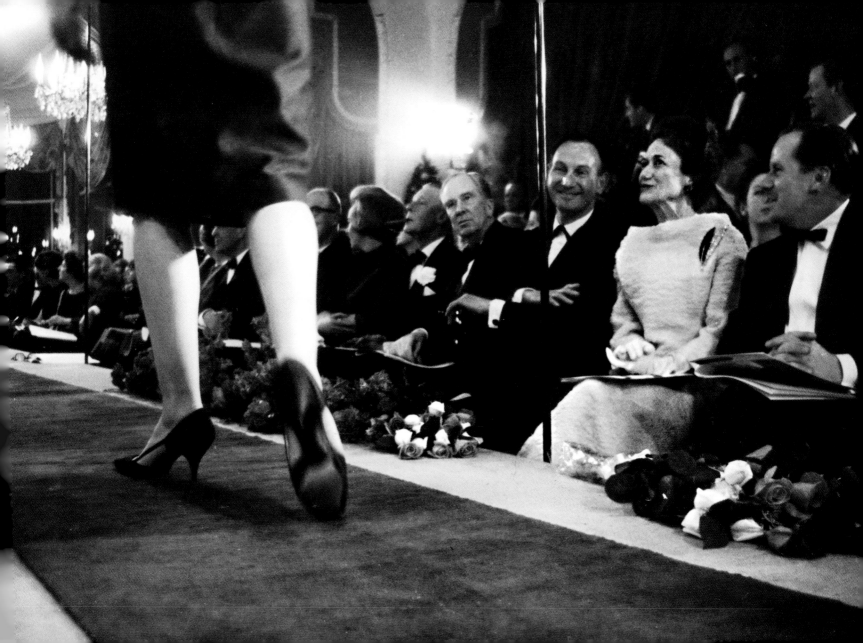

Because I am untrained I approach
my designs in an unconstrained
way and I feel a freedom in this. It is
unconventional but it means outcomes
are not limited by traditional boundaries.

Trelise Cooper

How sweet! Really? Children's fashion always tries to turn them into dolls and little adults. No designer makes an exception here.
Three-year-old twin models showcase designs on the catwalk by TRELISE COOPER at Air New Zealand Fashion Week 2007.

1 2 3 4 5 6 7 8 9 10 11 12 13 14 15 16 17 18 19 20 21 22 23 24 25 26 27 28 29 30

APRIL

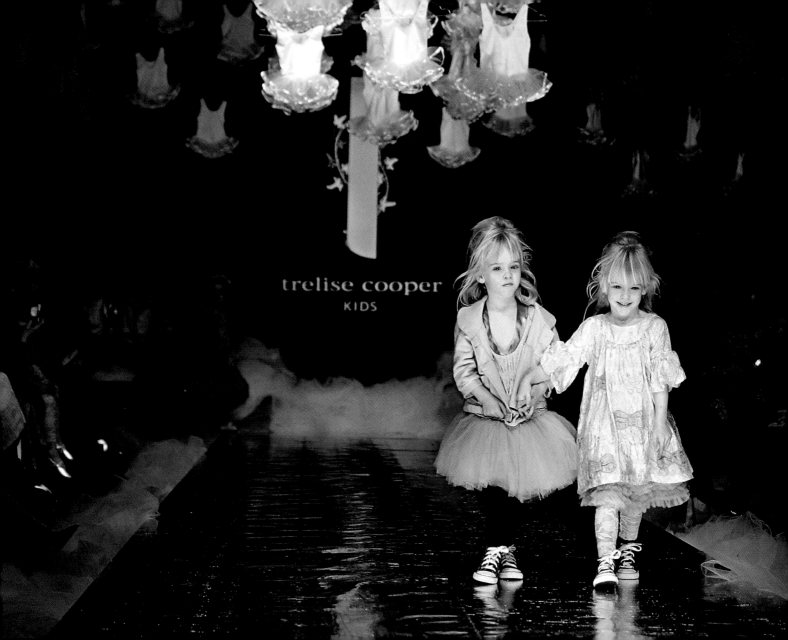

Fashion has a reason to be, because
in fashion you can find new kinds of
expression about human beings. It's
my way to communicate.

Ann Demeulemeester

Deliberately asymmetric cuts and understated, earthy tones are typical
characteristics of the collections of Ann Demeulemeester. She is one of the
most unusual and successful Belgian designers.
A model shows off a creation by Belgian designer ANN DEMEULEMEESTER for
the Fall/Winter 2006/07 ready-to-wear collections, Paris.

1 2 3 4 5 6 7 8 9 10 11 **12** 13 14 15 16 17 18 19 20 21 22 23 24 25 26 27 28 29 30

APRIL

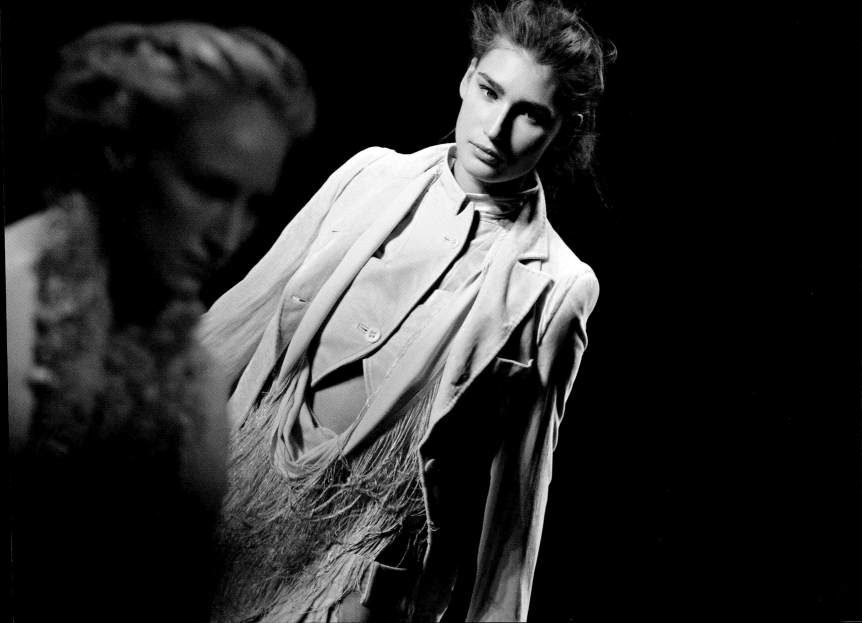

The future of fashion? It has none.
The trend is no fashion. We are getting
nakeder and nakeder.

Thierry Mugler

Sometimes tighter, sometimes wider—sometimes in plain colors, and sometimes patterned; hot pants simply refuse to die. Even the luxury fashion house of Gucci revived the trendy short shorts for slim women with plenty of courage.
A model presents a creation by GUCCI, Spring/Summer 2007 women's collections, Milan.

1 2 3 4 5 6 7 8 9 10 11 12 **13** 14 15 16 17 18 19 20 21 22 23 24 25 26 27 28 29 30

APRIL

Grace surrounds elegance
and clothes it.

Joseph Joubert

Emilio Pucci was a star of the 1960s. His shrill, brightly printed dresses revealed the influence of op art and psychedelia. Those who look back nostalgically and with a certain longing to those bygone days will automatically remember the name of Pucci.
Designer EMILIO PUCCI with models wearing his creations, 1962.

1 2 3 4 5 6 7 8 9 10 11 12 13 **14** 15 16 17 18 19 20 21 22 23 24 25 26 27 28 29 30

APRIL

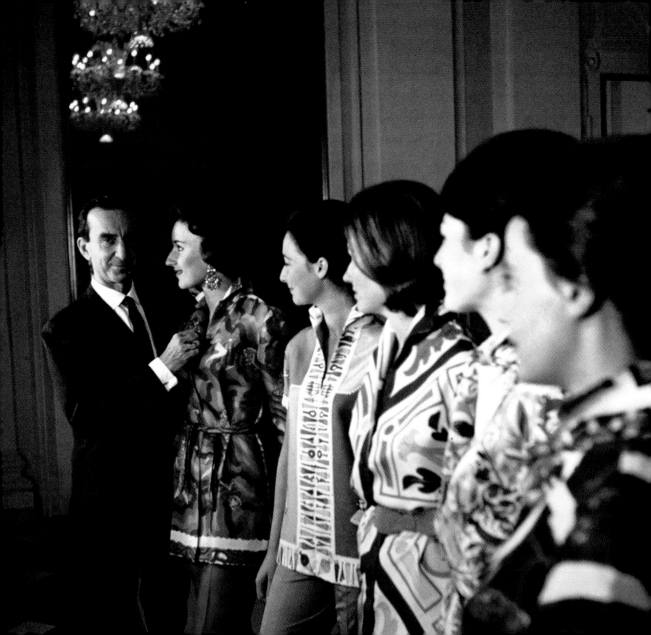

When people think of my clothes
they think romantic and feminine with
a lot of embellishment. I love folkloric
and vintage, so there's all those
elements thrown in. Then there's
always rock 'n' roll...

Anna Sui

A light, almost transparent summer dress with puff sleeves by the American designer Anna Sui. The pattern recalls Missoni, but Sui likes "playing" with the motifs of the 1970s.
A model walks the runway during the ANNA SUI Spring/Summer 2008 fashion show at Mercedes-Benz Fashion Week, New York.

1 2 3 4 5 6 7 8 9 10 11 12 13 14 **15** 16 17 18 19 20 21 22 23 24 25 26 27 28 29 30

APRIL

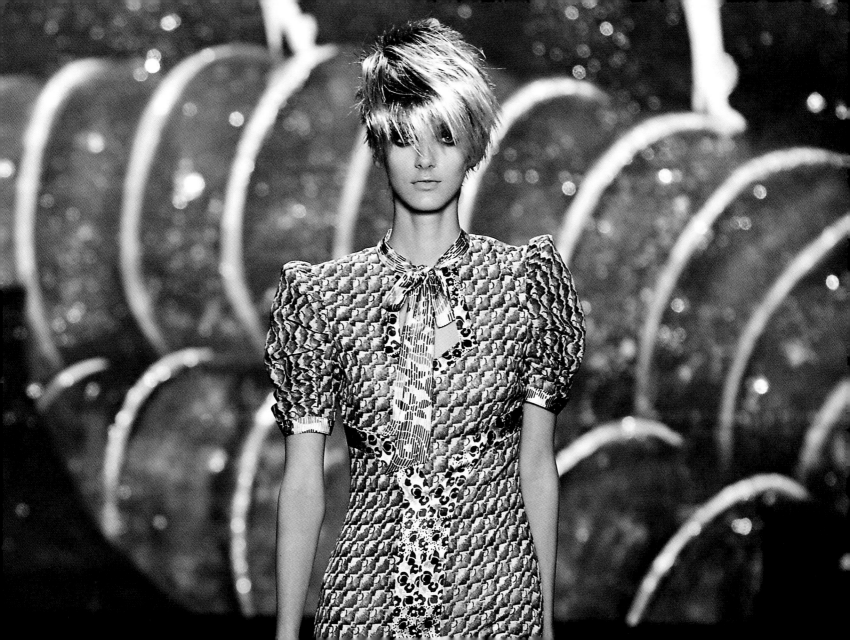

I like to think that I can introduce people
to the idea of simplicity and elegance.

Giorgio Armani

The great Giorgio Armani always aimed for simplicity in fashion. He still does. The Italian fashion designer almost invariably wears black pants and a T-shirt. When it comes to ladies, however, Armani is less parsimonious with regard to fabric.
Fashion designer GIORGIO ARMANI with a model, Milan, 1979.

1 2 3 4 5 6 7 8 9 10 11 12 13 14 15 **16** 17 18 19 20 21 22 23 24 25 26 27 28 29 30

APRIL

Materials were at the heart of our work, the lines mirroring the contemporary woman, who is determined, elegant, self-assured, and confident about change. A woman who is forging a new relationship with the world, with nature, with others.

Paco Rabanne about his work with Rosemary Rodriguez

Latex, lacquer, leather—and metal. Paco Rabanne (b. 1934) never thought much of gentle femininity. The master has remained true to himself to this day. His unapproachable Amazons still wear thigh-high boots and dresses made of metal or plastic tiles. In 1966, Rabanne even fixed his first collection together with pliers and eyelets.

Models walk down the runway during the PACO RABANNE Fall/Winter 2001/02 collection show, Paris.

1 2 3 4 5 6 7 8 9 10 11 12 13 14 15 16 **17** 18 19 20 21 22 23 24 25 26 27 28 29 30

APRIL

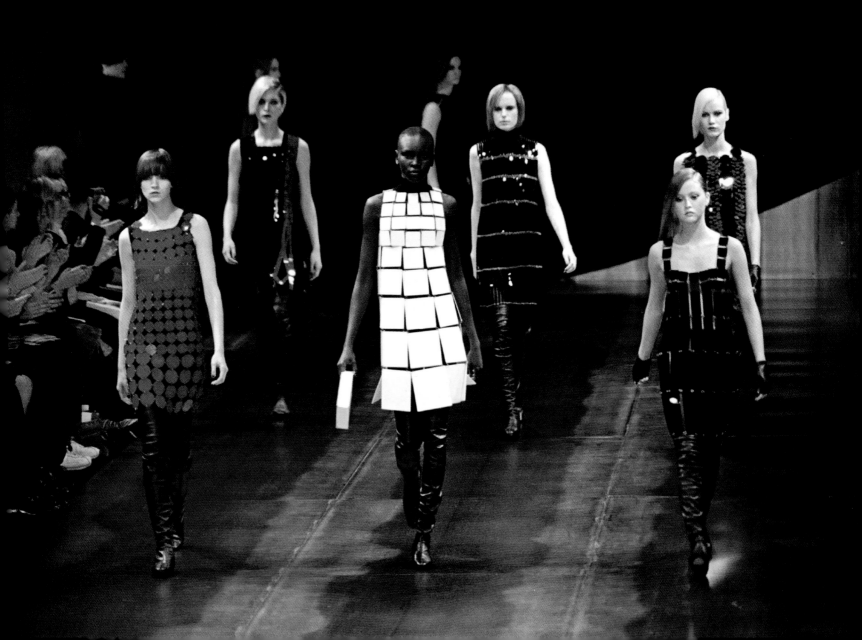

Tribal techno—with ethnic touches.

Rifat Ozbek

Springs or feathers? Why does the model wearing such imaginative, exuberant headgear look so unhappy? We shall never find out.
A model presents a creation by Turkish designer RIFAT OZBEK, Spring/Summer 2007 women's collections, Milan.

1 2 3 4 5 6 7 8 9 10 11 12 13 14 15 16 17 **18** 19 20 21 22 23 24 25 26 27 28 29 30

APRIL

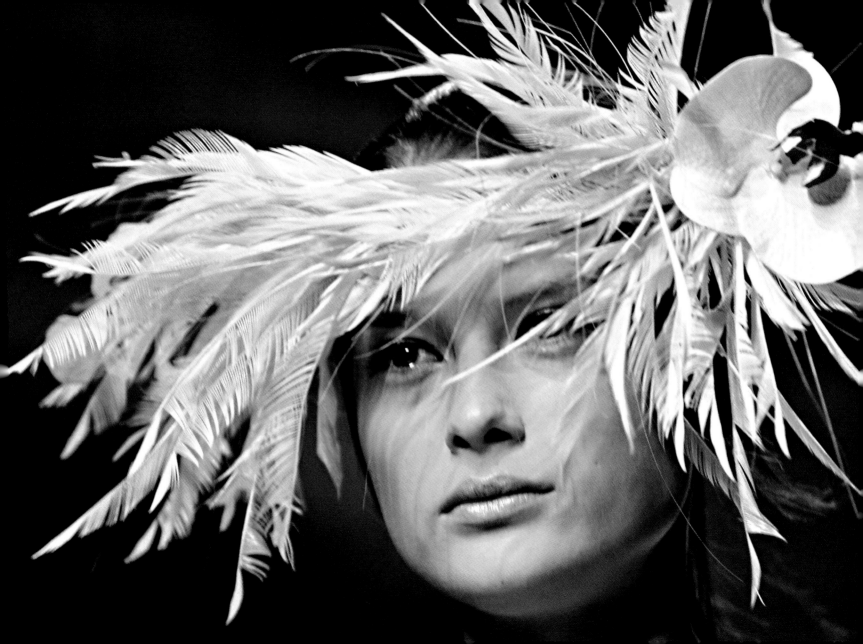

To avoid fashion is just as wrong as
to exaggerate it.

Jean de La Bruyère

Next, please! Dots and checks were very popular patterns for full dresses and
fitted costumes during the 1950s.
Five models pose in the latest outfits at a betting window at Roosevelt Raceway,
Westbury, New York, 1958.

1 2 3 4 5 6 7 8 9 10 11 12 13 14 15 16 17 18 19 20 21 22 23 24 25 26 27 28 29 30

APRIL

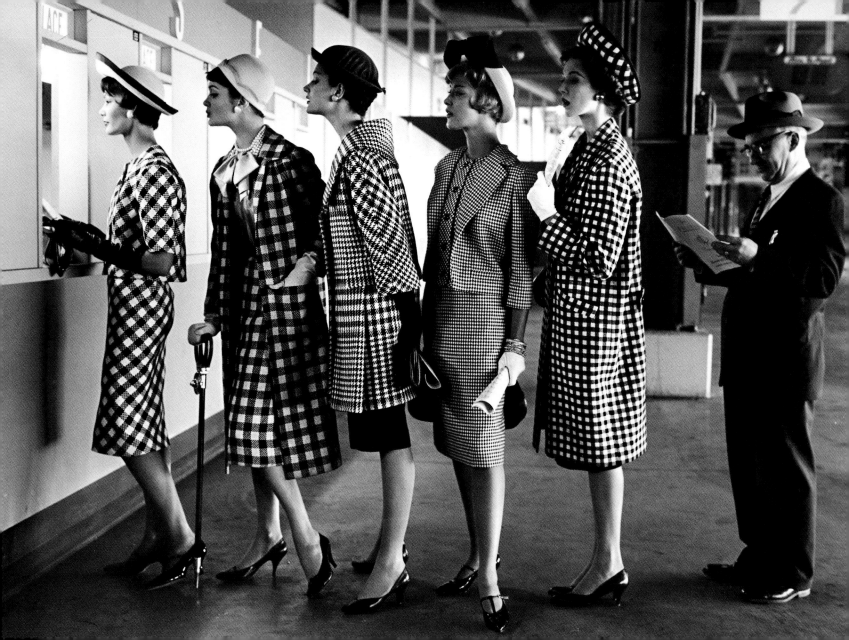

I'd like men to think about evolving into something more sophisticated, more seductive. To explore the possibility of an entirely new masculinity.

Hedi Slimane

Hedi Slimane (b. 1968) had the reputation of being a reformer of men's fashion. Commuting between Berlin and Paris, the artist was famous for tearing down all conventions of the fashion circus. From 2000, Slimane was chief designer of men's fashion at Christian Dior. The end of the road came in 2007. It was not a happy ending. The industry held their breath as they watched a fairy-tale career suddenly end.

A model presents a design by HEDI SLIMANE for DIOR at the Fall/Winter 2006/07 men's ready-to-wear collections, Paris.

1 2 3 4 5 6 7 8 9 10 11 12 13 14 15 16 17 18 19 20 21 22 23 24 25 26 27 28 29 30

APRIL

De la Renta's couture hand is so sure that he makes the most complex embellishments—from fur collars to alligator and tortoiseshell belts to sparkling mink shoes—seem easy rather than showy. The finesse in the work, rare in America, marks out the designer as exceptional in his uptown grace.

Suzy Menkes, *The New York Times*

The name of the American Oscar de la Renta is synonymous with elegant, flattering, feminine fashion which is not afraid of glamour, but that avoids extravagant escapades.

Designer OSCAR DE LA RENTA stands on the runway surrounded by his models at a show in New York, 1996.

1 2 3 4 5 6 7 8 9 10 11 12 13 14 15 16 17 18 19 20 21 22 23 24 25 26 27 28 29 30

APRIL

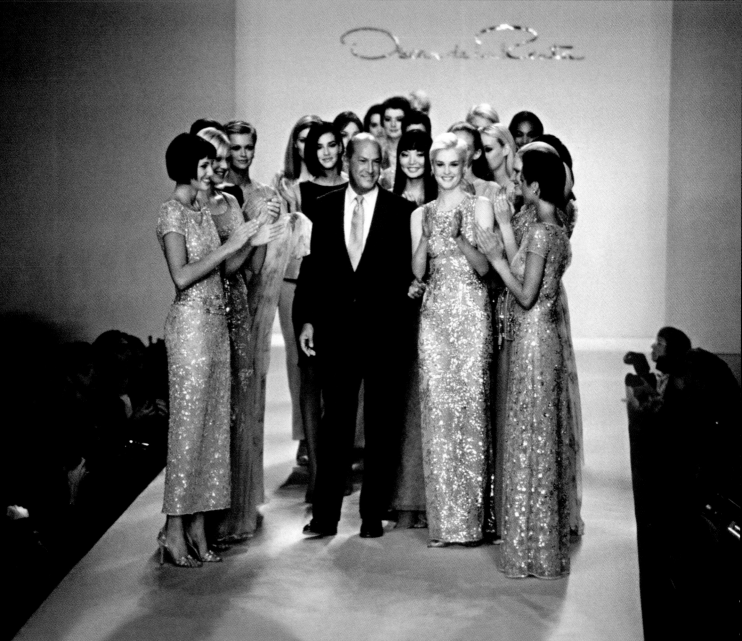

Diamonds are a girl's best friend.

Marilyn Monroe in *Gentlemen Prefer Blondes*

The Rome-based house of Bulgari is famous for perfumes, accessories, and handbags, as well as its luxurious jewelry creations. Today it also runs an exclusive hotel group.
Jewelry at the BVLGARI store at Kurfürstendamm, Berlin, 2004.

1 2 3 4 5 6 7 8 9 10 11 12 13 14 15 16 17 18 19 20 21 22 23 24 25 26 27 28 29 30

APRIL

There were great models before and after
Suzy, but she was something else—a
red-headed force of nature, a wolf in
chic clothing, the one flesh-and-blood
woman in a world of exquisite creatures.

Richard Avedon

The photographer Richard Avedon has taken some of the most beautiful and best fashion photographs in the world. His "shots of style" are works of art. Classics of timeless beauty—like the outfit which Suzy Parker wore in this picture at the end of the 1950s.
American model and actress SUZY PARKER poses in the latest fashion, late 1950s.

1 2 3 4 5 6 7 8 9 10 11 12 13 14 15 16 17 18 19 20 21 22 23 24 25 26 27 28 29 30

APRIL

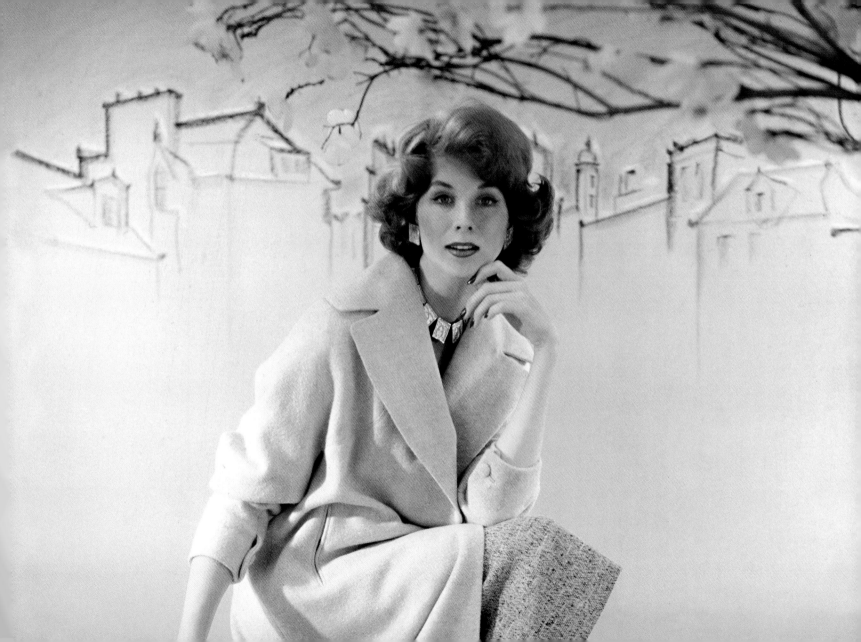

A beautiful flower does not exist.
There's only a moment when a flower
looks beautiful.

Yohji Yamamoto

Five feet ten inches tall (1.80 m) and with the (almost unvarying) measurements
34-24-34 (86-61-82)! Born in 1980, Brazilian top model Gisèle Caroline
Nonnenmacher Bündchen is of German extraction and the uncontested (and
according to Forbes the best-paid) superstar of the fashion scene.
GISELE BÜNDCHEN displays a creation by Brazilian designer COLCCI from the
Fall/Winter 2007/08 collection at Rio Fashion Week.

1 2 3 4 5 6 7 8 9 10 11 12 13 14 15 16 17 18 19 20 21 22 23 **24** 25 26 27 28 29 30

APRIL

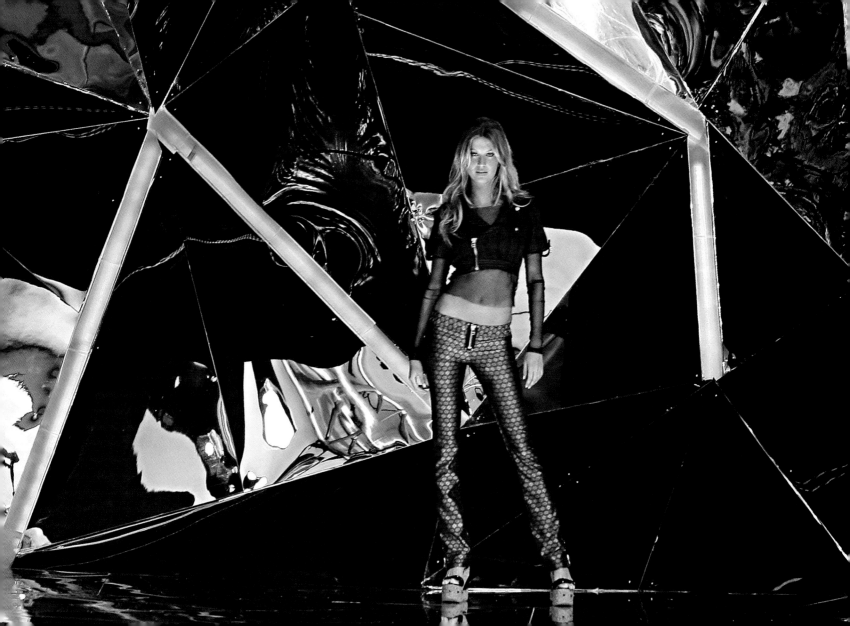

Fashion is transient, trends come and go.
I believe in style, not fashion.

Ralph Lauren

When a woman wears a leather outfit it can cause an accident. Nina Ricci quite clearly found inspiration in the uniform of the French traffic police for this suit with cape.
Model BEVERLY SCOTT stopping traffic in a NINA RICCI leather gendarme suit, 1963.

1 2 3 4 5 6 7 8 9 10 11 12 13 14 15 16 17 18 19 20 21 22 23 24 25 26 27 28 29 30

APRIL

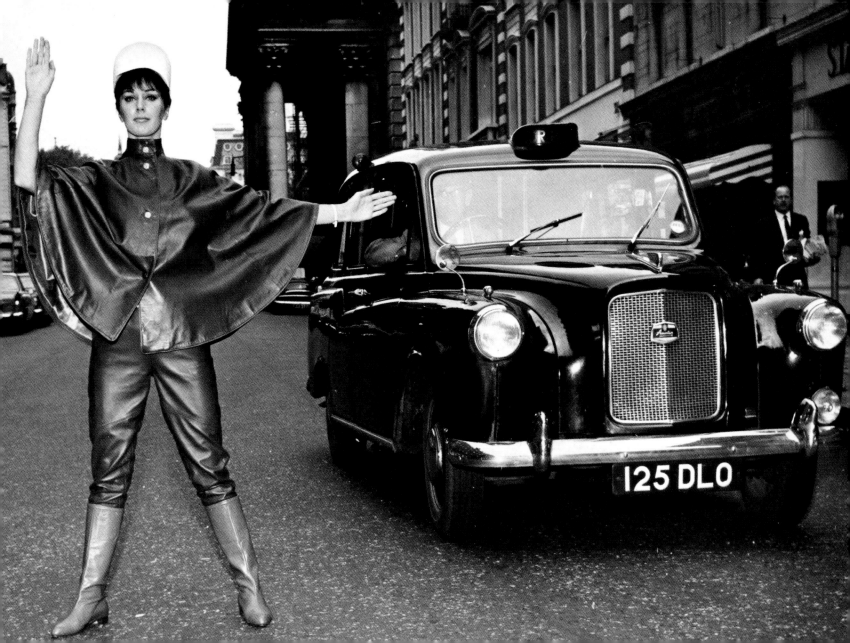

Beauty is whatever anyone thinks
is beautiful.

Rei Kawakubo

Was it really so hot on the catwalk? Or, who pulled the male models out of
the water? Neither. When a fashion show is staged, absolutely nothing is left to
chance. The "wet look" is meticulously executed styling.
Models walk the catwalk during the COMME DES GARÇONS Homme Plus fashion
show as part of the Spring/Summer 2008 Paris Fashion Week.

1 2 3 4 5 6 7 8 9 10 11 12 13 14 15 16 17 18 19 20 21 22 23 24 25 26 27 28 29 30

APRIL

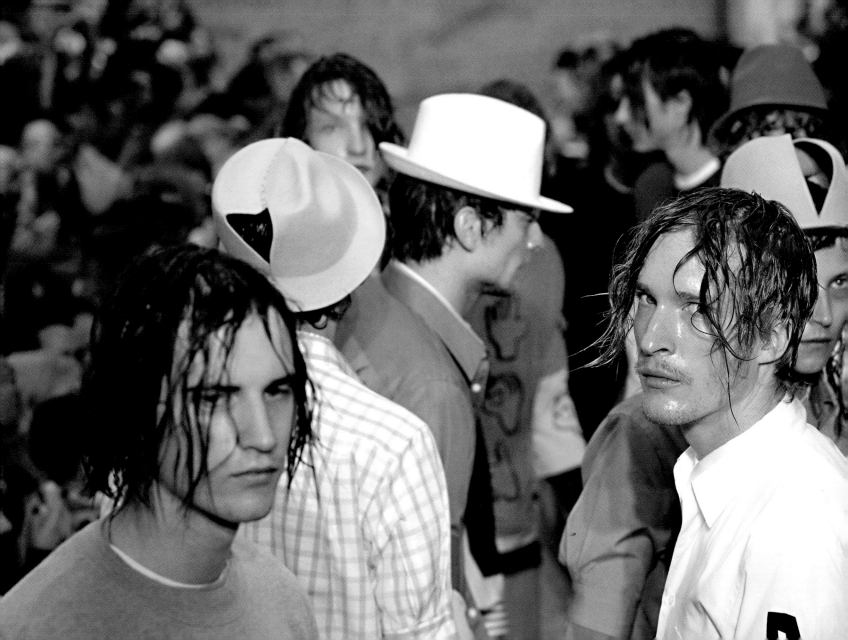

Enjoy your life, fashion is not that important.

Dries van Noten

The *jeune créateur* Dries Van Noten was born in Antwerp in 1958. The famous Belgian designer loves neutral colors, classic lines, and transparent fabrics—and yet, Van Noten often introduces color accents with great skill.
A model walks the catwalk during the DRIES VAN NOTEN fashion show as part of Paris Fashion Week Fall/Winter 2007/08.

1 2 3 4 5 6 7 8 9 10 11 12 13 14 15 16 17 18 19 20 21 22 23 24 25 26 27 28 29 30

APRIL

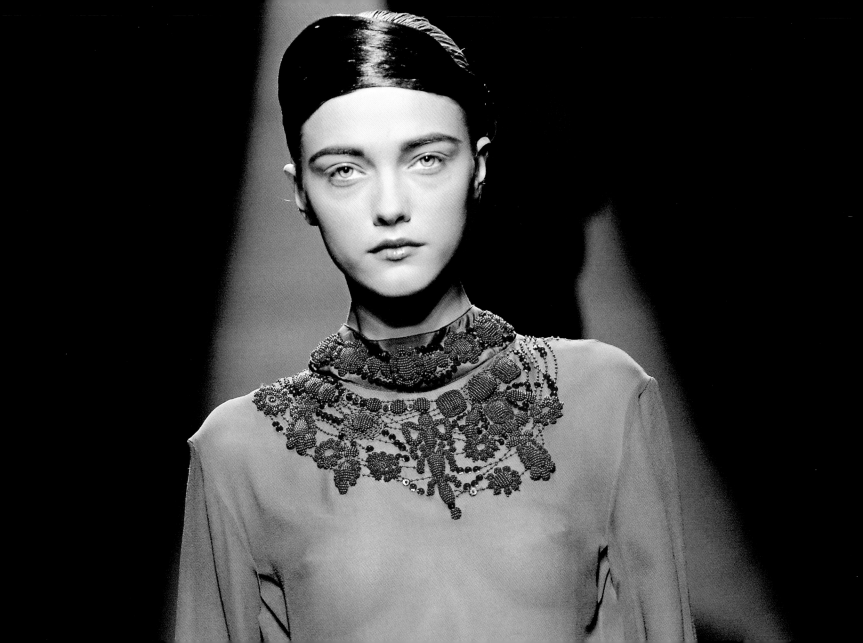

It was because of Garbo that I left MGM. In her last picture they wanted to make her a sweater girl, a real American type. I said, "When the glamour ends for Garbo, it also ends for me. She has created a type. If you destroy that illusion, you destroy her." When Garbo walked out of the studio, glamour went with her, and so did I.

Gilbert Adrian

The fashion designer Gilbert Adrian (1903–1959) was born in Connecticut and saw himself primarily as the "costume creator" of the great Hollywood actresses. His theatrical creations that emphasized the shoulders were worn by Greta Garbo, Jean Harlow, and—most stylishly of all—Joan Crawford. Adrian once commented sarcastically, "Who would ever have thought that my entire career would rest on the shoulders of Joan Crawford?"

Triple image of a model demonstrating the swirling motion of a jersey gown by ADRIAN, 1947.

1 2 3 4 5 6 7 8 9 10 11 12 13 14 15 16 17 18 19 20 21 22 23 24 25 26 27 28 29 30

APRIL

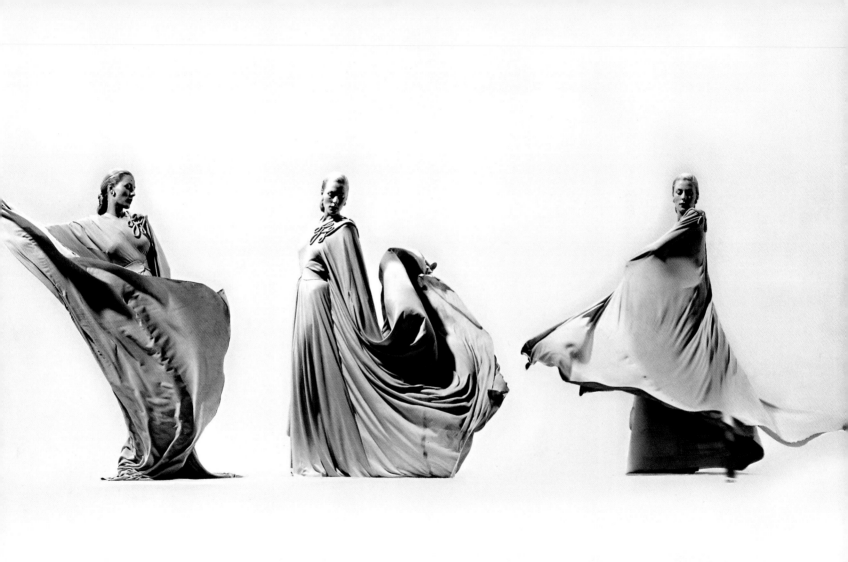

Hi. I'm not home right now, but my
shoes are, so leave them a message!

Carrie Bradshaw's answering machine, *Sex and the City*

Whoever takes a woman's shoes away is a wicked person. And whoever steals her "Manolos" is a thief. The pulse of shoe fans and fetishists, male and female, starts to race at the mention of the name Manolo Blahnik. The Spanish shoe designer's stilettos guarantee sex appeal for anyone's feet.
The new "diva shoe" by MANOLO BLAHNIK graces the collection at the Godiva Store, Beverly Hills Center Shopping Mall, Los Angeles, 2005.

1 2 3 4 5 6 7 8 9 10 11 12 13 14 15 16 17 18 19 20 21 22 23 24 25 26 27 28 29 30

APRIL

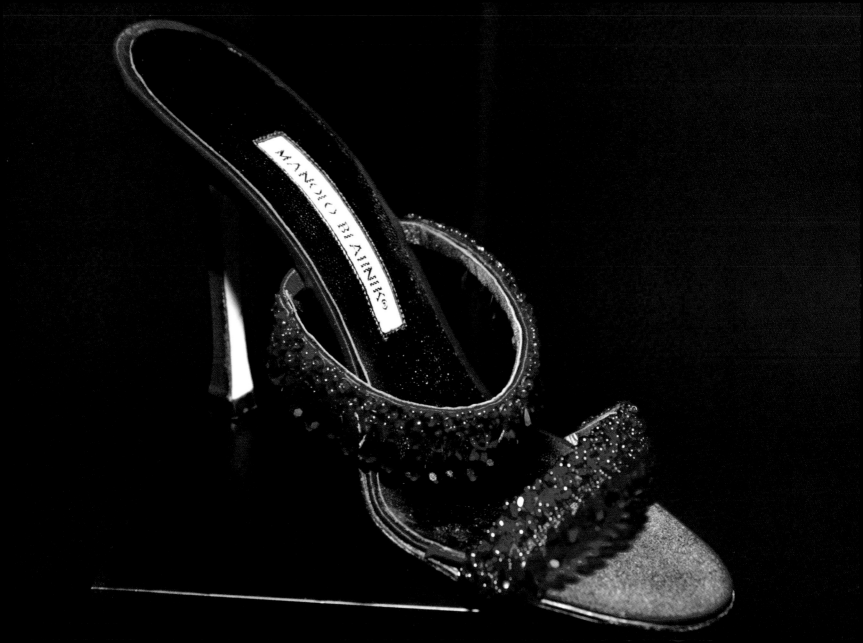

Rosemary Rodriguez explores the
depths of light, the brightness of
white, and the dazzle of metal.

Paco Rabanne

Where do we come from? Who are we? Where are we going? Fashion cannot
answer such fundamental philosophical questions, but at least it can pose them.
Time and time again.
A Chinese model parades a creation by Spanish designer ROSEMARY RODRIGUEZ
for PACO RABANNE during the 2004 Shanghai Fashion Week.

1 2 3 4 5 6 7 8 9 10 11 12 13 14 15 16 17 18 19 20 21 22 23 24 25 26 27 28 29 30

APRIL

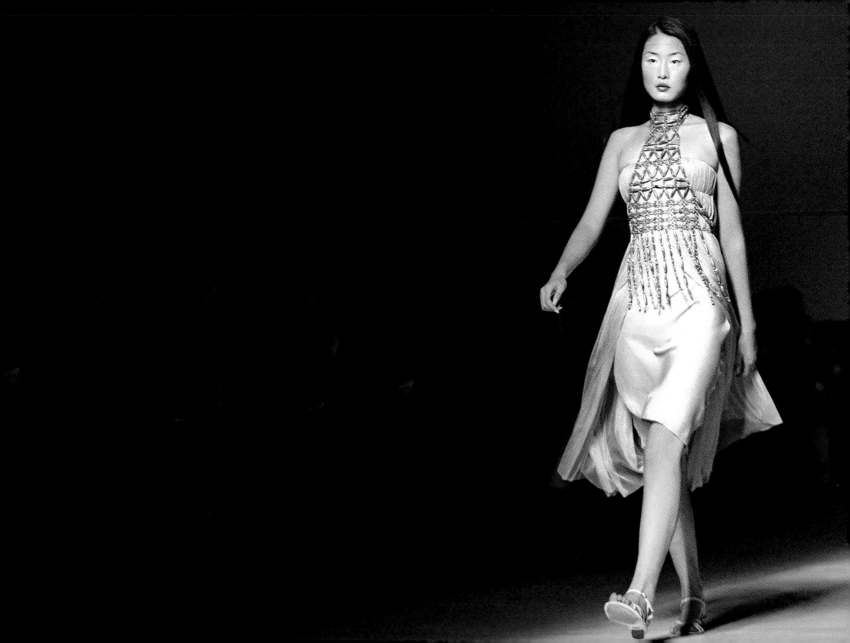

I like to imagine being in the skin
of women.

Olivier Theyskens

Italian dressmaker Nina Ricci (1883–1970) opened a fashion salon in Paris in 1932.
As you can see, the designers have remained faithful to the founder's style to this
day—the creations which bear the Nina Ricci label must be romantic, glamorous,
and unabashedly feminine.
A model presents a creation by Belgian designer OLIVIER THEYSKENS for NINA RICCI
during the Spring/Summer 2008 ready-to-wear collection show in Paris.

1 2 3 4 5 6 7 8 9 10 11 12 13 14 15 16 17 18 19 20 21 22 23 24 25 26 27 28 29 30 31

MAY

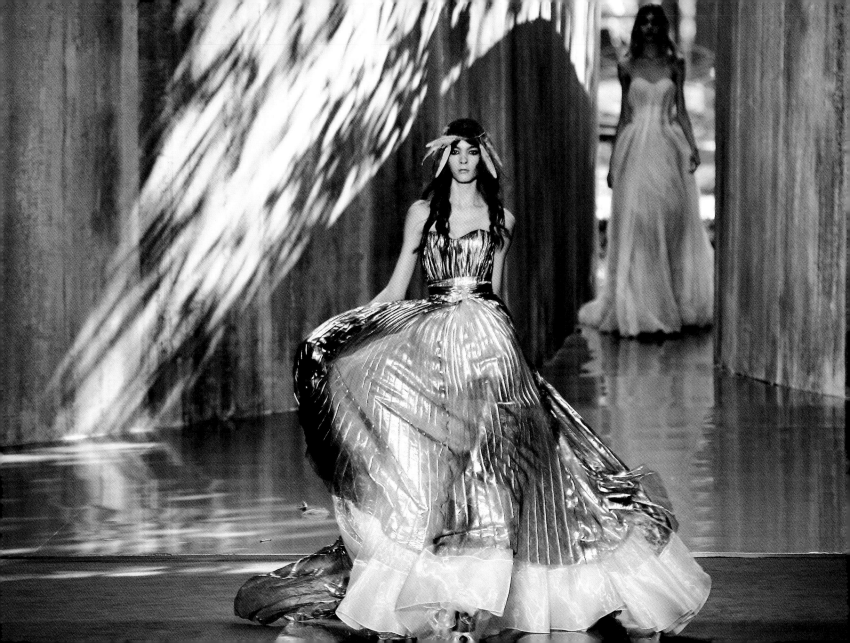

We must never confuse elegance
with snobbery.

Yves Saint Laurent

Group picture with man. Typical of the 1930s—the slender, narrow silhouette
of the evening gowns.
The South African-born fashion designer VICTOR STIEBEL with a group of models
wearing his designs, 1934.

1 2 3 4 5 6 7 8 9 10 11 12 13 14 15 16 17 18 19 20 21 22 23 24 25 26 27 28 29 30 31

MAY

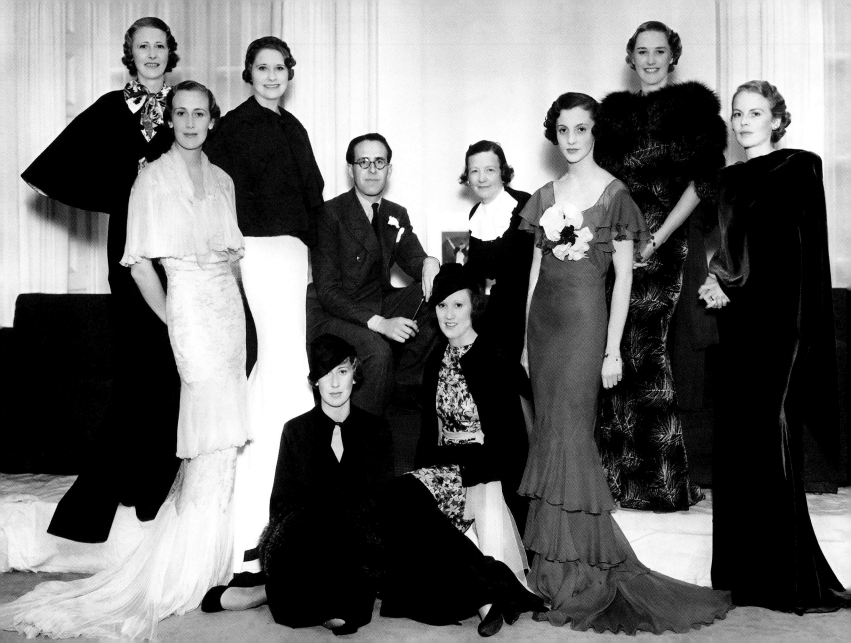

I'm surrounded by critical women.
If I stopped challenging myself, they'd
refuse to work with me. I like that.

Junya Watanabe

Junya Watanabe (b. 1961) was the protégé of Rei Kawakubo, the creative head of Comme des Garçons. This design shows an appreciation of fashion history; the combination of tweed jacket and hat evokes the great Coco Chanel.
A model presents a creation by Japanese designer JUNYA WATANABE during the Fall/Winter 2007/08 ready-to-wear collection show in Paris.

1 2 **3** 4 5 6 7 8 9 10 11 12 13 14 15 16 17 18 19 20 21 22 23 24 25 26 27 28 29 30 31

MAY

They starved for luxury.
He gave them plenty.

Diana Vreeland

The actress Julia Roberts claims "Fashion is like being infected with something new." Twice a year fashion journalists all over the world wait, here in front of Dior at 30, avenue Montaigne in Paris, to catch the latest bug—so that they can then infect everyone else.

Reporters and fashion pundits mingle outside CHRISTIAN DIOR's boutique in Paris at the launch of the Fall/Winter collection, August 1953.

1 2 3 **4** 5 6 7 8 9 10 11 12 13 14 15 16 17 18 19 20 21 22 23 24 25 26 27 28 29 30 31

MAY

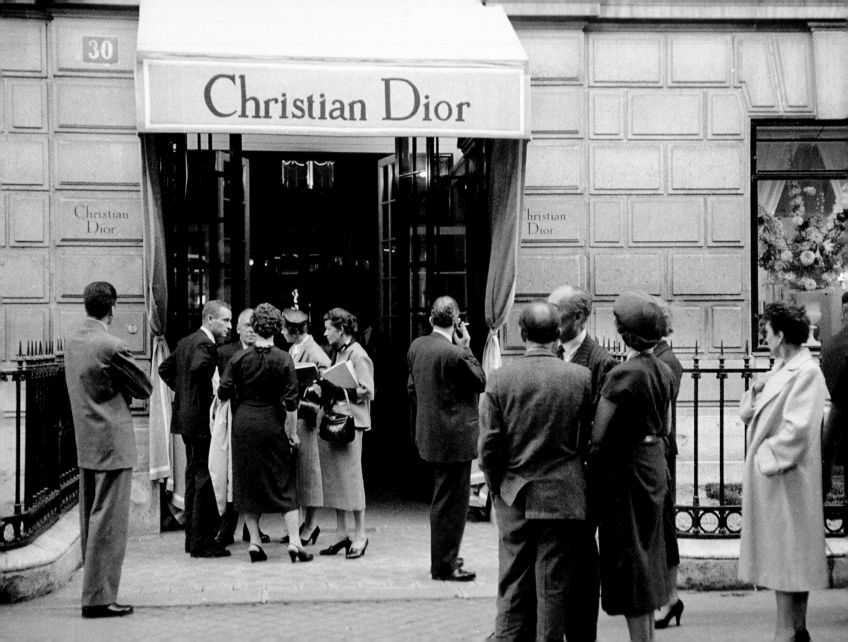

I find it easy to make things seem naughty. I quite like the idea of doing something more intelligent.

Marc Jacobs

At the end of the nineteenth century, Louis Vuitton became famous for his exclusive luggage. After the sinking of the Titanic, the brown-and-beige Louis Vuitton suitcases bobbed around for days on the waves of the Atlantic. For decades things were very quiet around the venerable fashion house—until 1997, when the U.S. designer Marc Jacobs (b. 1963) was made responsible for the LV design. With trendy colors, crazy ideas, and the most expensive materials, he made sure that the label with the two letters *L* and *V* achieved cult status once again.

A model presents a creation by U.S. designer MARC JACOBS for LOUIS VUITTON during the Spring/Summer 2008 ready-to-wear collection show in Paris.

1 2 3 4 **5** 6 7 8 9 10 11 12 13 14 15 16 17 18 19 20 21 22 23 24 25 26 27 28 29 30 31

MAY

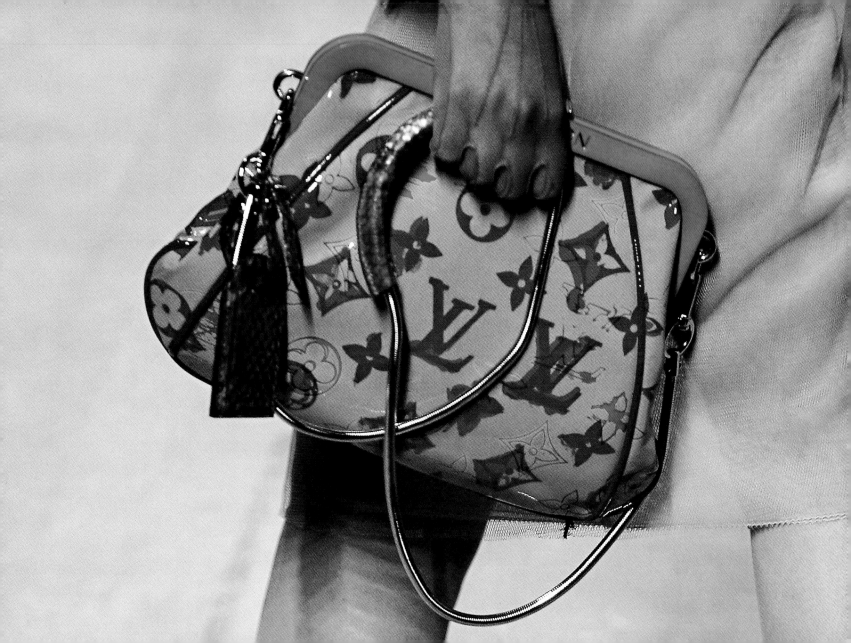

It's difficult to be avant-garde today.
People have got used to everything.

Vivienne Westwood

A wedding dress as a cocoon. But what sort of woman will emerge from the chrysalis after the wedding?
Veiled bride—a model in a creation by British designer VIVIENNE WESTWOOD at Russian Fashion Week in Moscow, April 2007.

1 2 3 4 5 **6** 7 8 9 10 11 12 13 14 15 16 17 18 19 20 21 22 23 24 25 26 27 28 29 30 31

MAY

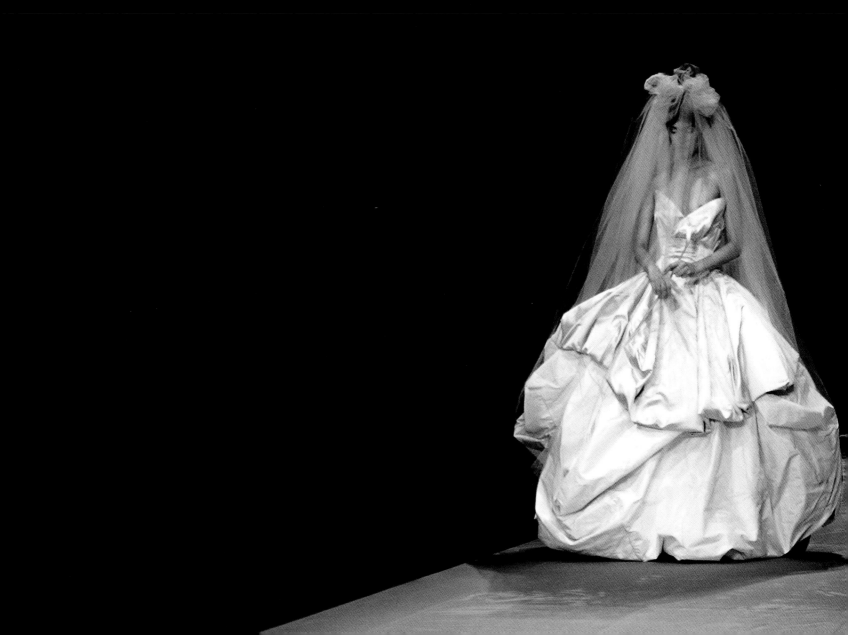

The link between architecture and design is very subtle: one has to choose the right material for the job. In both fields, I prefer pure and rigorous lines.

Gianfranco Ferré

Gianfranco Ferré was known as an "architect" of fashion because of his clear, structured style. He died in a Milan hospital in 2007 at the age of 62. His death was a shock for the entire fashion world, which had lost one of the truly great, quiet geniuses from among its ranks.
Models wearing daring creations from GIANFRANCO FERRÉ's Spring/Summer 2005 women's collection at Milan Fashion Week.

1 2 3 4 5 6 7 8 9 10 11 12 13 14 15 16 17 18 19 20 21 22 23 24 25 26 27 28 29 30 31

MAY

Princess Diana truly was England's rose.
She had a magical aura about her.
I always felt she really understood how
to use fashion as the silent language
and let clothes do the talking for her
when she couldn't, the way a movie
star in the silent films did.

John Galliano

In the person of Princess Diana, cult and fashion formed a rare liaison that obsessed, above all, the media. Over the centuries only a handful of women have succeeded not only in using fashion to shape their image, but also in leaving a lasting mark on fashion themselves. Diana was one of them.
Diana, Princess of Wales, wearing a creation designed by milliner FREDERICK FOX, 1985.

1 2 3 4 5 6 7 **8** 9 10 11 12 13 14 15 16 17 18 19 20 21 22 23 24 25 26 27 28 29 30 31

MAY

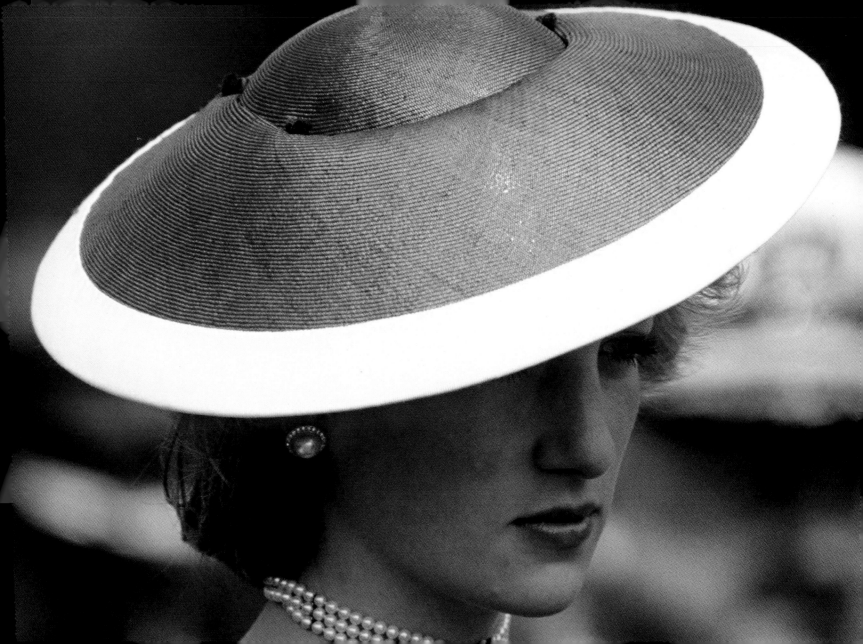

A woman's not going to buy a little skirt
for a lot of money if it's not for seduction.
What else are clothes made for?

Azzedine Alaïa

Azzedine Alaïa was one of the great couturiers of the 1980s. His severe cuts promised sex appeal, and the fabrics often used by the Tunisian designer included leather or synthetics such as Lycra. In the meantime, Alaïa has increasingly withdrawn from the fashion business.
A 2005 exhibition at the fashion house of designer AZZEDINE ALAÏA in Paris shows clothes by French designer PAUL POIRET.

1 2 3 4 5 6 7 8 9 10 11 12 13 14 15 16 17 18 19 20 21 22 23 24 25 26 27 28 29 30 31

MAY

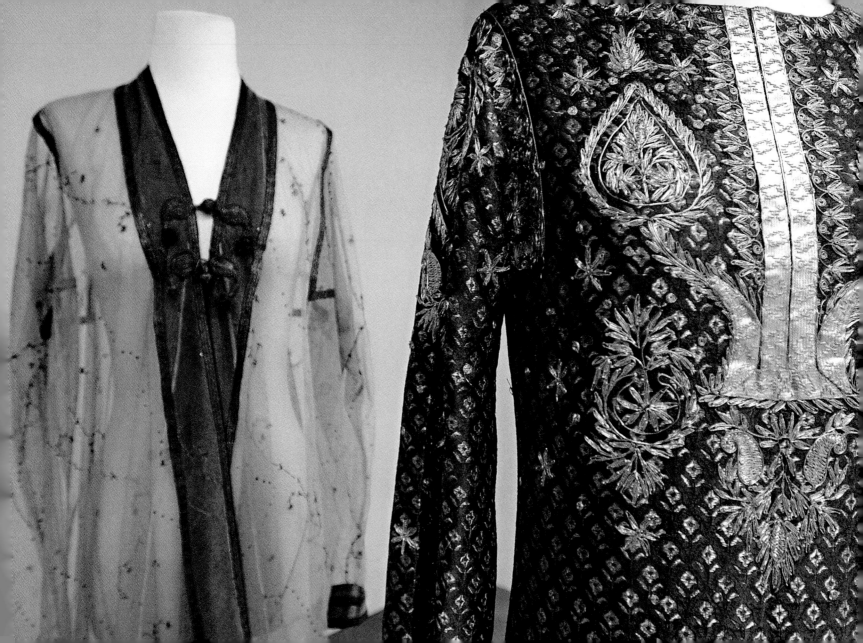

All classes mingled under the creaking roof (of Biba). There was no social distinction. Their common denominator was youth and rebellion against the establishment.

Barbara Hulanicki, founder of Biba

Consistency is the name of the game. Skirts became shorter and shorter and sunglasses larger and larger. Biba's crazy boutiques were indispensable landmarks of the shopping paradise of Swinging London. You could buy here-today-gone-tomorrow fashionable rubbish like oversized glasses as well as the miniskirt, just invented by Mary Quant.

"Can you see me?"—a salesgirl in the household department of the legendary London department store Biba, 1973.

1 2 3 4 5 6 7 8 9 **10** 11 12 13 14 15 16 17 18 19 20 21 22 23 24 25 26 27 28 29 30 31

MAY

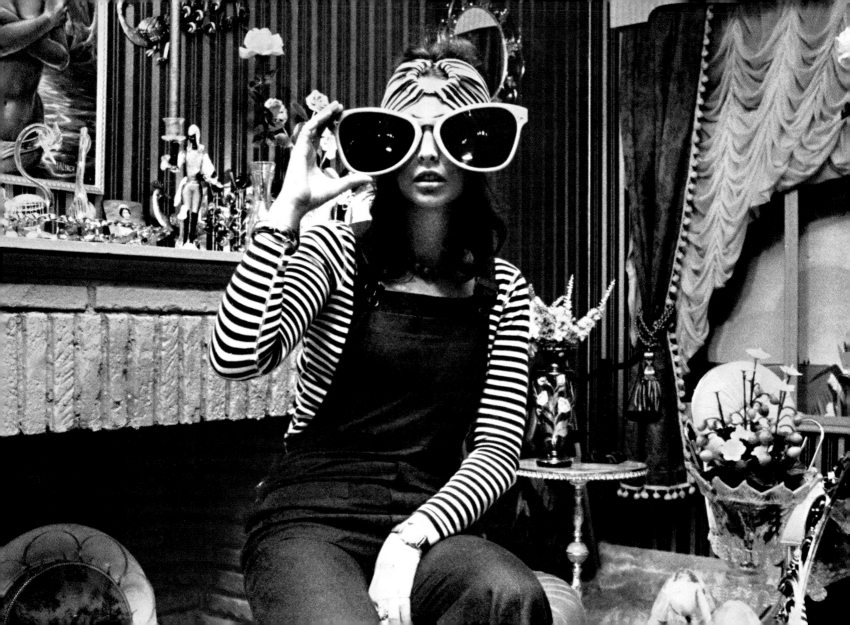

When people think about my clothes,
it is very much about the timeless
elegance. They never go out of fashion.

Colette Dinnigan

"What men like about women's clothes is to imagine what they would look like without them." Was the Irish playwright Brendan Francis Behan perhaps describing this model in her extravagant gown?
A model walks the catwalk during the presentation of the COLETTE DINNIGAN collection at the Vogue NAB catwalk show as part of Rosemount Australian Fashion Week Spring/Summer 2007 in Sydney.

1 2 3 4 5 6 7 8 9 10 **11** 12 13 14 15 16 17 18 19 20 21 22 23 24 25 26 27 28 29 30 31

MAY

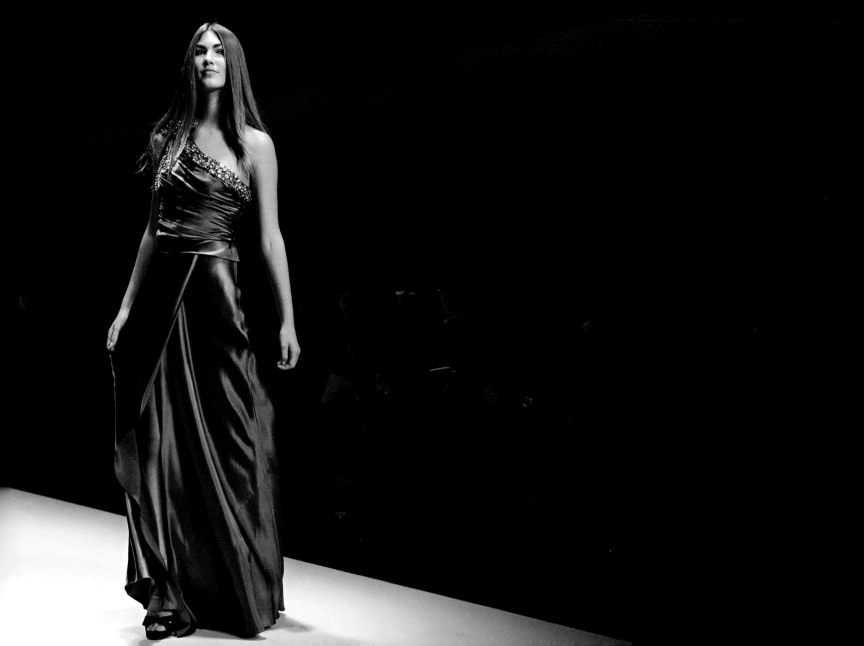

You have to design for the lives
American women lead today.

Claire McCardell, 1955

It would take more than that to throw a sailor off balance. Really? During the 1950s, lookouts might all too easily fall from the crow's nest at the sight of women in such attractive bathing suits.
A woman modeling two plaid beach outfits, 1950s.

1 2 3 4 5 6 7 8 9 10 11 12 13 14 15 16 17 18 19 20 21 22 23 24 25 26 27 28 29 30 31

MAY

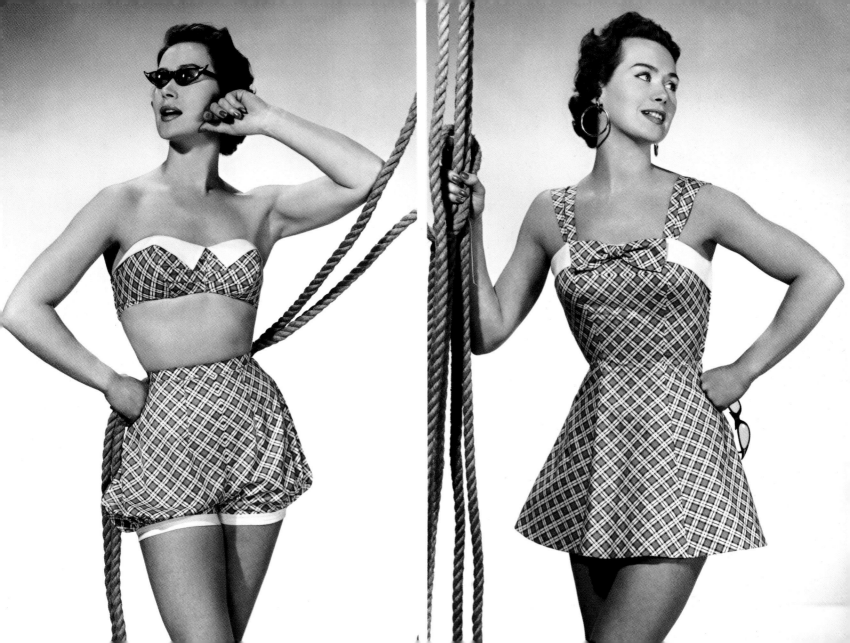

I'm a very down-to-earth designer in the sense that I love that mix of really classic, traditional, historical design with real fashion. I love fashion for its throw-away of-the-moment value, but I enjoy mixing it with something that's really thought about.

Christopher Bailey, Burberry

Breastplate or chain mail. Fashion has always enjoyed quoting and re-interpreting military motifs—or making fun of them.
A model presents a creation by fashion house BURBERRY PRORSUM during the Spring/Summer 2007 women's collections in Milan.

1 2 3 4 5 6 7 8 9 10 11 12 **13** 14 15 16 17 18 19 20 21 22 23 24 25 26 27 28 29 30 31

MAY

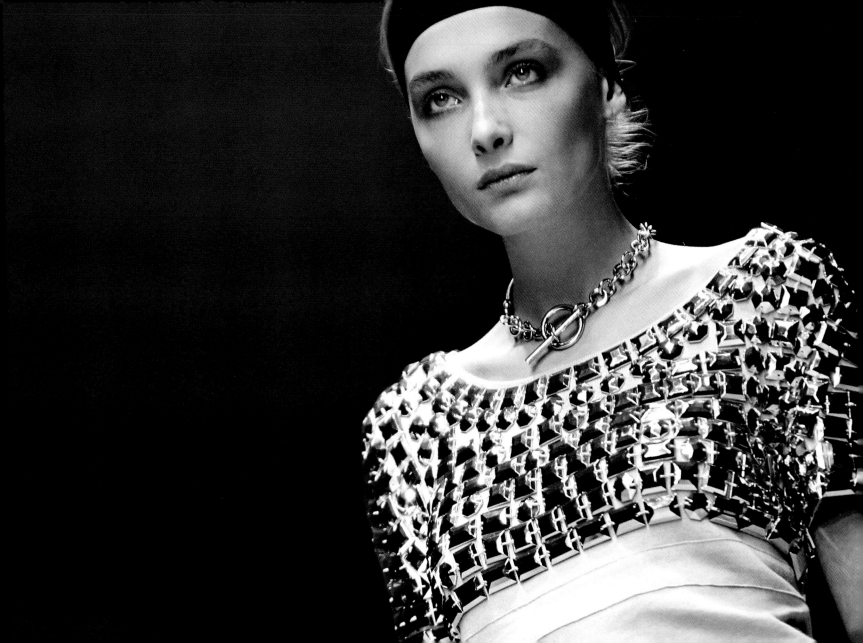

I don't know who invented high heels,
but all women owe him a lot.

Marilyn Monroe

Glass shoes—a dream vision that for centuries seemed possible only in the make-believe world of fairy tales. But then, in the 1970s, Plexiglas finally made the dream of feet that seem to float on air come true.

Silver kid platform shoes with Plexiglas heels, 1973.

1 2 3 4 5 6 7 8 9 10 11 12 13 **14** 15 16 17 18 19 20 21 22 23 24 25 26 27 28 29 30 31

MAY

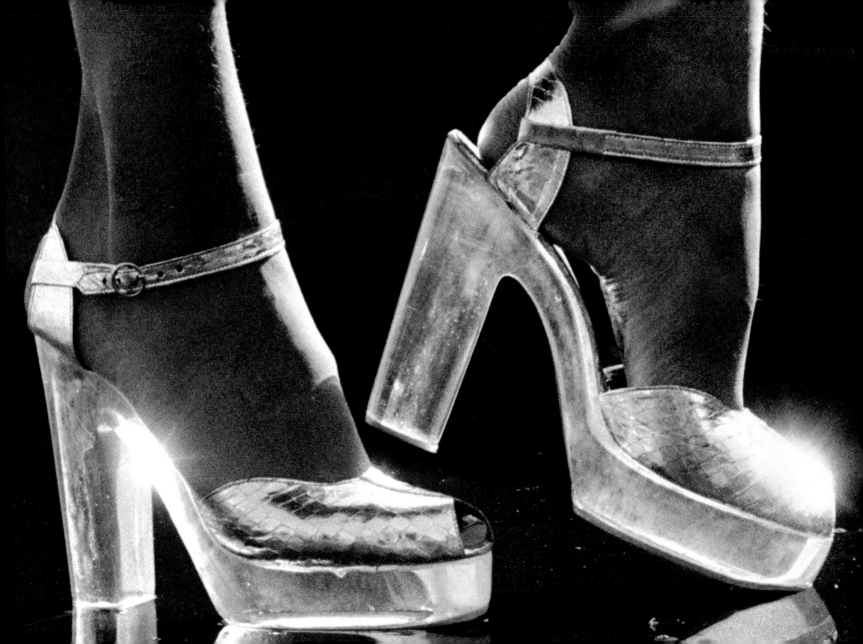

Fashion and sportswear didn't mix in the past.
In the 1980s, you wouldn't wear a sneaker with
a suit like you do today. And jeans weren't con-
sidered sportswear—that was casual wear. Today
all of that is crossing over, and it's given us an
opportunity to develop connections to fashion.

Philippe Lacoste

Often copied but never equaled—the Lacoste polo shirt, the classic among
all polo shirts! In 1933 the tennis(!) player René Lacoste cut his shirt sleeves to
improve his freedom of movement. The polo shirt was born. Incidentally, tennis
legend Lacoste's tenacity on Center Court earned him the nickname
"Crocodile"—and the reptilian logo found its way onto the shirt.
Models walk the runway during the LACOSTE 2008 fashion show in New York.

1 2 3 4 5 6 7 8 9 10 11 12 13 14 **15** 16 17 18 19 20 21 22 23 24 25 26 27 28 29 30 31

MAY

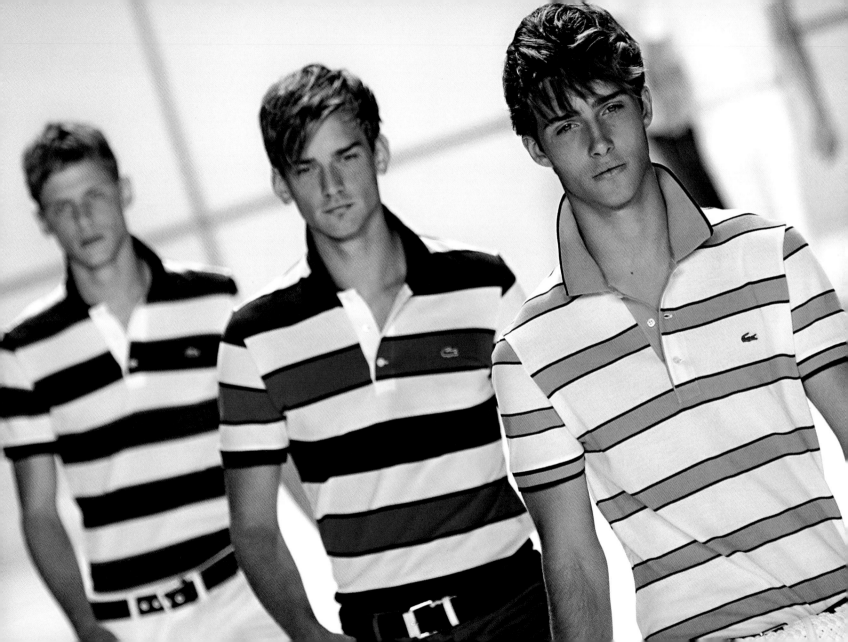

I depend on Givenchy the same
way that American women depend
on their psychiatrists.

Audrey Hepburn

There are photos in which the word "fashion" loses its meaning; photos which
show something on a higher plane—style.
IVY NICHOLSON is wearing an outfit by HUBERT DE GIVENCHY, 1952.

1 2 3 4 5 6 7 8 9 10 11 12 13 14 15 **16** 17 18 19 20 21 22 23 24 25 26 27 28 29 30 31

MAY

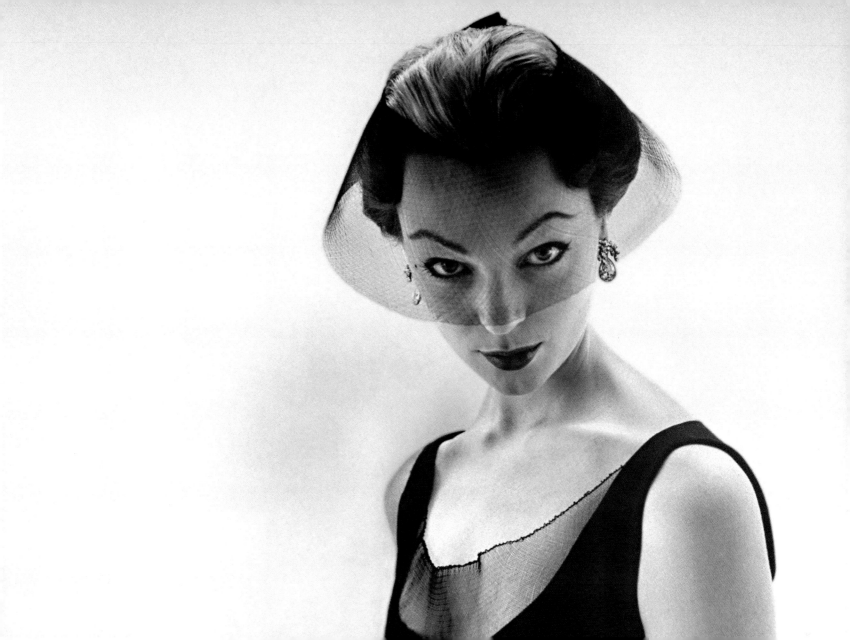

I've survived quite a few generations.
That's because I never lost my enthu-
siasm. I wake up every morning like
on Christmas Day, waiting for the gifts.

Karl Lagerfeld

Cut-off gloves—they are an invention from the world of cycling and found their
way via the punk and fetish scene of urban youth into the front lines of fashion.
It was there that Karl Lagerfeld made them famous (and likes wearing them
himself).
A model presents a creation by German designer KARL LAGERFELD during the
Fall/Winter 2007/08 ready-to-wear collection show in Paris.

1 2 3 4 5 6 7 8 9 10 11 12 13 14 15 16 17 18 19 20 21 22 23 24 25 26 27 28 29 30 31

MAY

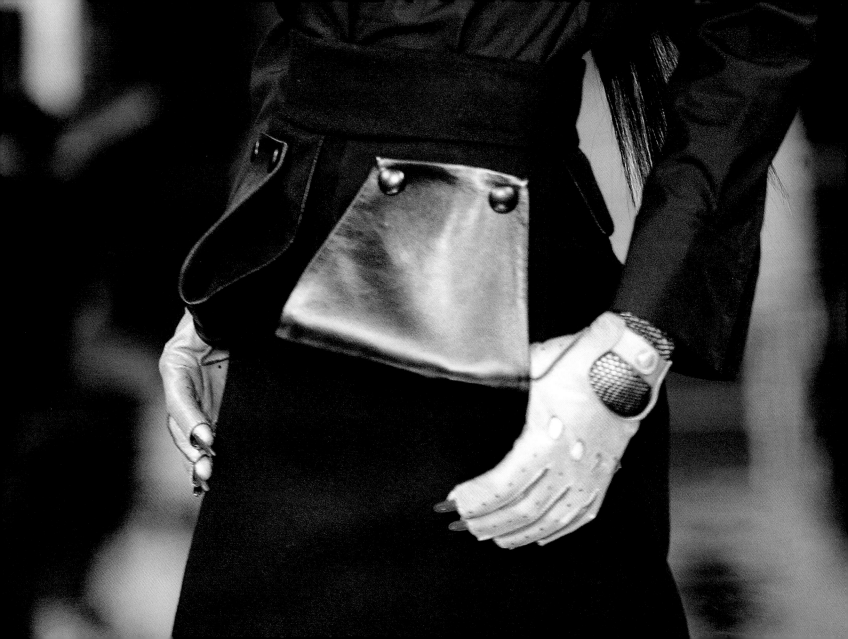

At the risk of being thought soulless and without denying my interest in architecture and interior decoration, I must admit that clothes are my whole life.

Christian Dior

"The Gentle Dictator" was what German fashion journalist Charlotte Seeling called fashion god Christian Dior. After his death in 1957, other designers adopted the famous couture house and his great name (often less dictatorially)—the result is sometimes Japanese, but always very stylish.
Enchanting geisha—a model on the catwalk during the CHRISTIAN DIOR fashion show as part of the Spring/Summer 2007 haute couture collections in Paris.

1 2 3 4 5 6 7 8 9 10 11 12 13 14 15 16 17 **18** 19 20 21 22 23 24 25 26 27 28 29 30 31

MAY

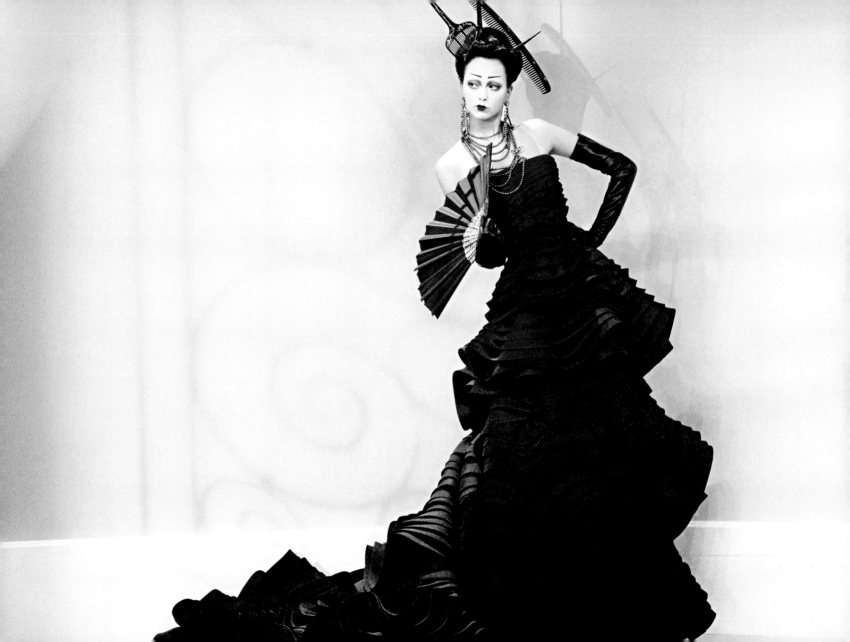

Fashion can be bought by anybody;
style takes discernment. It has to do
with individuality.

Bill Blass

Is maestro Bill Blass pulling his model's ear—or is he just thinking, which earrings with which dress? Probably the latter. It was not only in America in the 1970s that Blass was regarded as one of the nicest people in the fashion industry— he was also famous for his party dresses and luxurious cocktail dresses.
Fashion designer BILL BLASS in a dressing room with models before a show of his designs, 1977.

1 2 3 4 5 6 7 8 9 10 11 12 13 14 15 16 17 18 19 20 21 22 23 24 25 26 27 28 29 30 31

MAY

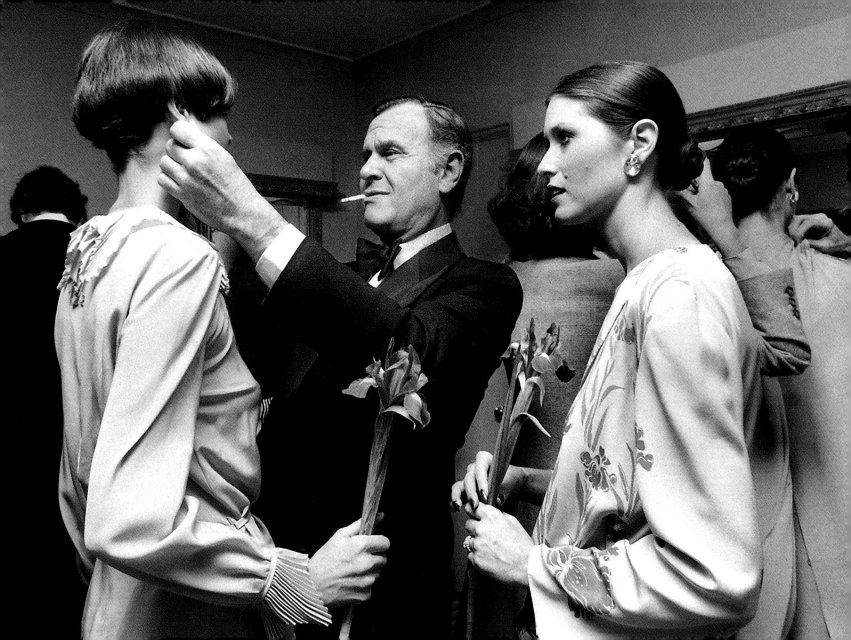

For me, elegance is not to pass
unnoticed but to get to the very
soul of what one is.

Christian Lacroix

Queen of the Night? Cleopatra? Dominatrix? Seductress? The fashion of
designer Christian Lacroix weds different images of woman to man's fantasies.
The inimitable Lacroix style impresses with absolute opulence, baroque excess,
and over-the-top sensuousness.
Mysterious model—a creation by CHRISTIAN LACROIX during the
Fall/Winter 2001/02 haute couture show in Paris.

1 2 3 4 5 6 7 8 9 10 11 12 13 14 15 16 17 18 19 20 21 22 23 24 25 26 27 28 29 30 31

MAY

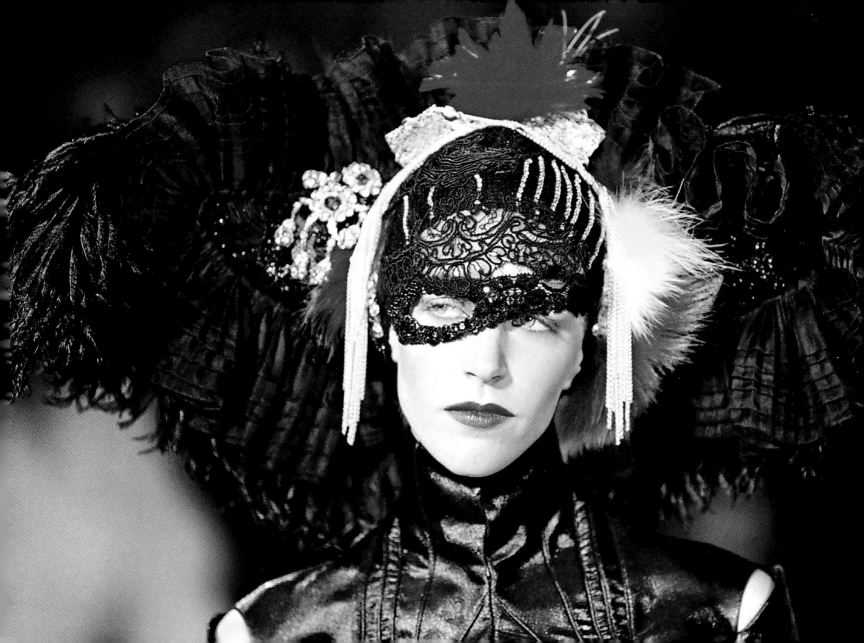

Beauty when most unclothed
is clothed best.

Phineas Fletcher

Beautiful underwear makes people happy. So does good food.
Cheerful get-together on the runway—VICTORIA'S SECRET fashion show. 2006.

1 2 3 4 5 6 7 8 9 10 11 12 13 14 15 16 17 18 19 20 21 22 23 24 25 26 27 28 29 30 31

MAY

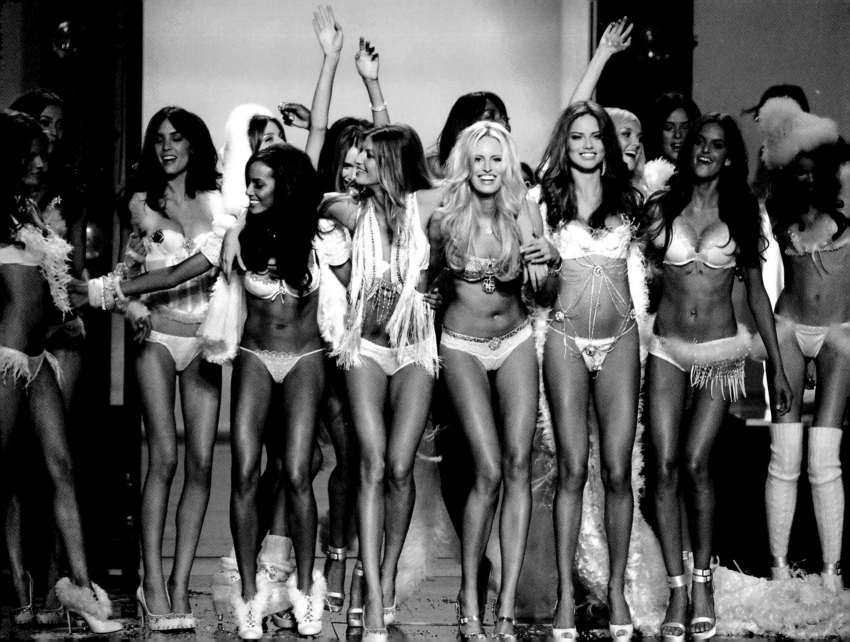

Beauty without grace is like a fishing hook without a worm.

Ninon de Lenclos

Fishing for compliments! Ninon de Lenclos, the French courtesan, *salonnière*, and bon vivant of the seventeenth century was no doubt right with her comment—and if beauty and grace are united (as in this photo), then the angler may even catch one.

A model presents the hat "Karibik" by German label CHRISTA MODE at the Idego Fashion Fair in Düsseldorf, 2007.

1 2 3 4 5 6 7 8 9 10 11 12 13 14 15 16 17 18 19 20 21 22 23 24 25 26 27 28 29 30 31

MAY

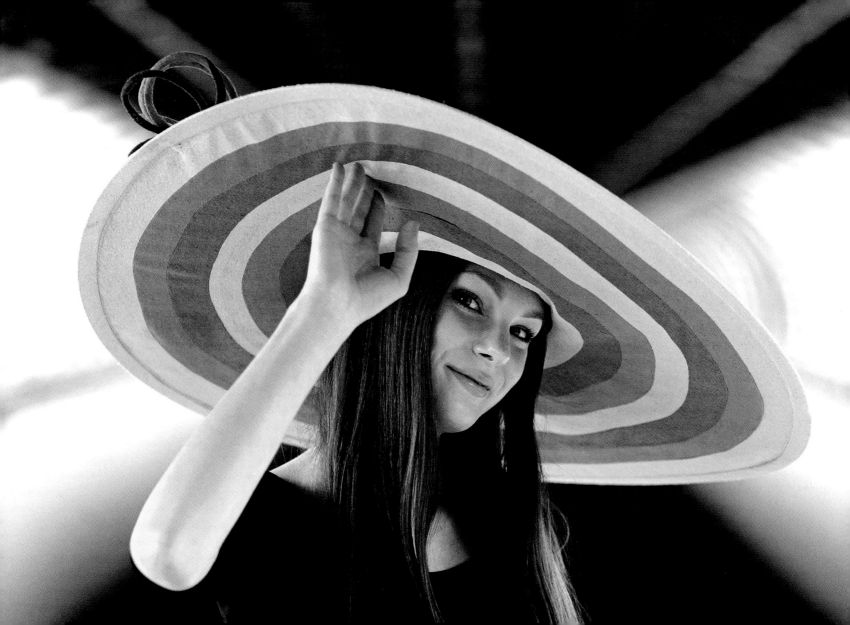

I like glamorous things, and I hate
Aran sweaters and corduroy trousers.
Anything dowdy, I loathe. I like
diamonds, furs, color, and glamour.

Julien MacDonald

You can think differently from the time in which you live, but you may never dress differently. Never. Otherwise the light in which you are standing may suddenly be switched off.

Model Lily Cole walks down the runway at the JULIEN MACDONALD fashion show as part of London Fashion Week Spring/Summer 2006.

1 2 3 4 5 6 7 8 9 10 11 12 13 14 15 16 17 18 19 20 21 22 23 24 25 26 27 28 29 30 31

MAY

julienmacdonald
london

In the forties and the fifties every woman wanted to dress like the movie stars.

Oscar de la Renta

Grace and beauty. Time and again we look to the past in our search for women to whom these words apply. Then we find Grace Kelly, and are happy that at least there exist photographs of such women.
Portrait of American actress GRACE KELLY in a strapless gown with a sprig of flowers tucked into her bodice, photographed in 1954, one year before her wedding to Prince Rainier of Monaco.

1 2 3 4 5 6 7 8 9 10 11 12 13 14 15 16 17 18 19 20 21 22 23 24 25 26 27 28 29 30 31

MAY

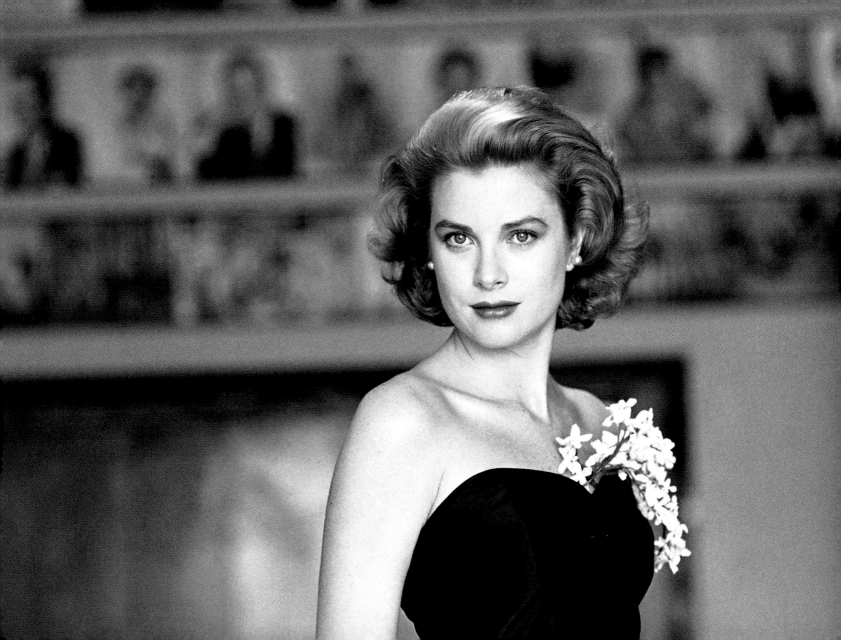

Man is the hunter;
woman is his game:
The sleek and shining creatures
of his chase,
We hunt them for the beauty
of their skins;
They love us for it, and we ride
them down.

Lord Alfred Tennyson

The clicking and whirring of the camera—that is the real, the true musical accompaniment of the fashion world.
Photographers take pictures of a model on the catwalk at the PETER JENSON fashion show in London, 2006.

1 2 3 4 5 6 7 8 9 10 11 12 13 14 15 16 17 18 19 20 21 22 23 24 **25** 26 27 28 29 30 31

MAY

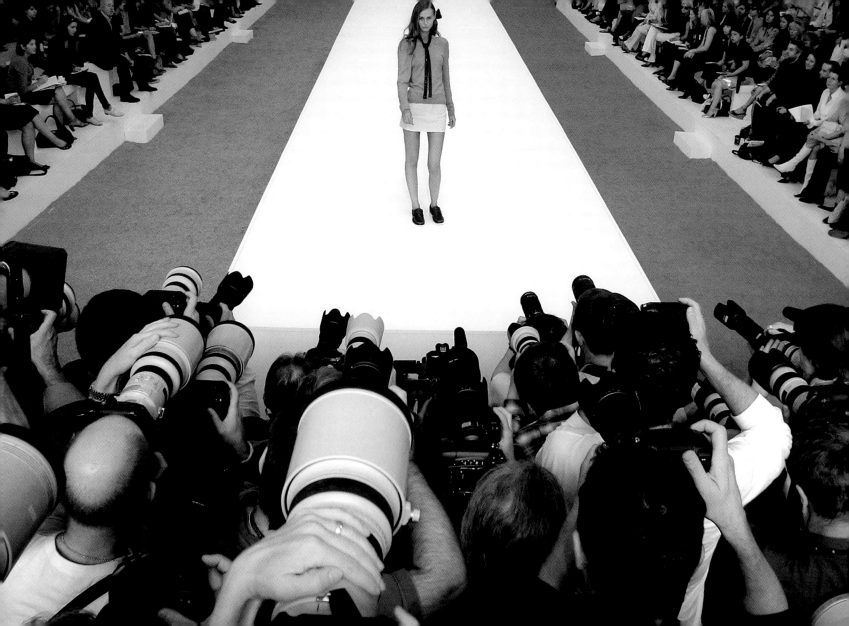

I suppose I design for a kind of
Amazonian woman; someone
who's not afraid of her body
and wants to go out and show it.

Julien MacDonald

When a woman's outfit is so perfect that even her fingernails match her scarf,
it is a sign that not only the devil is in the details—so is fashion.
A model presents an outfit by British designer JULIEN MACDONALD during the
Fall/Winter 2004/05 collection in London.

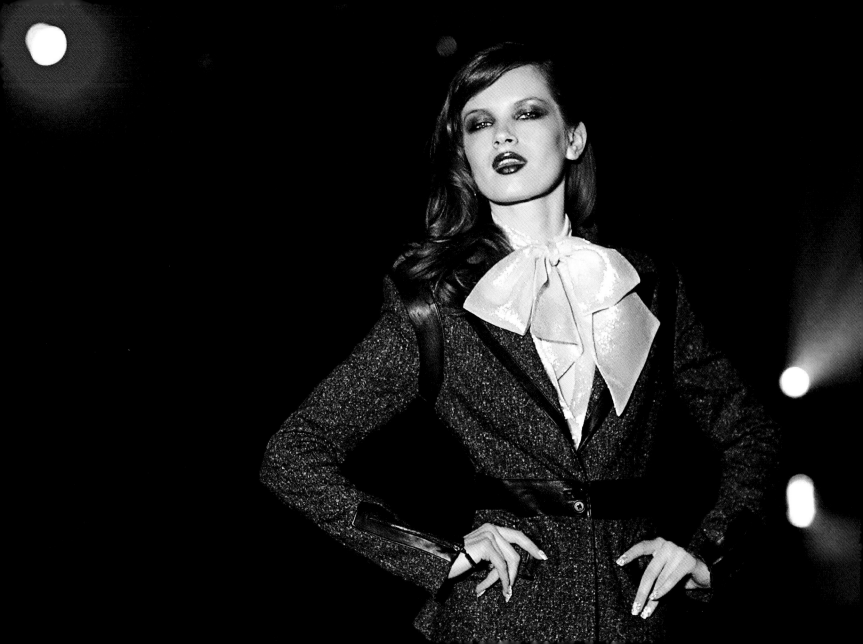

Girls continue to look at themselves
in the mirror… that's fine by me. I despise
narcissism, but approve of vanity.

Diana Vreeland

"The most sinister invention of all is the mirror. Where do people find the courage to look in it?" wondered the Irish poet Brendan Behan. The poor fellow appears not to have known any women—they don't need to be courageous.
Woman at a mirror adjusting her hat, 1950s.

1 2 3 4 5 6 7 8 9 10 11 12 13 14 15 16 17 18 19 20 21 22 23 24 25 26 **27** 28 29 30 31

MAY

Everyone who is smart says they hate
fashion, that it's such a waste of time.
I have asked many super-serious
people, "Then why is fashion so popular?"
Nobody can answer that question.

Miuccia Prada

We know what the successful designer and businesswoman Miuccia Prada can
hear—cries of "Bravo" and "Bravissimo." Fashion is like the theater—all effort is
expended for the final applause.
Italian designer MIUCCIA PRADA acknowledges applause prior to Prada's 2007
men's collection show during Milan Fashion Week.

1 2 3 4 5 6 7 8 9 10 11 12 13 14 15 16 17 18 19 20 21 22 23 24 25 26 27 28 29 30 31

MAY

I want to reach and touch people
through my own expression.

Naoki Takizawa

1 2 3 4 5 6 7 8 9 10 11 12 13 14 15 16 17 18 19 20 21 22 23 24 25 26 27 28 **29** 30 31

MAY

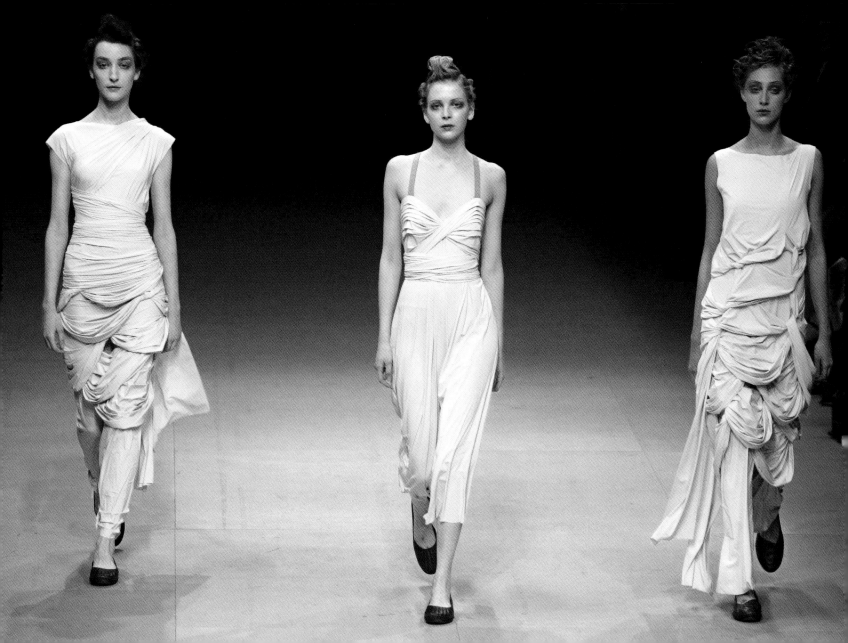

Whenever I've tried to make myself
a bit more mass, it never worked.

Zandra Rhodes

Zandra Rhodes (b. 1940) is the Grande Dame of the British fashion circus—and
its most exotic character. Not only because she designs crazy clothes, but
also (and especially) because of her hair, invariably colored pinkish-purple.
Princess Diana was one of her customers.
Hand in hand—models present creations from the ZANDRA RHODES
Fall/Winter 2006/07 collection in Moscow.

1 2 3 4 5 6 7 8 9 10 11 12 13 14 15 16 17 18 19 20 21 22 23 24 25 26 27 28 29 30 31

MAY

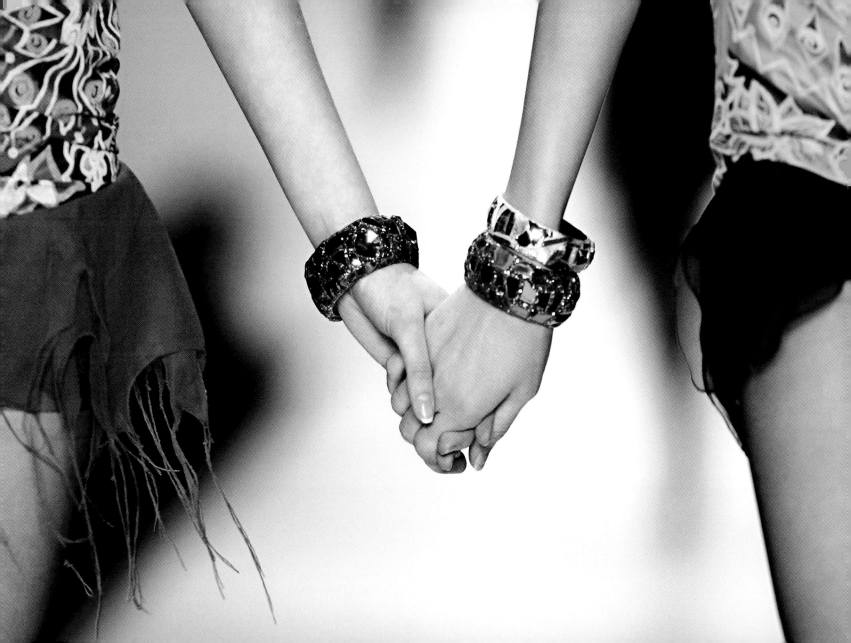

Simplicity is the soul of
modern elegance.

Bill Blass

Plain and simple in design, but expensive in fabric and finish. That is her style.
That is the classic style which German fashion designer Jil Sander so successfully
represents.
A model walks down the runway at the JIL SANDER show as part of the
Milano Collezioni Uomo Spring/Summer 2006 in Milan.

1 2 3 4 5 6 7 8 9 10 11 12 13 14 15 16 17 18 19 20 21 22 23 24 25 26 27 28 29 30 31

MAY

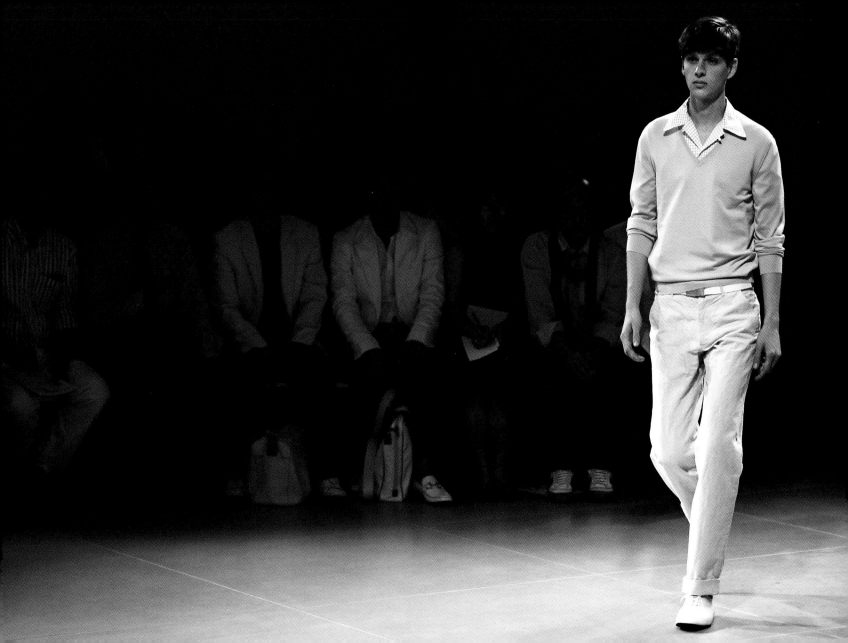

I am always driven to push forward, searching for what is modern. That's what motivates me.

Donatella Versace

Eva Herzigová (b. 1973) hasn't been able to shake off the title "Miss Wonderbra" since she appeared on oversized posters in New York's Times Square for a 1994 Wonderbra advertising campaign by the American company Sara Lee. Her career as a model really took off after that.

Czech Model Eva Herzigová wears an outfit from the VERSACE Fall/Winter 2003/04 collection during Milan Fashion Week.

1 2 3 4 5 6 7 8 9 10 11 12 13 14 15 16 17 18 19 20 21 22 23 24 25 26 27 28 29 30

JUNE

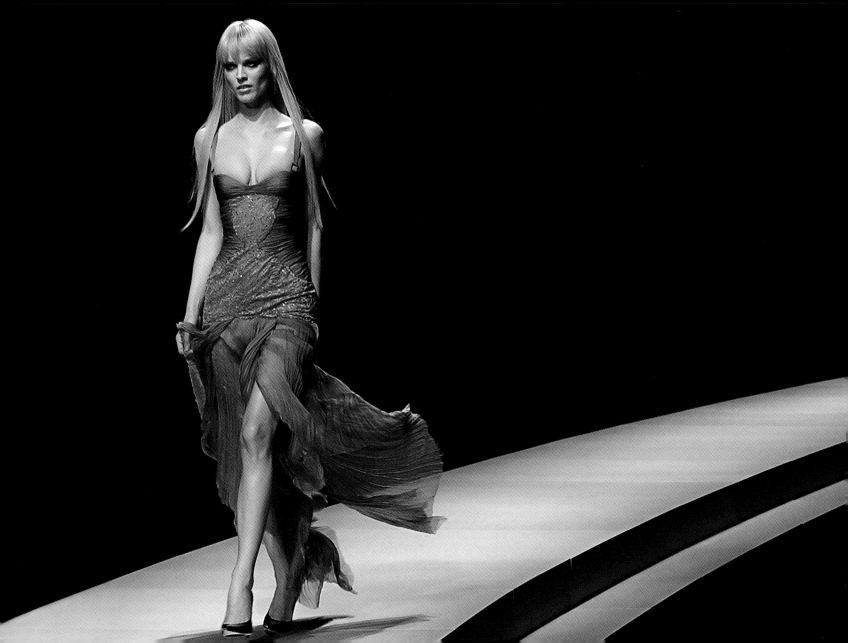

I am a professional dilettante, I do
the many things I do just for the sake
of doing them. It's on the border of
hysteria but it doesn't bother me!

Karl Lagerfeld

Coco Chanel (1883–1971), the greatest woman designer of the twentieth century, came from a poor family. She became an emancipated woman in Paris during the 1920s, designing her first "little black dress" in 1926. She had countless affairs with men and counted the most famous artists of her time—including Cocteau, Stravinsky, and Picasso—as her closest friends. CC lived most of the time in the Hotel Ritz in Paris (where she also died) and created a vast fashion empire. The typical CC style is clean-cut and severe without losing its femininity, as the famous Chanel suit—designed in 1954 and a fashion classic—proves. Karl Lagerfeld, who became chief designer of the Chanel fashion empire in 1984, has led the company to new creative and economic heights. So the model in the photo has every reason for her sphinx-like smile.

A model presents a creation by German designer KARL LAGERFELD for CHANEL during the Spring/Summer 2007 ready-to-wear collections in Paris.

1 2 3 4 5 6 7 8 9 10 11 12 13 14 15 16 17 18 19 20 21 22 23 24 25 26 27 28 29 30

JUNE

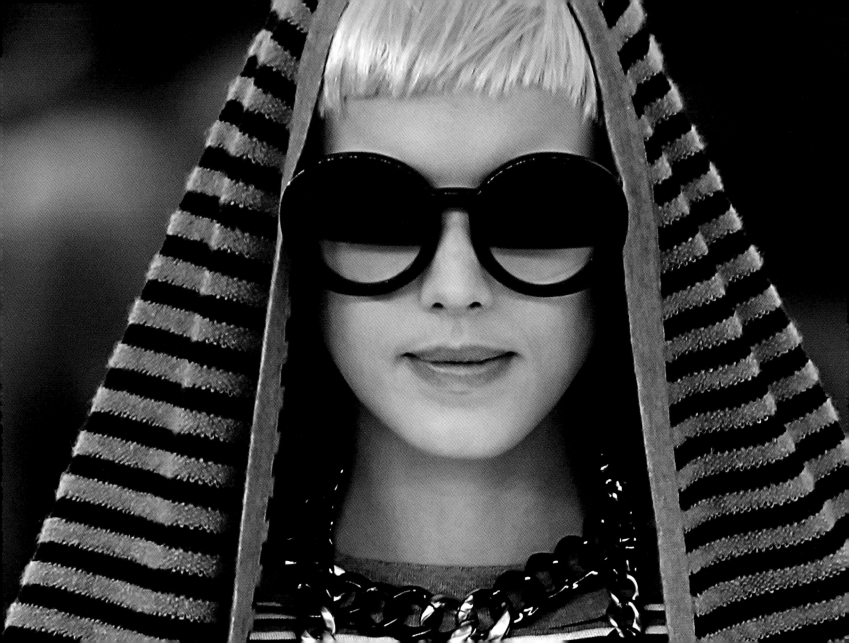

Five years ago in Paris, if you said sportswear people thought you meant a running suit, but now everyone is acknowledging it. Ultimately, sportswear is not the fight word because it's just the idea of singular pieces that are not designed to be worn strictly one way.

Michael Kors

Fast shoes—sporting soles. Today, Nike sneakers stand for speed worldwide. An artistic display of new NIKE sneakers at the Women's Spring 2007 Footwear Collection & Reception, New York, 2006.

1 2 3 4 5 6 7 8 9 10 11 12 13 14 15 16 17 18 19 20 21 22 23 24 25 26 27 28 29 30

JUNE

I never think about whether the skirt is wide enough to walk in, how the wearer will look getting into and out of a taxi…. I consider the beauty and artistic value of a fashion, not its utility.

Hubert de Givenchy

"You cannot create a personality with clothing. It only ever functions as far as the neck," maintained the Viennese fashion designer Helmut Lang. That is basically correct, and yet Lang was obliged to revise his words in the case of this lady. High-buttoned cuffs with black-embroidered ruffles as part of a creation by HUBERT DE GIVENCHY, 1952.

1 2 3 4 5 6 7 8 9 10 11 12 13 14 15 16 17 18 19 20 21 22 23 24 25 26 27 28 29 30

JUNE

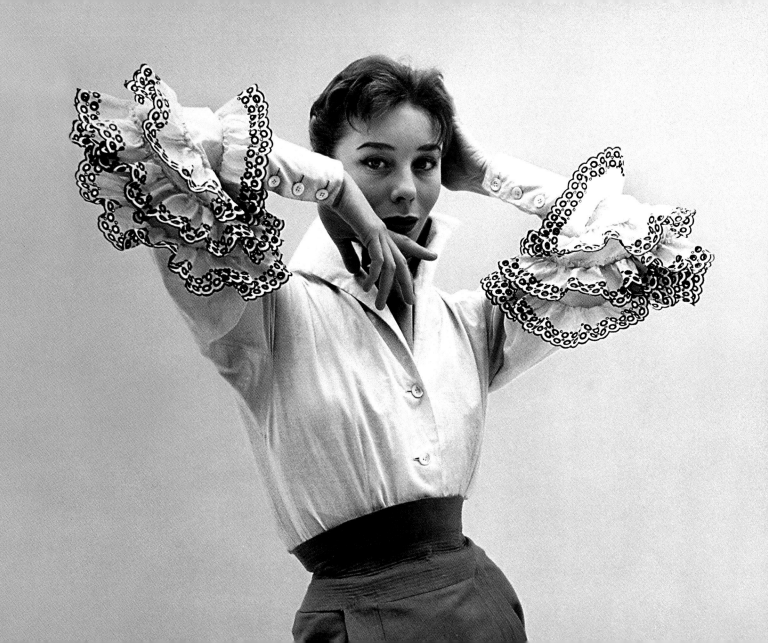

If a woman rebels against high-heeled shoes, she should take care to do it in a very smart hat.

George Bernard Shaw

They can get higher, but not safer. Is that the message behind the playful little padlock accessory on these shoes? But does the padlock have to make sense? No, it would be better not to enquire too closely about the meaning of an accessory when it comes to shoe fashion. It's better not to.

A shoe decorated with a security padlock is displayed in the window of the DIOR store on Rodeo Drive in Los Angeles, 2002.

5

1 2 3 4 5 6 7 8 9 10 11 12 13 14 15 16 17 18 19 20 21 22 23 24 25 26 27 28 29 30

JUNE

I never look at other people's work.
My mind has to be completely
focused on my own illusions.

Alexander McQueen

Spider-Woman? Parachutist landing? Flag-bearer? In any case, the model shows the stuff that fashion dreams are made of.
A model presents a creation for ALEXANDER MCQUEEN during the Fall/Winter 2003/04 ready-to-wear collections in Paris.

1 2 3 4 5 6 7 8 9 10 11 12 13 14 15 16 17 18 19 20 21 22 23 24 25 26 27 28 29 30

JUNE

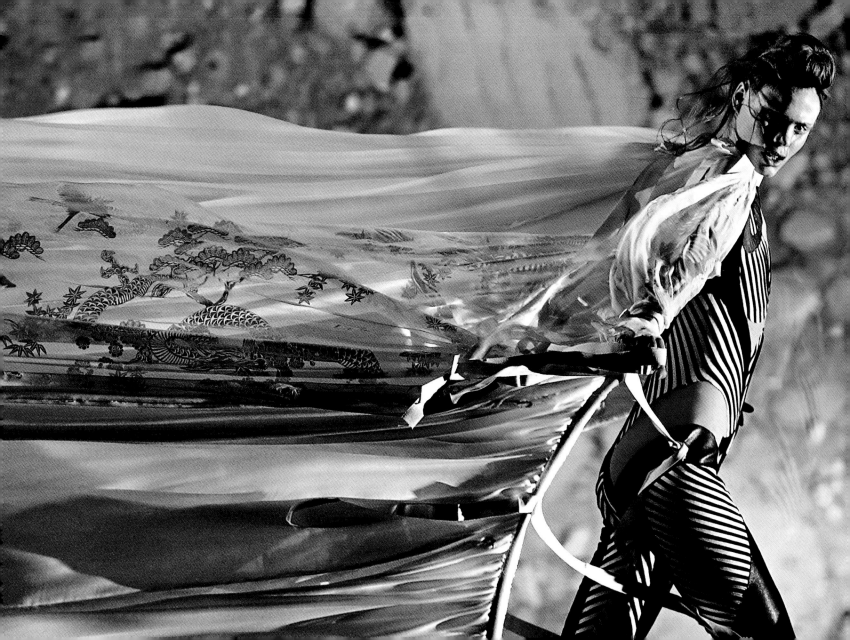

Glamour combined with comfort
is the only modern answer.

Michael Kors

"Only the best ingredients, with the simplest possible method"—what sounds like a chef's recipe is actually the fashion credo of the American fashion designer Michael Kors (b. 1959). In this ensemble, the "star chef" was probably thinking of adding some lemongrass and lime.

A colorful ensemble from the MICHAEL KORS Spring 2008 collection at Mercedes-Benz Fashion Week in New York.

1 2 3 4 5 6 7 8 9 10 11 12 13 14 15 16 17 18 19 20 21 22 23 24 25 26 27 28 29 30

JUNE

Today, there is no fashion, really. There are just... choices. Women dress today to reveal their personalities. They used to reveal the designer's personality. Until the 70s, women listened to designers. Now women want to do it their own way. There are no boundaries. And without boundaries, there is no fashion.

Oscar de la Renta

A model's path down the catwalk consists of running the gauntlet beneath the critical, penetrating gaze of fashion journalists, arbiters of style, and the professional audience. She must be sure about the dress, not about herself. The dress gives her the strength she needs.
A model walks the catwalk in a dress from Dominican designer OSCAR DE LA RENTA during the Fall 2005 fashion shows in New York.

1 2 3 4 5 6 7 8 9 10 11 12 13 14 15 16 17 18 19 20 21 22 23 24 25 26 27 28 29 30

JUNE

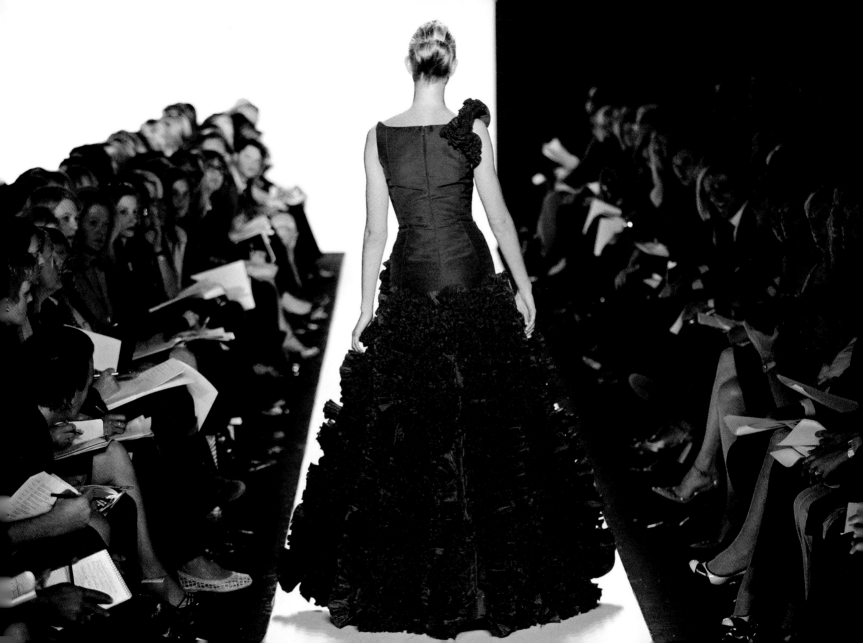

I don't believe in people who think
that clothes are not important.

Miuccia Prada

And now just imagine the little bouquet of flowers was not there. How boring
that would be.
Jemima Khan's PRADA handbag on display before a Marie Curie gala evening
and charity auction at the Royal Exchange in London, March 2006.

1 2 3 4 5 6 7 8 9 10 11 12 13 14 15 16 17 18 19 20 21 22 23 24 25 26 27 28 29 30

JUNE

Haute couture is a young woman
we need to equip with grandeur.

Eymeric François

"Women who show it all when wearing a dress have nothing to make men curious about." On this occasion actress Raquel Welch had no idea how full of enthusiasm and curiosity men would be as they tugged at these laces.
A model wears a creation by EYMERIC FRANÇOIS, 2007.

1 2 3 4 5 6 7 8 9 **10** 11 12 13 14 15 16 17 18 19 20 21 22 23 24 25 26 27 28 29 30

JUNE

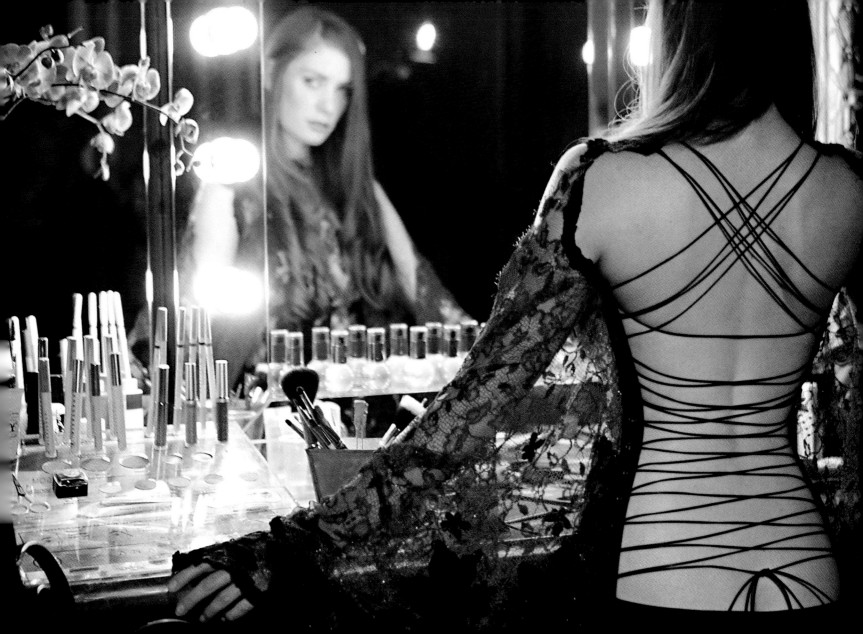

It's important to excite the imagination
of a woman.

Oscar de la Renta

Exquisite embroidery! But just look at her red feet. "Only the gynecologist and the shoemaker know what women really suffer," said Gustave Flaubert. His Madame Bovary would have surely fallen in love with this dress by Oscar de la Renta.
A model presents a creation by Dominican designer OSCAR DE LA RENTA during the Spring 2006 fashion show as part of Olympus Fashion Week in New York.

1 2 3 4 5 6 7 8 9 10 **11** 12 13 14 15 16 17 18 19 20 21 22 23 24 25 26 27 28 29 30

JUNE

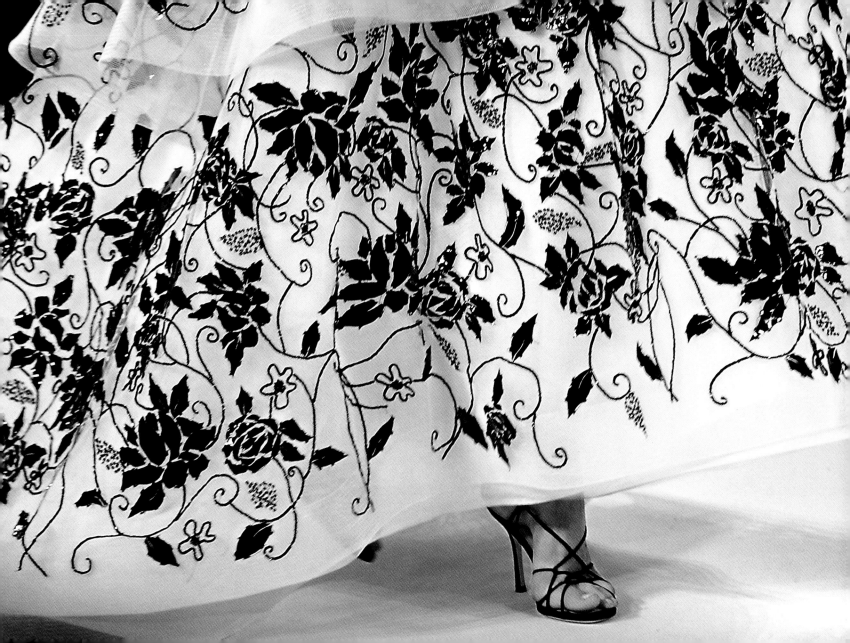

Whatever I design, it has to please my eye. If I go
to work on an office block, I'll draw the office that
I want to walk into. If it's a piece of crystal, it must
feel the way I want it to feel in my hand. If it's
women's wear, it must be something I'd like to
see my wife dressed in.

John Rocha

Natural elegance, discreet luxury, and the comeback of decorative elements
determine John Rocha's current look. As you can see, outfits that radiate
feminine nonchalance are the focal point of this designer's creations.
A model walks down the catwalk during the JOHN ROCHA show at London
Fashion Week at the Duke of York's Headquarters on Kings Road, September 2003.

1 2 3 4 5 6 7 8 9 10 11 12 13 14 15 16 17 18 19 20 21 22 23 24 25 26 27 28 29 30

JUNE

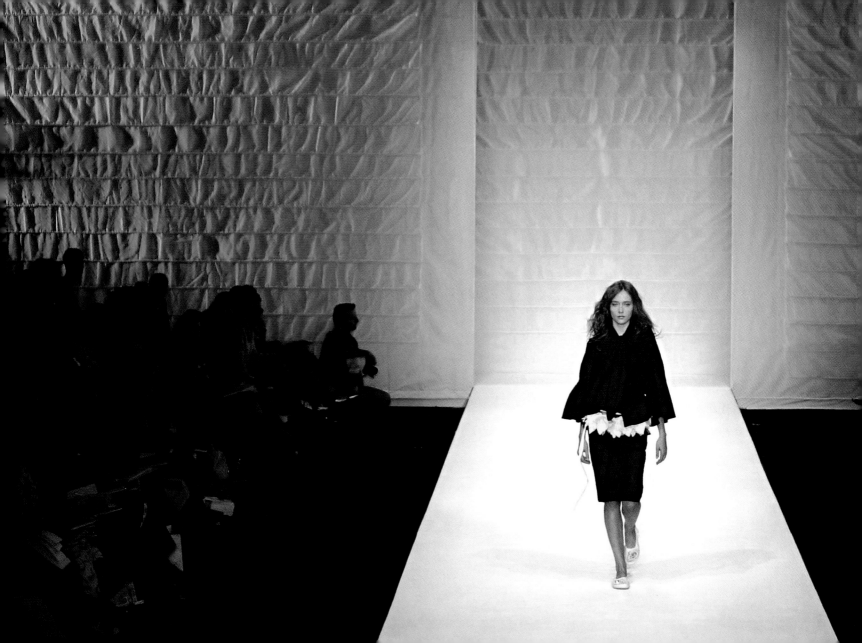

I think it's amusing that someone
who is famous for taking her clothes
off becomes famous because of her
clothes! I do love dressing up, though.

Dita von Teese

Pure styling! And yet today's fashion icons only imitate the poses and looks of
the past, of the good old days. Strange.
Dancer DITA VON TEESE poses at the Blush Ball charity event at the Natural History
Museum in London, 2006.

1 2 3 4 5 6 7 8 9 10 11 12 **13** 14 15 16 17 18 19 20 21 22 23 24 25 26 27 28 29 30

JUNE

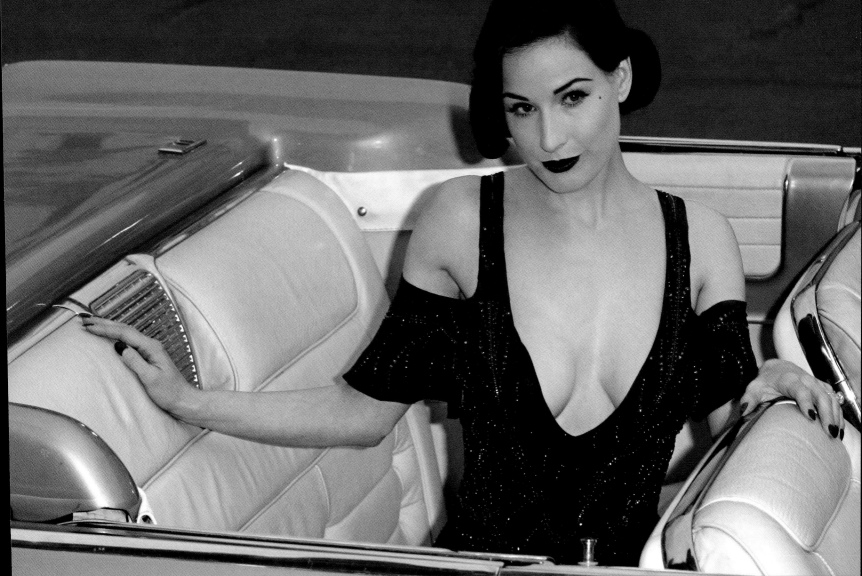

I was excited by this idea of taking
culture to the streets and changing
the whole way of life, using culture
as a way of making trouble.

Malcolm McLaren

Fancy dress or not? That is the question here. What is permitted for artists and
society birds of paradise will hardly be suitable as everyday office wear for
a turnaround manager.
Designer and Sex Pistols manager MALCOM MCLAREN poses during a 1982
photo session at the Chateau Marmont in West Hollywood, California.

1 2 3 4 5 6 7 8 9 10 11 12 13 **14** 15 16 17 18 19 20 21 22 23 24 25 26 27 28 29 30

JUNE

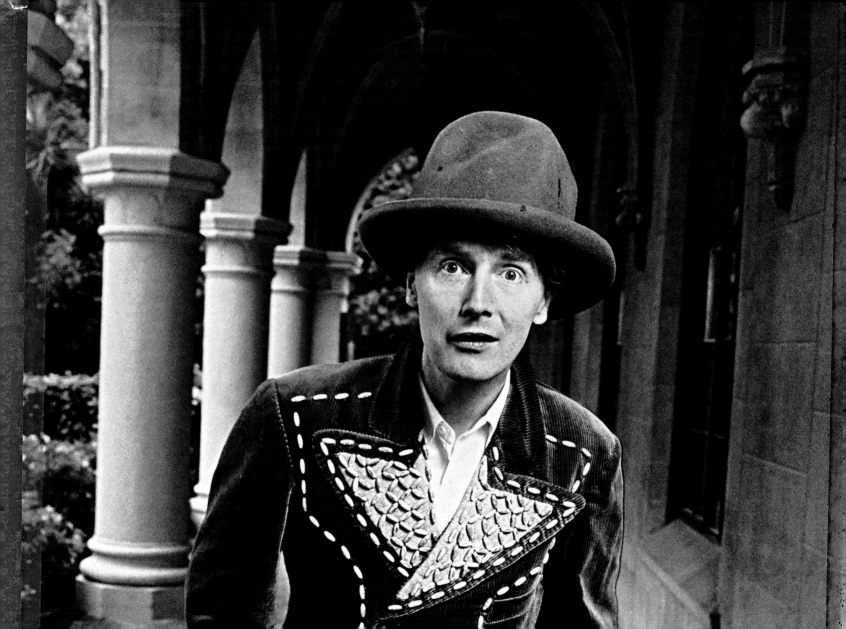

People think partnerships arise because of a shared vision, but we don't feel that way. We've both got strong minds and personalities, so because of that equality we fight much more. That's why it works.

Suzanne Clements and Inacio Ribeiro

Asia meets Art Nouveau and a dress that consciously quotes the 1920s. But if the model were to stand just a foot to the right, the entire attractive composition would be completely lost.
A model presents a creation by Suzanne Clements and Inacio Ribeiro for CACHAREL during the Fall/Winter 2007/08 ready-to-wear collection show in Paris.

1 2 3 4 5 6 7 8 9 10 11 12 13 14 **15** 16 17 18 19 20 21 22 23 24 25 26 27 28 29 30

JUNE

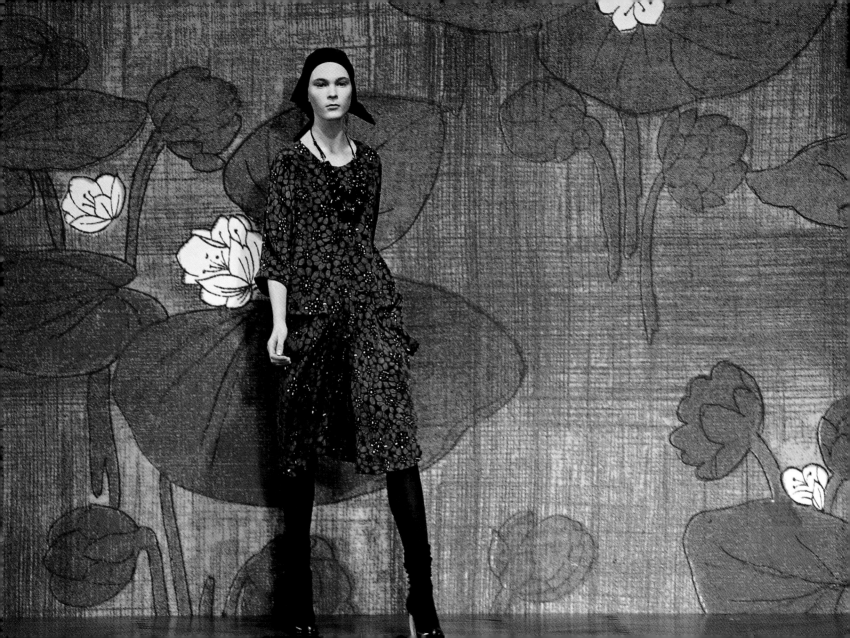

It's so much to do with seeing the
originality of things in themselves. You
have to be able to recognize originality
in order to abstract from it what you
need. This is the process often referred
to as inspiration.

Vivienne Westwood

"Résistance" is the message on her dress. Designer Vivienne Westwood is
definitely a resistance fighter in the fashion world. Resistance against convention.
A political message.
A model presents a creation by British designer VIVIENNE WESTWOOD during the
Spring/Summer 2008 ready-to-wear collection show in Paris.

1 2 3 4 5 6 7 8 9 10 11 12 13 14 15 16 17 18 19 20 21 22 23 24 25 26 27 28 29 30

JUNE

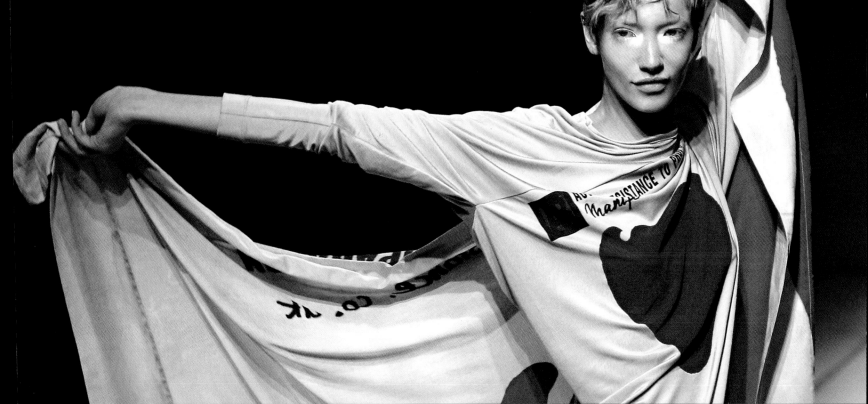

The eternal feminine draws us up.

Johann Wolfgang von Goethe

"It is more a question of what is in a woman's face than what is on it," asserted Hollywood actress Claudette Colbert. Her colleague BB would no doubt agree.
French actress BRIGITTE BARDOT stars in Jean-Luc Godard's film *Le Mepris*, 1963.

1 2 3 4 5 6 7 8 9 10 11 12 13 14 15 16 **17** 18 19 20 21 22 23 24 25 26 27 28 29 30

JUNE

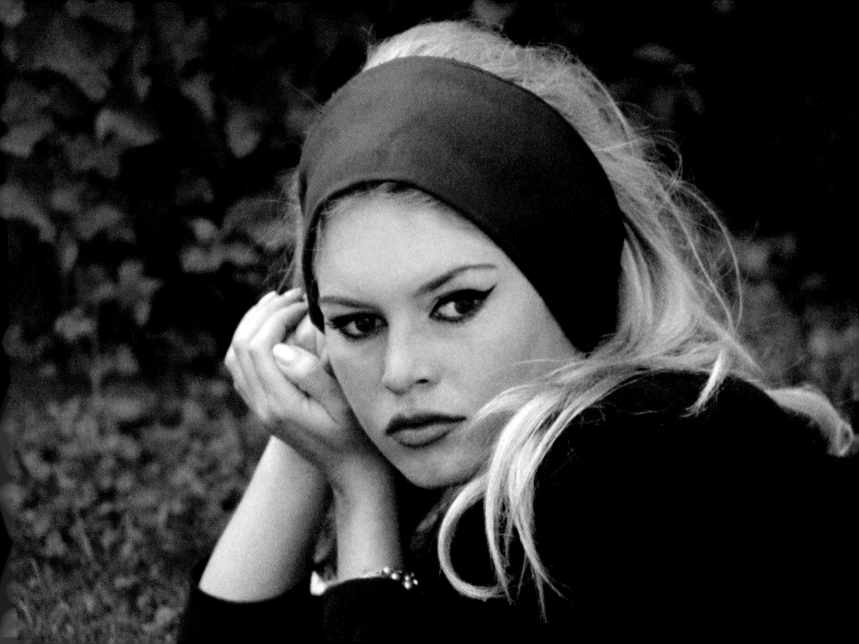

Quality is remembered long after
price is forgotten.

Aldo Gucci

The look is known as Casual Chic and suggests a laid-back style. But do we
really want to roll up the sleeves of our jacket? Only models can do that.
A model displays a design by Italian fashion house GUCCI during the
Fall/Winter 2006/07 men's ready-to-wear collections in Milan.

1 2 3 4 5 6 7 8 9 10 11 12 13 14 15 16 17 **18** 19 20 21 22 23 24 25 26 27 28 29 30

JUNE

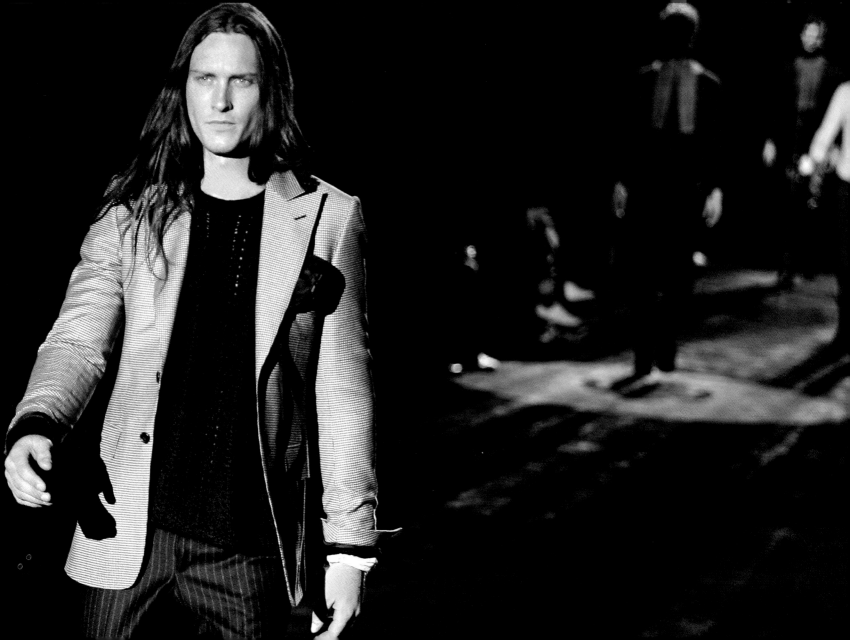

As a fashion designer, costume archives
and picture galleries are essential to my
work; ideas depend on maintaining
the links with tradition.

Vivienne Westwood

"We are all naked inside our clothes," wrote Heinrich Heine succinctly.
The model would no doubt agree with the poet's observation.
A model walks the catwalk in a billowing robe during the VIVIENNE WESTWOOD
fashion show as part of Russian Fashion Week in Moscow, April 2007.

1 2 3 4 5 6 7 8 9 10 11 12 13 14 15 16 17 18 19 20 21 22 23 24 25 26 27 28 29 30

JUNE

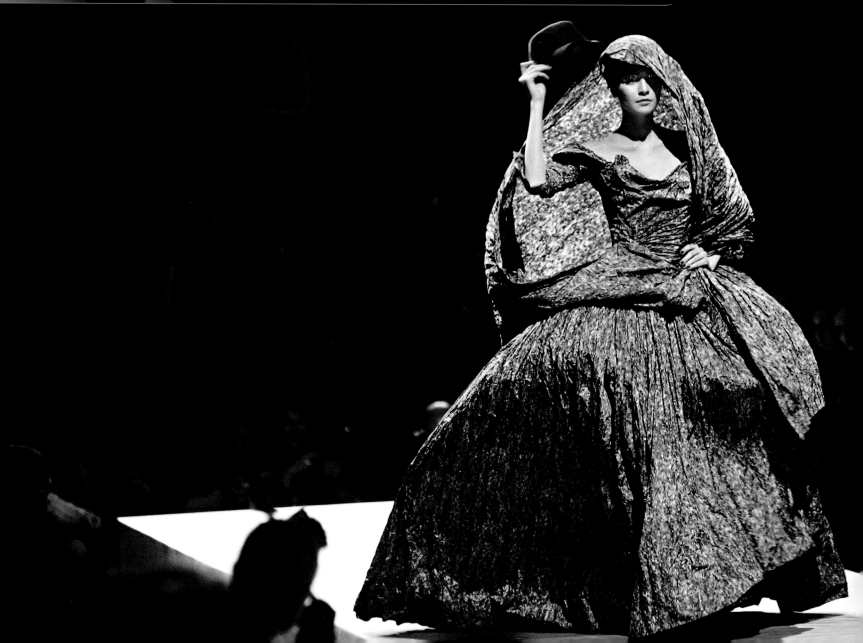

The bikini is the atom bomb of fashion.

Diana Vreeland

The route from here to the string tanga was just a small cut for the fashion designer, but a giant leap for mankind. Was it really a leap we had to take?

A young woman poses in a knitted swimsuit on a sea wall, ca. 1930.

1 2 3 4 5 6 7 8 9 10 11 12 13 14 15 16 17 18 19 20 21 22 23 24 25 26 27 28 29 30

JUNE

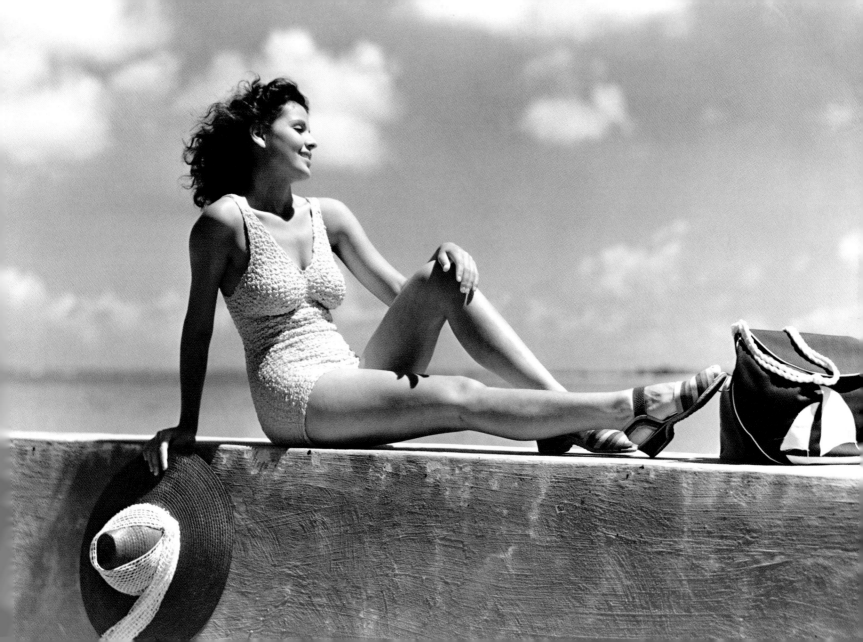

Sex appeal to me is someone who's relaxed.
I don't think you can be sexy if you're not
relaxed. Especially in America, the beauty
standard has become so uptight, so worked.
I don't find that sexy at all. Sexy people are
usually very comfortable with themselves—
comfortable while you're falling apart.

Tom Ford

Since Tom Ford started designing clothes for Gucci at the end of the 1990s,
the old Italian fashion brand, founded in 1923 as a saddle maker's workshop,
has soared to economic heights that no one had ever dreamt of. The longing
for status and the desire for luxury—today Gucci fulfills both perfectly.
A model displays a creation by Italian fashion house GUCCI during the
Fall/Winter 2006/07 women's ready-to-wear collection in Milan.

1 2 3 4 5 6 7 8 9 10 11 12 13 14 15 16 17 18 19 20 21 22 23 24 25 26 27 28 29 30

JUNE

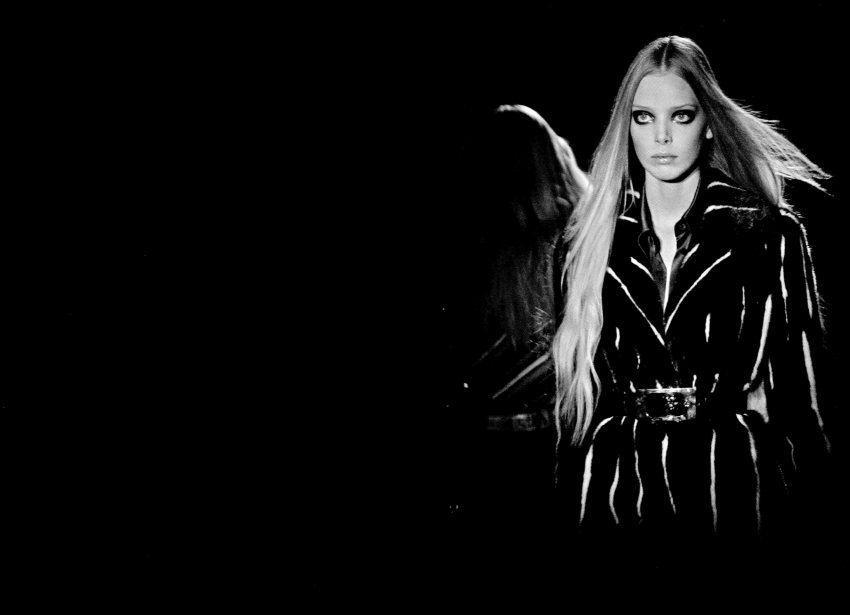

The Hermès scarf—bold, colorful, luxurious, ebullient—is something of a fashion banner.

The New York Times, 1985

Hermès printed silk scarves, often decorated with equestrian motifs, are world famous and greatly coveted. The first *Carré Hermès* was introduced to the world in 1937. Today there are almost 1,000 designs and each year about a dozen new patterned scarves are added to the collection.
A HERMÈS scarf with heraldic design, 1990.

1 2 3 4 5 6 7 8 9 10 11 12 13 14 15 16 17 18 19 20 21 22 23 24 25 26 27 28 29 30

JUNE

The inner space is seen by peering
through the eye.

Jil Sander

Simple and touching—in other words, typically Jil Sander. In this creation the
designer follows the current trend toward metallic effects.
A model walks down the catwalk during the JIL SANDER fashion show as part
of Milan Fashion Week Fall/Winter 2007/08.

1 2 3 4 5 6 7 8 9 10 11 12 13 14 15 16 17 18 19 20 21 22 23 24 25 26 27 28 29 30

JUNE

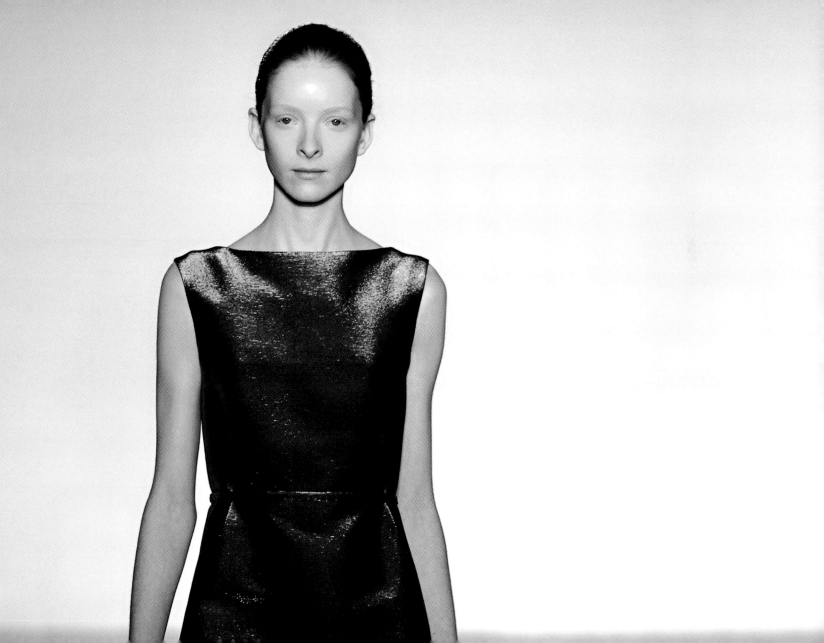

I come from a different era and I design
clothes for our era.

Alexander McQueen

Women speak with their bodies, and we listen to them with our eyes. So what
is this model telling us as she stands there, wrapped in light fabric?
A model poses in a dress by British designer ALEXANDER MCQUEEN at Earls Court
in London, June 2004.

1 2 3 4 5 6 7 8 9 10 11 12 13 14 15 16 17 18 19 20 21 22 23 **24** 25 26 27 28 29 30

JUNE

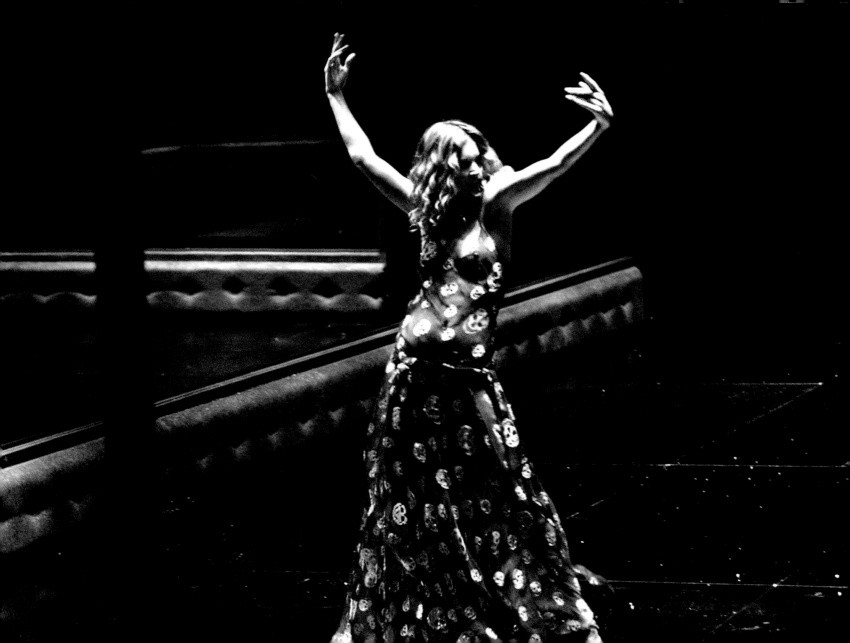

Everyone has a head so everyone has the
possibility of wearing (a hat). What the line of
a hat does is alter the shape of the face, and
the point of wearing a hat is to make you look
more attractive. It transforms the face better
than cosmetic surgery will and is less painful.

Philip Treacy

An old aphorism says, "Better crazy the hat than the head." It forgets to mention
that some hats are enough to drive you crazy.
A model presents an outlandish creation by British designer PHILIP TREACY during
the Fall/Winter 2001/02 haute couture collections in Paris.

1 2 3 4 5 6 7 8 9 10 11 12 13 14 15 16 17 18 19 20 21 22 23 24 25 26 27 28 29 30

JUNE

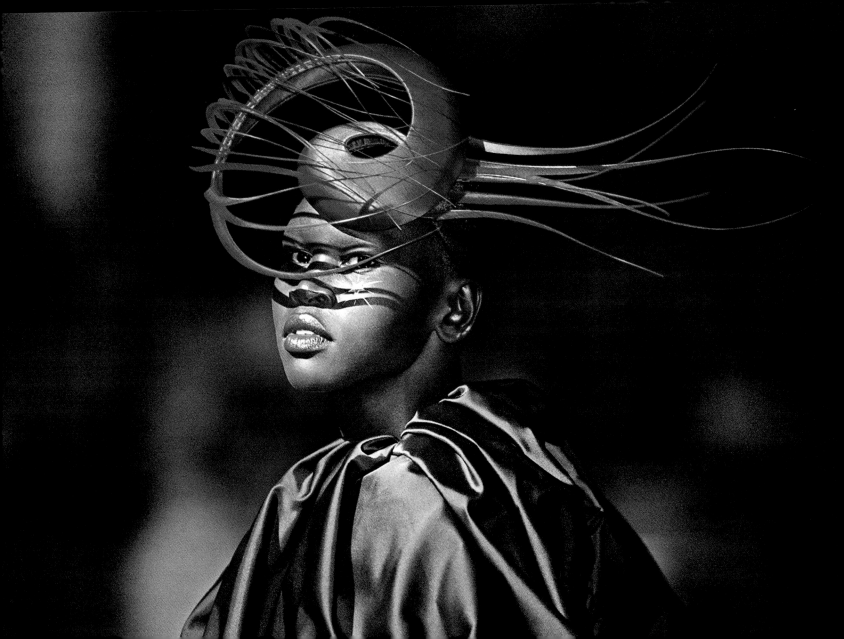

There are different kinds of beauty,
and I always try to show that.

Jean Paul Gaultier

Christ child? Madonna? Saint? Twice a year, the designer Jean Paul Gaultier
reinvents woman from scratch in each of her favorite roles. Gaultier is without
a doubt the greatest in his field in this respect.
A model walks down the catwalk during the JEAN PAUL GAULTIER show as part
of the Spring/Summer 2007 haute couture collections in Paris.

1 2 3 4 5 6 7 8 9 10 11 12 13 14 15 16 17 18 19 20 21 22 23 24 25 **26** 27 28 29 30

JUNE

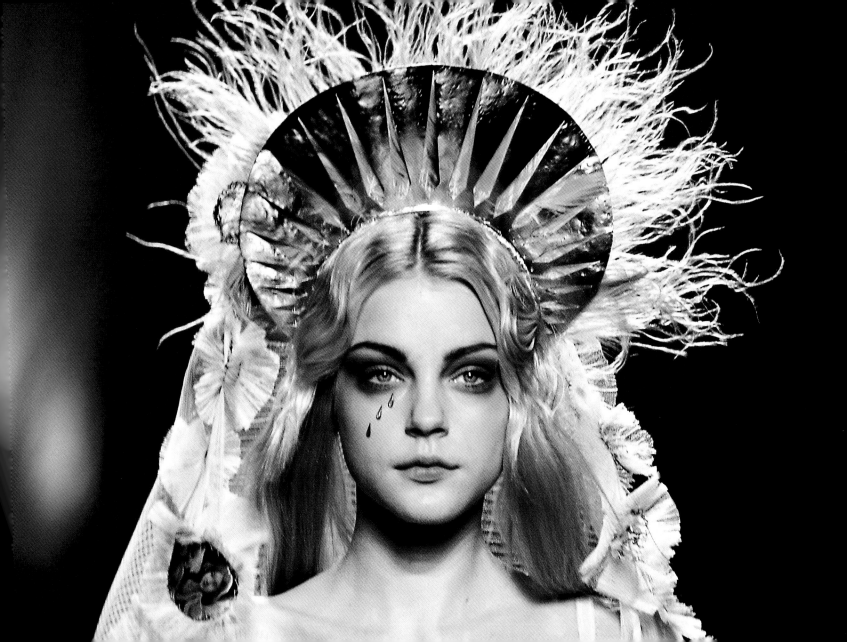

I believed in a new elegance, in a new fashion in step with the changes in women and the world: essence, simplicity, rigor, sober beauty, restrained colors. This conviction suggested a way of being, and a way of operating in keeping with a new concept of the classic.

Giorgio Armani

For decades Giorgio Armani (b. 1934) has convinced the world with his timeless, unadorned style. The Grand Master of Italian designer fashion also stands out for his remarkable business sense. Since 1991, even Alitalia stewardesses have been wearing Armani.

GIORGIO ARMANI poses amid his own creations at a retrospective exhibition of his work at the Baths of Diocletian in Rome, 2004.

1 2 3 4 5 6 7 8 9 10 11 12 13 14 15 16 17 18 19 20 21 22 23 24 25 26 27 28 29 30

JUNE

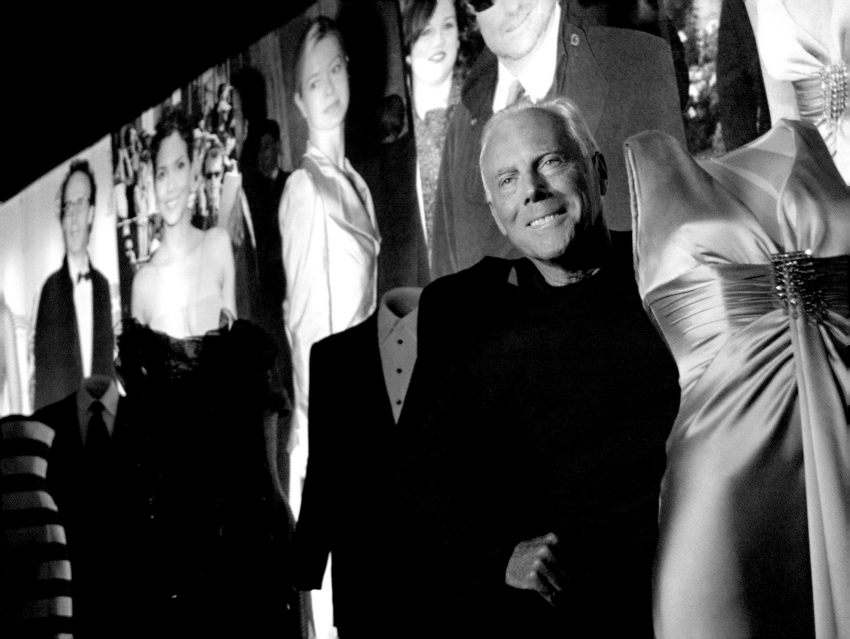

Youth! There is nothing like youth. The middle-aged are mortgaged to Life. The old are in Life's lumber-room. But youth is the Lord of Life. Youth has a kingdom waiting for it. Every one is born a king, and most people die in exile.

Oscar Wilde

Fashion is pop culture—and pop culture makes fashion.
British pop group DURAN DURAN, 1983.

1 2 3 4 5 6 7 8 9 10 11 12 13 14 15 16 17 18 19 20 21 22 23 24 25 26 27 28 29 30

JUNE

Fashion is art and it must remain
a dream that materializes in beautiful
clothes, free of any scheme.

Anna Molinari

The Italian designer Anna Molinari has fun with fashion. This little red dress shows Molinari's love for the lightness of being. But what if the fingernails were white instead?
A model presents a creation by Italian designer ANNA MOLINARI for Blugirl during the Spring/Summer 2007 women's collections in Milan.

1 2 3 4 5 6 7 8 9 10 11 12 13 14 15 16 17 18 19 20 21 22 23 24 25 26 27 28 29 30

JUNE

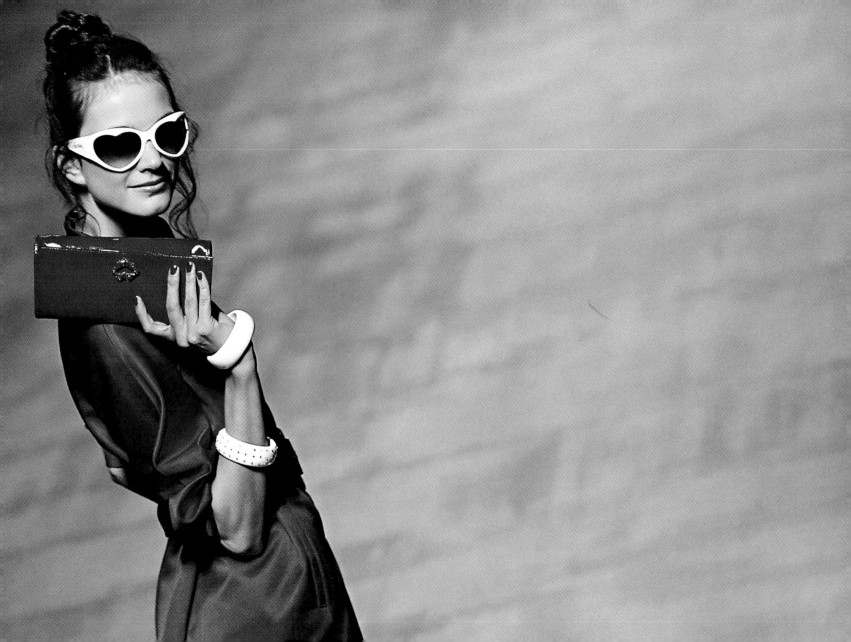

Designers have become as famous
as their customers.

Oscar de la Renta

Stitch for stitch for stitch... Haute couture creations are all made by hand.
That means they have a certain aura and—of course—a certain price.
Richly embroidered fabric from the OSCAR DE LA RENTA Fall 2005 collection at
Olympus Fashion Week in New York City.

1 2 3 4 5 6 7 8 9 10 11 12 13 14 15 16 17 18 19 20 21 22 23 24 25 26 27 28 29 30

JUNE

Most women prefer to trip to hell
in high heels than to walk flat-heeled
to heaven.

William A. Rossi

If Eve had worn these shoes as an erotic signal in Paradise, the business with
the apple would probably have been superfluous. But there was no Prada
boutique in Eden.
PRADA shoes create a flattering silhouette, 2003.

1 2 3 4 5 6 7 8 9 10 11 12 13 14 15 16 17 18 19 20 21 22 23 24 25 26 27 28 29 30 31

JULY

Adornment is never anything except
a reflection of the heart.

Coco Chanel

Handled with pliers? Of course not, but armor can still be sexy. Designer Paco Rabanne's metallic fashion bore witness to a lifelong penchant for chain mail. A model presents a dress for PACO RABANNE as part of the Fall/Winter 2004/05 collections at Paris Fashion Week.

1 2 3 4 5 6 7 8 9 10 11 12 13 14 15 16 17 18 19 20 21 22 23 24 25 26 27 28 29 30 31

JULY

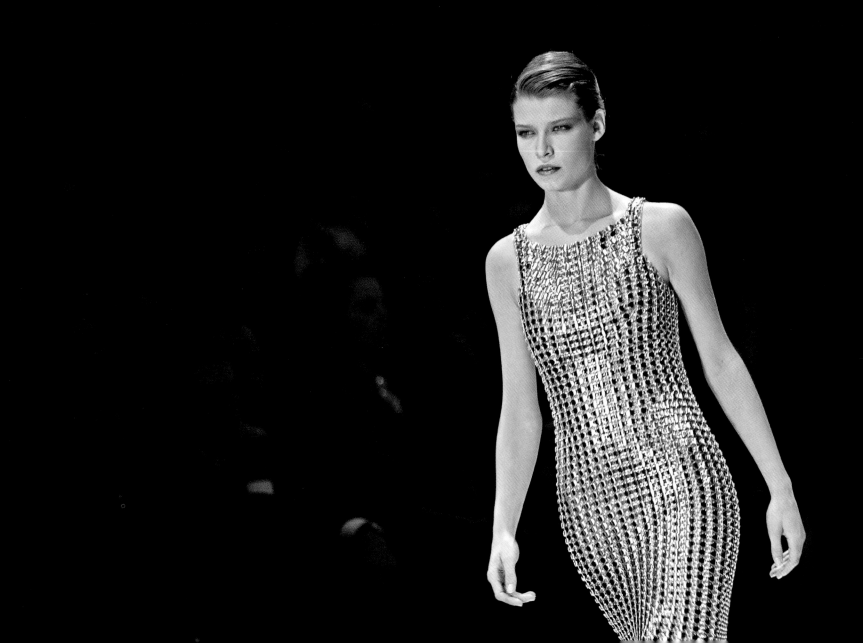

Snobbery has gone out of fashion, and
in our shops you will find duchesses
jostling with typists to buy the same dress.

Mary Quant

She invented the miniskirt during the 1960s—the British designer Mary Quant
(b. 1934). Women want and need freedom of movement—that was the miniskirt's
political statement in the Swinging Sixties; the sex appeal was the logical result.
Fashion designer MARY QUANT framed by mini-skirted models, London, 1988.

1 2 **3** 4 5 6 7 8 9 10 11 12 13 14 15 16 17 18 19 20 21 22 23 24 25 26 27 28 29 30 31

JULY

A person who sees only fashion
in fashion is a fool.

Honoré de Balzac

To the Golden Globes or the Oscars? Will she want to own it and wear it, or not?
Film star Cate Blanchett seems to have not quite made up her mind.
Roberta Armani (right) and actresses Hélène de Fougerolles, Camilla Belle, and
Cate Blanchett watch from the front row at the GIORGIO ARMANI haute couture
show during Paris Fashion Week Fall/Winter 2007/08.

1 2 3 4 5 6 7 8 9 10 11 12 13 14 15 16 17 18 19 20 21 22 23 24 25 26 27 28 29 30 31

JULY

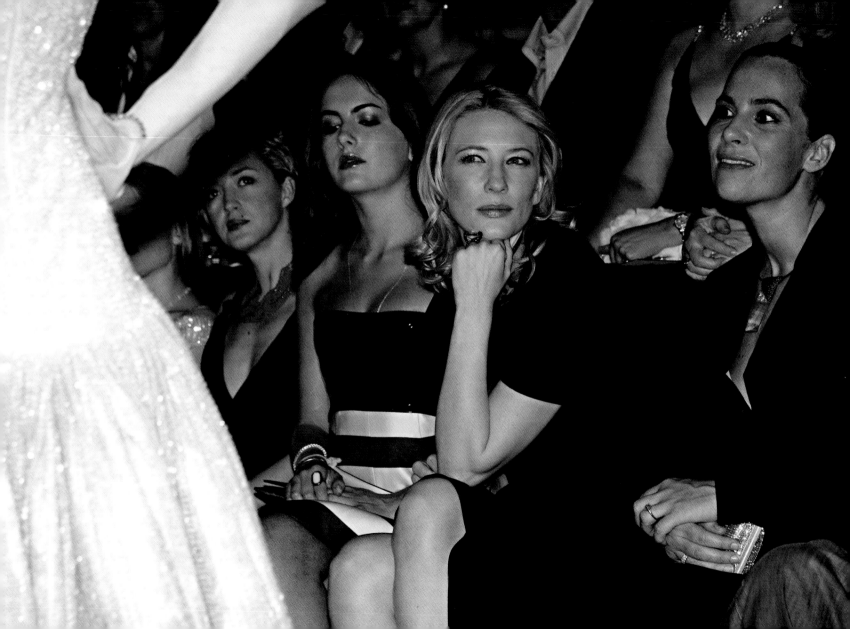

One should either be a work of art,
or wear a work of art.

Oscar Wilde

Patterns out of an LSD trip—until you feel dizzy. During the 1960s, psychedelic op-art effects not only caused violent irritation in the works of artist Victor Vasarely, they were also very popular in fashion.
Black-and-white geometric op-art motifs on a full-length evening dress by ROBERTO CAPUCCI, complemented by a hat and cuffs of black ostrich feathers, 1965.

1 2 3 4 **5** 6 7 8 9 10 11 12 13 14 15 16 17 18 19 20 21 22 23 24 25 26 27 28 29 30 31

JULY

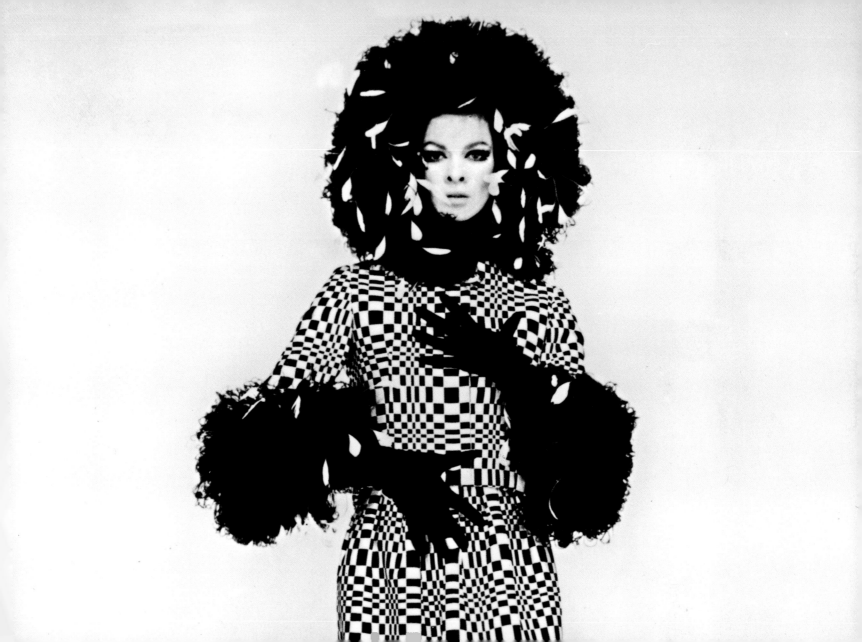

It's all about codes, and I love working
with them. I like taking an idea and
pushing it all the way.

Eymeric François

It could be a portrait by Goya, but it isn't. This opulent, glamorous dream in gold
with a white coat was created by the young French fashion designer Eymeric
François. In his hands women become queens—and courtesans.
A model poses in a creation by EYMERIC FRANÇOIS, 2007.

1 2 3 4 5 **6** 7 8 9 10 11 12 13 14 15 16 17 18 19 20 21 22 23 24 25 26 27 28 29 30 31

JULY

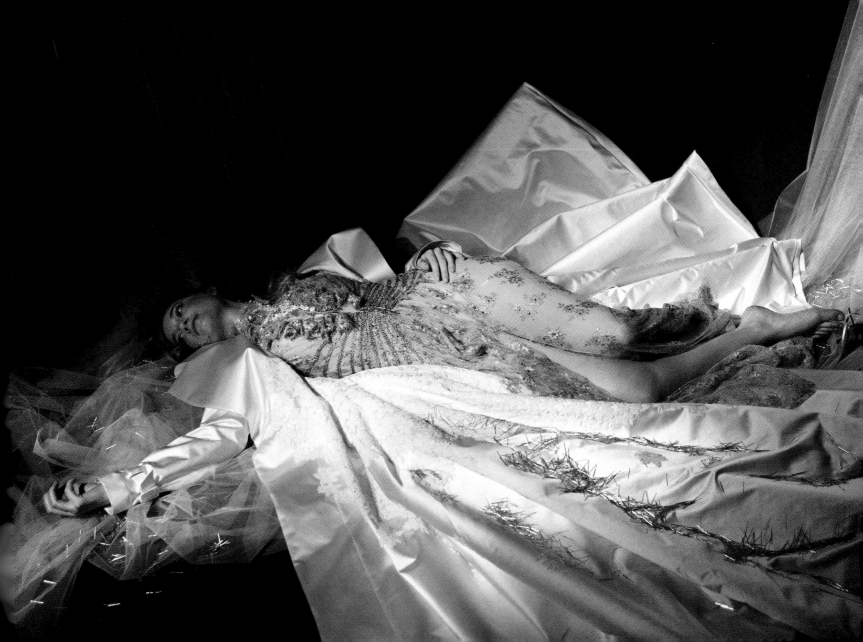

Things are entirely what they appear to
be and behind them… there is nothing.

Jean-Paul Sartre

A black bouquet. Sometimes it looks as if a flower is growing out of the silk.
A model displays a creation by CHRISTIAN LACROIX as part of the
Spring/Summer 2004 collection during Dubai Fashion Week.

1 2 3 4 5 6 7 8 9 10 11 12 13 14 15 16 17 18 19 20 21 22 23 24 25 26 27 28 29 30 31

JULY

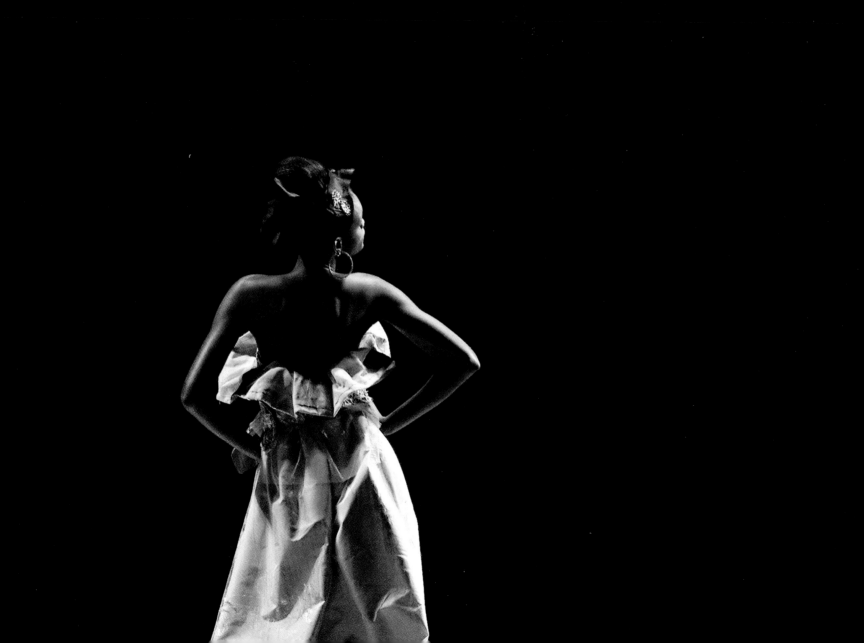

Jeanne Lanvin built her house of couture around beautifully crafted garments designed with a unique aesthetic that combined simplicity and naiveté with romanticism.

Jan Glier Reeder

Billowing metal—billowing fabric. During the 1950s, the outlines of cars and clothes captivated observers with their clean-cut lines and softly shaped curves.
A model twirling a black and white dress with detachable scarf by LANVIN, 1954.

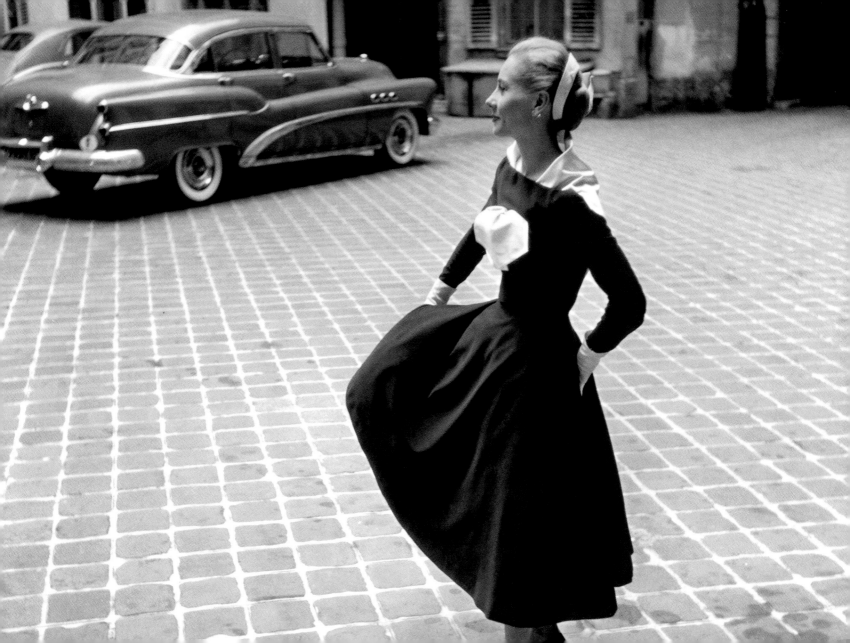

Fashion dies very young so we
must forgive it everything.

Jean Cocteau

Spaghetti al dente? The American designer Donna Karan was quite right
when she said, "Design knows only one direction—the unexpected one."
A creation by British designer JULIEN MACDONALD for GIVENCHY at the
Fall/Winter 2002/03 haute couture collections in Paris.

1 2 3 4 5 6 7 8 9 10 11 12 13 14 15 16 17 18 19 20 21 22 23 24 25 26 27 28 29 30 31

JULY

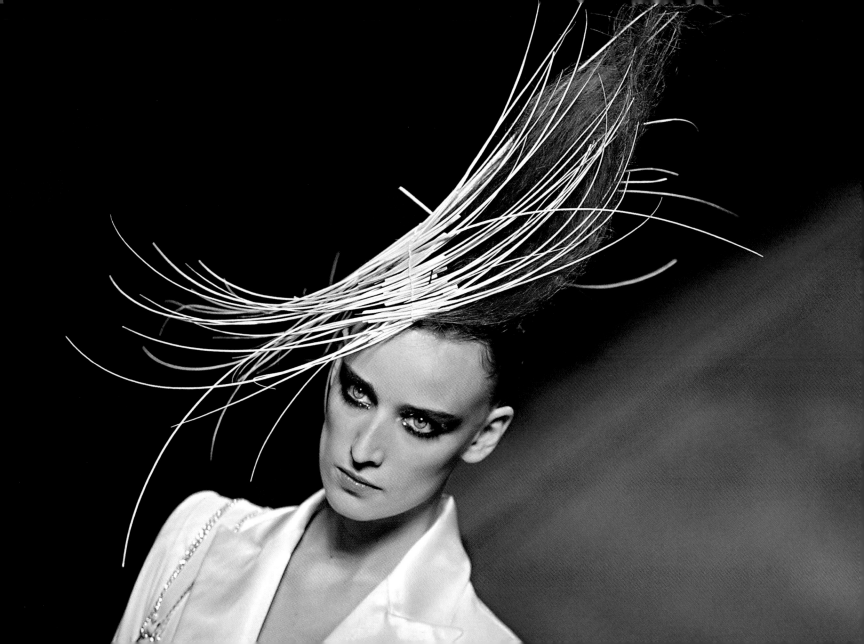

The corset is the most important part
of any of my work. It must be perfect.
If there is even a small problem with the
corset, then the entire dress will be
compromised. My dresses start with the
corset and are built upon it.

Eymeric François

"Couture Kid" Eymeric François is no longer really a child in the world of fashion.
Since 2000 he has been present at the "off calendar" of the haute couture
shows. Voluminous evening dresses with a thousand little details like embroidered
flowers, black crystals, feathers, and pearls are the eye-catchers of his collections.
The verdict—Fantastic!
A model presents a black and white leaf-patterned dress and headpiece by
French designer EYMERIC FRANÇOIS, 2007.

1 2 3 4 5 6 7 8 9 10 11 12 13 14 15 16 17 18 19 20 21 22 23 24 25 26 27 28 29 30 31

JULY

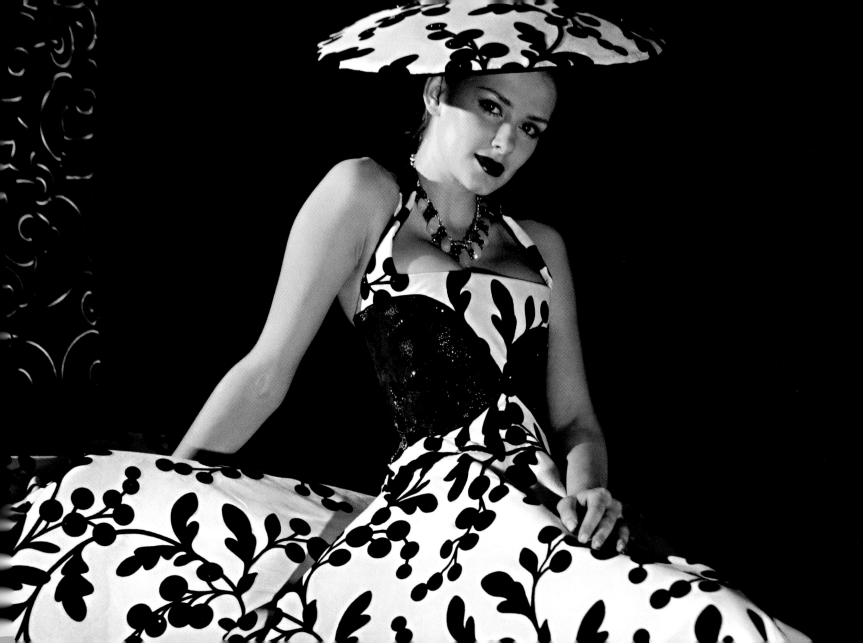

There is something eerie about a museum of costume (…) We experience a sense of the uncanny when we gaze at garments that had an intimate relationship with human beings long since gone to their graves. For clothes are so much part of our living, moving selves that, frozen on display in the mausoleums of culture, they hint at something only half-understood, sinister, threatening; the atrophy of the body, and the evanescence of life.

Elizabeth Wilson

Wedding dresses are her domain, and these seem to have been inspired by stage director Bob Wilson. Born in 1949, Vera Wang is an American designer of Chinese extraction who began her career as a fashion designer with her famous Vera Wang Bridal House in New York. These days Wang also successfully creates fashion for a woman's life after the ceremony.

A VERA WANG bridal exhibit at the Whitney Museum of American Art, New York, 2003.

1 2 3 4 5 6 7 8 9 10 11 12 13 14 15 16 17 18 19 20 21 22 23 24 25 26 27 28 29 30 31

JULY

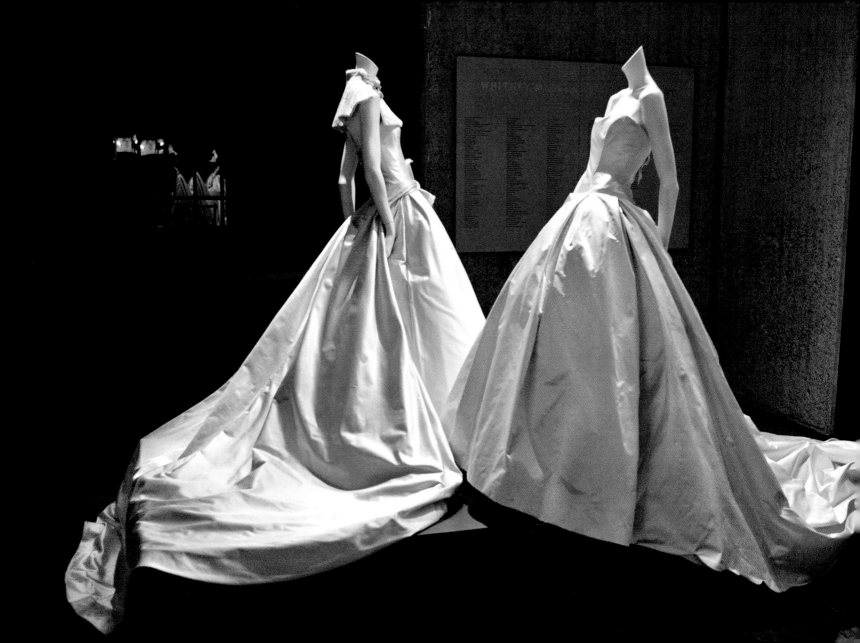

For me, eroticism is only one element among many in fashion, such as the color and weave of the cloth.

Christian Lacroix

When the designer names Pucci and Lacroix are united—as here—the fashion acquires an air of Portofino or Positano, Capri or Amalfi in the 1970s. Even today. Models display transparent outfits of the EMILIO PUCCI collection, designed by CHRISTIAN LACROIX, during the Spring/Summer 2004 Milan Fashion Week.

1 2 3 4 5 6 7 8 9 10 11 12 13 14 15 16 17 18 19 20 21 22 23 24 25 26 27 28 29 30 31

JULY

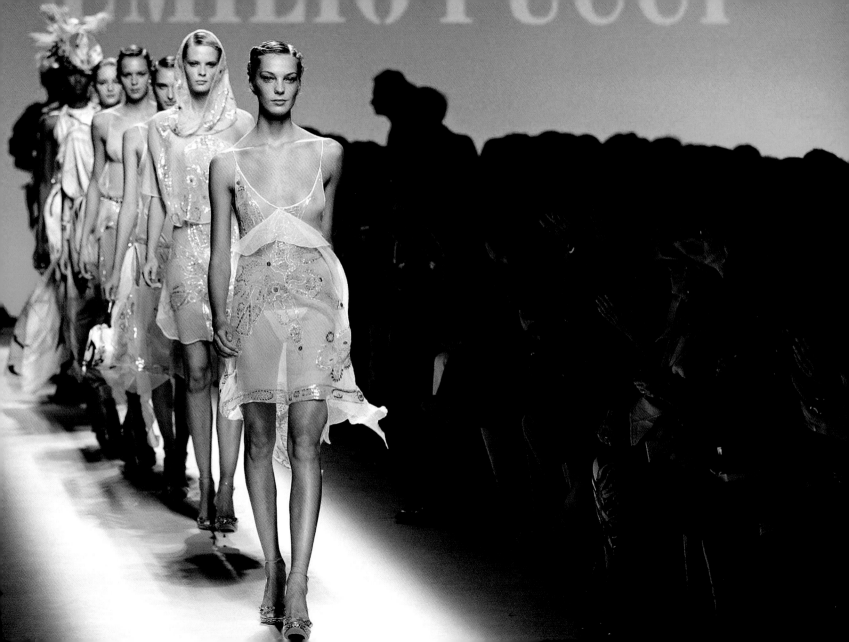

Fashion must be the intoxicating release
from the banality of the world.

Diana Vreeland

And what if the banality of everyday life had invaded the world of fashion long
ago, and twice a year? It would certainly be a pity.
A model in a DOLCE & GABBANA creation, Spring/Summer 2007, during
Milan Fashion Week.

1 2 3 4 5 6 7 8 9 10 11 12 13 14 15 16 17 18 19 20 21 22 23 24 25 26 27 28 29 30 31

JULY

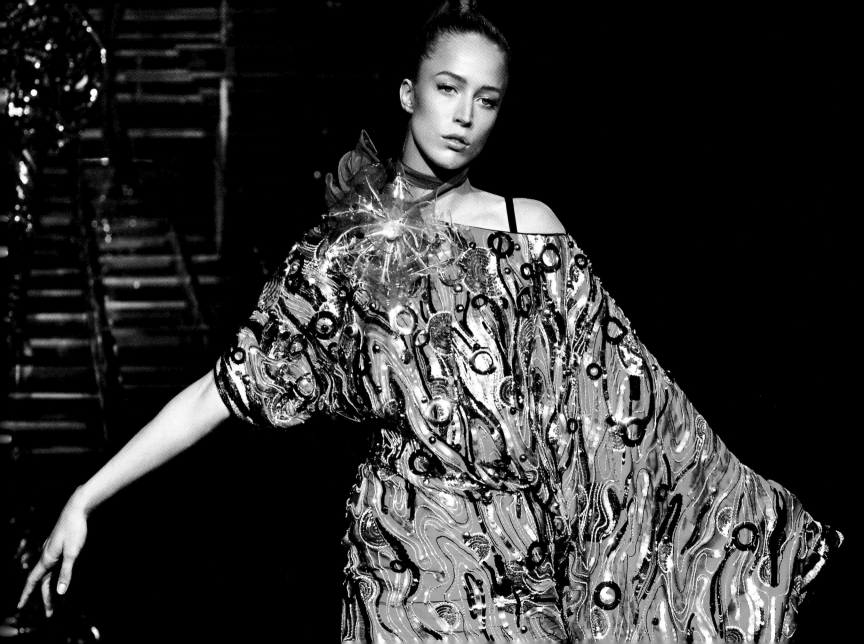

His clothes are classy, sexy and make you feel beautiful.

Singer Janet Jackson, on Bill Blass designer Michael Vollbracht

And if the sole of the shoe were not red—we would perhaps say: pretty, but not enough.

Bare at the top and long at the bottom—a model walks the catwalk in a gown by BILL BLASS during Olympus Fashion Week Fall 2005, New York.

1 2 3 4 5 6 7 8 9 10 11 12 13 **14** 15 16 17 18 19 20 21 22 23 24 25 26 27 28 29 30 31

JULY

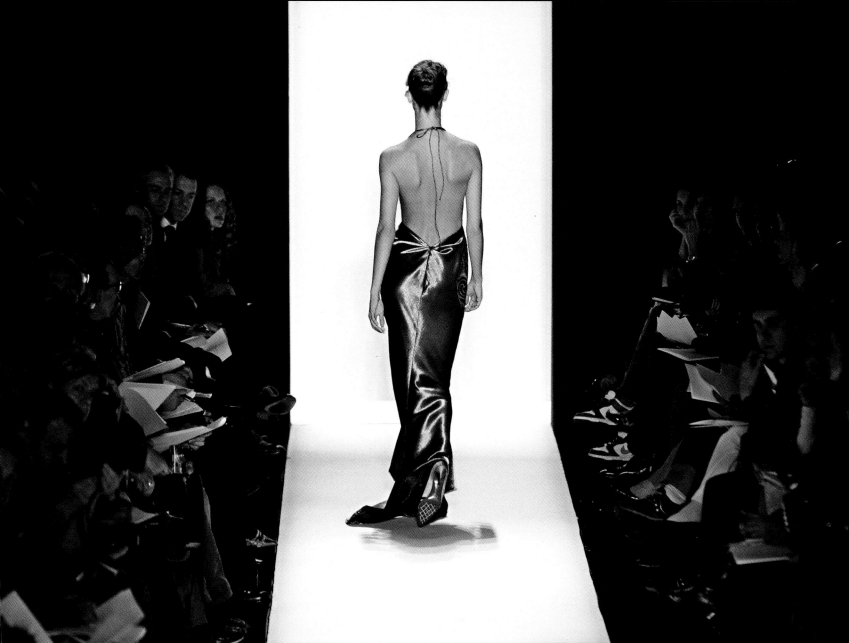

Every fashionably dressed person considers himself a representative of his century or decade.

Jean Paul

For generations, the sailor dress and sailor suit were absolutely indispensable for well-dressed children. Maritime clothing was also indispensable in literature. After all, what would have become of Effi Briest without the sailor dress, and what would Thomas Mann's beach life on Venice's Lido have looked like without this "uniform"?

Swimwear circa 1890—vacationers posing in bathing suits on the beach in Santa Monica, Los Angeles.

1 2 3 4 5 6 7 8 9 10 11 12 13 14 **15** 16 17 18 19 20 21 22 23 24 25 26 27 28 29 30 31

JULY

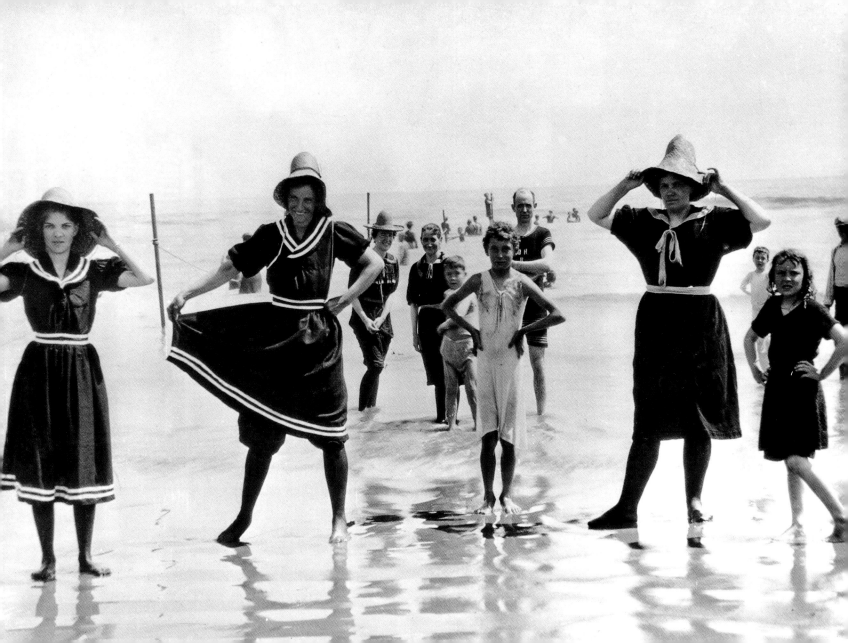

The best part of a party is getting
dressed to go.

Nan Kempner

Unfortunately, a happy marriage does not depend upon the opulence of
the wedding dress. Princess Diana proved this point all too tragically.
Formal portrait of LADY DIANA SPENCER in her wedding dress designed by
DAVID and ELIZABETH EMANUEL, July 29 1981.

1 2 3 4 5 6 7 8 9 10 11 12 13 14 15 **16** 17 18 19 20 21 22 23 24 25 26 27 28 29 30 31

JULY

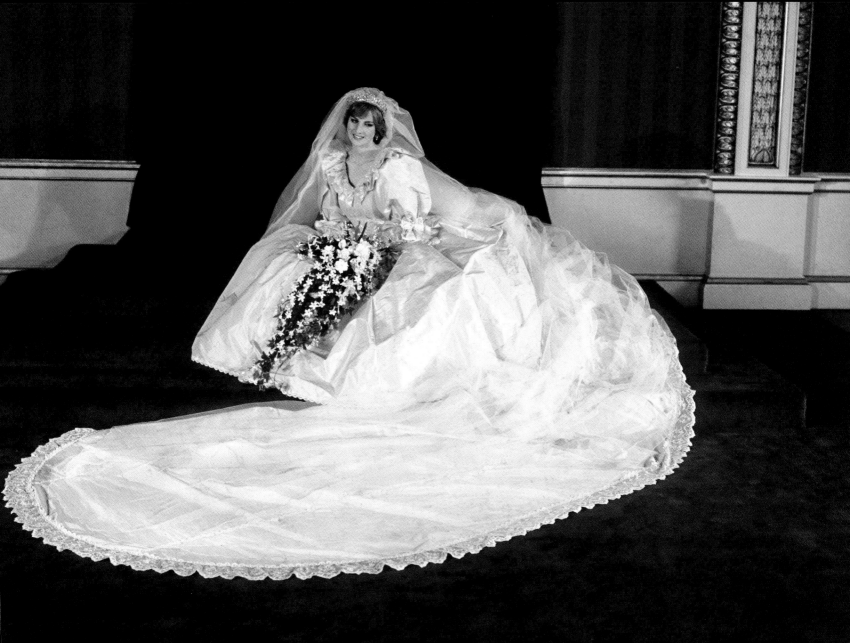

There is a mysterious stillness and
intimacy of a woman doing her hair
and make-up which attracts me.

Pedro Almodóvar

We always want the very opposite of what we have. Those with straight hair
want curls—and those with curls would prefer theirs to be straight. Supermodel
Naomi Campbell seems to be no exception.
Supermodel NAOMI CAMPBELL has her hair done backstage at MATTHEW
WILLIAMSON's Spring/Summer 2000 show during London Fashion Week.

1 2 3 4 5 6 7 8 9 10 11 12 13 14 15 16 **17** 18 19 20 21 22 23 24 25 26 27 28 29 30 31

JULY

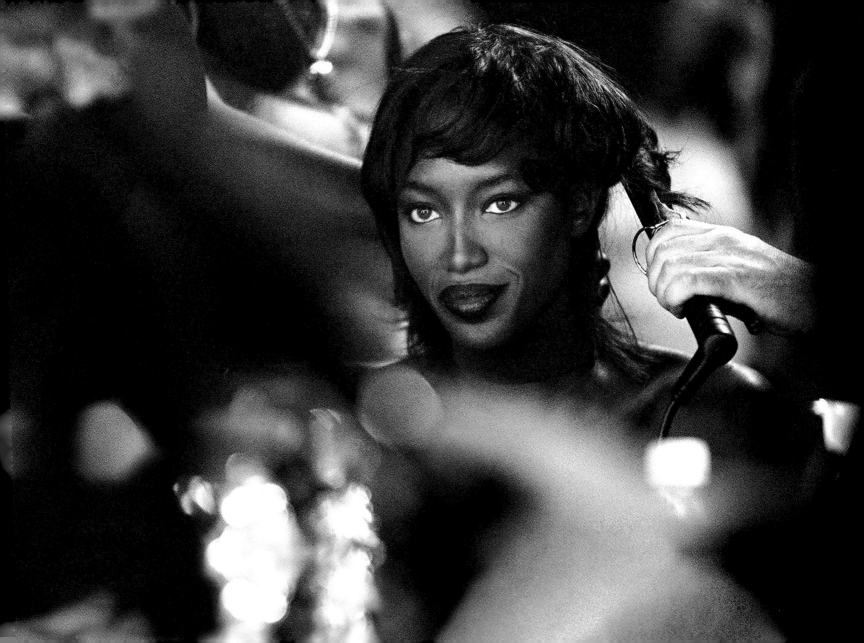

(London) seemed so cool at the time.
You thought, "London has the Beatles,
they have Twiggy and Jean Shrimpton,
they have the Stones, they have Biba."
You thought, "Oh my god, I've never
seen anything like this."

Anna Sui

There is a time for every purpose under heaven. Narrow trousers, high shirt collars, and the jacket double-breasted if you like—in 1960s London Mick Jagger and Keith Richards, both "bad boys" in their day, were pretty well-dressed—if you compare them with today's rappers.

Stylish rockers—the ROLLING STONES take a walk through London's Green Park, 1967.

1 2 3 4 5 6 7 8 9 10 11 12 13 14 15 16 17 **18** 19 20 21 22 23 24 25 26 27 28 29 30 31

JULY

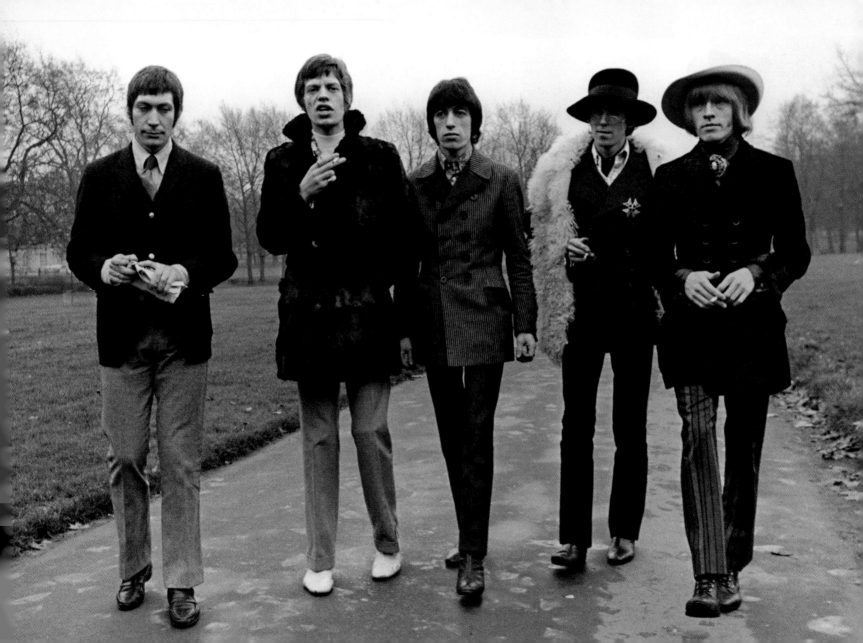

I like a woman to be arrogant and
daring. The woman who is arrogant
doesn't look like anyone else.

Yves Saint Laurent

Paillette is French for sequin. The countless glittering metal or plastic tiles sewn
onto fabric produce a shimmering effect—but it can easily go wrong. The danger
of being nothing but the tiny glittering flicker of a Carnival fashion joke is stitched
onto the dress, along with the sequins.
A model wears an outfit by JULIEN MACDONALD from his Fall/Winter 2003/04
collection at London Fashion Week.

1 2 3 4 5 6 7 8 9 10 11 12 13 14 15 16 17 18 19 20 21 22 23 24 25 26 27 28 29 30 31

JULY

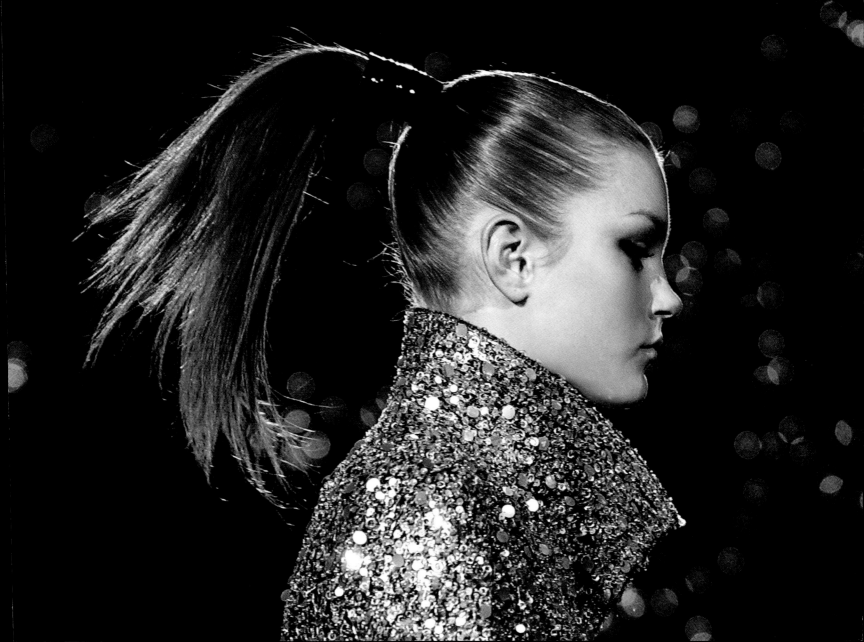

Is not the most erotic part of
the body wherever the clothing
affords a glimpse?

Roland Barthes

The voyeur, the peeping Tom who pursues his passion under water, should always
wear goggles and, of course, as much as possible avoid murky water.
Headless—underwater shot of actress DAPHNE DAYLE (center) clad in a topless,
one-piece bathing suit by AMER in a swimming pool in Paris, 1964.

1 2 3 4 5 6 7 8 9 10 11 12 13 14 15 16 17 18 19 20 21 22 23 24 25 26 27 28 29 30 31

JULY

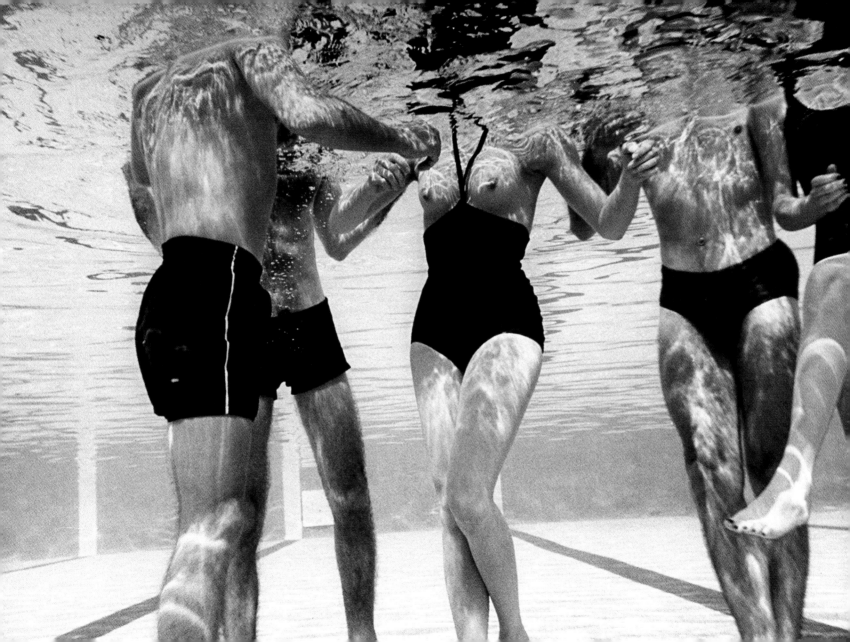

I like his music; I like his brain,
his looks, and his style.

Vivienne Westwood, on Marilyn Manson.

In fact, Moschino is absolutely not Marilyn Manson's style—the clothing designed
under this label is simply too light, too amusing. The rock musician is leaning
forward—but perhaps only in order to be himself seen.
U. S. musician MARILYN MANSON watches the presentation of Italian fashion
house MOSCHINO during the Fall/Winter 2006/07 women's ready-to-wear
collection in Milan.

1 2 3 4 5 6 7 8 9 10 11 12 13 14 15 16 17 18 19 20 21 22 23 24 25 26 27 28 29 30 31

JULY

There are kinds of things that just don't have any good explanation. I suppose you could say that if it had been a really nice animal, something sympathetic, then maybe nothing would have happened. Suppose I had picked a rooster. Well, that's French, but it doesn't have the same impact.

René Lacoste, tennis player and founder of Lacoste, about his logo

One of the most frequently counterfeited fashion logos. But be careful with those cheap polo shirts from the Far East with this reptile on the breast—some product pirates were so stupid that the crocodile's tail curves downwards.

A world-famous label—runway background at the LACOSTE Spring 2006 fashion show during Olympus Fashion Week in New York.

1 2 3 4 5 6 7 8 9 10 11 12 13 14 15 16 17 18 19 20 21 22 23 24 25 26 27 28 29 30 31

JULY

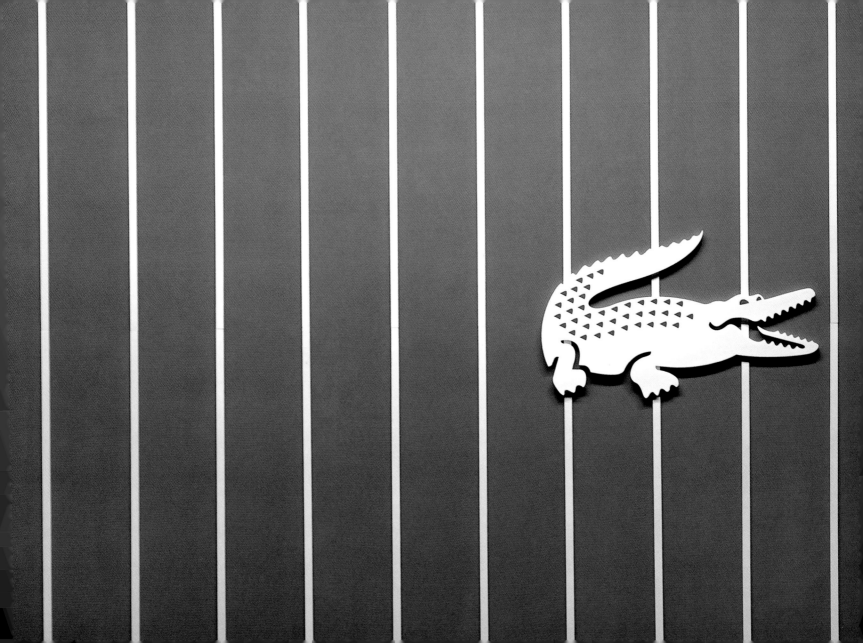

Fashion is not art. Never. I am not a painter or a sculptor. My role is to do clothes. Fashion is a reflection of the times, and that's hard enough to do.

Jean Paul Gaultier

At the end of every fashion show, the maestro reappears during the final procession with a model wearing a wedding dress. Here, this moment provides Jean Paul Gaultier a welcome opportunity to once again show off the floor-length man's skirt he promotes.

Designer JEAN PAUL GAULTIER walks with a model during the 2004 Shanghai Fashion Week.

1 2 3 4 5 6 7 8 9 10 11 12 13 14 15 16 17 18 19 20 21 22 **23** 24 25 26 27 28 29 30 31

JULY

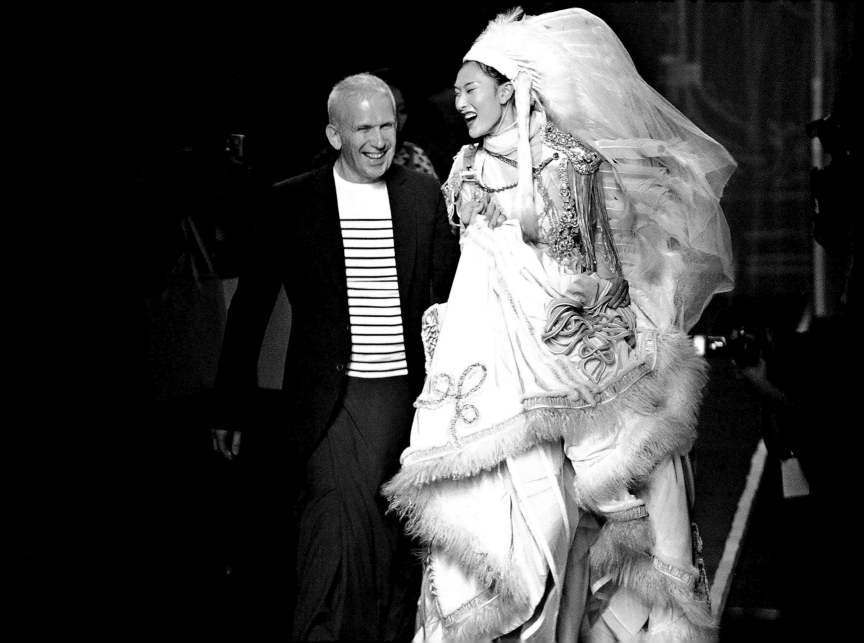

Enter the ateliers of the great couturiers
and you will feel that you're not in
a shop but in the studio of an artist
who intends to make of your dress
a portrait of yourself, and one that
resembles you.

Paul Poiret

"In this dress I find music in your body—a *grazioso* in these ankles; a *cantabile* in these charming curves; a *misterioso* in these knees; and the magnificent *andante* of voluptuousness…"—Frank Wedekind's and Alban Berg's *Lulu*. She must have looked like this in a Poiret dressing gown—the man-eating woman of the 1920s.
A model wearing a dressing gown by French designer PAUL POIRET, 1925.

1 2 3 4 5 6 7 8 9 10 11 12 13 14 15 16 17 18 19 20 21 22 23 24 25 26 27 28 29 30 31

JULY

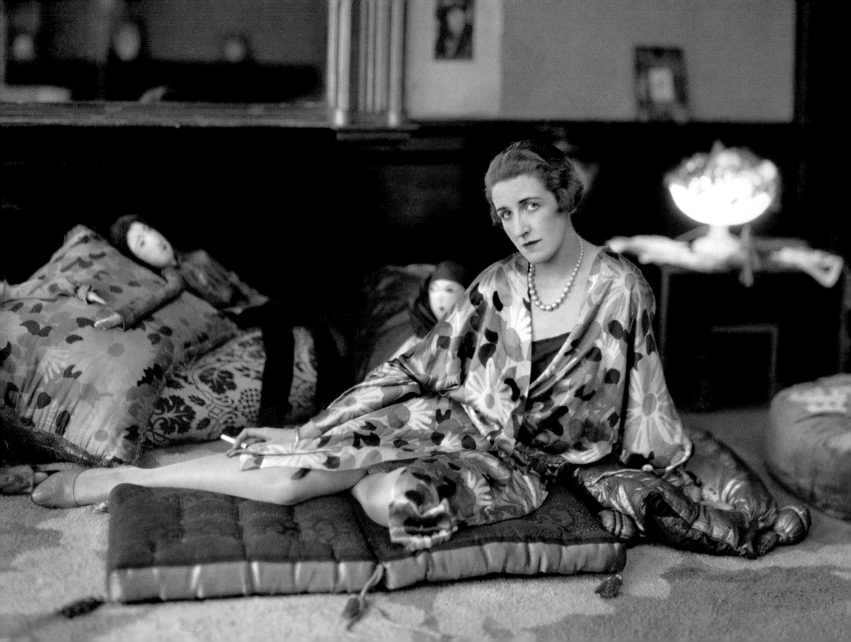

I believe that all my inspiration has always come from my childhood.

Jean-Charles de Castelbajac

Eros in cardinal red! The French fashion and industrial designer Jean-Charles de Castelbajac is extremely versatile in his creativity. He has also designed robes for Pope John Paul II—and for cardinals.
Models present creations by designer JEAN-CHARLES DE CASTELBAJAC during the Spring/Summer 2007 ready-to-wear collections in Paris.

1 2 3 4 5 6 7 8 9 10 11 12 13 14 15 16 17 18 19 20 21 22 23 24 25 26 27 28 29 30 31

JULY

Genius is one percent inspiration,
ninety-nine percent perspiration.

Thomas Alva Edison

The French couturier Jacques Fath (1912–1954) started designing hats, and in 1947 was the first French designer to create a ready-to-wear collection for the American market. Fath was a society darling, a businessman, and a couturier all rolled into one.
JACQUES FATH working on one of his designs, 1941.

1 2 3 4 5 6 7 8 9 10 11 12 13 14 15 16 17 18 19 20 21 22 23 24 25 26 27 28 29 30 31

JULY

The only rule is don't be boring.

Paris Hilton

Fin de siècle... reinvented every hundred years.
A model walks down the runway during the GIVENCHY haute couture
Fall/Winter 2000/01 fashion show in Paris.

1 2 3 4 5 6 7 8 9 10 11 12 13 14 15 16 17 18 19 20 21 22 23 24 25 26 **27** 28 29 30 31

JULY

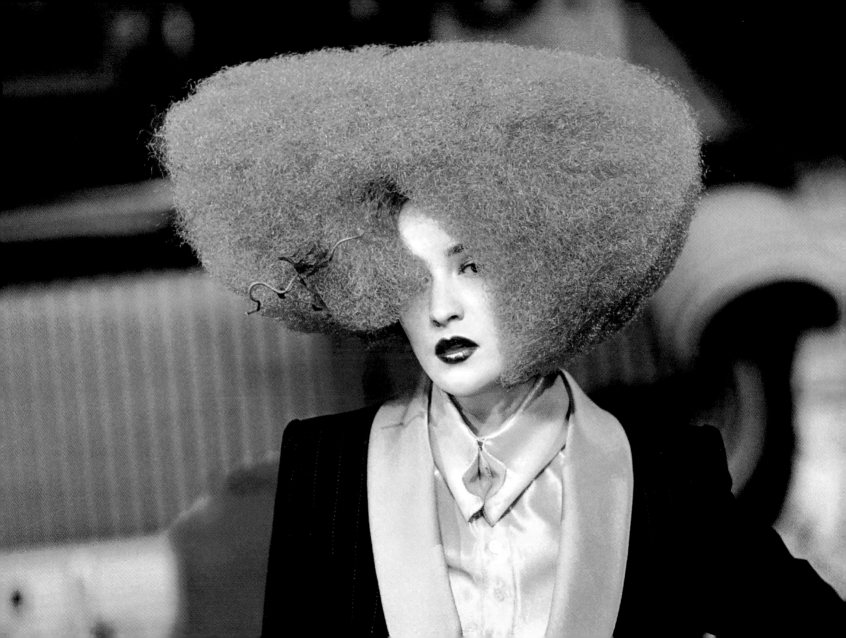

Jeans represent freedom, they signify
democracy in fashion.

Giorgio Armani

Denim became the fabric that united all classes. If you wear jeans you can make
a fashion statement—or a philosophical or political one. That is why these tight
pants are not merely fashion. Jeans are like life itself, and they only start to look
really good when they have acquired a patina of age.
LEVI STRAUSS jeans—not just for carpenters and cowboys.

1 2 3 4 5 6 7 8 9 10 11 12 13 14 15 16 17 18 19 20 21 22 23 24 25 26 27 28 29 30 31

JULY

Nudity in my shows is about
purity and the body's power.
Clothes cocoon the body.

Hussein Chalayan

Sweet and delicious—when clothing is so distressed. But do we really want to
take a hammer to our clothes at night?
Models chip away from each other clothing made from sugar icing—a dramatic
part of the presentation of creations by HUSSEIN CHALAYAN for the Spring/Summer
2001 collection at London Fashion Week.

1 2 3 4 5 6 7 8 9 10 11 12 13 14 15 16 17 18 19 20 21 22 23 24 25 26 27 28 29 30 31

JULY

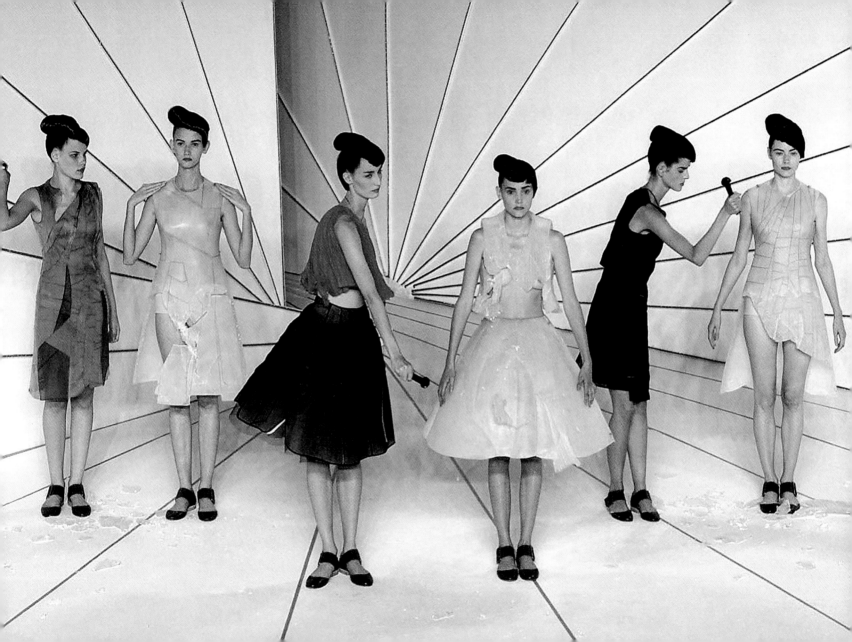

I am as Parisian as I am Japanese.

Kenzo Takada

Kenzo Takada (b. 1939) from Japan has a feeling for dramatic entrances. His fashion is very poetic and his design invariably a feast for the senses. Especially in the hard-fought perfume market, his label, which belongs to the French luxury goods concern LVMH, has been able to maintain its position with new fragrances. A model walks down the catwalk during the KENZO fashion show as part of Paris Fashion Week Spring/Summer 2007.

1 2 3 4 5 6 7 8 9 10 11 12 13 14 15 16 17 18 19 20 21 22 23 24 25 26 27 28 29 30 31

JULY

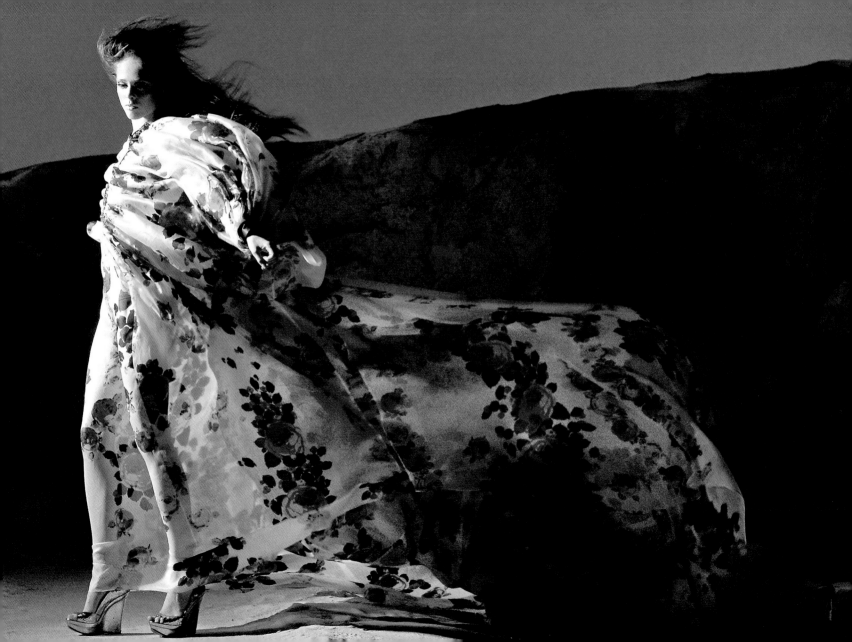

At Cacharel, the British team of Suzanne Clements and Inacio Ribeiro took on the clichés of couture detailing with trompe l'œil print interpretations of bows and brocades. The effect was spirited, sweet—even whimsical.

Ginia Bellafante

"She wears her clothes as if she had tossed them on with a tuning fork." Jonathan Swift's quotation generates a lot more mystery than these light summer dresses. Did the tuning fork give rise to the casual disarray on her body, or compose the (color) tones so harmoniously? Who knows—sometimes it is better to interpret fashion than literature.
Models grace the runway during the CACHAREL Spring/Summer 2001 fashion show in Paris.

1 2 3 4 5 6 7 8 9 10 11 12 13 14 15 16 17 18 19 20 21 22 23 24 25 26 27 28 29 30 31

JULY

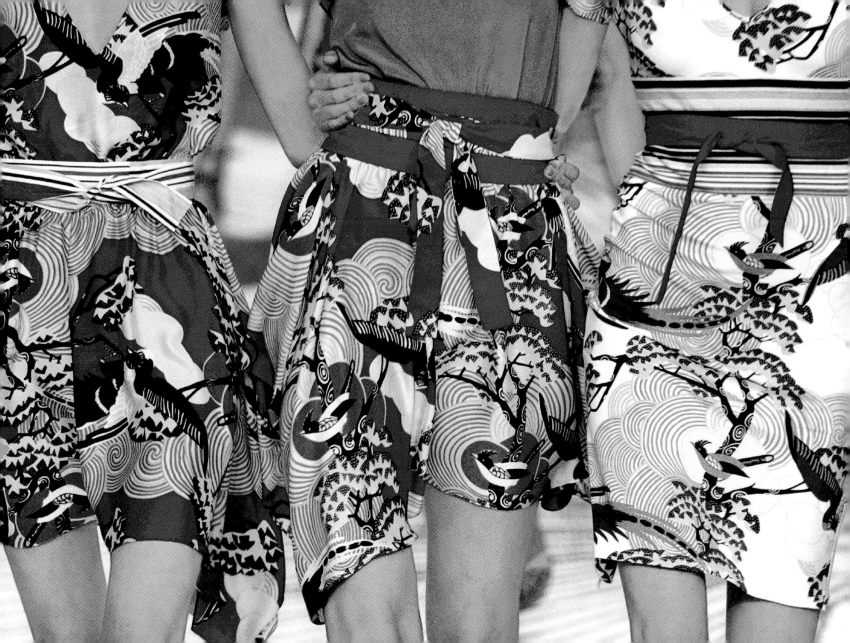

I hope that one thing people get from
my shoes is a sense of fun.

Patrick Cox

Patrick Cox (b. 1963) was born in Canada, arrived to London at the age of 20,
studied shoe design, and embarked on a meteoric ascent. He owed it above all
to his crazy designs for eccentric designers like Vivienne Westwood, Anna Sui,
and Katherine Hamnett. Cox has since become somewhat "quieter," and designs
footwear for the great traditional brand Charles Jourdan.
British model and actress ELIZABETH HURLEY poses for the PATRICK COX Spring/
Summer 2006 advertising campaign.

1 2 3 4 5 6 7 8 9 10 11 12 13 14 15 16 17 18 19 20 21 22 23 24 25 26 27 28 29 30 31

AUGUST

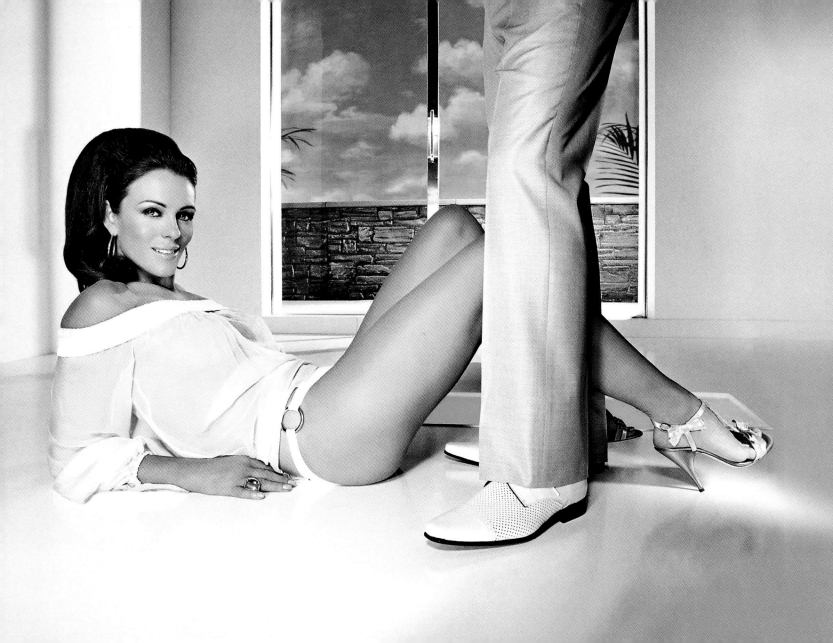

What is beautiful is good, and who
is good will soon be beautiful.

Sappho

But what is beautiful? Yang Sung Sook thinks he knows.
A model showcases a creation by Y&M YANG SUNG SOOK at the Seoul Collection
Spring/Summer 2008 Womenswear Fashion Event, Seoul.

1 2 3 4 5 6 7 8 9 10 11 12 13 14 15 16 17 18 19 20 21 22 23 24 25 26 27 28 29 30 31

AUGUST

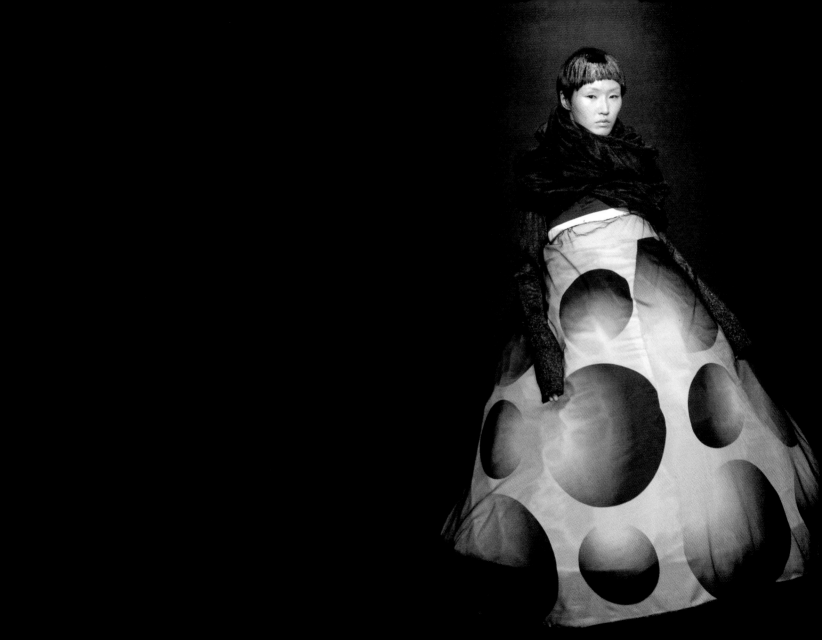

It's very good, in a way, that people copy.
It's not always good copies, but it's good
for Mr. Courrèges because… it shows
that his style has kept up for 40 years.

Coqueline Courrèges

A dog's eye view provides a completely different angle on fashion—especially
the miniskirt. However, you are also close to the trashcans and tailpipes—if you
are a dog.
ANDRÉ COURRÈGES, creator of the first miniskirt fashions, admires a model wearing
one of his latest miniskirts on a street in Paris, 1990.

1 2 3 4 5 6 7 8 9 10 11 12 13 14 15 16 17 18 19 20 21 22 23 24 25 26 27 28 29 30 31

AUGUST

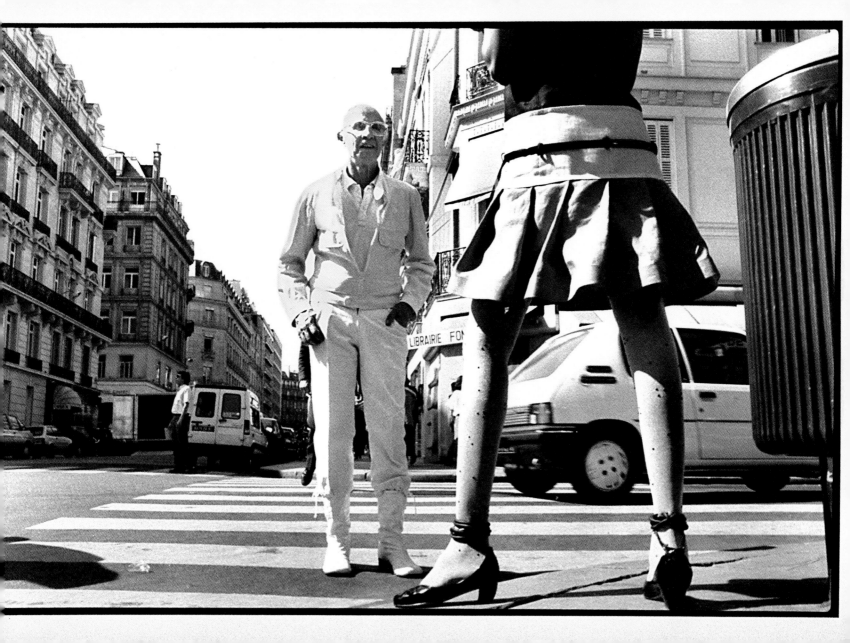

Sex is the bread and butter of Domenico Dolce and Stefano Gabbana… In the hands of an intelligent woman, a body-suit or a rubbery blouse can be made to look beautiful as well as exciting.

Cathy Horyn, *The New York Times*, 2006

"Fashion is very strange. Fashion designers can make as many mistakes as they like. There will always be millions of women who are prepared to pay for them," commented singer Barbra Streisand in an interview. Who would dare to contradict her?

Model wearing a creation by DOLCE & GABBANA during the Spring/Summer 2007 women's collections, Milan.

1 2 3 4 5 6 7 8 9 10 11 12 13 14 15 16 17 18 19 20 21 22 23 24 25 26 27 28 29 30 31

AUGUST

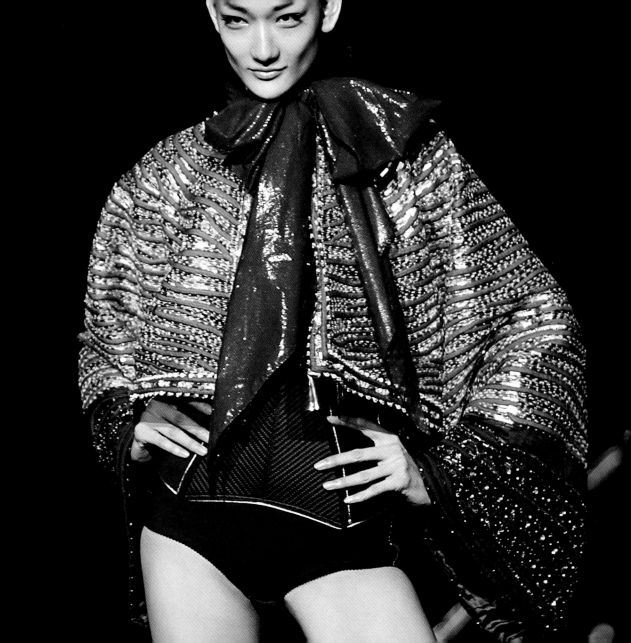

The functional must be the soul of a
dress, its composition, its interior rhythm…
aesthetics is the envelope.

How sweet! Women in the 1960s were more like dolls. But definitely not dolly birds.
Models wearing red and white ready-to-wear fashions by ANDRÉ COURRÈGES,
1968.

André Courrèges

1 2 3 4 **5** 6 7 8 9 10 11 12 13 14 15 16 17 18 19 20 21 22 23 24 25 26 27 28 29 30 31

AUGUST

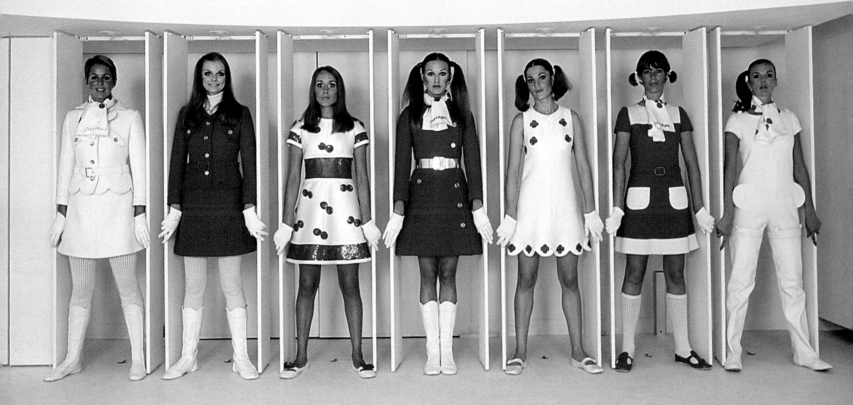

It is not enough to conquer; one must also know how to seduce.

Voltaire

Serpent and shoe with the same intention? Definitely. Nothing seduces men more easily than slingback pumps entwining themselves snake-like around a woman's ankle. Everything else is a lie.

An Egyptian cobra guards a ruby, sapphire, and diamond sandal by RENE CAOVILLA at Harrods department store in London, 2007.

1 2 3 4 5 **6** 7 8 9 10 11 12 13 14 15 16 17 18 19 20 21 22 23 24 25 26 27 28 29 30 31

AUGUST

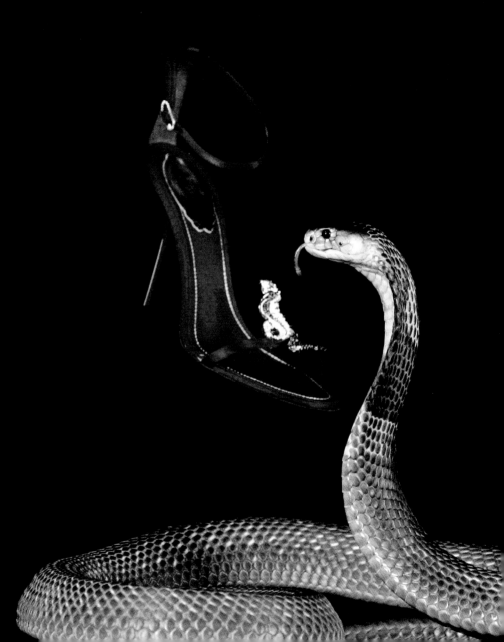

Wherever you find fashion trends, must-haves, or what's hot you can be certain you will never find Rei Kawakubo of Comme des Garçons.

Hilary Alexander

The dandy or snob look is always on the comeback in men's fashion. It seems unlikely, however, that platform shoes for men will catch on—although in fashion you have to be prepared for anything.

High pants and platform shoes round out the outfit for this creation in the COMME DES GARÇONS Fall/Winter 2007/08 men's collection, Paris.

1 2 3 4 5 6 7 8 9 10 11 12 13 14 15 16 17 18 19 20 21 22 23 24 25 26 27 28 29 30 31

AUGUST

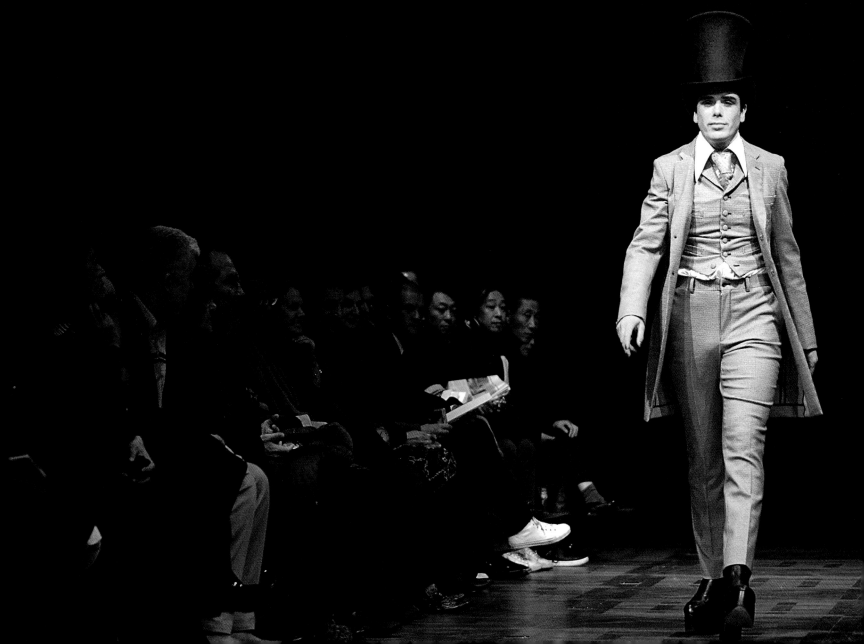

And I was as fed up as anybody, not having nice, fully-fashioned glamour stockings.

Dame Barbara Castle

They were all the rage in the 1980s—printed stockings, often with tartan patterns. But did they really radiate erotic charm? In fashion, it is often a great advantage to be able to forget.

Thigh-high stockings in bold leaf, blotch, and stripe patterns, photographed by Evelyn Floret, 1988.

1 2 3 4 5 6 7 **8** 9 10 11 12 13 14 15 16 17 18 19 20 21 22 23 24 25 26 27 28 29 30 31

AUGUST

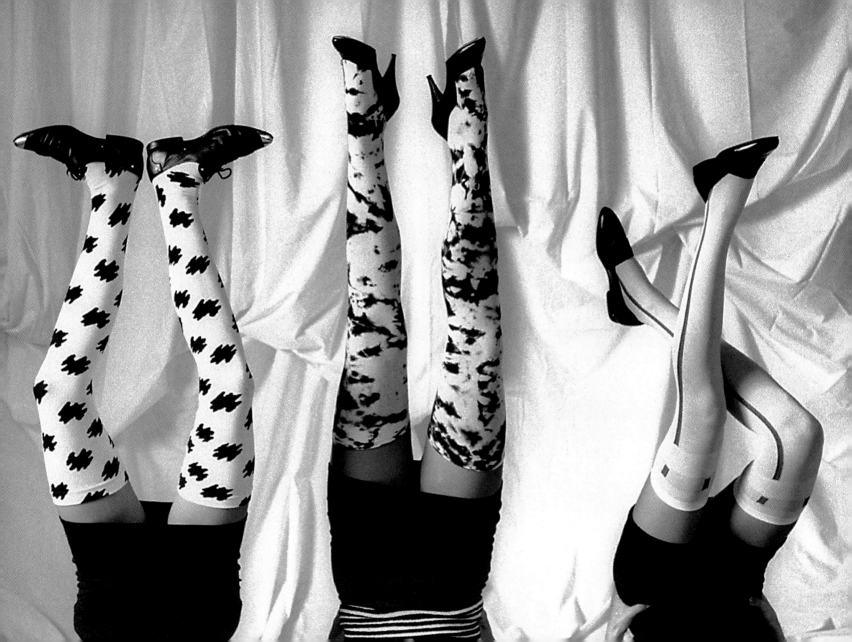

Women can do everything men can do,
and they can do it sometimes better.

Jean Paul Gaultier

Modern, emancipated women in the 1920s, like Dolly Tree, reached for the scissors—for their hair and (as designers) for the fabric.
Fashion and costume designer DOLLY TREE poses in kimono-style nightwear with a model of the cartoon character Corky the Cat, ca. 1925.

1 2 3 4 5 6 7 8 **9** 10 11 12 13 14 15 16 17 18 19 20 21 22 23 24 25 26 27 28 29 30 31

AUGUST

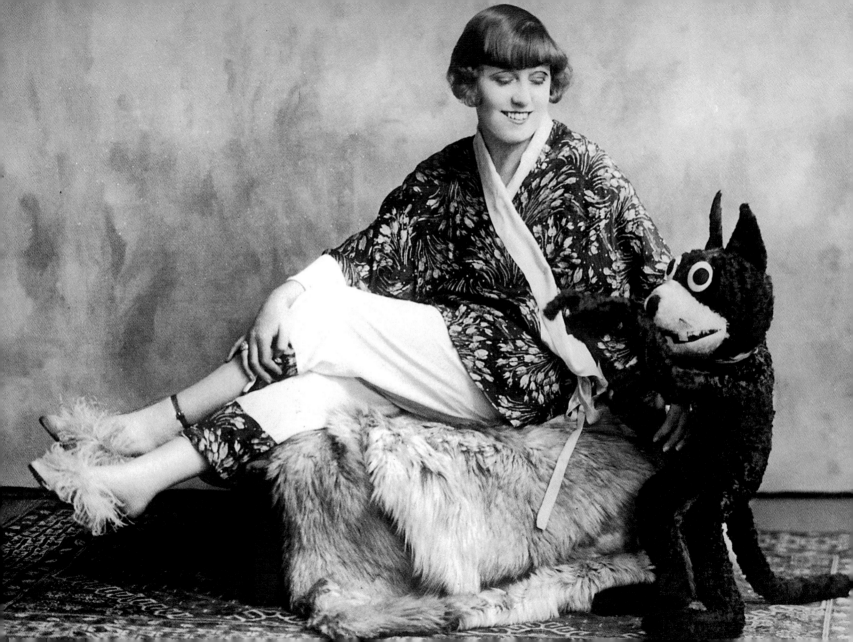

I am growing up—I don't want to be known only for mad, crazy things and rhinestones.

Julien MacDonald

Feathered woman. Designers often find their inspiration in the world of ornithology. The result—birds of paradise on the catwalk.
Dress by British designer JULIEN MACDONALD at the opening of London Fashion Week 2005.

1 2 3 4 5 6 7 8 9 **10** 11 12 13·14 15 16 17 18 19 20 21 22 23 24 25 26 27 28 29 30 31

AUGUST

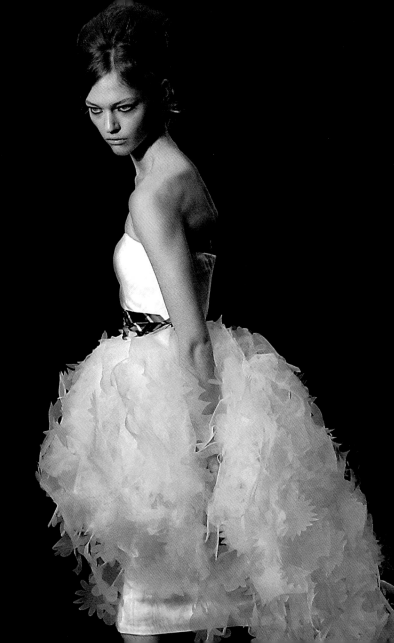

... the classic Biba dolly was very pretty and young. She had an upturned nose, rosy cheeks, and a skinny body with long asparagus legs and tiny feet. She was square-shouldered and quite flat-chested. Her head was perched on a long, swanlike neck. Her face was a perfect oval, her lids were heavy with long, spiky lashes. She looked sweet but was as hard as nails.

Biba founder Barbara Hulanicki

It could be an art déco dream. But no. The 1970s also often borrowed leopard and tiger-skin patterns, and liked to drape a woman like a statuesque goddess. Also typical seventies—the circular bed.

Archetype of the innocent nymph—English model TWIGGY lounging on a leopardskin bed at BIBA's Kensington store, 1971.

1 2 3 4 5 6 7 8 9 10 11 12 13 14 15 16 17 18 19 20 21 22 23 24 25 26 27 28 29 30 31

AUGUST

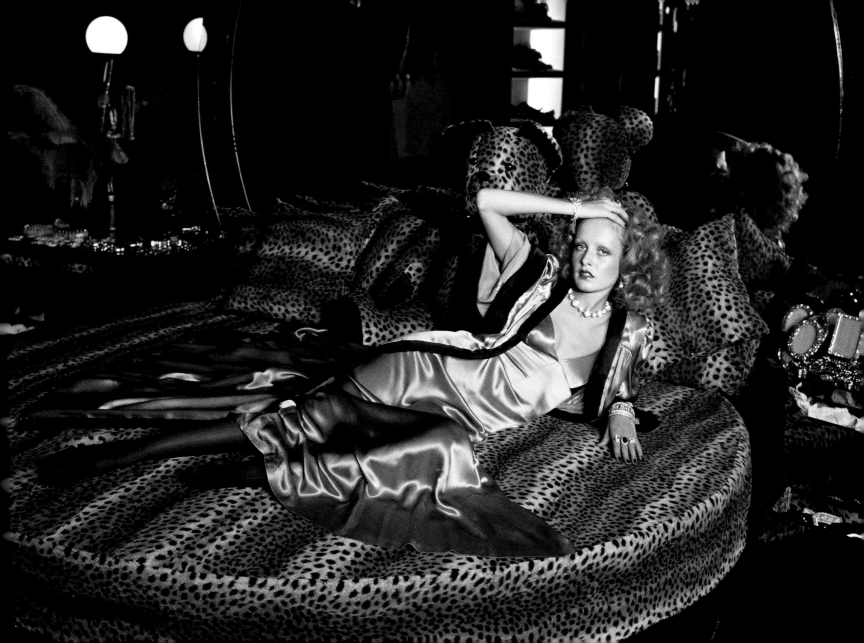

I like to design simple things but that
are not basic. I'd say I'm natural, quite
opinionated, and that I don't like to
stand out too much.

Hussein Chalayan

It is sometimes difficult to sleep with such a fashionable hairstyle… but fashion
never sleeps anyway.
A model presents a creation by HUSSEIN CHALAYAN at London Fashion Week, 2000.

1 2 3 4 5 6 7 8 9 10 11 12 13 14 15 16 17 18 19 20 21 22 23 24 25 26 27 28 29 30 31

AUGUST

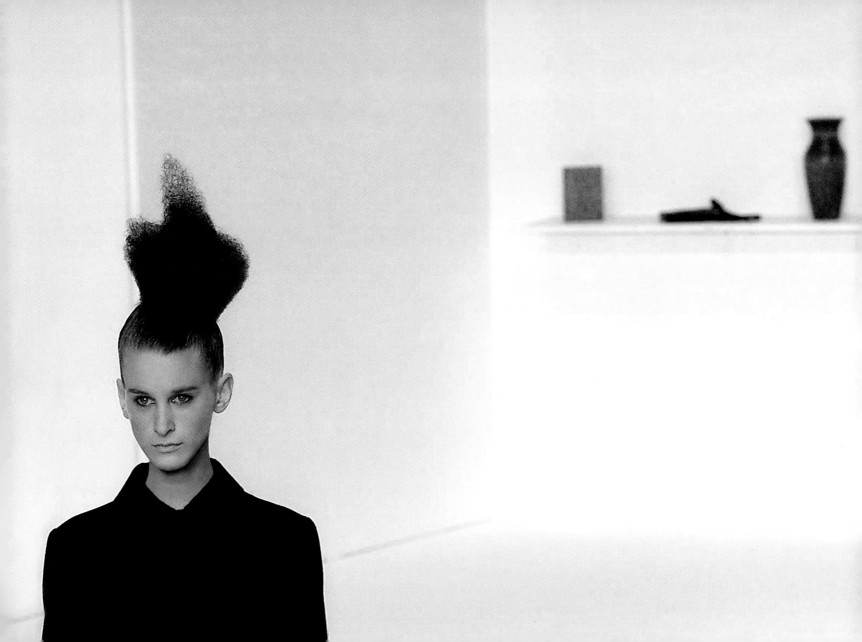

Illusion is the first of all pleasures.

Oscar Wilde

It sparkles here, there, and everywhere! Like glass stones, real diamonds have also conquered the fashion world as luxury appliqués. Everything sparkles, everything is covered with them—jeans and bikinis, evening dresses and, of course, sinful, sinfully expensive underwear.
GISÈLE BÜNDCHEN presents a diamond-studded bra by VICTORIA'S SECRET, 2006.

1 2 3 4 5 6 7 8 9 10 11 12 **13** 14 15 16 17 18 19 20 21 22 23 24 25 26 27 28 29 30 31

AUGUST

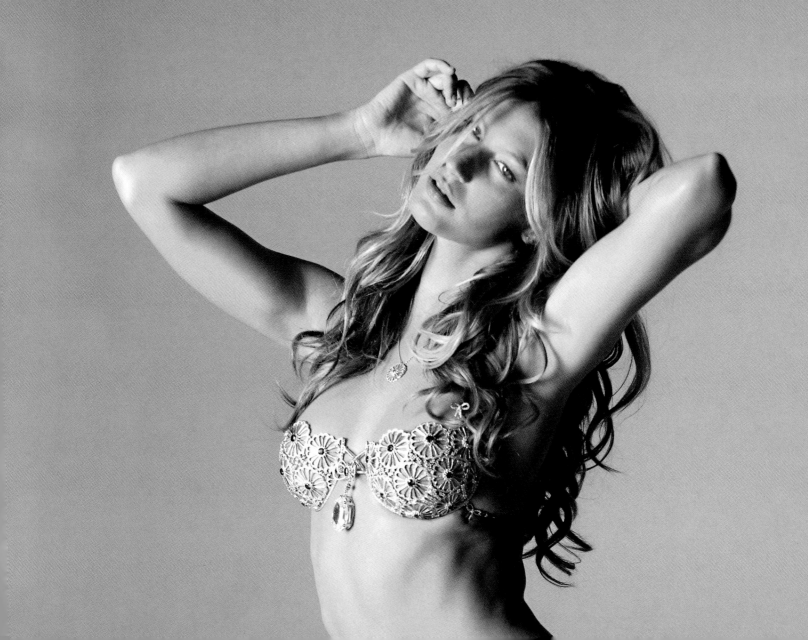

Fashion is a branch of the visual
and performing arts.

Camille Paglia

The sculpture or the model? Which came first?
American model DOVIMA next to a sculpture of a woman in Stanley Donen's
film *Funny Face*, 1957.

1 2 3 4 5 6 7 8 9 10 11 12 13 14 15 16 17 18 19 20 21 22 23 24 25 26 27 28 29 30 31

AUGUST

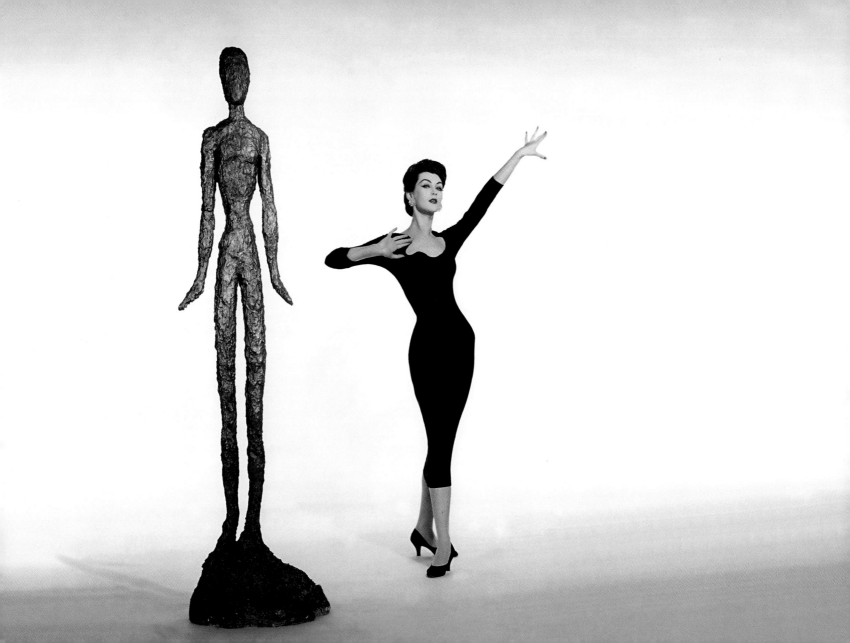

I have chosen today to bid adieu to this profession that I have loved so much … I tell myself that I created the wardrobe of the contemporary woman, that I participated in the transformation of my times.

Yves Saint Laurent

The German fashion journalist Charlotte Seeling called Yves Saint Laurent "The genius of the century." Diana Vreeland, the unforgettable editor-in-chief of U.S. *Vogue*, agreed with her, "Coco Chanel and Christian Dior were giants, but Saint Laurent is a genius." Born in 1936, the artist was the only worthy successor of the great Christian Dior. *YSL*—three letters which stand for the famous Mondrian dress, along with other designs that made fashion history. Until his death in 2008, beautiful, important women like Laetitia Casta and Cathérine Deneuve were among the designer's closest friends and muses.

French designer YVES SAINT LAURENT with model LAETITIA CASTA (left) and actress CATHÉRINE DENEUVE (right) at his final presentation at the Centre George Pompidou, Paris, 2002.

1 2 3 4 5 6 7 8 9 10 11 12 13 14 **15** 16 17 18 19 20 21 22 23 24 25 26 27 28 29 30 31

AUGUST

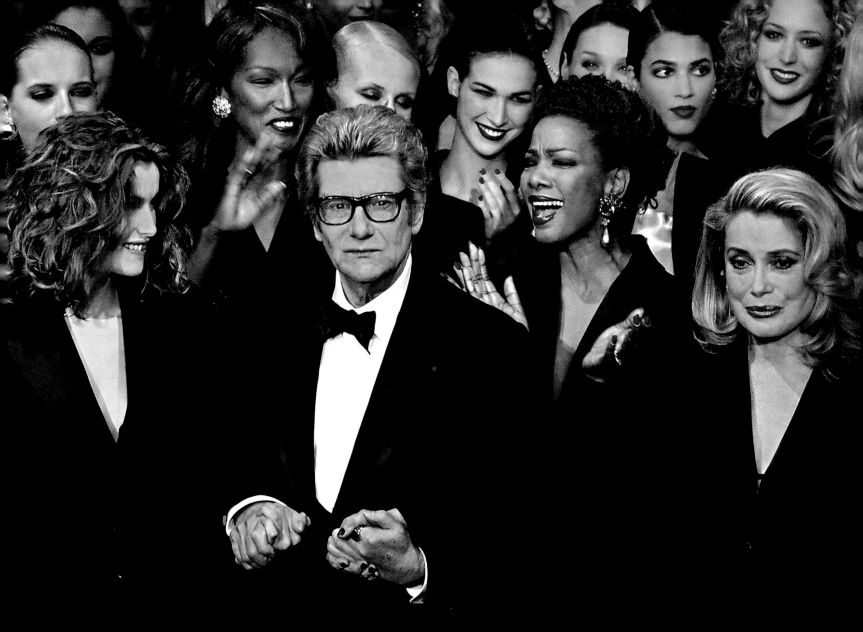

When in doubt, wear red.

Bill Blass

Woman, an unidentified flying object. Fashion exists in order to attract attention—an end that justifies (almost) every means.
A model wears a creation by designer HUSSEIN CHALAYAN during the Fall/Winter 2007/08 ready-to-wear collection show in Paris.

1 2 3 4 5 6 7 8 9 10 11 12 13 14 15 **16** 17 18 19 20 21 22 23 24 25 26 27 28 29 30 31

AUGUST

The clothes weren't that important.
It was a whole attitude.

Ossie Clark

Looking back at fashion always produces strange feelings. Filled with a mixture of embarrassment and retrospective pride, we nonetheless find ourselves thinking—so that is how we used to dress. Really? Just like that?
Models Linda Keith, Chrissie Shrimpton, Suki Poitier, and Annie Sabroux present winter fashions by OSSIE CLARK and ALICE POLLOCK, London, 1967.

1 2 3 4 5 6 7 8 9 10 11 12 13 14 15 16 **17** 18 19 20 21 22 23 24 25 26 27 28 29 30 31

AUGUST

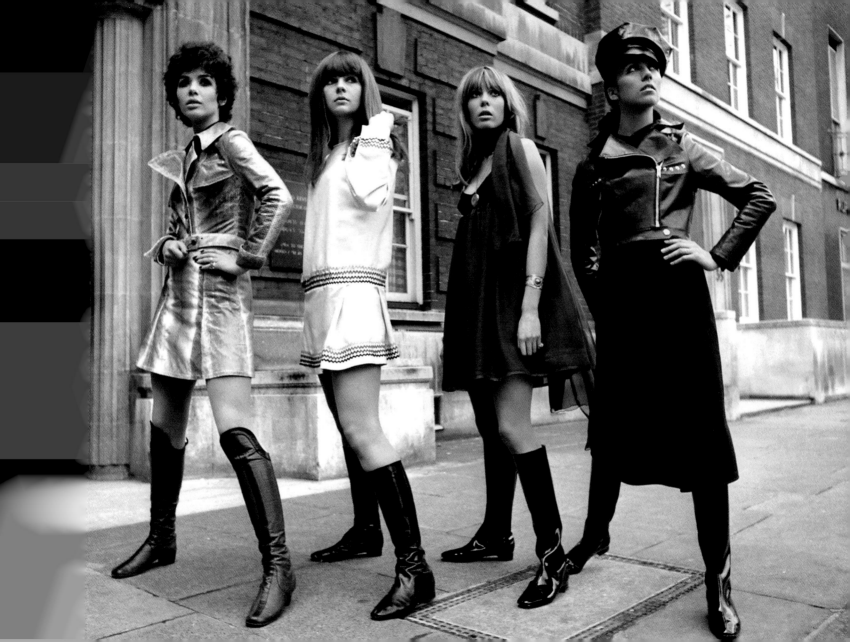

I always like beauty and find it fascinating.
Beauty is certainly better than ugliness.

Miuccia Prada

It is the subtle nuances and wealth of details that combine to produce
a really glamorous evening dress.
Embroidered bodice, detail of an elegant evening gown.

1 2 3 4 5 6 7 8 9 10 11 12 13 14 15 16 17 18 19 20 21 22 23 24 25 26 27 28 29 30 31

AUGUST

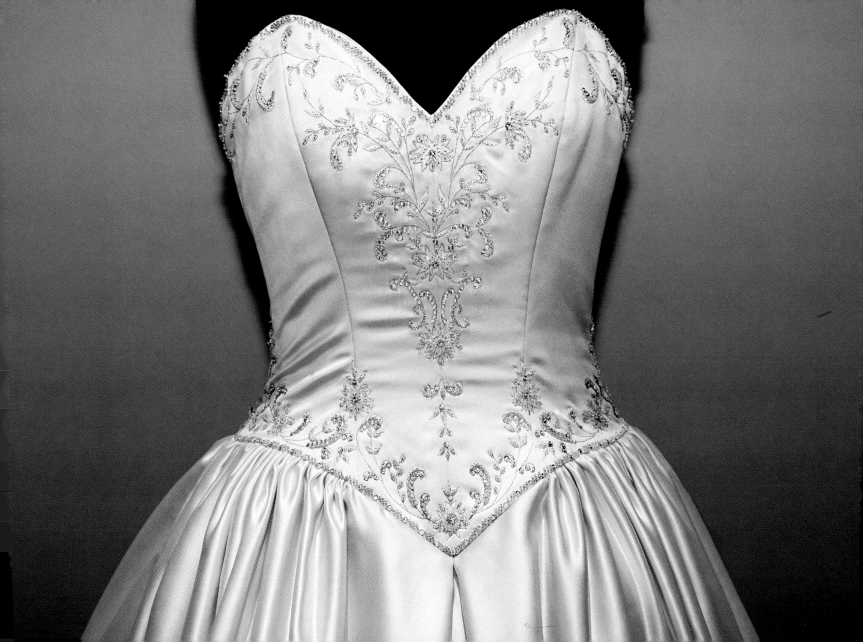

Nothing wears clothes, but Man;
nothing doth need
But he to wear them.

George Herbert

The collections created by Jean Elizabeth Muir (1933–1995) impressed by virtue of their combination of sex appeal and chic, and their unusually precise cuts. A dog watches the JEAN MUIR Spring/Summer 2006 fashion show during London Fashion Week at the Royal Academy of Art.

1 2 3 4 5 6 7 8 9 10 11 12 13 14 15 16 17 18 **19** 20 21 22 23 24 25 26 27 28 29 30 31

AUGUST

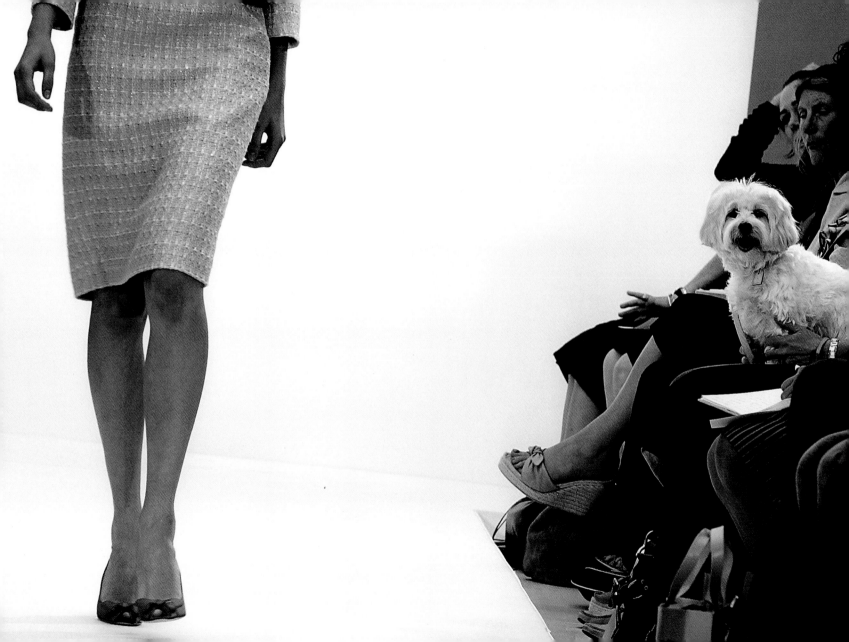

Sex has never been an obsession with
me. It's just like eating a bag of crisps.
Quite nice, but nothing marvellous.

Boy George

Pure provocation as part of the act. All too rapidly, fashion makes the provocative
protest attitude of the individual in the crowd seem like established opinion. Who
would turn around today to take a second look at a jacket with "fuck me" on it?
British singer BOY GEORGE of CULTURE CLUB outside his home in St John's Wood,
London, 1986.

1 2 3 4 5 6 7 8 9 10 11 12 13 14 15 16 17 18 19 **20** 21 22 23 24 25 26 27 28 29 30 31

AUGUST

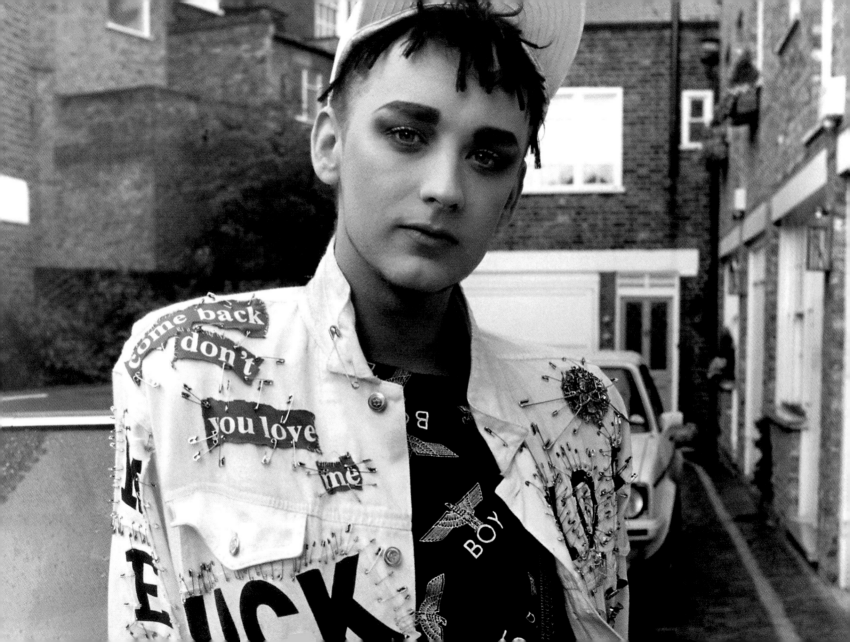

I am blessed or cursed, depending on
how you look at it, with an incurably
restless spirit and the ability to work hard.

Salvatore Ferragamo

"There is no unhappier creature under the sun than a fetishist who longs for a
lady's shoe and has to put up with the entire woman," wrote the Viennese cynic
and chronicler Karl Kraus.
A collection of FERRAGAMO shoes, Florence, 1947.

1 2 3 4 5 6 7 8 9 10 11 12 13 14 15 16 17 18 19 20 21 22 23 24 25 26 27 28 29 30 31

AUGUST

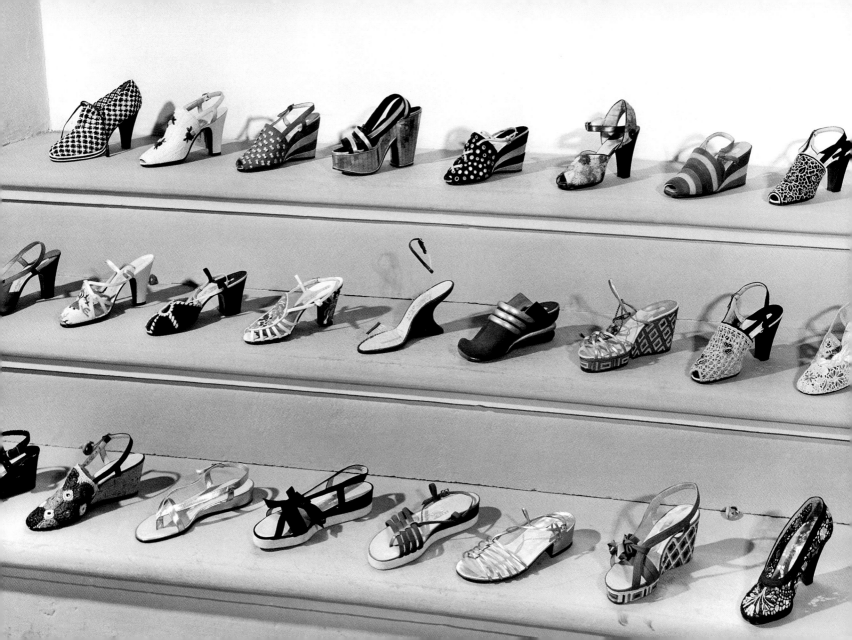

In his mind there was a certain ideal kind of woman, different than the women we see in magazines or on runways—not a trendy woman but a real woman.

Franca Sozzani, on Gianfranco Ferré

Fashion always plays with distance—those who reveal their upper body with such transparency often veil their faces all the more.

A model presents a combined lace and pinstripes outfit by GIANFRANCO FERRÉ for CHRISTIAN DIOR's Spring/Summer 1996 ready-to-wear collection in Paris.

1 2 3 4 5 6 7 8 9 10 11 12 13 14 15 16 17 18 19 20 21 22 23 24 25 26 27 28 29 30 31

AUGUST

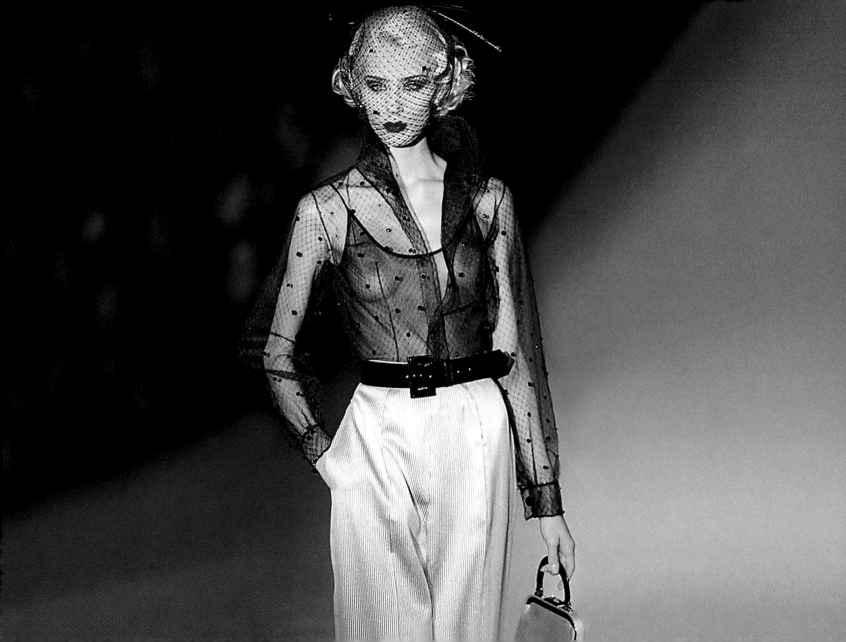

To be honest, I love all the clichés about Paris and French things. I was born into it. It's because I appreciate so much about what's happening in the other countries, in Japan, in America, in Africa, in Morocco, in Spain, in Italy also, that I also appreciate very French things.

Jean Paul Gaultier

The more creative the head, the more eccentric the decoration. During the first decade of the twentieth century, sophisticated ladies appeared in public weighed down by heavy hats, and wrapped in gowns made with yards of fabric. Their skirts reached to the ground, flaring outwards towards the hem like a bell and furnished with ruffles and pleats that often ended in a small train.
Embarras de richesses—women inspect hats from MAISON CORBIER at the Exposition Chapeaux in Paris, 1905.

1 2 3 4 5 6 7 8 9 10 11 12 13 14 15 16 17 18 19 20 21 22 23 24 25 26 27 28 29 30 31

AUGUST

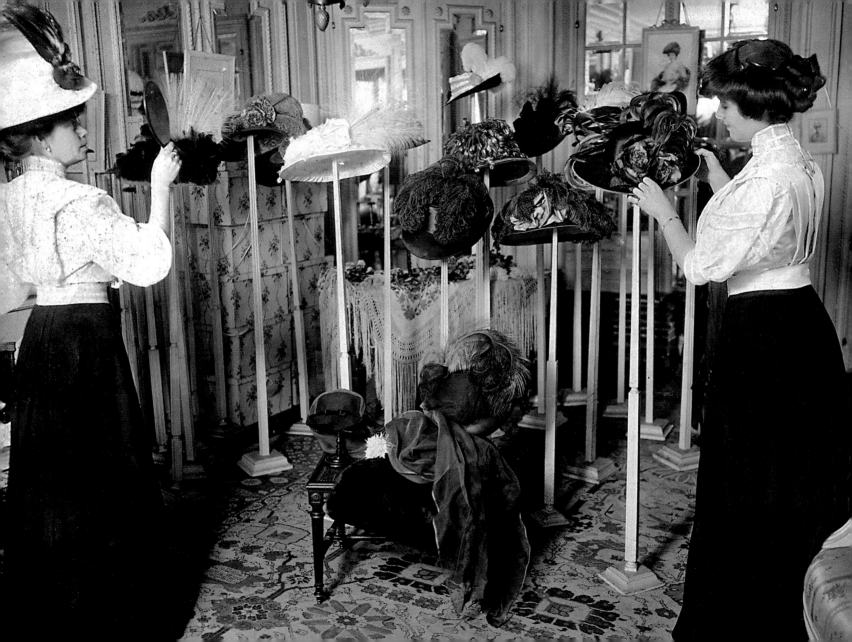

A real feminine vision… it's from there where we should start!

Ella Zahlan

Decorated with beads, the bustier is emphasized in a very feminine manner that suggests both the severity and the playfulness of this elegant creation.
A creation by Lebanese designer ELLA ZAHLAN at the Fall/Winter 2007/08 haute couture collection show during Fashion Week in Rome, 2007.

1 2 3 4 5 6 7 8 9 10 11 12 13 14 15 16 17 18 19 20 21 22 23 24 25 26 27 28 29 30 31

AUGUST

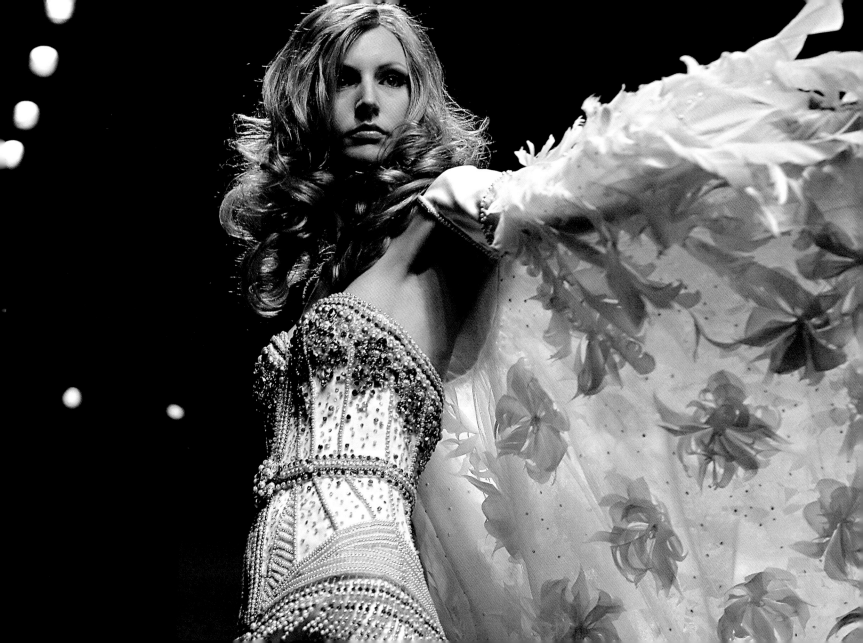

… a natural look … wholesome without being bland, strong without being tough, a girl who has character rather than a rigidly painted mask of beauty.

Ted Morgan on model Beverly Johnson

Halston. The brand of the seventies for all those who wanted to take part fashion-wise in the casual "American way of life." Floating gowns for women between the beach and the backyard barbecue. In the meantime, for cosmopolitan men there was Halston's "Z-14" perfume for men. In its time it was an eau-de-toilette with cult status.
Model BEVERLY JOHNSON presents a pastel chiffon dress by HALSTON with a neckline which plunges in a V to the waist, 1975.

1 2 3 4 5 6 7 8 9 10 11 12 13 14 15 16 17 18 19 20 21 22 23 24 25 26 27 28 29 30 31

AUGUST

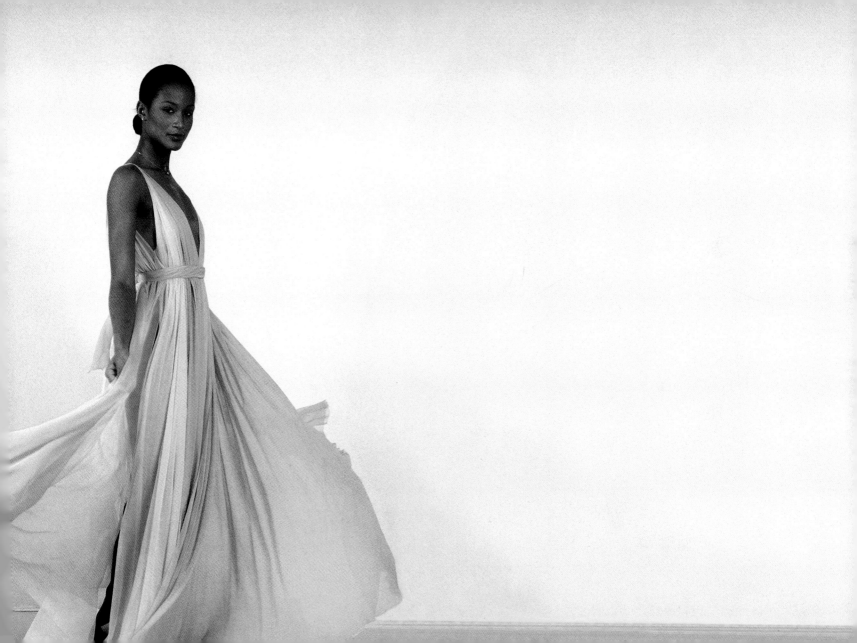

Real fashion change comes from real changes in real life. Everything else is just decoration.

Tom Ford

It is comforting to see what designers themselves wear. For Tom Ford, the rule is less is more! Blue jeans and a white shirt, that is *the* very best combination to get the better of all fashion rules and dictates, and to be "simply well dressed" on every occasion.
U.S. designer TOM FORD on the catwalk at the end of the GUCCI collection during the Spring/Summer 2004 Milan Fashion Week.

1 2 3 4 5 6 7 8 9 10 11 12 13 14 15 16 17 18 19 20 21 22 23 24 25 26 27 28 29 30 31

AUGUST

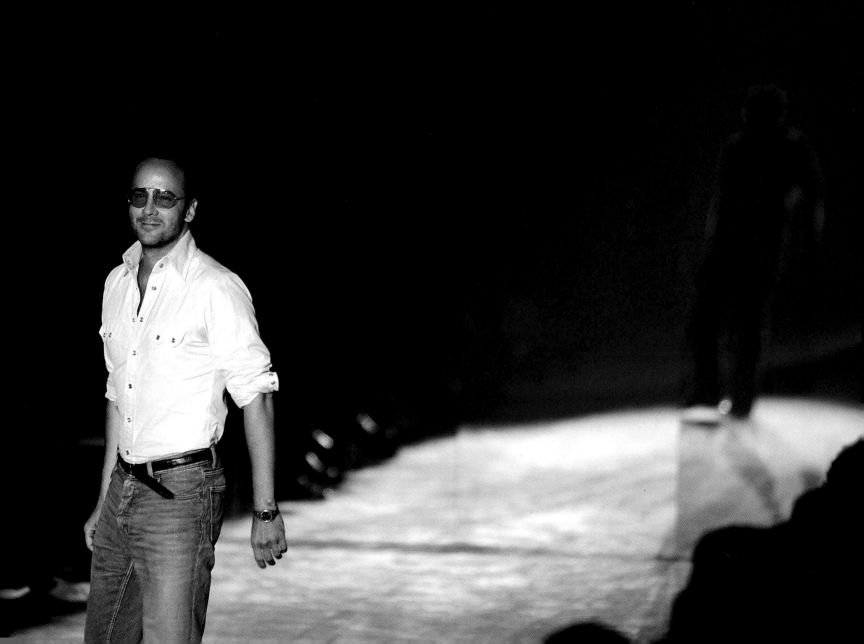

Fashion is born by small facts, trends, or even politics, never by trying to make little pleats and furbelows, by trinkets, by clothes easy to copy, or by the shortening or lengthening of a skirt.

Elsa Schiaparelli

Elsa Schiaparelli (1890–1973), "La Schiap," opened her couture salon on Place Vendôme in Paris in 1934. She was a self-made woman who earned a reputation as a designer and a marketing genius. Schiaparelli loved extravagant appearances, which is why the photographer-artist Man Ray liked to portray her in this way.
Model in a mink-trimmed peignoir designed by ELSA SCHIAPARELLI, 1951.

1 2 3 4 5 6 7 8 9 10 11 12 13 14 15 16 17 18 19 20 21 22 23 24 25 26 27 28 29 30 31

AUGUST

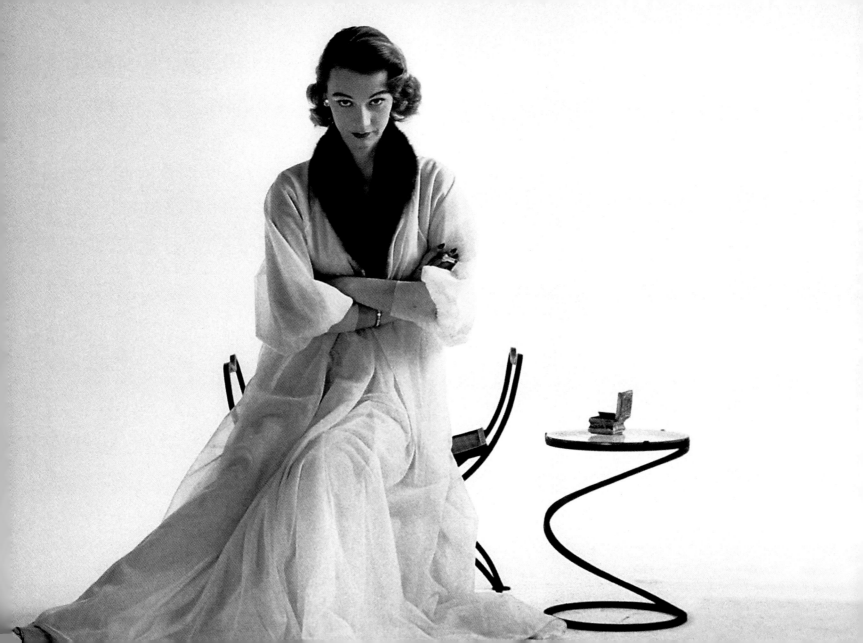

I don't like black and I don't like showing a lot of body. I like to be at ease in my clothes, which for me means loose and casual.

Agatha Ruiz de la Prada

Agatha Ruiz de la Prada is one of the few female Spanish designers. To date she has attracted attention with her colorful interior design (lamps) and her bright children's collections.
Model in a long green dress by Spanish designer AGATHA RUIZ DE LA PRADA during the second day of the Spring/Summer collection at Mexican Fashion Week 2004 in Mexico City.

1 2 3 4 5 6 7 8 9 10 11 12 13 14 15 16 17 18 19 20 21 22 23 24 25 26 27 28 29 30 31

AUGUST

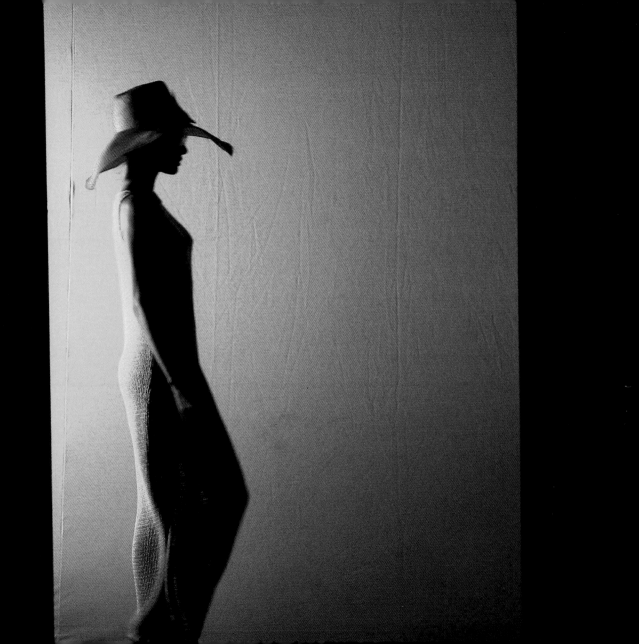

He was the very archetype of the new urban man who came from nowhere and for whom appearance was reality.

Elizabeth Wilson

During the 1960s, men's fashion emphasized the shoulders, tailoring slim jackets with patch pockets and styling narrow pant legs. The patterns were checked and orthodox—the thought behind them was less conventional.

Five men's styles from the International Fashion Council's fashion show Man '67 at the Europa Hotel, London. The suits are designed (from left to right) by IFC members in Spain, the U.S., Germany, Great Britain, and Spain.

1 2 3 4 5 6 7 8 9 10 11 12 13 14 15 16 17 18 19 20 21 22 23 24 25 26 27 28 **29** 30 31

AUGUST

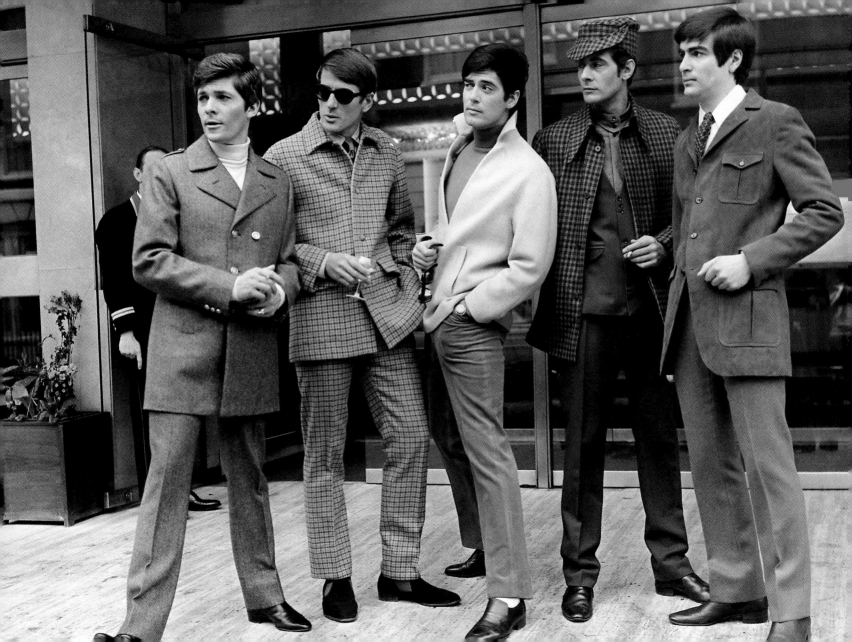

There is something very mean in her way of seduction. They are female Don Giovannis. They conquer people around them.

Emanuel Ungaro

"Kill couture!" shouted the youthful Emanuel Ungaro in the 1960s. Born in Aix-en-Provence in 1933, today the "Don Juan of designers," as Ungaro was known until his marriage to Italian Laura Fanfani, has long since arrived in the world of haute couture himself. Cathérine Deneuve and Sharon Stone appreciate the invariably elegant Ungaro style, which typically combines brilliant colors and exuberant patterns with generous cuts. The Norwegian designer Peter Dundas also follows the trend.

Creations made for the UNGARO collection by Norwegian designer PETER DUNDAS, presented at the Spring/Summer 2007 ready-to-wear collections in Paris.

1 2 3 4 5 6 7 8 9 10 11 12 13 14 15 16 17 18 19 20 21 22 23 24 25 26 27 28 29 30 31

AUGUST

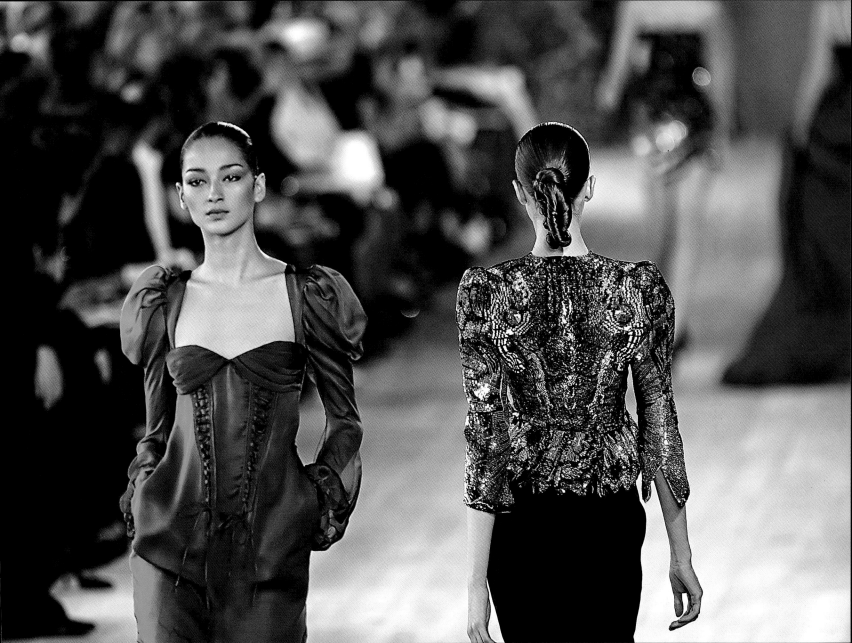

My school is the world, and my teacher is the people. It is very important not to stay cloistered in the office if you want to create. We have to go out in society to understand how people live and dress in their real lives.

Alberta Ferretti

The Italian fashion designer Alberta Ferretti (b. 1950) from Cattolica helped out in her mother's dressmaker's salon. At the age of 18 she opened her first fashion boutique and six years later presented her first collection. Ferretti became famous for her feminine clothes of unhemmed chiffon with playful appliqué. She is an astute businesswoman who holds a majority share in the Italian fashion house Moschino.
Models walk down the catwalk during the PHILOSOPHY BY ALBERTA FERRETTI fashion show as part of Milan Fashion Week Spring/Summer 2007.

1 2 3 4 5 6 7 8 9 10 11 12 13 14 15 16 17 18 19 20 21 22 23 24 25 26 27 28 29 30 31

AUGUST

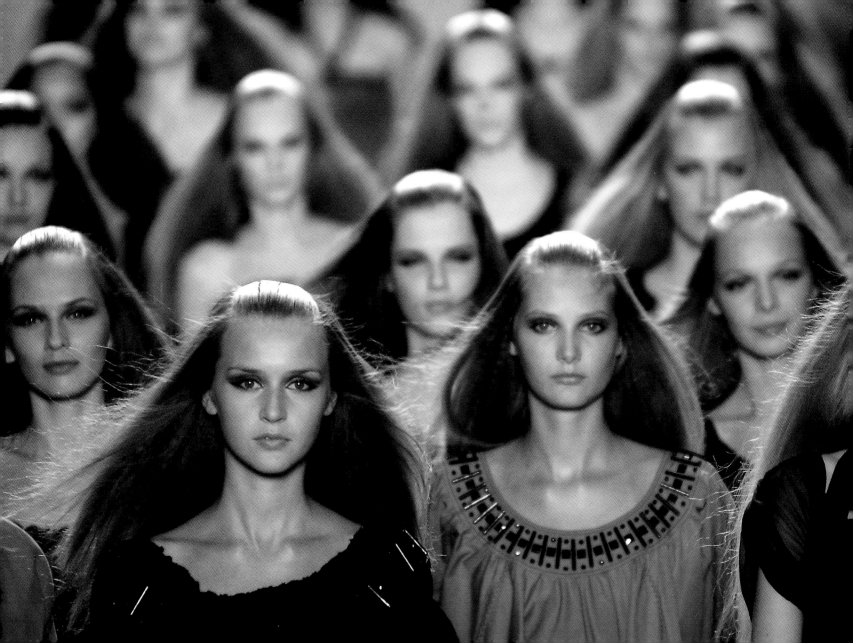

I don't believe that clothes can start
a revolution, but I do believe that
fashion is often a manifestation of
a sociological or political climate.

Tom Ford

Fascinating view! Young designers in particular take an increasingly radical perspective on fabric and cut. In this case we could re-interpret a comment by film comedian Groucho Marx to suit the world of fashion; he observed that people who see through women miss a great deal.

A model presents a creation by the young designers of KOEFIA, the international academy for haute couture and costume art, as part of the Fall/Winter 2006/07 women's collection, Rome, 2006.

1 2 3 4 5 6 7 8 9 10 11 12 13 14 15 16 17 18 19 20 21 22 23 24 25 26 27 28 29 30

SEPTEMBER

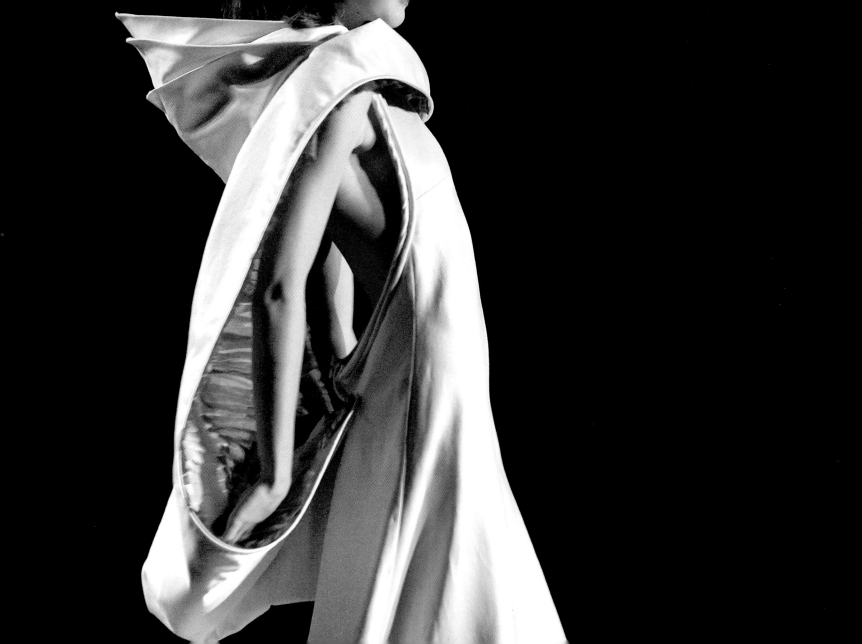

You have Nureyev, Picasso, Callas,
and Yves—for me these are the great
artistic figures of the 20th century.

Baroness Philippine de Rothschild

Like a scene from a film by Chabrol or Truffaut—the maestro YSL and his creation.
And in fact his muse and friend, the great actress Cathérine Deneuve, said about
the designer, "His day clothes help a woman to face a world of strangers. Saint
Laurent designs for women with a double life." Like Chabrol after all?
Designer YVES SAINT LAURENT, ex-wonder boy of DIOR, works with a fashion model
at his own fashion house in Paris, 1965.

1 2 3 4 5 6 7 8 9 10 11 12 13 14 15 16 17 18 19 20 21 22 23 24 25 26 27 28 29 30

SEPTEMBER

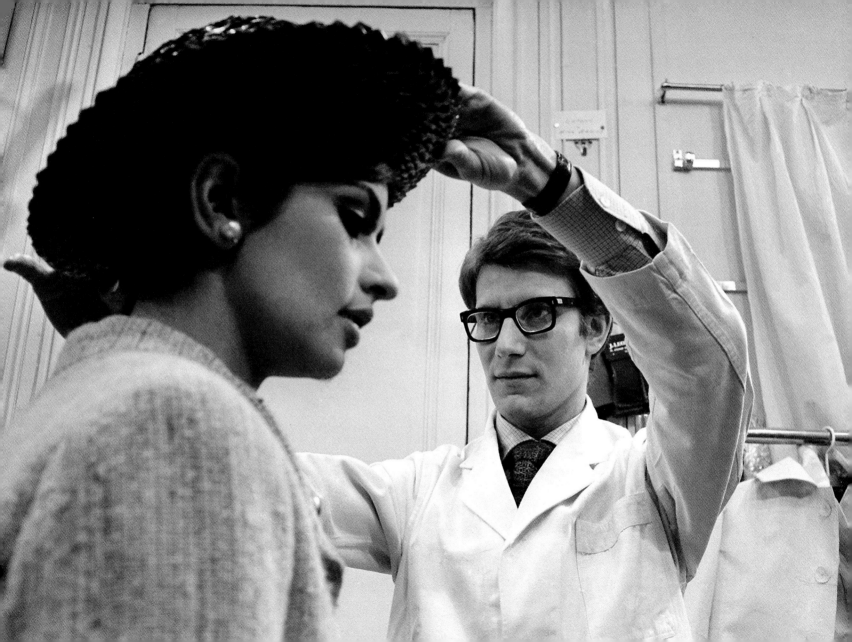

An epoch which calls everything into
question is one that opens new avenues
for people who want to experiment.
If everything is uncertain, then everything
is possible. And all these people bring
new energy, new ideas.

Hedi Slimane

Over the long haul he couldn't stand them—the provocations, that is, that
Hedi Slimane once devised as the designer of Dior's men's collection. For fashion
insiders, his departure in 2007 from the great Paris couture house did not come
as a complete surprise.
A model presents a creation by HEDI SLIMANE for DIOR during the
Spring/Summer 2006 ready-to-wear collection. Paris.

1 2 3 4 5 6 7 8 9 10 11 12 13 14 15 16 17 18 19 20 21 22 23 24 25 26 27 28 29 30

SEPTEMBER

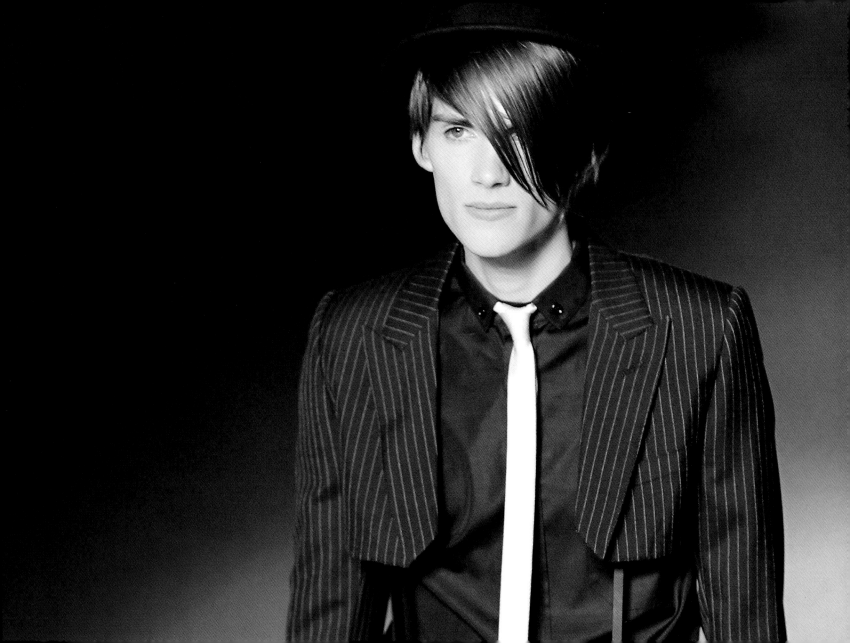

I was stigmatized by being a bridal
designer for a long time. I am amazed
I have been able to move beyond it.
I had really all but given up trying,
but I did it because it was my lifelong
dream.

Vera Wang

The bow on the dress—the woman as a gift. The ribbon seems to be saying:
Pull on me. Unpack me.
VERA WANG collection at Olympus Fashion Week 2004 in New York.

1 2 3 4 5 6 7 8 9 10 11 12 13 14 15 16 17 18 19 20 21 22 23 24 25 26 27 28 29 30

SEPTEMBER

I have but the simplest taste—I am always satisfied with the best.

Oscar Wilde

The chic of the early teens. As debutantes, daughters were dressed up like little ladies. They looked so decorous and chaste when they were introduced into society—with a wasp waist and wide, flared skirt.

Debutantes cross Piccadilly Street on their way to Hyde Park to pose for photographs before the annual Berkley Debutantes Ball in London.

1 2 3 4 **5** 6 7 8 9 10 11 12 13 14 15 16 17 18 19 20 21 22 23 24 25 26 27 28 29 30

SEPTEMBER

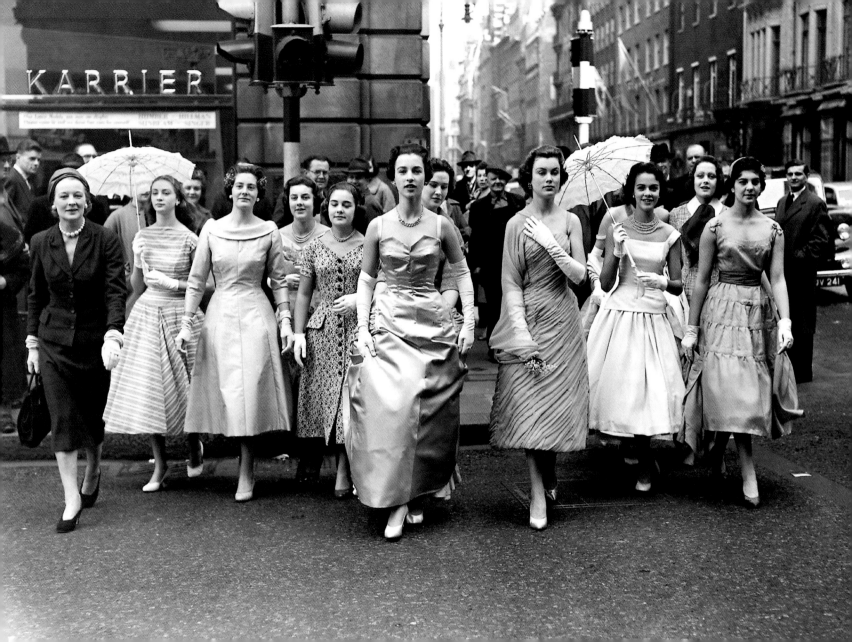

The Dolce & Gabbana style is neither taken off nor put on, but lives inside, around, and next to the person who looks for and chooses it.

Domenico Dolce and Stefano Gabbana

Domenico Dolce (b. 1958) and Stefano Gabbana (b. 1960) met in 1980 and have been working together ever since, maintaining a delicate equilibrium between elegance and provocation that has made them the darlings of Hollywood starlets, and at times the target of European governments.
A model shows off a creation by Italian fashion house DOLCE & GABBANA during the Spring/Summer 2007 women's collections in Milan.

1 2 3 4 5 6 7 8 9 10 11 12 13 14 15 16 17 18 19 20 21 22 23 24 25 26 27 28 29 30

SEPTEMBER

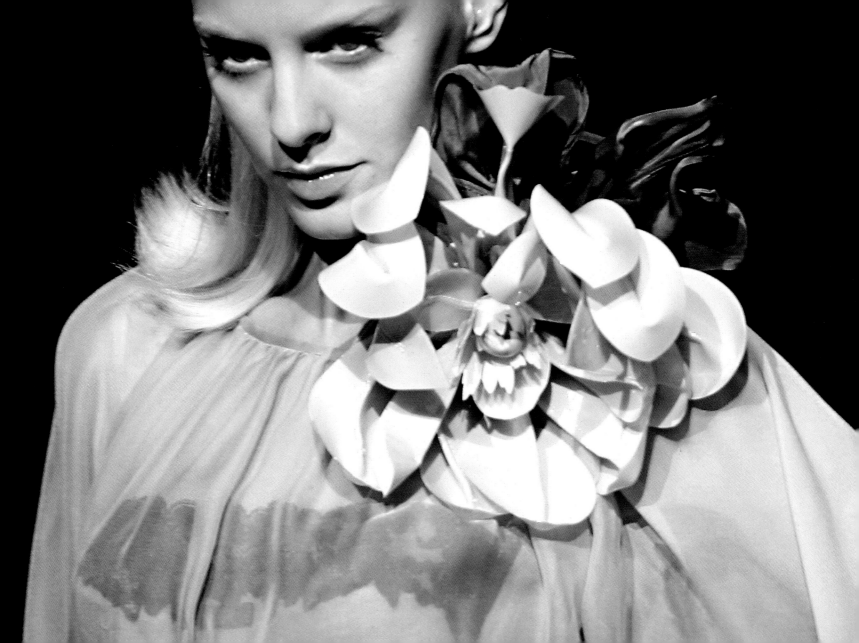

Charm is, in its essence, preferably
an element of femininity.

Die Dame, 1937

"No barking, poodle!"—Eve, the eternal woman, is trying to tempt you.
The fashion breed of the 1950s was also fairly obedient. Animals have often
served as live accessories for fashion-conscious women.
A model wearing a poodle petticoat talking to a real poodle, 1951.

1 2 3 4 5 6 **7** 8 9 10 11 12 13 14 15 16 17 18 19 20 21 22 23 24 25 26 27 28 29 30

SEPTEMBER

Fashion is a form of ugliness
so intolerable that we have
to alter it every six months.

Oscar Wilde

Poets and intellectuals sometimes make mistakes when judging fashion. Even dandy Oscar Wilde, known for his susceptibility to the aberrations of fashion. Models show clothes at the GHOST show at the British Fashion Council during London Fashion Week, 2005.

1 2 3 4 5 6 7 8 9 10 11 12 13 14 15 16 17 18 19 20 21 22 23 24 25 26 27 28 29 30

SEPTEMBER

Women's fashion shouldn't be
to pleasure a gay man, because
after (all) he has no use for her.

José Enrique Oña Selfa

Daedalus and Icarus proved it—wings alone are not always enough for takeoff. That applies especially to the world of fashion, even with the lingerie fashion of Victoria's Secret. An erotic forced landing might well be the result of this winged outfit—wings are awkward when it comes to the game of love.
Models at the VICTORIA'S SECRET fashion show descend to the runway, New York, 2001.

1 2 3 4 5 6 7 8 9 10 11 12 13 14 15 16 17 18 19 20 21 22 23 24 25 26 27 28 29 30

SEPTEMBER

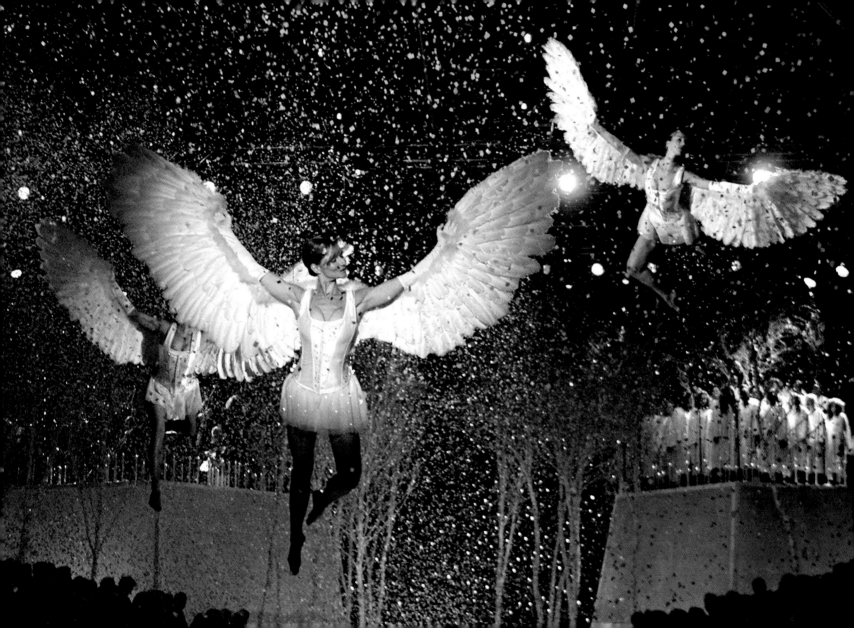

More than a refuge for people with good taste and the means to pay for it, couture is the ultimate fantasy trip. In couture, you get the silence of hidden seams and impeccable craft, but you should also get the mind-expanding experience of imagination. And that's what made Mr. Gaultier's Madame-meets-Ming express a great ride.

Cathy Horyn, *The New York Times*, 2001

He has often proved it. In his love of mixed styles the French designer Jean Paul Gaultier—perpetually polishing up his bad-boy-image—is capable of anything. This femme fatale asiatique demonstrates it yet again.

A model presents an ensemble for JEAN PAUL GAULTIER for the Fall/Winter 2001/02 haute couture collections in Paris.

1 2 3 4 5 6 7 8 9 **10** 11 12 13 14 15 16 17 18 19 20 21 22 23 24 25 26 27 28 29 30

SEPTEMBER

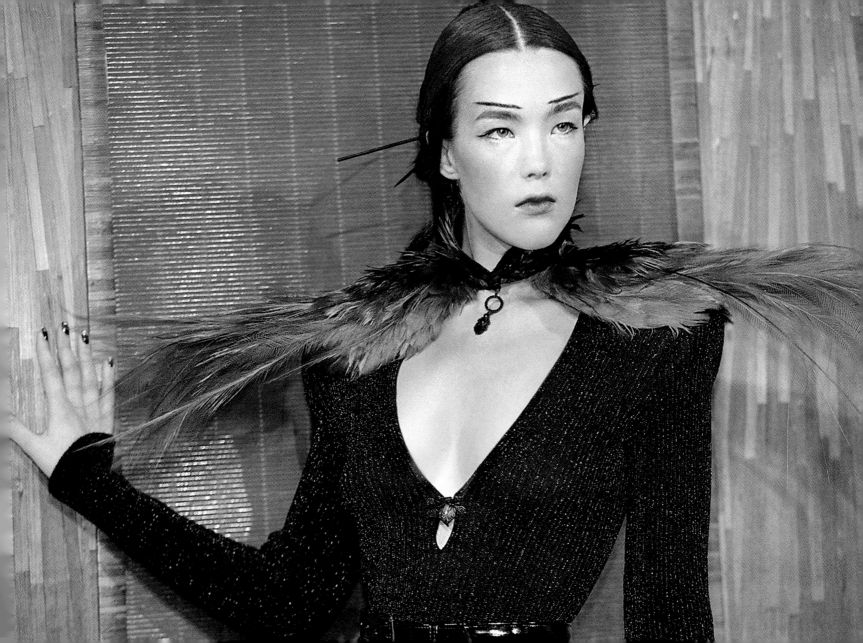

In all of nature there are no apprentices,
only masterpieces.

Johann Peter Hebel

Nature's perfection. The pearl. The tear.
A Polynesian black pearl necklace rests on an oyster shell.

1 2 3 4 5 6 7 8 9 10 **11** 12 13 14 15 16 17 18 19 20 21 22 23 24 25 26 27 28 29 30

SEPTEMBER

I guess I'm a brand. People believe in me,
I do have a following and a look, and
if there needs to be a package, well I'm
a pink package.

Betsey Johnson

From attics, flea markets, or out of Granny's wardrobe—fashion likes to quote the
hippie chick of the early 1970s. Of course the look includes a prettily embroidered
knitted cardigan and striped stockings.
Designer BETSEY JOHNSON walks the runway during Olympus Fashion Week in
New York, February 2005.

1 2 3 4 5 6 7 8 9 10 11 **12** 13 14 15 16 17 18 19 20 21 22 23 24 25 26 27 28 29 30

SEPTEMBER

Fashion is at once both caterpillar and butterfly. Be a caterpillar by day and a butterfly at night… there must be dresses that crawl and dresses that fly.

Coco Chanel

Madame Butterfly—or an insectophobe's variation of Hitchcock's *The Birds*? A truly imaginative and highly decorative inspiration by designer Alexander McQueen.
A butterfly-ornamented headpiece during the ALEXANDER MCQUEEN Spring/Summer 2008 ready-to-wear show at Paris Fashion Week.

1 2 3 4 5 6 7 8 9 10 11 12 **13** 14 15 16 17 18 19 20 21 22 23 24 25 26 27 28 29 30

SEPTEMBER

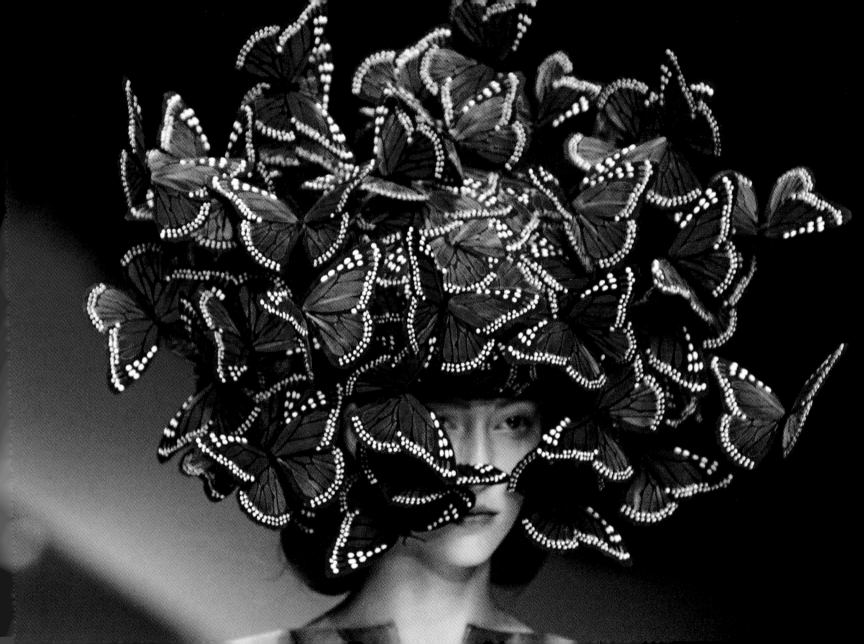

I'm not a social person. Not that I'm not at ease. I'm pretty good, but it bores me. Not the people, but the whole thing. What for? It's not very productive. I only want to do what I have to do: fashion, photography, books. And that's all.

Karl Lagerfeld

"He" can wear shirts like that! And gloves like that! And a ponytail! Yes, even in the dark we forgive him for wearing his sunglasses. For "he" is Karl Lagerfeld, and responsible for the designs of couture house Chanel.
German designer KARL LAGERFELD arrives at the end of his CHANEL Spring/Summer 2007 haute couture show in Paris.

1 2 3 4 5 6 7 8 9 10 11 12 13 **14** 15 16 17 18 19 20 21 22 23 24 25 26 27 28 29 30

SEPTEMBER

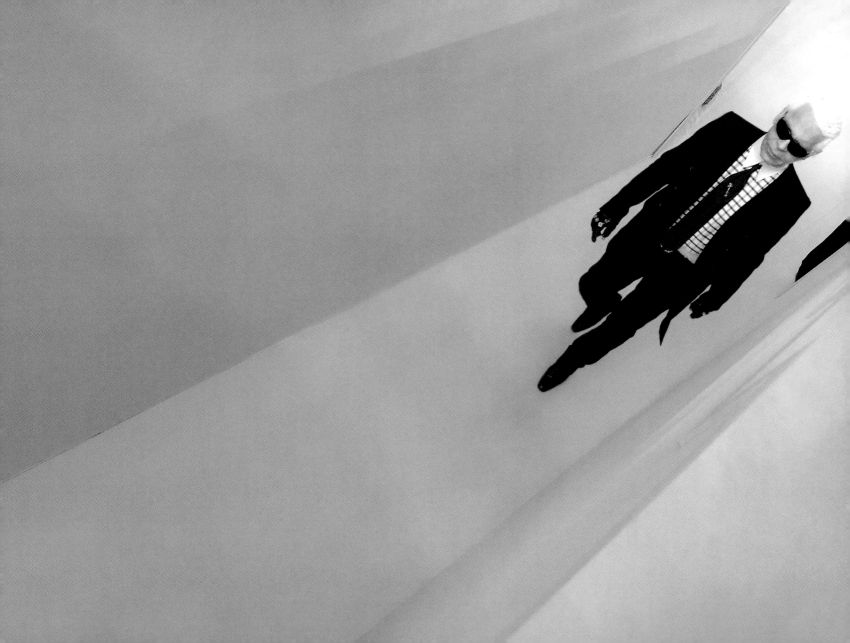

In this sea of banality, distinction and elegance of dress is of more value today than it ever was before.

Vivienne Westwood

The verdict—magnificent. The great British designer Vivienne Westwood understands better than anyone how to mix punk with Louis XIV in the fashion world, apparently rummaging through Marie Antoinette's wardrobe, then flirting afterwards with courtesans.

Theatrical creations by British designer VIVENNE WESTWOOD on display at an exhibition at Palazzo Reale in Milan, 2007.

1 2 3 4 5 6 7 8 9 10 11 12 13 14 15 16 17 18 19 20 21 22 23 24 25 26 27 28 29 30

SEPTEMBER

I have often made reference to the
"Ferré lexicon," that is, the consistent set
of signs that connote my style and
show up clearly in all my collections.

Gianfranco Ferré

Business as usual? If only that were so! Unfortunately, reality doesn't look the way
it does at Ferré. The reality is that men at the office and on the 8 o'clock flight
still wear badly-fitting suits and jackets.
Models walk the runway at the GIANFRANCO FERRÉ show during the Spring/
Summer 2006 Milan Menswear Week.

1 2 3 4 5 6 7 8 9 10 11 12 13 14 15 16 17 18 19 20 21 22 23 24 25 26 27 28 29 30

SEPTEMBER

Fashion is not about what works
for men and what works for women.
It's about a look of the moment.

Tom Ford

A dream in white—a dream by Gucci. Dreams are the Sundays of thought.
Or of fashion?
A model wears an outfit from the GUCCI Fall/Winter 2003/04 collection in Milan.

1 2 3 4 5 6 7 8 9 10 11 12 13 14 15 16 **17** 18 19 20 21 22 23 24 25 26 27 28 29 30

SEPTEMBER

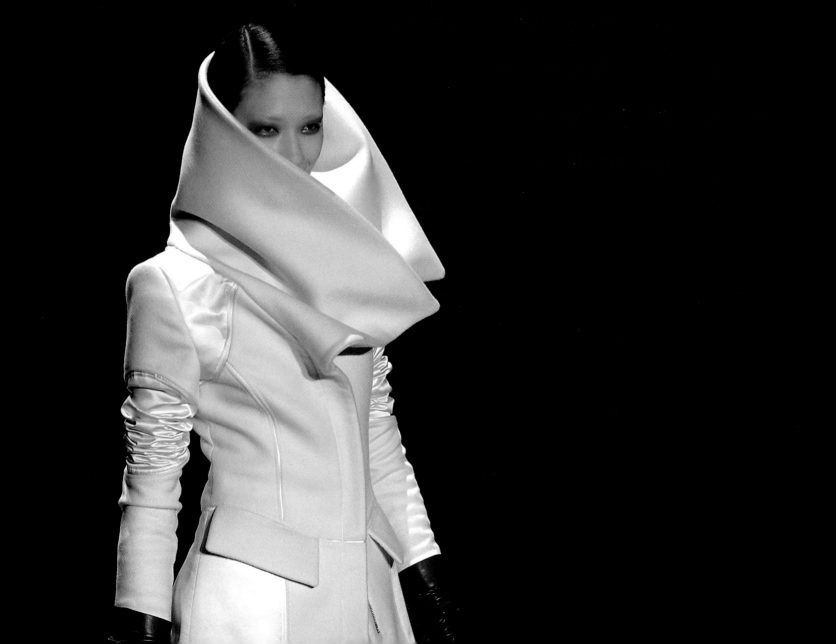

Women have the whip-hand now.
They feel they can express themselves,
through their clothes, more forcefully.

Jasper Conran

If we were to make confetti of all the price tags and brand labels in the world—
the sun would probably be eclipsed for months and life on Earth would end.
British model LILY COLE stands in a hall of confetti at the Fall/Winter 2007/08
collection show by JASPER CONRAN at London Fashion Week.

1 2 3 4 5 6 7 8 9 10 11 12 13 14 15 16 17 **18** 19 20 21 22 23 24 25 26 27 28 29 30

SEPTEMBER

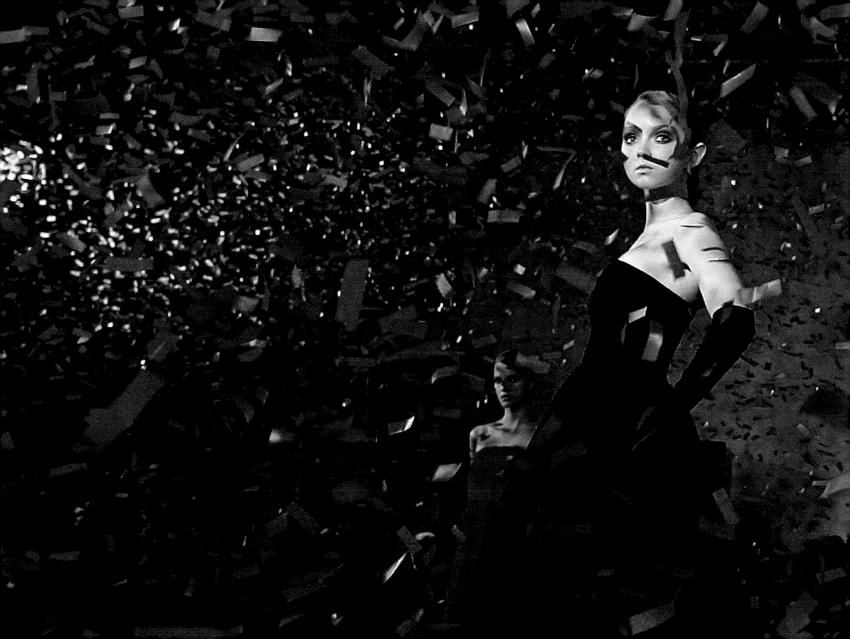

The clothes I prefer are those I'm inventing for a life that doesn't yet exist—the world of tomorrow.

Pierre Cardin

Severe, matter-of-fact, futuristic. The fashion of Pierre Cardin, born of the spirit of the late 1960s. Over-the-knee boots have sadly never returned in "this" form (low heels and closely fitting at the back of the knee)—not even on the legs of Julia Roberts in *Pretty Woman*.
Models wearing dresses and boots by PIERRE CARDIN, 1968.

1 2 3 4 5 6 7 8 9 10 11 12 13 14 15 16 17 18 **19** 20 21 22 23 24 25 26 27 28 29 30

SEPTEMBER

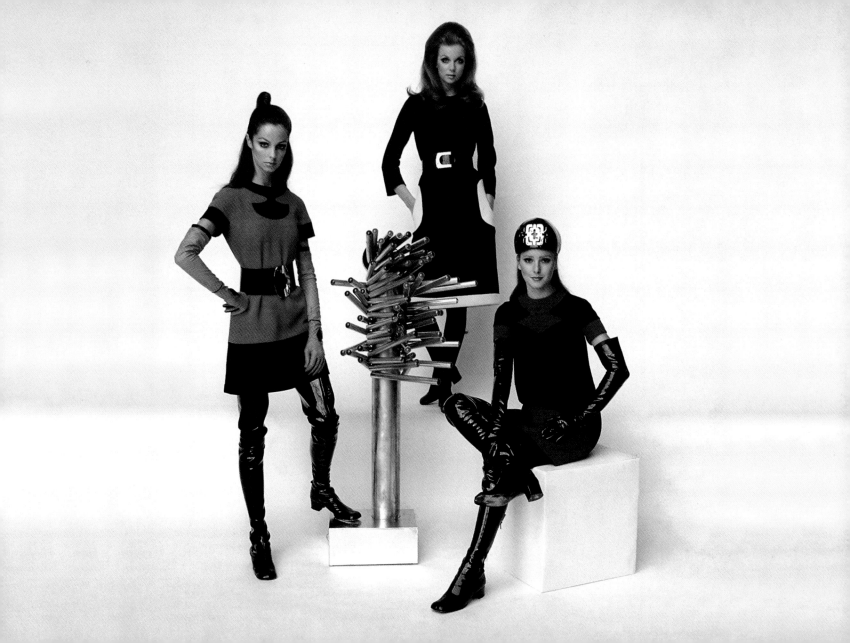

Fashion to me is like walking a tightrope,
where you risk falling off into the ridicu-
lous, but if you can stay on that tightrope
you can achieve a triumph.

Vivienne Westwood

No, fashionistas are not terrorists. Really?
Close-up of a t-shirt by British designer VIVIENNE WESTWOOD during the
Spring/Summer 2006 ready-to-wear collections in Paris.

1 2 3 4 5 6 7 8 9 10 11 12 13 14 15 16 17 18 19 20 21 22 23 24 25 26 27 28 29 30

SEPTEMBER

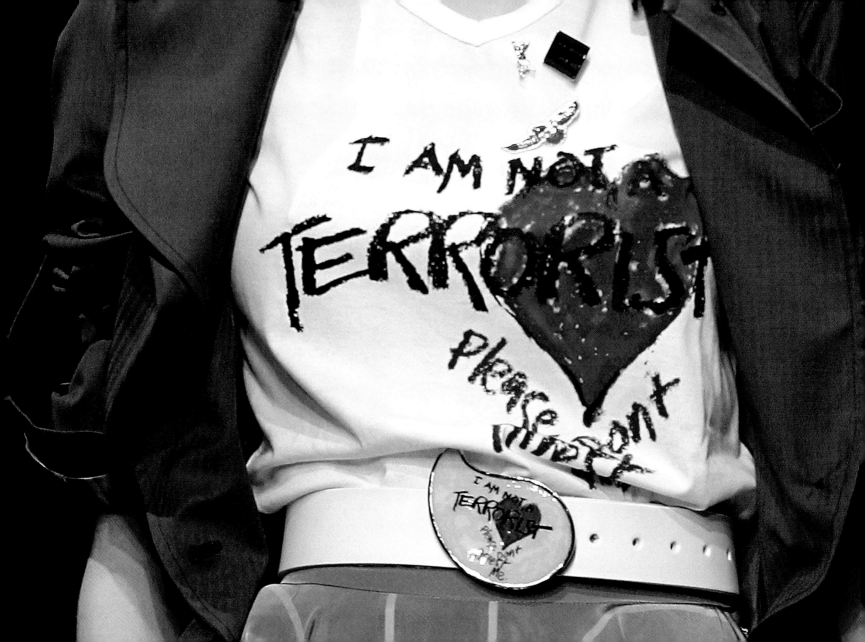

I have heard with admiring submission
the experience of the lady who declared
that the sense of being perfectly well-
dressed gives a feeling of inward tranquili-
ty which religion is powerless to bestow.

Ralph Waldo Emerson

Only in black! "The little black dress" has not been out of fashion since Coco
Chanel invented it. It was—and still is—the "safe bet" for every woman in every
social situation—extremely elegant but never too conspicuous. Today it is present
in every designer collection—and in the wardrobe of every well-dressed, intelli-
gent woman.
Designer ARNOLD SCAASI fits an elegant made-to-order lace cocktail dress on
his favorite model, CONNIE COOK, at his studio in New York, 1990.

1 2 3 4 5 6 7 8 9 10 11 12 13 14 15 16 17 18 19 20 21 22 23 24 25 26 27 28 29 30

SEPTEMBER

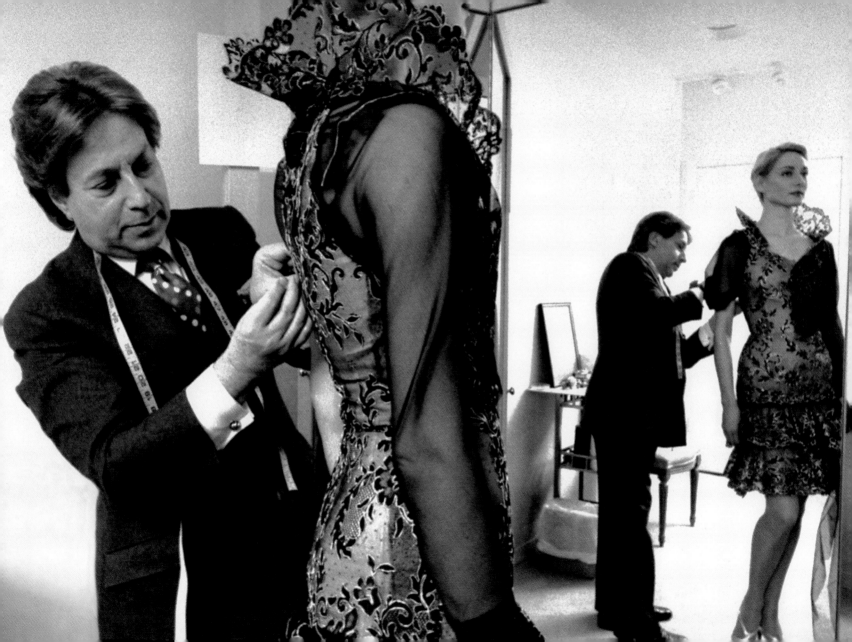

Women are a fascinatingly wilful sex.
Every woman is a rebel, and usually
in wild revolt against herself.

Oscar Wilde

The Mexican actress Lupe Vélez (1908–1944) achieved what very few others managed, the transition from silent to talking films. The diva was regarded as arrogant and extravagant; she was the wife of Johnny Weissmüller and the mistress of Gary Cooper. Madame Vélez was dissatisfied with her fashion couturiers and often designed her own theatrical wardrobe. She died of an overdose of prescription drugs.
LUPE VÉLEZ reclines in a chair wearing an evening gown which she designed, 1939.

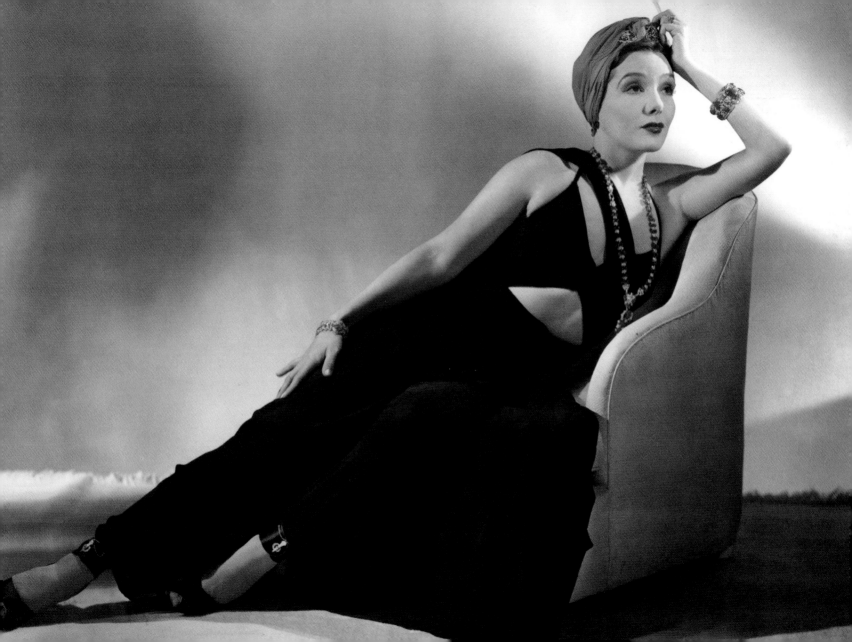

Some people dream of having a big
swimming pool—with me, it's closets.

Audrey Hepburn

The booming markets in the Far East guarantee increasing sales figures, especially
for the European luxury and fashion industries. Lanvin, the famous Paris couture
house, is expanding into China. It is not alone in doing so.
Presentation of the LANVIN 2005 collection at a fashion show in Beijing.

1 2 3 4 5 6 7 8 9 10 11 12 13 14 15 16 17 18 19 20 21 22 23 24 25 26 27 28 29 30

SEPTEMBER

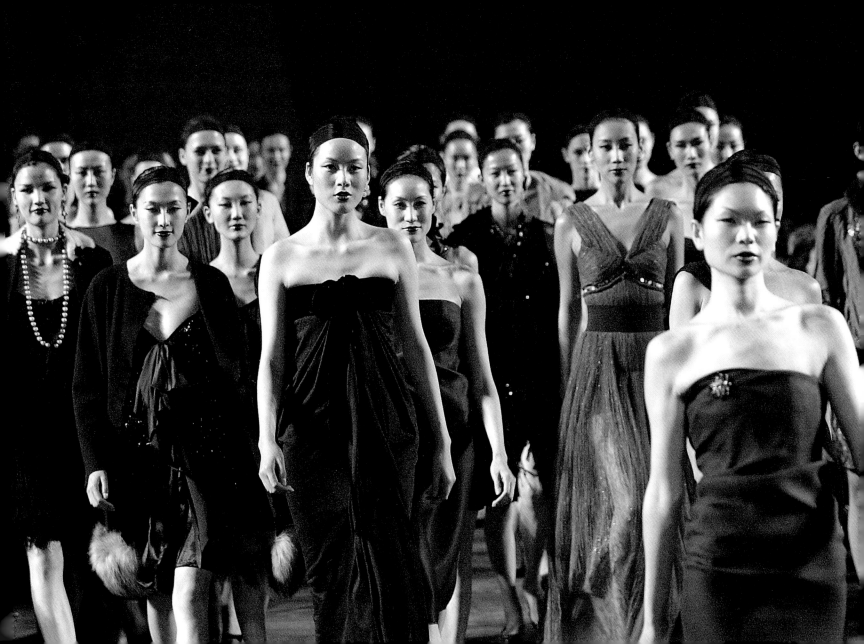

I love old things. Modern things are so cold. I need things that have lived.

Barbara Hulanicki, founder of Biba

Typical of the 1950s—a woman never went out without a hat. Hats always had a small crown, even if the brim was wide and the wearer's face was surrounded by flowers, veils, or feathers. The effect was the filtered look.

A woman in a wide-brimmed hat with veil, ca. 1955.

1 2 3 4 5 6 7 8 9 10 11 12 13 14 15 16 17 18 19 20 21 22 23 **24** 25 26 27 28 29 30

SEPTEMBER

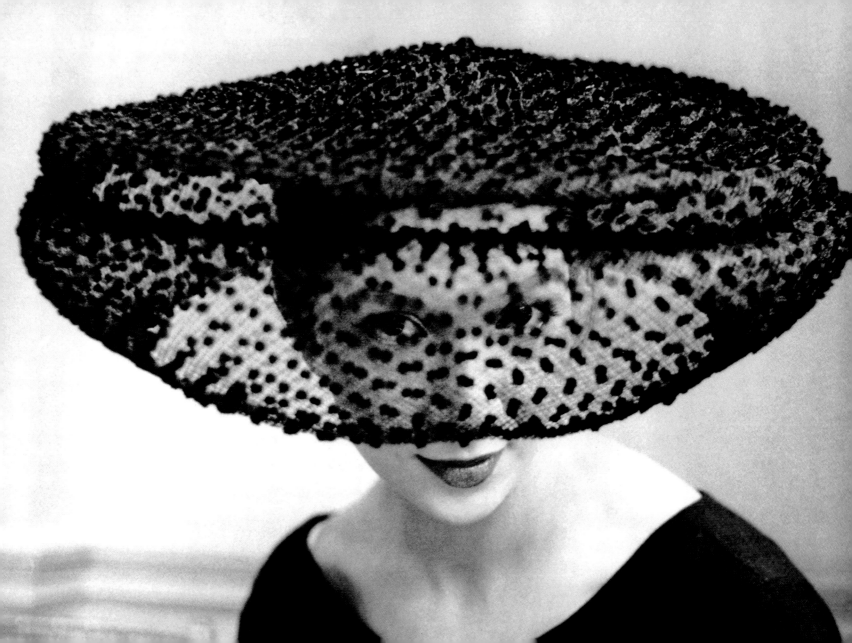

He's really just the epitome of
American style and glamour.

Victoria Beckham, on Oscar de la Renta

Pretty to look at. Women seem to always put their shoes neatly and tidily beside each other. Men are careless about such details—as they unfortunately are in many other aspects of fashion.
A pair of shoes backstage at the OSCAR DE LA RENTA Spring 2006 show during Olympus Fashion Week in New York.

1 2 3 4 5 6 7 8 9 10 11 12 13 14 15 16 17 18 19 20 21 22 23 24 25 26 27 28 29 30

SEPTEMBER

If you can't be elegant,
at least be extravagant!

Franco Moschino

Pleated fabric (Fr.: plissée) proves it—pleats are pretty when they are intentional.
When it is a question of the "right" pleats.
A model presents a creation by Italian fashion house MOSCHINO during
the Fall/Winter 2006/07 ready-to-wear collections in Milan.

1 2 3 4 5 6 7 8 9 10 11 12 13 14 15 16 17 18 19 20 21 22 23 24 25 26 27 28 29 30

SEPTEMBER

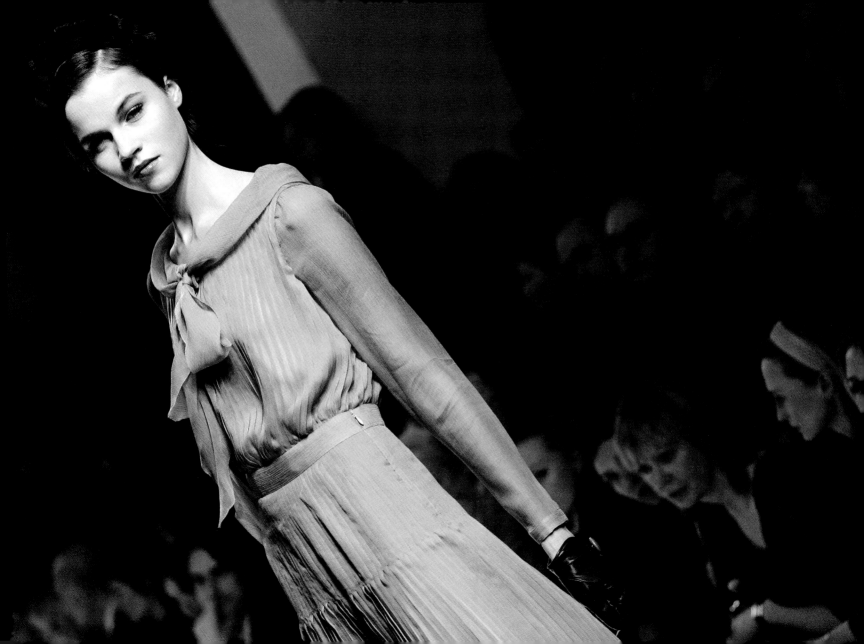

The essence of fashion is its
changeability. It satisfies the curiosity,
the human drive towards what is new.

Karl Lagerfeld

Salvatore Ferragamo (1898–1960) was an Italian shoe designer. His name adorns
the company to this day. He began his career in the 1920s in California, where
he even designed shoes for the film industry. Today the Ferragamo label is
synonymous with exclusive leather accessories, shoes, and bags.
A model wears a handbag from the FERRAGAMO Spring/Summer 2006 women's
collection at Milan Fashion Week.

1 2 3 4 5 6 7 8 9 10 11 12 13 14 15 16 17 18 19 20 21 22 23 24 25 26 27 28 29 30

SEPTEMBER

I believe the bodystocking or
a form of it will be the main element
of fashions of the future.

Jacques Fonteray

The most versatile woman of our times—Madonna. For the video of her song
"Hung Up," the pop chameleon quoted not only the musical style of the 1970s,
but also the fashion of the era—blow-dried hair for a night at the disco, oversized
sunglasses, tight-fitting leather jacket. The unadulterated sex style of the seventies.
MADONNA poses for a portrait backstage at the 12th annual MTV Europe Music
Awards 2005 in Lisbon.

1 2 3 4 5 6 7 8 9 10 11 12 13 14 15 16 17 18 19 20 21 22 23 24 25 26 27 **28** 29 30

SEPTEMBER

Elegance is not achieved by being dressed according to trends, but it is a way in which one presents oneself to others.

Gianfranco Ferré

The Shadow Man? Designers like Ferré (or Versace) often select imaginative prints for their shirt and blouse designs.
Shirt with silhouette design by GIANFRANCO FERRÉ as part of the Spring/Summer 2007 men's collection, Milan.

1 2 3 4 5 6 7 8 9 10 11 12 13 14 15 16 17 18 19 20 21 22 23 24 25 26 27 28 **29** 30

SEPTEMBER

Sexy has a lot to do with intelligence and self confidence. My generation doesn't need a very short hemline to prove they're sexy. You can look sexy just by baring your shoulder rather than exposing the whole lot.

Frida Giannini, Artistic Director of Gucci

"Elegance is refusal," said Coco Chanel. All great fashion designers obey this intelligent comment. So, this evening dress by Gucci is only as elegant as it is because it refuses all decoration, reaching its full effect through its sophisticated cut.

A model presents a creation by GUCCI at the Spring/Summer 2006 women's collection show, Milan.

1 2 3 4 5 6 7 8 9 10 11 12 13 14 15 16 17 18 19 20 21 22 23 24 25 26 27 28 29 30

SEPTEMBER

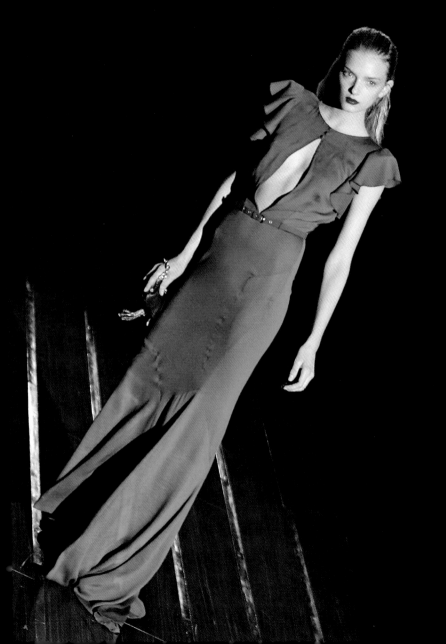

(Women) who have self-confidence
and are sure about their power will find
clothes in which they recognize their
own personality.

Christian Lacroix

"If there is a couturier who embodies the spirit of the 1980s, then it has to be
Christian Lacroix," observed Charlotte Seeling, fashion journalist and former head
of German *Vogue*. "Nobody drew on unlimited resources as he did, no one else
presented the whole wealth of his baroque fantasy so artistically in an orgy of
colors and patterns, velvet and silk, lace and embroidery, frills and drapes, deco-
rations and jewels." No one has ever described the Lacroix style more accurately.
A creation by CHRISTIAN LACROIX worn by a model at the Spring/Summer 2006
ready-to-wear collections in Paris.

1 2 3 4 5 6 7 8 9 10 11 12 13 14 15 16 17 18 19 20 21 22 23 24 25 26 27 28 29 30 31

OCTOBER

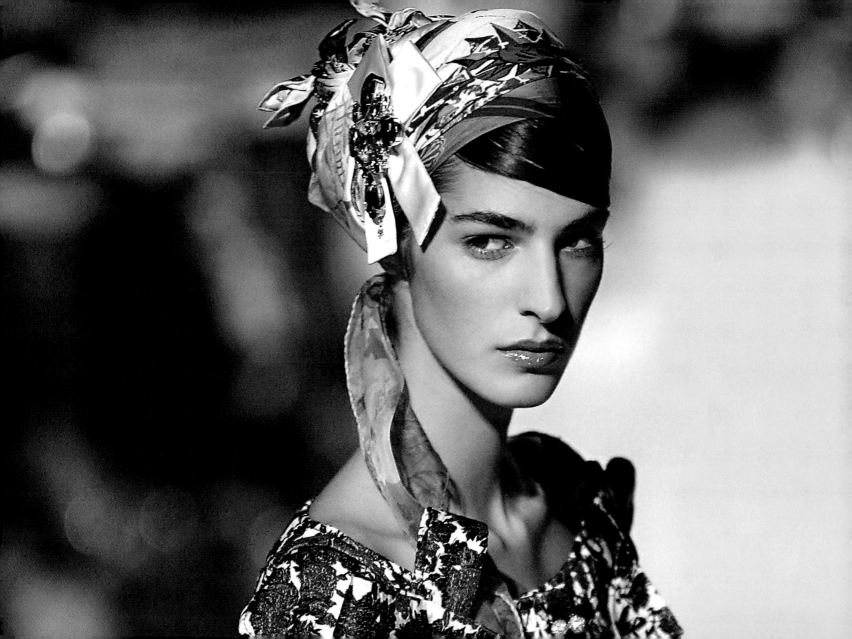

I like fashion to go down into the
street, but I can't accept that it should
originate there.

Coco Chanel

Without a dressmaker's model, known in technical jargon as a "stockman,"
nothing is possible in a fashion designer's atelier. The stockman has hardly
changed to this day, except that the measurements are catered to the era's
ideal of beauty. The stockman's waist has shrunk from 23 inches (58cm) in Dior's
day, to 21 inches (53cm) today.
French designer JACQUELINE DE RIBES works with assistants in her studio, 1985.

1 2 3 4 5 6 7 8 9 10 11 12 13 14 15 16 17 18 19 20 21 22 23 24 25 26 27 28 29 30 31

OCTOBER

And just when I think I hate fashion,
I hate clothes—I'm seized by this crazy
thing that I have to do.

Isaac Mizrahi

The decorative effect which the appliqué lace, leather, or diamanté achieve is sometimes so powerful that any additional jewelry would be too much. Something stylish women know.
Detail from the ISAAC MIZRAHI Fall 2007 collection at Mercedes-Benz Fashion Week in New York.

3
1 2 3 4 5 6 7 8 9 10 11 12 13 14 15 16 17 18 19 20 21 22 23 24 25 26 27 28 29 30 31

OCTOBER

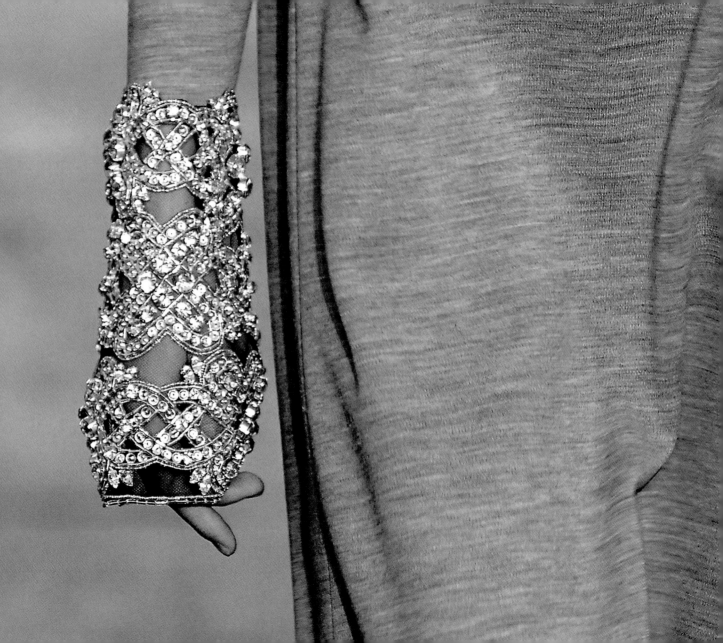

Models are there to look like
mannequins, not like real people.
Art and illusion are supposed to
be fantasy.

Grace Jones

The Diesel brand was founded in 1978 by Renzo Rosso. The company motto is
"Diesel for Successful Living." The house design has established itself worldwide as
streetwear for the everyday, and the countless licenses for watches, spectacles,
bags, and accessories contribute to the way the Diesel label crosses all frontiers.
Grace Jones's outfit is seen much less often on the street. A pity really.
Singer GRACE JONES walks the runway at the DIESEL Fall 2006 fashion show at the
Hammerstein Ballroom in New York, 2006.

1 2 3 4 5 6 7 8 9 10 11 12 13 14 15 16 17 18 19 20 21 22 23 24 25 26 27 28 29 30 31

OCTOBER

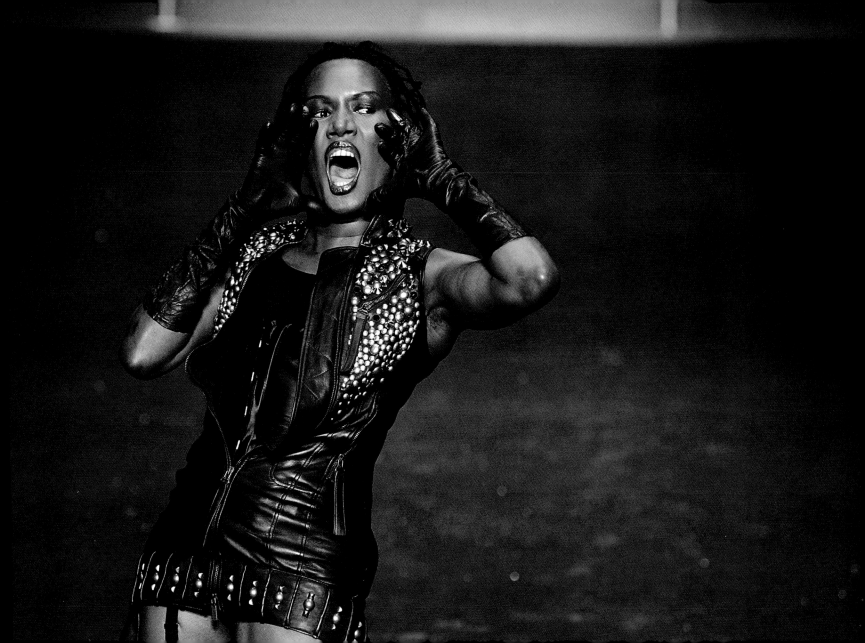

She was like a general, obsessed
by the desire to win.

Maurice Sachs

Coco Chanel, the greatest career women in the world of fashion. But CC created
something besides fashion—style.
COCO CHANEL, legendary French couturière, Paris, 1936.

1 2 3 4 **5** 6 7 8 9 10 11 12 13 14 15 16 17 18 19 20 21 22 23 24 25 26 27 28 29 30 31

OCTOBER

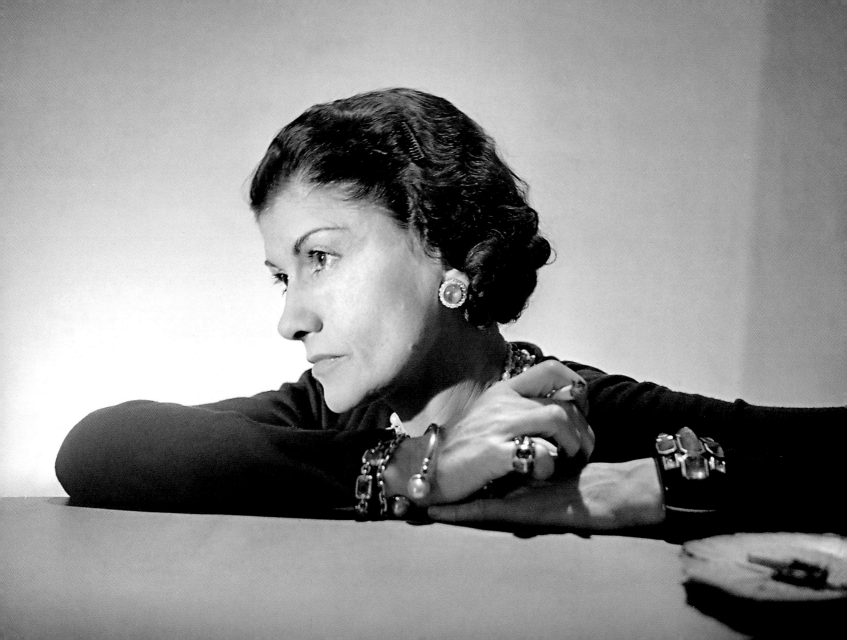

A businesswoman should be able to walk into any high-level meeting and feel good about herself. That is what I always keep in mind.

Mary Ann Restivo

In their severe suits, the businesswomen of the 1980s did not stand like that for long on the streets of New York. They had no time for that. They found their place in the high-rise offices. They pursue their careers there. After all, businesswomen think as clearly and objectively as their fashion looks.
Three models present designs by MARY ANN RESTIVO, New York, 1987.

1 2 3 4 5 **6** 7 8 9 10 11 12 13 14 15 16 17 18 19 20 21 22 23 24 25 26 27 28 29 30 31

OCTOBER

I have never believed in the philosophy
of the outfit. I have always believed in
one beautiful piece and then you build
around it with, let's say, something
secondhand.

Stella McCartney

Stella McCartney (b. 1971) is Paul McCartney's daughter. After studying fashion
she became the head designer of Chloé in 1997 and left the company in 2001
in order to create fashion under her own label. Since 2004 she has designed a
collection for Adidas and for the Paris department store Printemps. In 2005/2006,
the Stella McCartney collections could even be bought in select branches of
H&M. McCartney is a keen animal rights campaigner and vegetarian. She calls
her fashion "vegan."
British designer STELLA MCCARTNEY arrives at the ADIDAS by Stella McCartney LFW
Spring/Summer 2008 show during London Fashion Week, 2007.

1 2 3 4 5 6 7 8 9 10 11 12 13 14 15 16 17 18 19 20 21 22 23 24 25 26 27 28 29 30 31

OCTOBER

Every uniform corrupts one's character.

Max Frisch

She is also described as an icon of style—Kate Moss. In 1988, at the age of just 14, she was "discovered" by the founder of the Storm model agency at JFK Airport in New York. In the same year she signed a contract to model for Calvin Klein. Not even the negative headlines about her lifestyle have damaged her long-lasting career.

A make-up artist applies powder to the face of model KATE MOSS before a photo shoot, 1993.

1 2 3 4 5 6 7 **8** 9 10 11 12 13 14 15 16 17 18 19 20 21 22 23 24 25 26 27 28 29 30 31

OCTOBER

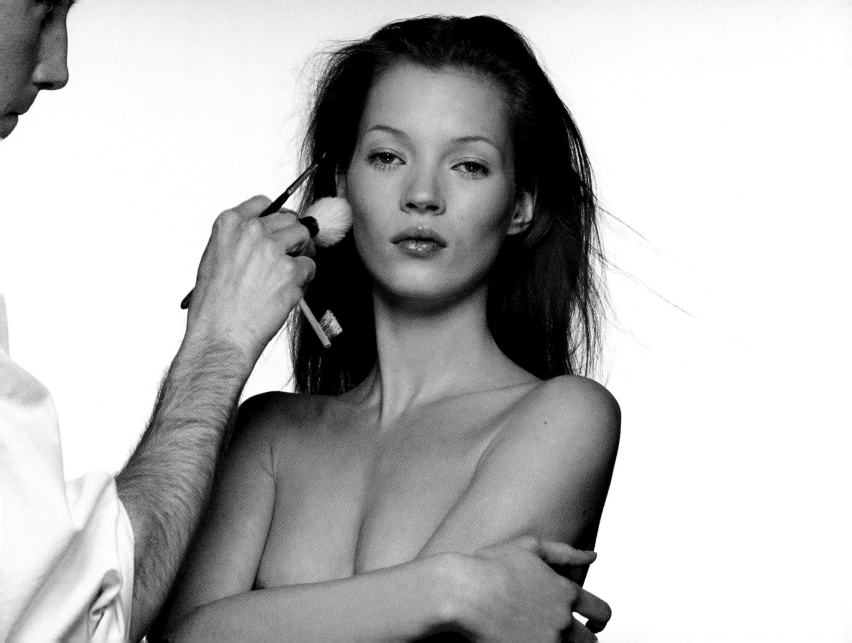

About half my designs are controlled
fantasy, 15 percent are total madness,
and the rest are bread-and-butter
designs.

Manolo Blahnik

The brushstroke that brought into being a dream for both sexes—women
dream of Manolo Blahnik shoes and men dream of women who are wearing
Manolo Blahnik shoes.
British shoe designer MANOLO BLAHNIK working on sketches for new designs in
his office, London, 1988.

1 2 3 4 5 6 7 8 9 10 11 12 13 14 15 16 17 18 19 20 21 22 23 24 25 26 27 28 29 30 31

OCTOBER

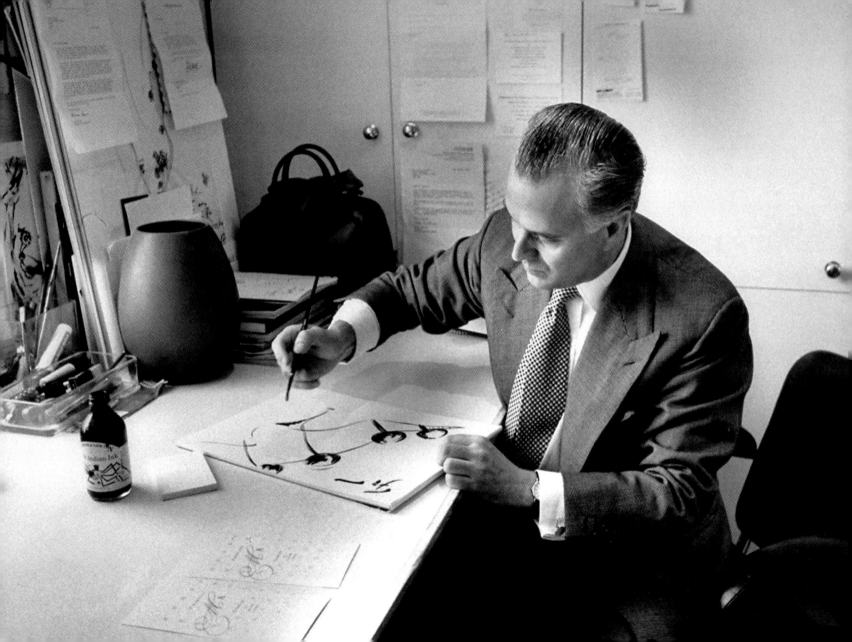

I see it as my responsibility to thoroughly clear out haute couture, to give it a new freshness and ease.

John Galliano

Don't worry—the snake is not real. Just printed silk. Or is it real after all? Fashion plays with illusion.

A model presents a creation by JOHN GALLIANO for DIOR at the Spring/Summer 2004 haute couture week in Paris.

1 2 3 4 5 6 7 8 9 **10** 11 12 13 14 15 16 17 18 19 20 21 22 23 24 25 26 27 28 29 30 31

OCTOBER

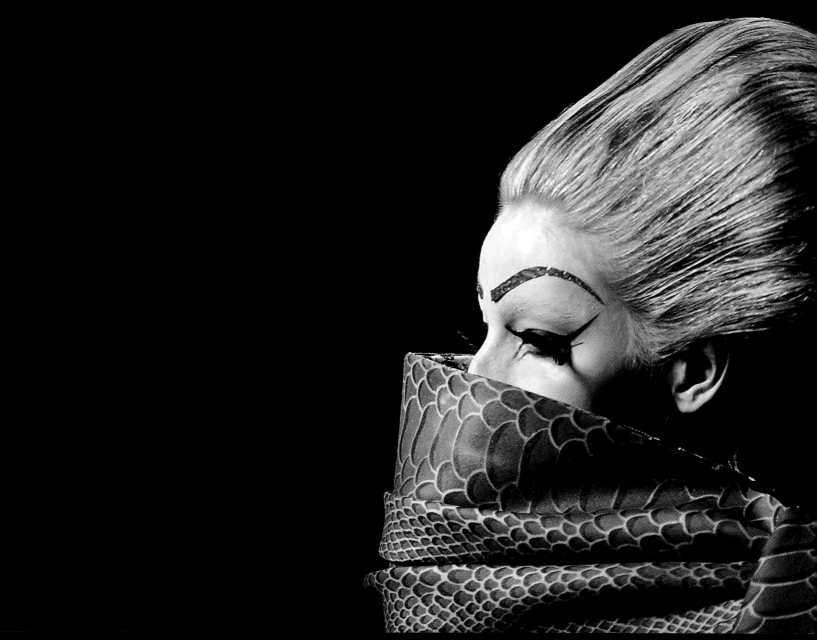

The secret of my success isn't hard to
fathom. I'm an OK designer and I'm
an OK businessman. A lot of people in
this profession forget the second half
of the equation. They think VAT stands
for vodka and tonic.

Paul Smith

Paul Smith (b. 1946) was dubbed a knight by the Queen. He is one of the United
Kingdom's most successful fashion designers. Both economically and creatively,
Sir Paul has a very good nose for wearable—in other words, sellable—fashion.
These light-as-air, romantic summer dresses prove it.
Models walk down the catwalk at the end of the PAUL SMITH women's fashion
show at London Fashion Week Spring/Summer 2006.

1 2 3 4 5 6 7 8 9 10 11 12 13 14 15 16 17 18 19 20 21 22 23 24 25 26 27 28 29 30 31

OCTOBER

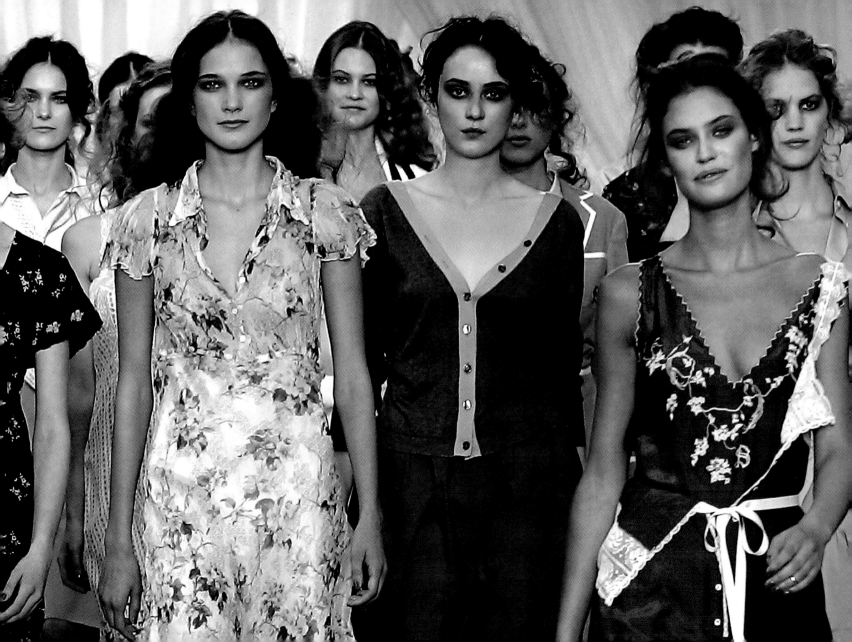

Sex is a bad thing because it rumples
the clothes.

Jacqueline Kennedy Onassis

After the roar of the 1920s, fashion lived a decade of understated elegance.
The Parisian couture house Lanvin demonstrated it with breathtakingly beautiful,
simple designs.
Austere elegance—model in a felt hat with brooch by French designer
JEANNE LANVIN, Paris, 1937.

1 2 3 4 5 6 7 8 9 10 11 12 13 14 15 16 17 18 19 20 21 22 23 24 25 26 27 28 29 30 31

OCTOBER

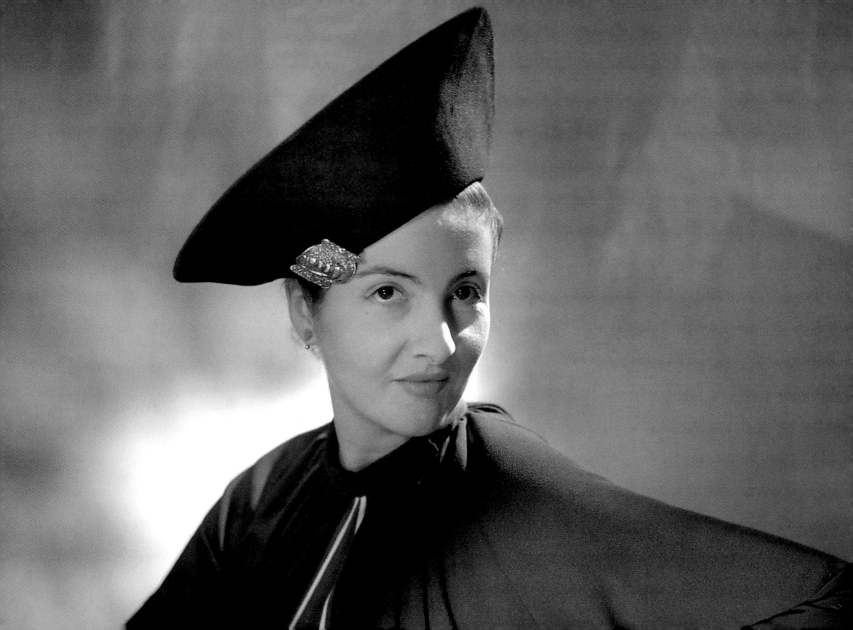

I was used to wearing finer clothes, as I had always been dressed in classic children's clothes. And I didn't see why (I, as) a member of the Communist Party shouldn't wear Yves Saint Laurent or Kenzo.

Miuccia Prada

Slingback pumps belong on your feet, not on the clothesline. Even if the fashion photographer thinks it is a creative coup.
Tweed-patterned, high-heeled shoes by MIUCCIA PRADA for her label MIU MIU, 1998.

1 2 3 4 5 6 7 8 9 10 11 12 **13** 14 15 16 17 18 19 20 21 22 23 24 25 26 27 28 29 30 31

OCTOBER

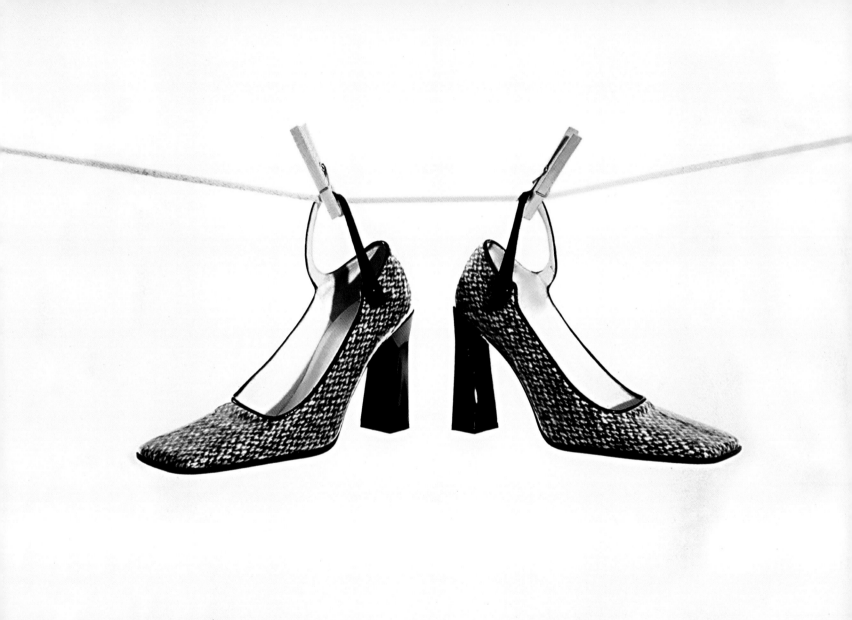

(Designers) have to be very modest.
The women choose. We have to feel
and sense what women want.

Yves Saint Laurent

It is true that the emancipated Marlene Dietrich favored the pants suit as early as the 1930s. But this clothing style needed several more decades before it conquered women's hearts. Only after 1963 did the pants suit really establish itself in women's fashion—as an everyday alternative to the dress or miniskirt.
Three models present pants suit fashions by YVES SAINT LAURENT, 1968.

1 2 3 4 5 6 7 8 9 10 11 12 13 **14** 15 16 17 18 19 20 21 22 23 24 25 26 27 28 29 30 31

OCTOBER

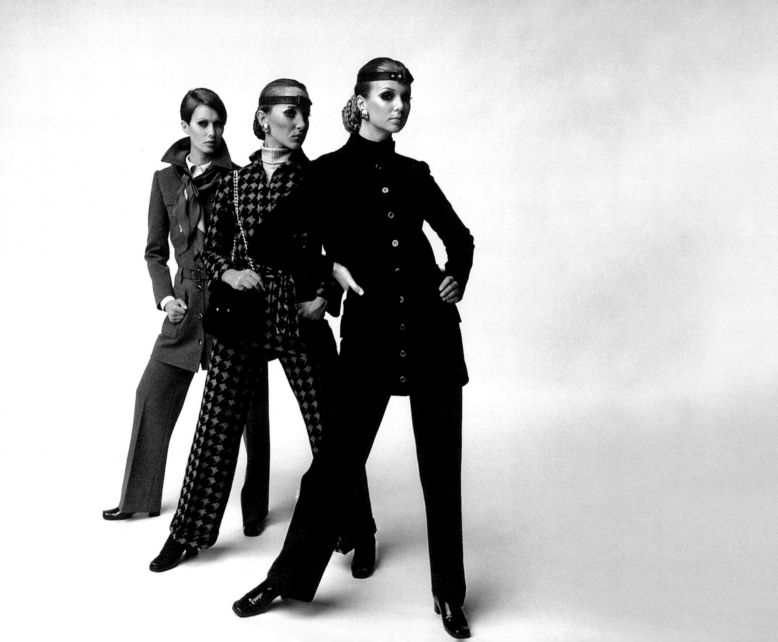

I like a woman to dress for an occasion, she could be completely dressed like a boy during the day and at night she could become a fashion bitch. I like juxtaposition. The most stylish woman for me dresses for an occasion rather than looking lady-like all the time.

Hussein Chalayan

Soft but voluminous shelter. An especially large silk square is simply tied over the broad-brimmed hat—a theatrical effect a woman might even think of herself when planning what to wear.
A model presents a voluminous creation by HUSSEIN CHALAYAN during the Spring/Summer 2007 ready-to-wear collections in Paris.

1 2 3 4 5 6 7 8 9 10 11 12 13 14 15 16 17 18 19 20 21 22 23 24 25 26 27 28 29 30 31

OCTOBER

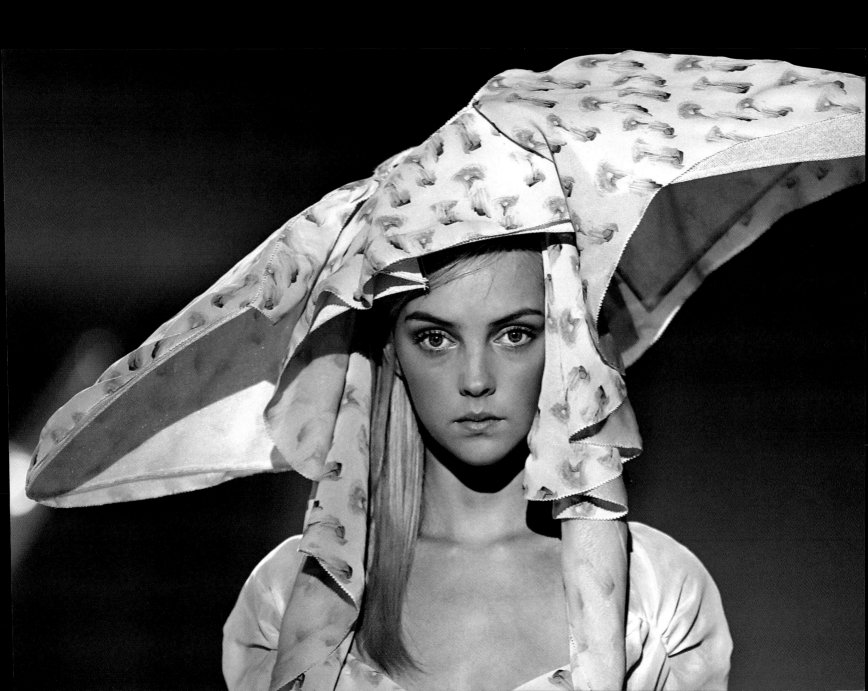

The name Rochas inspires me. Elements of lace, a Parisian couture approach, a femininity that is very intellectual and very beautiful but not that girly.

Olivier Theyskens, later designer for Rochas

Lavish—tulle: named for the French town of the same name where in the seventeenth century patternless strips of lace were widely found. The fine woven latticework with regular, hexagonal openings is often used for ball gowns, as the fabric guarantees a strikingly glamorous effect.
Detail of a dress from the ROCHAS Fall/Winter 2002/03 ready-to-wear collection, Paris.

1 2 3 4 5 6 7 8 9 10 11 12 13 14 15 **16** 17 18 19 20 21 22 23 24 25 26 27 28 29 30 31

OCTOBER

In all countries where vanity shows itself,
taste plays the first role, because it deter-
mines class differences and because,
between all the members of the upper
class, it is the best cement.

Germaine (Madame) de Staël

Only the very finest fabric is used. That applies especially to suits and jackets like
those produced by Brioni, Zegna, Armani, and Baldessarini for men's fashion.
Arthur O'Connel in conversation with Gaetano Savini, one of the creators of the
menswear label BRIONI, in his store in Rome, 1956.

1 2 3 4 5 6 7 8 9 10 11 12 13 14 15 16 17 18 19 20 21 22 23 24 25 26 27 28 29 30 31

OCTOBER

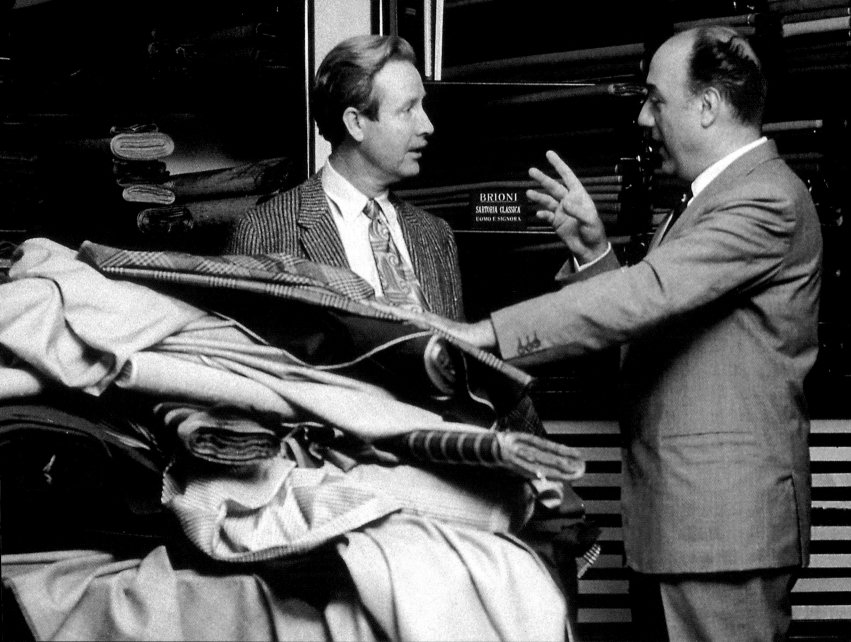

Fashion has a very exciting future;
I've never before felt such a seething
atmosphere.

John Galliano

Outer space or out of place? That is the question here. The answer cannot be that a woman in this outfit travels in an overcrowded subway car.
A model presents a design by JOHN GALLIANO for DIOR during the Fall/Winter 2002/03 haute couture collections in Paris.

1 2 3 4 5 6 7 8 9 10 11 12 13 14 15 16 17 **18** 19 20 21 22 23 24 25 26 27 28 29 30 31

OCTOBER

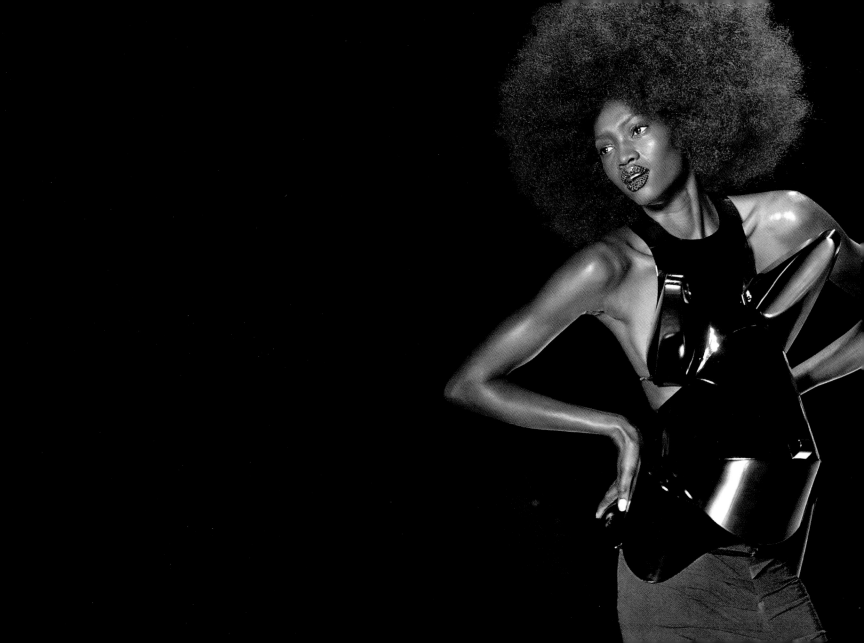

She had the beauty of a young goddess.
The luminous colour of her skin, her clear
ice-blue eyes, golden hair, exuberance,
joie de vivre, made her into a grandiose
creature, extra-terrestrial and at the
same time moving and irresistible.

Federico Fellini on Anita Ekberg

Anita Ekberg and Liz Taylor were the idols of the 1950s, an age when women adorned themselves with oversized, theatrical jewelry. Whether diamonds are stil a girl's best friend is doubtful. Today's modern woman, who flexes her muscles at the gym and in the office, is less flashy with her jewelry.
Swedish-born actress ANITA EKBERG with diamond jewelry by CARTIER, 1960.

1 2 3 4 5 6 7 8 9 10 11 12 13 14 15 16 17 18 19 20 21 22 23 24 25 26 27 28 29 30 31

OCTOBER

There are key elements that are our
constant and continuous sources of
inspiration (and that represent our
identity and our roots); that is to say, the
Mediterranean, Sicily, black and white,
and the films of Italian neo-realism.

Domenico Dolce and Stefano Gabbana

Even though the design of a bustier in black patent leather by
Dolce & Gabbana seems to quote bondage wear, it manages not
to be vulgar. D&G is always erotic and sexy—and never ordinary.
A model presents a creation by Italian fashion house DOLCE & GABBANA
during the Spring/Summer 2007 women's collections in Milan.

1 2 3 4 5 6 7 8 9 10 11 12 13 14 15 16 17 18 19 20 21 22 23 24 25 26 27 28 29 30 31

OCTOBER

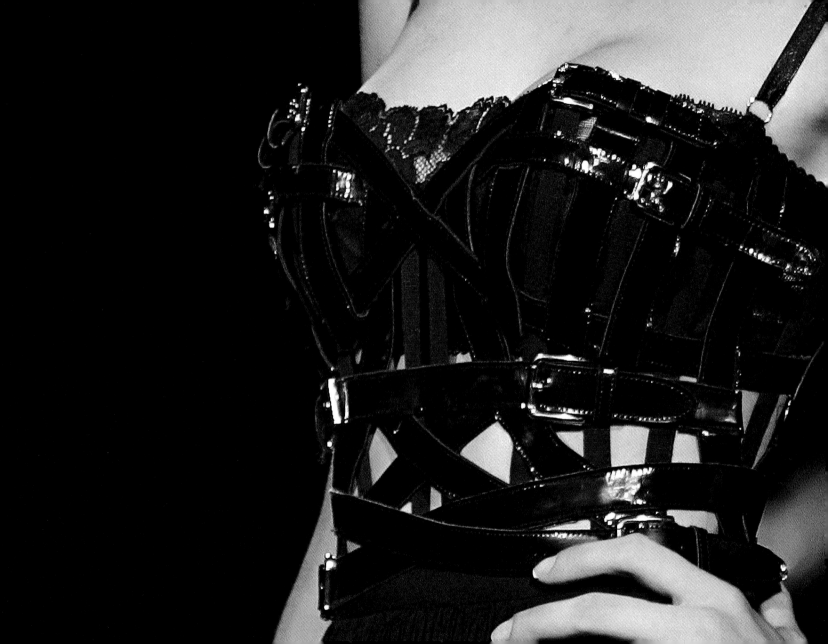

The economic logic of fashion
depends on making the
old-fashioned look absurd.

John Berger

English men's fashion during the 1960s radiated the snob appeal of a country estate. Men wore fur and capes, leather and tweed, trilby hats and Wellington boots. As this group photo of country gentlemen proves, even the most curious combinations produced a sort of harmony.

Elegant men's fashions from the sixties designed by HARDY AMIES, 1964: from an evening cape to more casual outfits to a tweed country suit with knee breeches.

1 2 3 4 5 6 7 8 9 10 11 12 13 14 15 16 17 18 19 20 21 22 23 24 25 26 27 28 29 30 31

OCTOBER

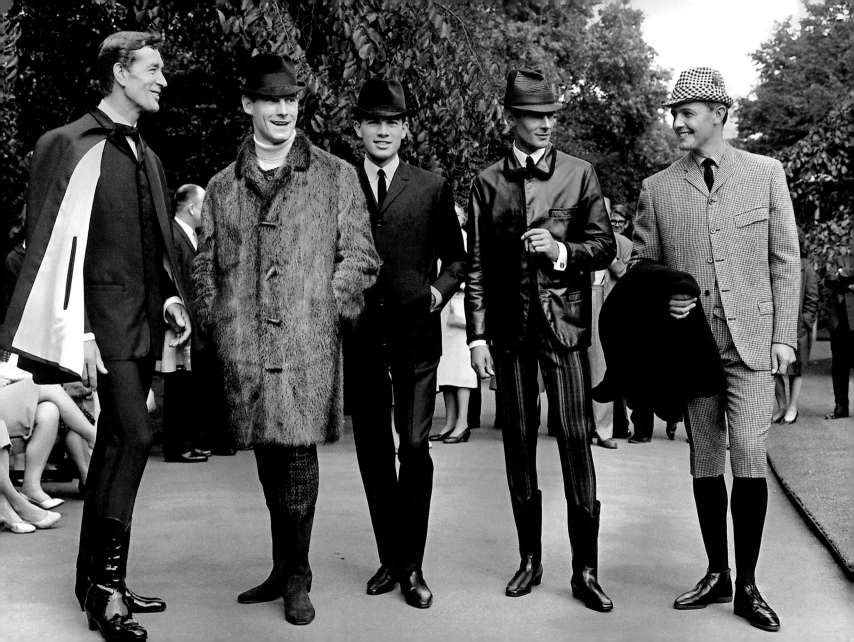

A dress has no life of its own unless
it is worn, and as soon as this happens
another personality takes over from
you and animates it, or tries to, glorifies
it or destroys it, or makes it into a song
of beauty.

Elsa Schiaparelli

Breastplate or bustier? For many designers, the most attractive way to emphasize
the female breast is with diamanté armor. It produces shiny, glittering effects in
women's evening wear.
Models walk the catwalk at the GIORGIO ARMANI fashion show during the
Fall/Winter 2007/08 haute couture collections at Paris Fashion Week.

1 2 3 4 5 6 7 8 9 10 11 12 13 14 15 16 17 18 19 20 21 22 23 24 25 26 27 28 29 30 31

OCTOBER

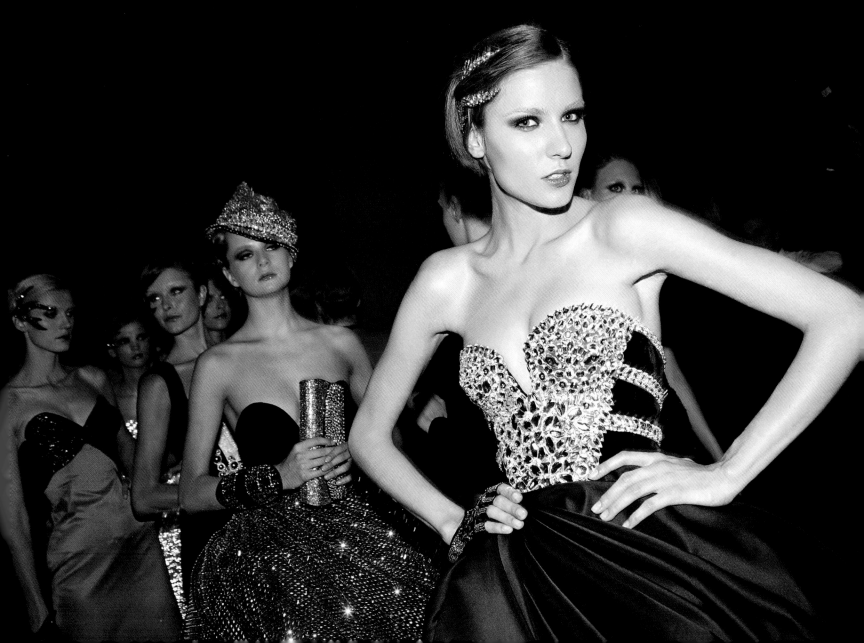

I'm sick to death of the saying,
"Elegance is utter simplicity." I think
it's a hoodwink. Some designers
just lack the inventiveness to
make it non-simple.

Norman Hartnell

In the 1920s, truly emancipated women wore their hair short and even took
their hat off indoors before sitting down on the sofa. What a daring revelation!
A model wearing a dress designed for Ascot by English couturier and court
dressmaker NORMAN HARTNELL, 1920s.

1 2 3 4 5 6 7 8 9 10 11 12 13 14 15 16 17 18 19 20 21 22 **23** 24 25 26 27 28 29 30 31

OCTOBER

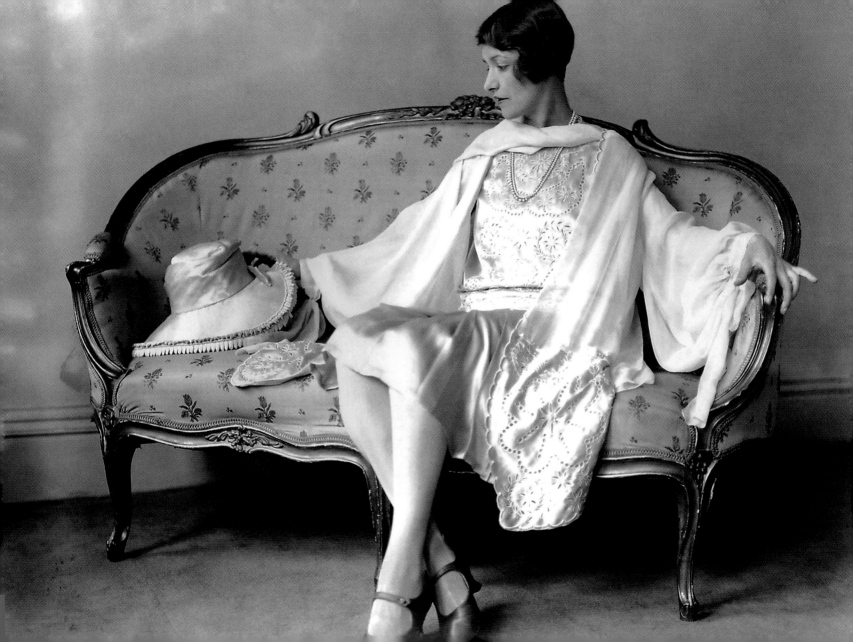

We got somewhere by making
something we thought was right,
not by sitting and thinking what
we could contrive that millions
of women will want.

Marc Jacobs

The impulse came from LV. Designer Marc Jacobs brought verve and eccentric design to the formerly somewhat dusty fashion concern Louis Vuitton, originally famous for its exclusive luggage. In the meantime, everything that bears the initials *LV* has achieved cult status—and thus frequently falls victim to the product pirates from the Far East.
An outfit with handbag by U.S. designer MARC JACOBS for LOUIS VUITTON during the Fall/Winter 2006/07 ready-to-wear collections in Paris.

1 2 3 4 5 6 7 8 9 10 11 12 13 14 15 16 17 18 19 20 21 22 23 24 25 26 27 28 29 30 31

OCTOBER

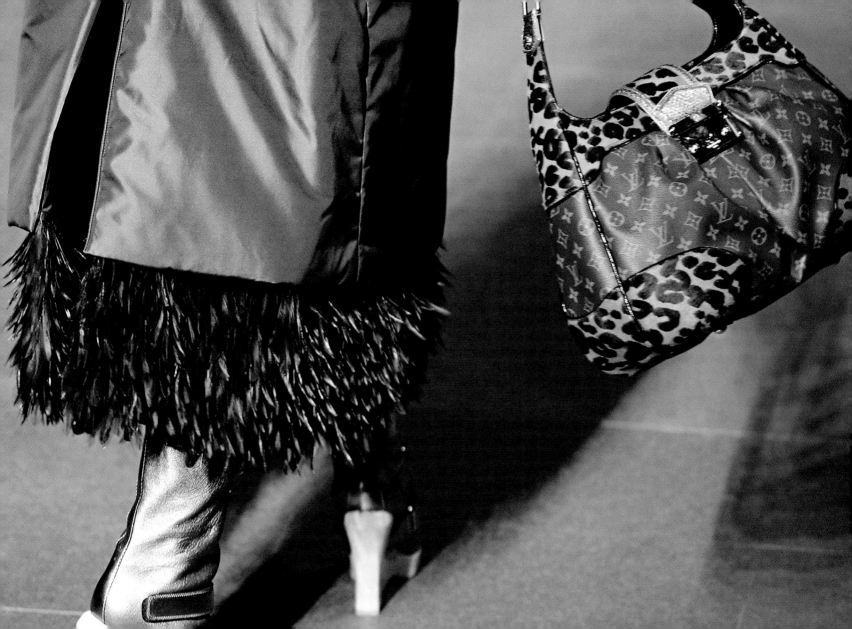

Among God's creatures two, the dog
and the guitar, have taken all the
sizes and all the shapes, in order not
to be separated from man.

Andrés Segovia

In the fashion world, dogs are particularly popular as four-legged accessories
(especially pugs, poodles, and Dalmatians). After all, man perceives fashion
through his five senses. He can presumably use a dog as a sixth sense to help
him find the right way.
Model and dog during French designer FRANCK SORBIER's Spring/Summer 2007
haute couture collection show in Paris.

1 2 3 4 5 6 7 8 9 10 11 12 13 14 15 16 17 18 19 20 21 22 23 24 25 26 27 28 29 30 31

OCTOBER

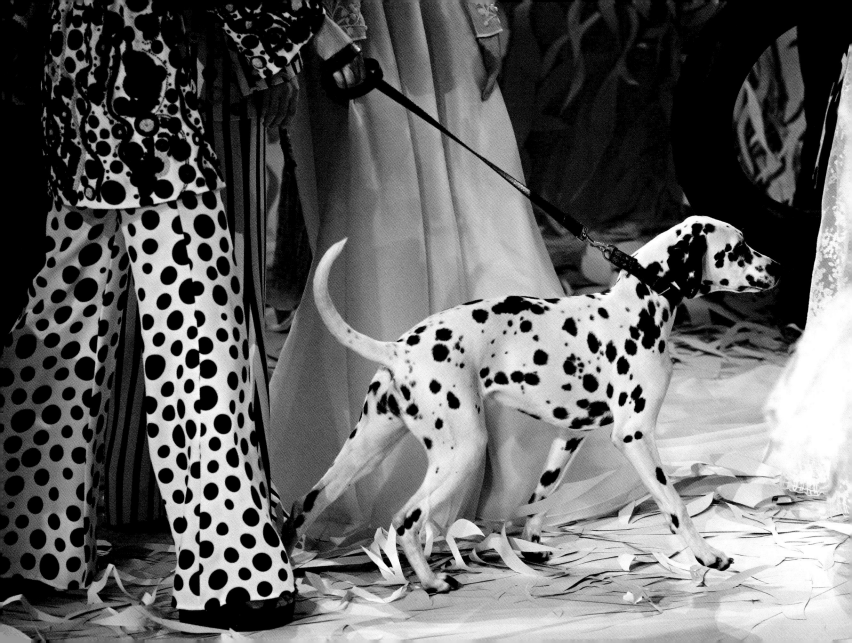

I want to do something to help
young people and to make them
understand the reality of fashion.

Giorgio Armani

They say that symmetry is the intelligence of idiots. Fashion designers almost
always lean towards the asymmetrical (except for those working in the 1960s).
Models on the catwalk at the GIORGIO ARMANI "One Night Only" show in London,
2006. The show sought to support the charitable 'Red' initiative to combat disease
in Africa.

1 2 3 4 5 6 7 8 9 10 11 12 13 14 15 16 17 18 19 20 21 22 23 24 25 26 27 28 29 30 31

OCTOBER

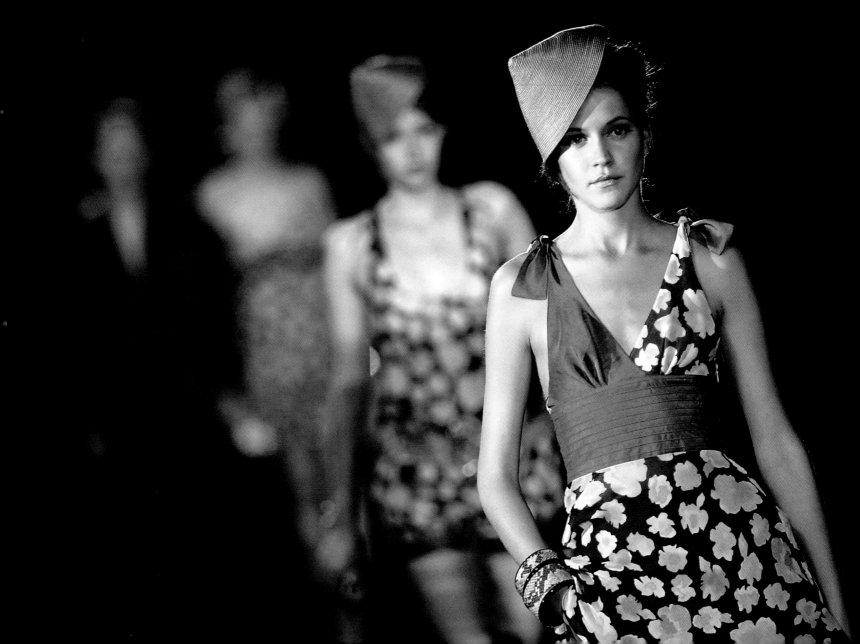

Being a good actor isn't easy.
Being a man is even harder. I want
to be both before I'm done.

James Dean

When smoking was still chic and cool—James Dean, without a T-shirt for a change, but wearing the timelessly popular combination of jeans and shirt. American actor JAMES DEAN leans against a dressing room trailer on the set of the film *Giant*, 1955.

1 2 3 4 5 6 7 8 9 10 11 12 13 14 15 16 17 18 19 20 21 22 23 24 25 26 27 28 29 30 31

OCTOBER

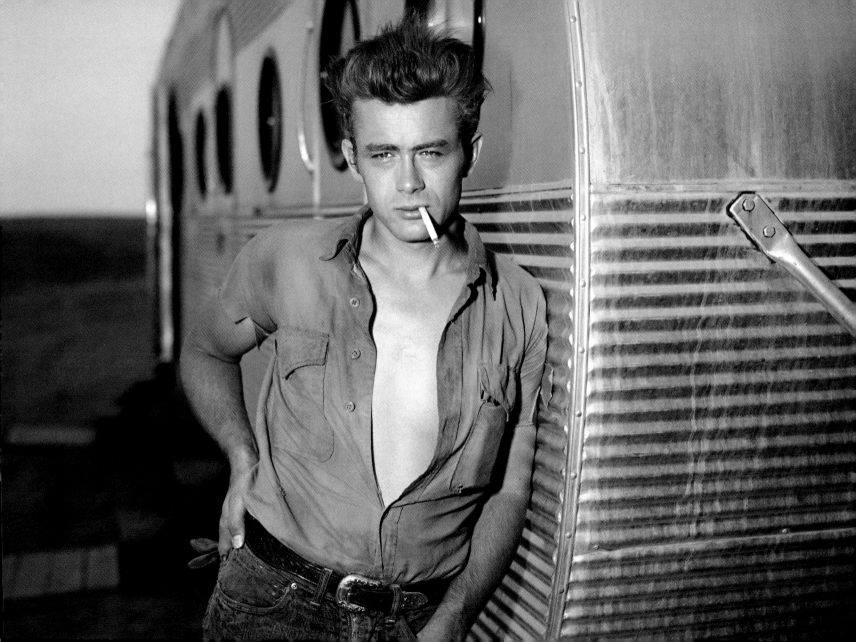

It used to be that we had six months to show something and then manufacture it. Now it only takes a week to copy something from an image on the Internet. So creatively, you have to be more and more unique.

Fendi CEO Michael Burke

Silver angels with puff sleeves—cut in layers. But why does the model look so sad? Does she really have no confidence in the power of glitter?
A model presents a dress by FENDI at Milan Fashion Week Spring/Summer 2007.

1 2 3 4 5 6 7 8 9 10 11 12 13 14 15 16 17 18 19 20 21 22 23 24 25 26 27 28 29 30 31

OCTOBER

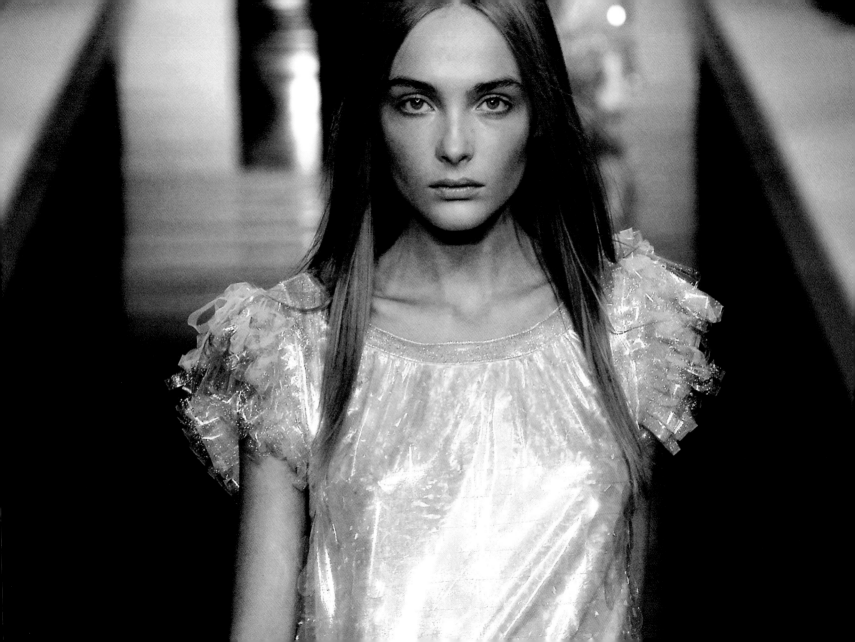

I am very nostalgic about the period
when women wore jewels and hats.
Now it's different.

Christian Lacroix

Fashion achieves its dream of flying with fabrics which float around the woman's body like clouds, like mist, like a breath of air—tulle, silk, or transparent, veil-like gauze.

Model DORIAN LEIGH sporting black picture hat and accordion-pleated, straight-hanging sheer dress, New York, 1950.

1 2 3 4 5 6 7 8 9 10 11 12 13 14 15 16 17 18 19 20 21 22 23 24 25 26 27 28 **29** 30 31

OCTOBER

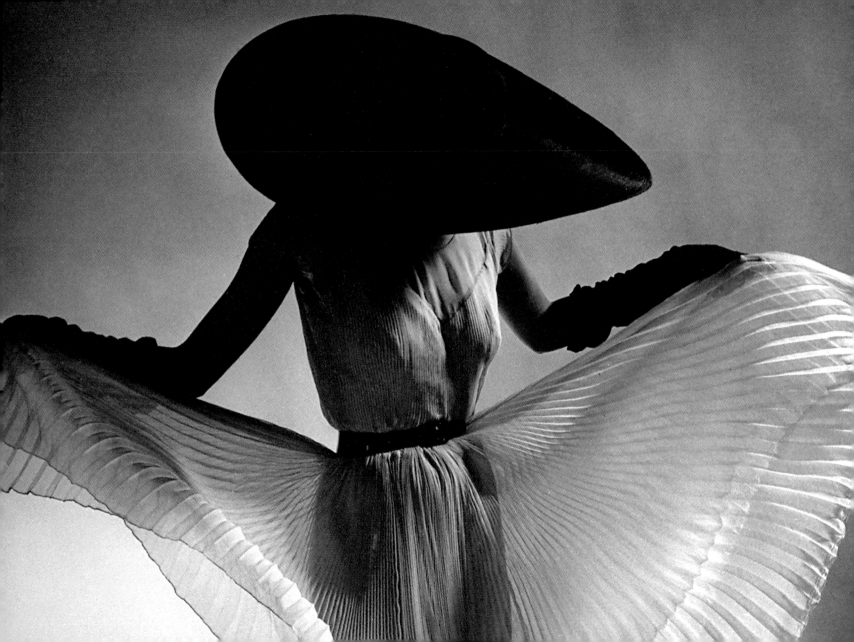

Over the years I have learned that what is important in a dress is the woman who is wearing it.

Yves Saint Laurent

Fashion has arrived to the red carpet and is no longer only seen on the catwalk. That is why the big film festivals in Cannes, Venice, and Berlin, as well as the Oscars and Golden Globe awards, are not only important for actresses, but also as a source of PR and advertising for couturiers. Who is wearing which designer? Who has style and who doesn't? Those are the questions the global media asks after the event.
Actress KEIRA KNIGHTLEY at the opening ceremony of the Venice Film Festival, August 2007.

1 2 3 4 5 6 7 8 9 10 11 12 13 14 15 16 17 18 19 20 21 22 23 24 25 26 27 28 29 30 31

OCTOBER

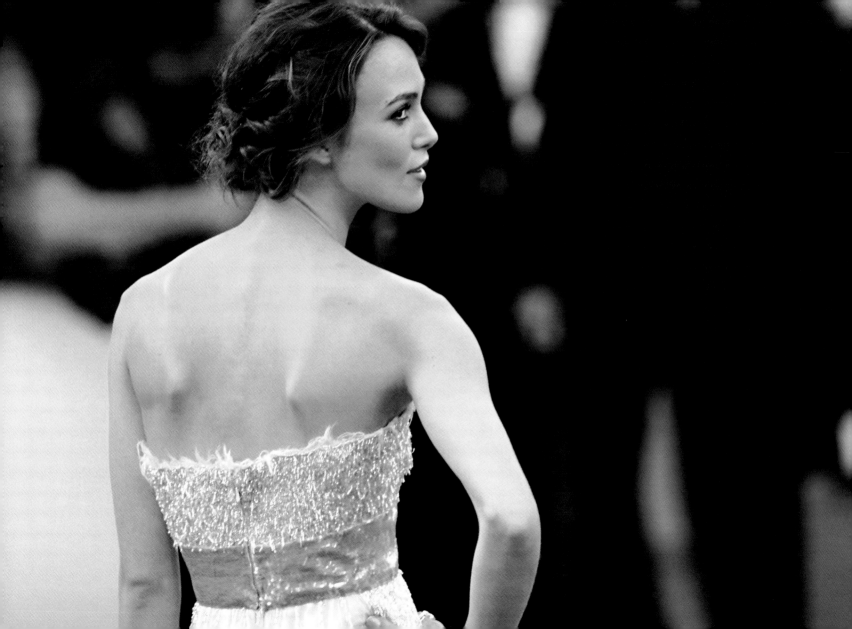

Man's view of himself has changed, as has women's view of man. Today it's plausible that a man is no longer forced to play the theatrical role of virility, and that he's able to show his sensitivity. … I think that this new sensitivity, which is finally being shown by men, is also a new form of seduction.

Jean Paul Gaultier

Jean Paul Gaultier is thus innocent of all sin. After all, the French designer's fashions are invariably anything but mediocre. Gaultier's creativity and fantasy save him from that—as does his sure hand when rummaging through the treasure chest of fashion history for inspiration.

A model displays a creation by French designer JEAN PAUL GAULTIER at the Fall/Winter 2007/08 men's ready-to-wear collection.

1 2 3 4 5 6 7 8 9 10 11 12 13 14 15 16 17 18 19 20 21 22 23 24 25 26 27 28 29 30 31

OCTOBER

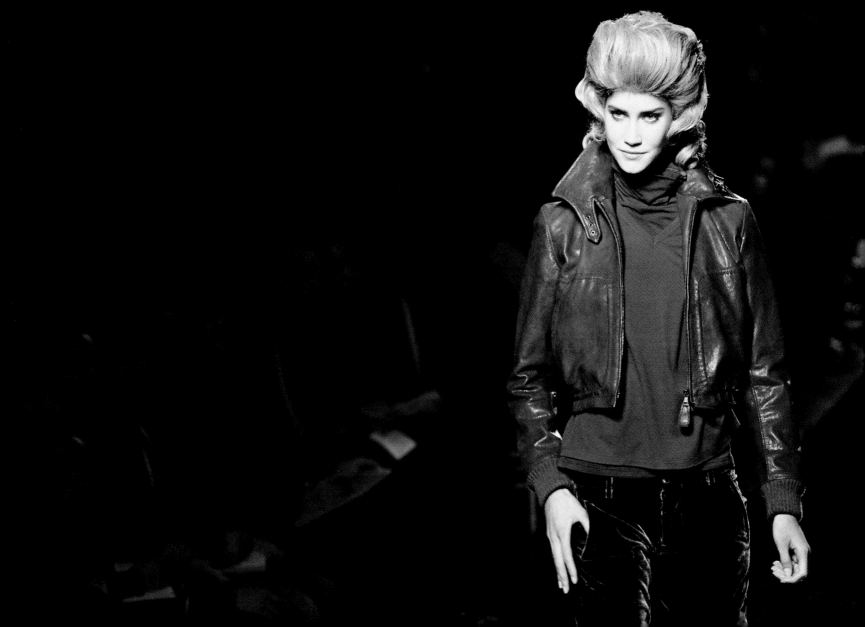

The secret is that the trench coat was never designed as a fashion item. It has therefore weathered time by evolving as a functional, stylish, iconic piece that works for both men and women.

Christopher Bailey

Thomas Burberry (1835–1889) patented his first water-repellent men's raincoat in 1879. During World War I this developed into the trench coat, named for the notorious army trenches. With its checked woolen lining the typical Burberry gabardine became nothing more than an "ordinary" raincoat and the brand lost its appeal. But it has enjoyed a renaissance since creative head Roberto Menichetti put the lining on the outside in the 1990s, hired Kate Moss to model, and Christopher Bailey took over the Burberry design in 2001. Nowadays the Burberry check can be seen everywhere and on everything: bikinis and shoes, ties, umbrellas—and dog collars.

Presentation of the legendary BURBERRY trench coat. Brenda Capwell, Miss Burberry 1970, poses in London's Trafalgar Square with three other models.

1 2 3 4 5 6 7 8 9 10 11 12 13 14 15 16 17 18 19 20 21 22 23 24 25 26 27 28 29 30

NOVEMBER

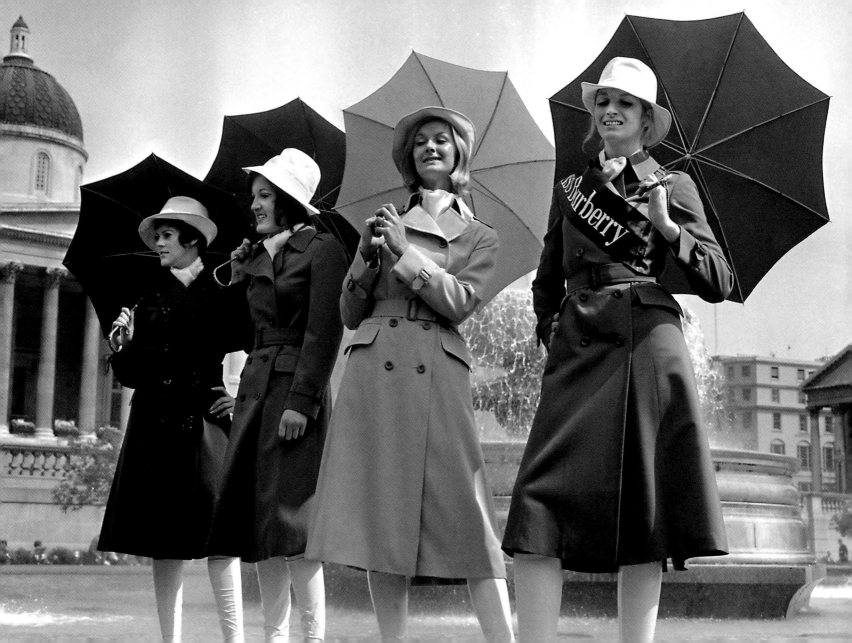

You can say that designing is quite easy; the difficulty lies in finding a new way to explore beauty.

Yohji Yamamoto

Yohji Yamamoto (b. 1943) is Japan's Grand Master of perfect pleating and asymmetrical cuts (also visible in the model's hairstyle!). Since 1984 he has also designed men's fashion and demonstrates his creativity in different ways—Yamamoto designed the costumes for the famous 1993 Bayreuth production of Wagner's *Tristan und Isolde*, and Wim Wenders has immortalized the designer on film.
Detail from the Spring/Summer 2007 ready-to-wear collection by YOHJI YAMAMOTO, Paris.

1 2 3 4 5 6 7 8 9 10 11 12 13 14 15 16 17 18 19 20 21 22 23 24 25 26 27 28 29 30

NOVEMBER

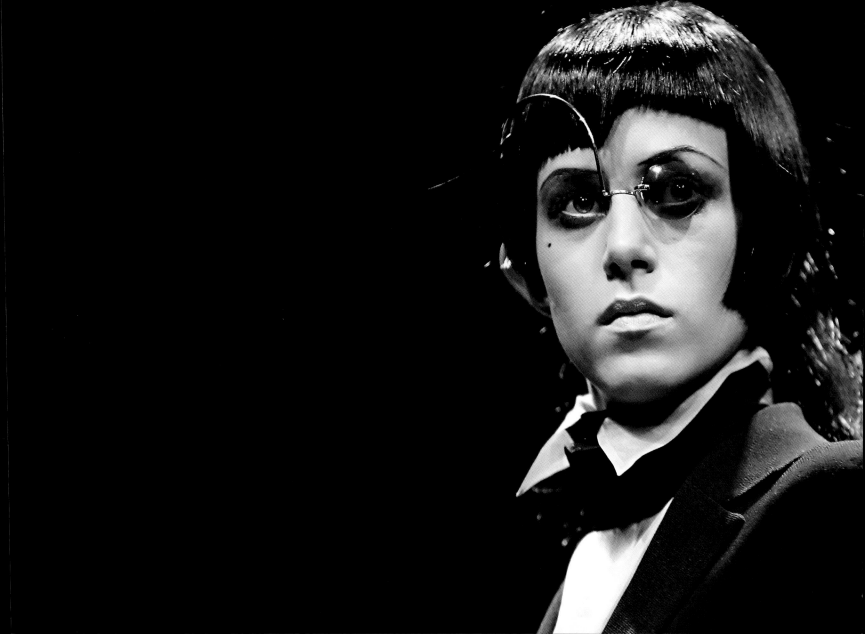

When I was 15, instead of going to sleep-away camp I spent the whole summer hanging out in the Fiorucci store. I had this wide-eyed glamour about these beautiful young people that globe-trotted from club to club dressing in these fabulous clothes. It was like a living, breathing fashion show that I wanted so much to be part of.

Marc Jacobs

Stage-managed exuberance. Fashion should be like real life—but perfect. To this day, technical effects like wind machines and dry-ice fog provide an extra dose of reality. It was the same in the 1970s, when Fiorucci, the cult label of the time, filled everyone with enthusiasm for its "exuberance."

"And, action!"—models perform a mock fight during a punk fashion show at the FIORUCCI clothing store in Beverly Hills, 1979.

3

1 2 3 4 5 6 7 8 9 10 11 12 13 14 15 16 17 18 19 20 21 22 23 24 25 26 27 28 29 30

NOVEMBER

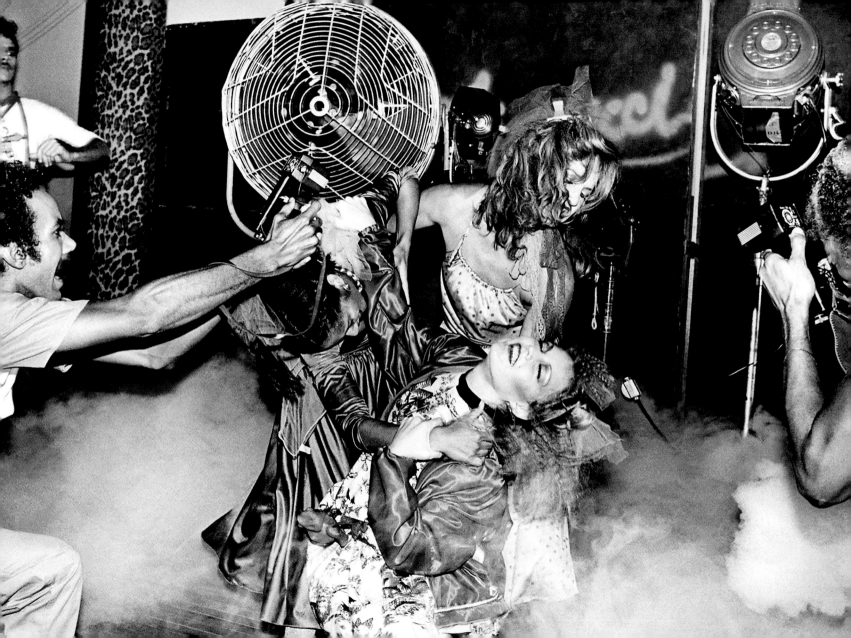

The maturity of middle age brings you a kind of distance and self assurance. Yesterday's extravagances are now classics. The trick is just follow your impulses, inspiration, and intuition with the conviction that they are stronger than the average, banal, pretentious way.

Christian Lacroix

The French designer Christian Lacroix, so famous for his opulence and pomp, for intoxicating colors and brilliant effects, prefers unadorned fashion when it comes to his own appearance. Like the artist Joseph Beuys, he seems to value the advantages of a jacket with numerous pockets.
CHRISTIAN LACROIX is applauded after the presentation of his Spring/Summer 2004 collection for EMILIO PUCCI during Milan Fashion Week 2003.

1 2 3 4 5 6 7 8 9 10 11 12 13 14 15 16 17 18 19 20 21 22 23 24 25 26 27 28 29 30

NOVEMBER

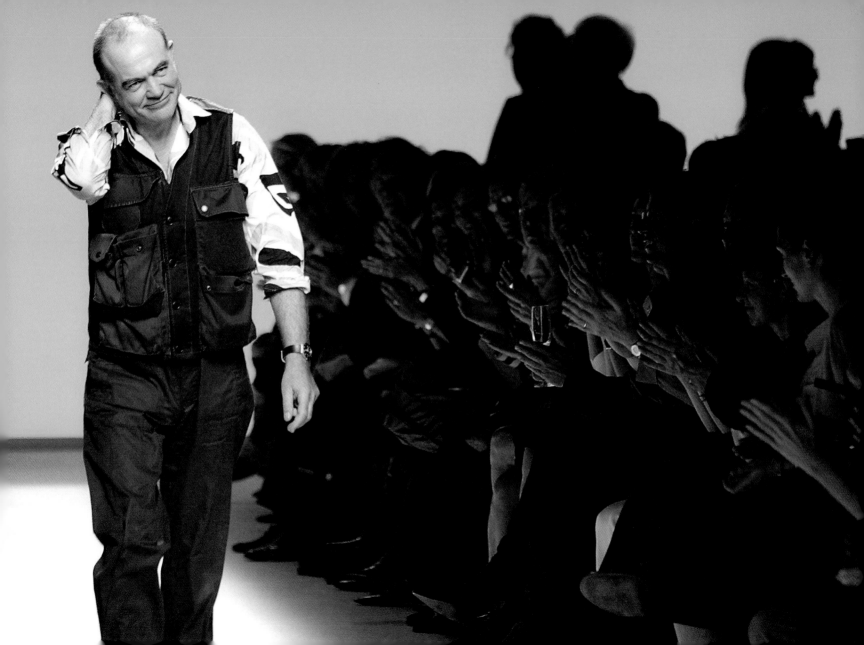

I find a multitude of influences
inspiring—homeless to the rich,
vulgar to the common.

Alexander McQueen

Woman as an Inca queen—or a bird of paradise? Ornithologically, a cross
between a parrot and a peacock hardly seems possible—but in fashion it is.
A model in a feather dress—a design from the Spring/Summer 2008
ALEXANDER MCQUEEN collection presented during Paris Fashion Week.

1 2 3 4 5 6 7 8 9 10 11 12 13 14 15 16 17 18 19 20 21 22 23 24 25 26 27 28 29 30

NOVEMBER

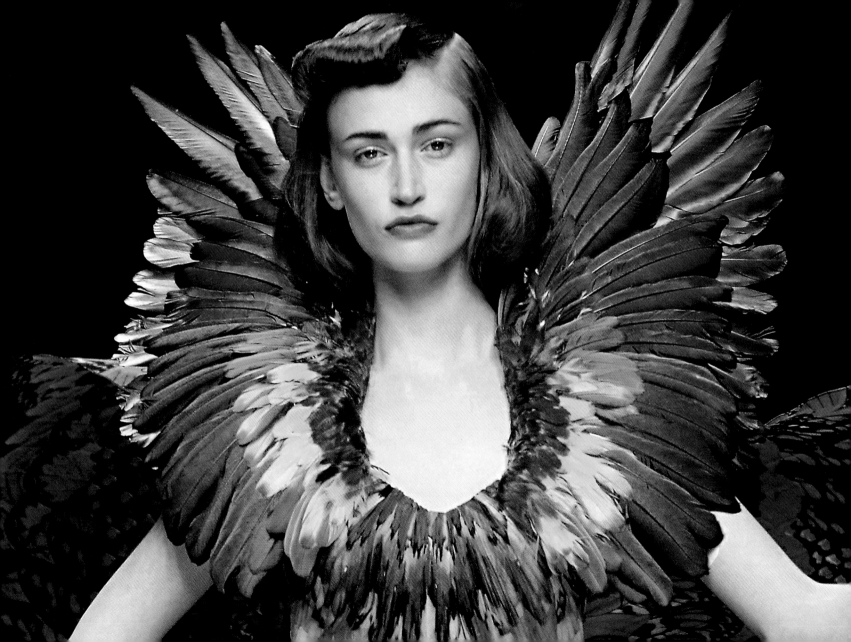

Punk is definitely part of my history. I'll never get rid of that, but let me tell you what I think street clothes are. They presume that there is an Establishment, and that they are therefore the "Anti-Establishment." I used to believe there was a door to kick down, but now I know it's not there at all. There are just jumps along the way.

Vivienne Westwood

With heavy footsteps through the subculture! In 1945, shortly after the war, Dr. Klaus Martens developed these robust boots with air-upholstered soles in Munich. They were based on army boots and workers' shoes. The legend of a lifelong guarantee for a pair of Air Wair Ltd's DocMartens persists—but it is just a legend.
Popular with punks and skinheads—the DOC MARTENS boot.

1 2 3 4 5 6 7 8 9 10 11 12 13 14 15 16 17 18 19 20 21 22 23 24 25 26 27 28 29 30

NOVEMBER

If everybody is not a beauty,
then nobody is.

Andy Warhol

So pale she looks ill. A fragile-looking pose in military-style boots—fashion, style,
or fad. Which will survive?
Actress CHLOÉ SEVIGNY at the Sundance Film Festival, 2003.

1 2 3 4 5 6 7 8 9 10 11 12 13 14 15 16 17 18 19 20 21 22 23 24 25 26 27 28 29 30

NOVEMBER

She was an enchanting wild thing,
a sensual, barbaric child, barely cloaked
in a white hazy cloud, a swath of mist,
in which her whole form was just visible.

Émile Zola, *La Curée*, 1871

Fashion photography developed alongside fashion itself. Its "shots of style"
became an undeniable form of visual art.
A KATE MOSS hologram at the ALEXANDER MCQUEEN Fall/Winter 2006/07 ready-to-
wear collection show, Paris.

1 2 3 4 5 6 7 8 9 10 11 12 13 14 15 16 17 18 19 20 21 22 23 24 25 26 27 28 29 30

NOVEMBER

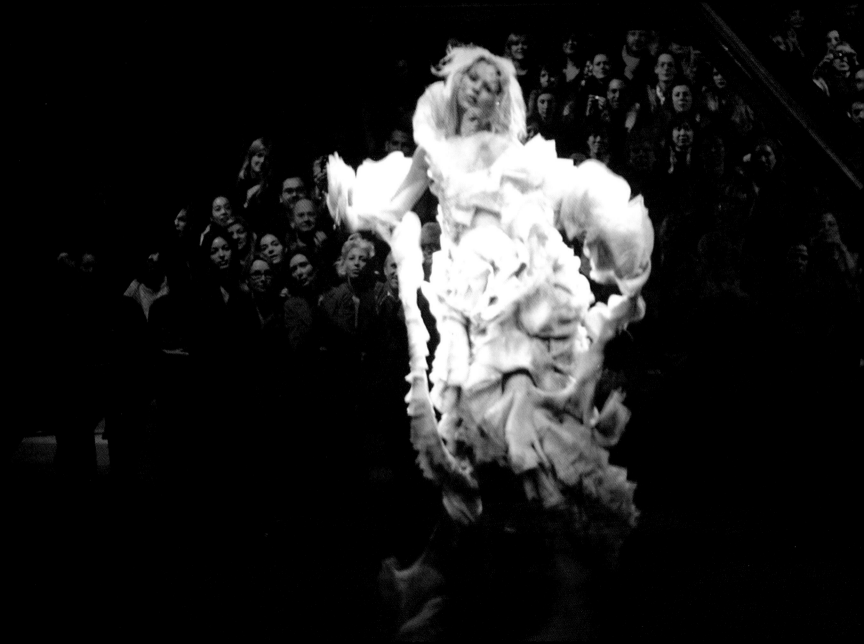

Fashion marks time.

Yohji Yamamoto

Jeanne Paquin (1869–1936) was a fashion pioneer. In 1906 she presented her "Empire dresses," and in 1914 she presented the first true fashion show in the Palace Theatre in London, with music, choreography, and stage settings. The creations she showed were called "Tango dresses," and were spectacular. The Paquin couture salon existed in Paris until 1956.
A model wearing a feathered headdress by PAQUIN.

1 2 3 4 5 6 7 8 9 10 11 12 13 14 15 16 17 18 19 20 21 22 23 24 25 26 27 28 29 30

NOVEMBER

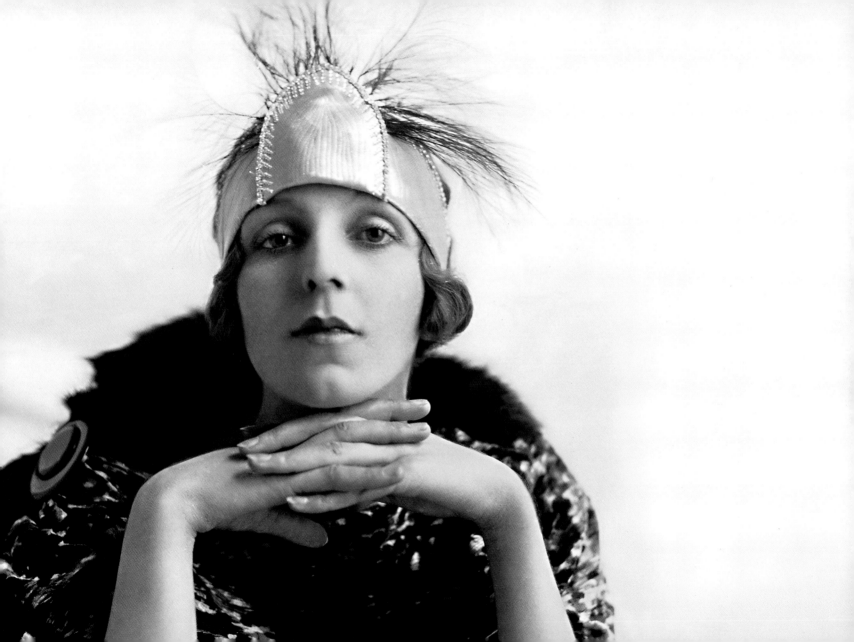

Bags are wonderful companions.
They have a secret inner life, they
never cheat on you, and still they
adorn every woman.

Jette Joop

It is important for a man that a woman carries a large handbag. He needs
somewhere to put his wallet, keys, sunglasses, and mobile phone. Never should
a man restrain a woman in her love of handbags. Never.
Presentation at the DIOR store in Beverly Hills: a bag from the Cruise Collection 2007.

1 2 3 4 5 6 7 8 9 10 11 12 13 14 15 16 17 18 19 20 21 22 23 24 25 26 27 28 29 30

NOVEMBER

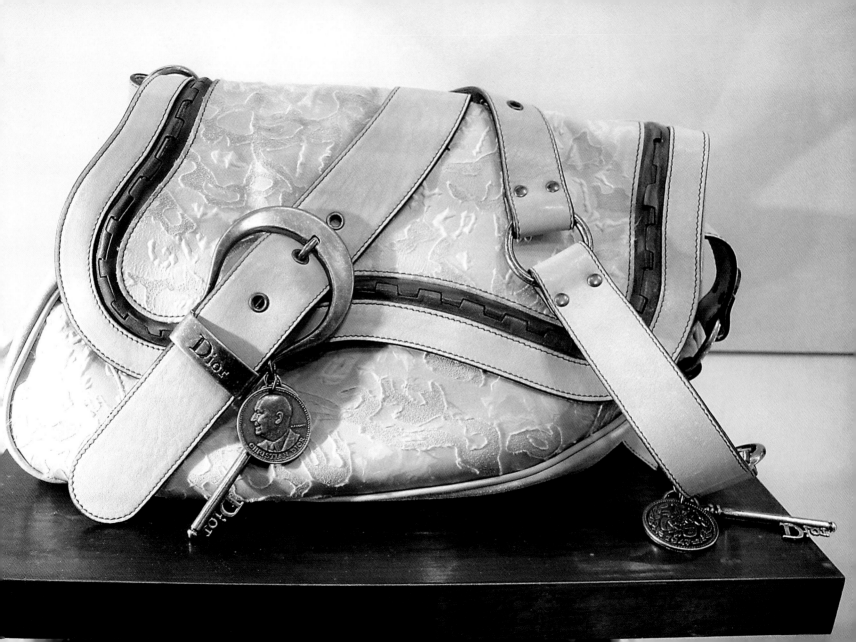

I adore pink! It's the navy blue of India!

Diana Vreeland

Puppet parade. Défilée. Catwalk. Runway. The words chosen to describe a fashion show are often quite strange.
Models walk the catwalk during the ALEXANDER MCQUEEN Spring/Summer 2008 fashion show, Paris.

1 2 3 4 5 6 7 8 9 10 11 12 13 14 15 16 17 18 19 20 21 22 23 24 25 26 27 28 29 30

NOVEMBER

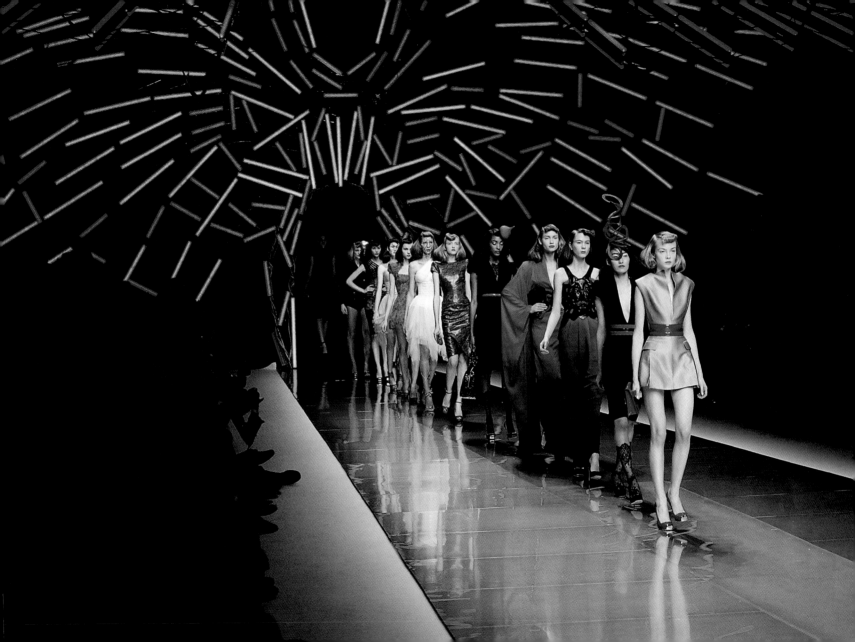

Elegance is no longer significant;
clothes have to be fun.

Yves Saint Laurent

During the 1970s, the sexual revolution and the "pill" emphasized the sexual aspects of fashion. Skin-tight "hot pants" really were "hot." Together with the miniskirt they proved just how little fabric it takes to provoke erotic attraction, and to write fashion history.
The twins Barbara and Elaine Rogers, students at the London College of Fashion, show off the latest HOT PANTS, 1971.

1 2 3 4 5 6 7 8 9 10 11 12 13 14 15 16 17 18 19 20 21 22 23 24 25 26 27 28 29 30

NOVEMBER

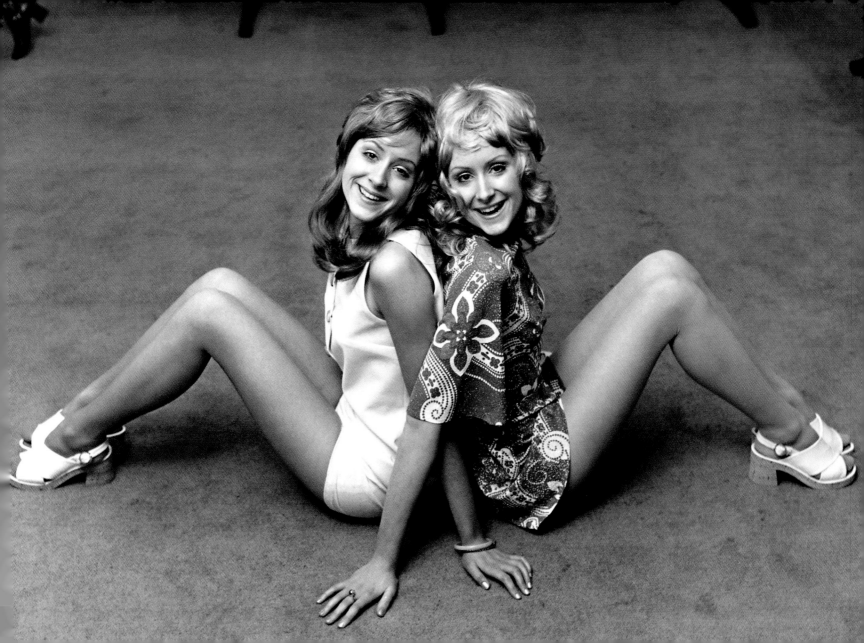

I like to think that I brought a certain
hedonism back to fashion.

Tom Ford

During the 1990s, the American fashion designer Tom Ford (b. 1962) made the
name of Gucci great again with his glamorous creations—after the fashion house
was declared bankrupt. In 2003 Ford then left Gucci in order to devote attention
to his own label.
Presenting the Fall/Winter 2005/06 ready-to-wear collection by OSVALDO BOOTANG
for GIVENCHY, Paris.

1 2 3 4 5 6 7 8 9 10 11 12 **13** 14 15 16 17 18 19 20 21 22 23 24 25 26 27 28 29 30

NOVEMBER

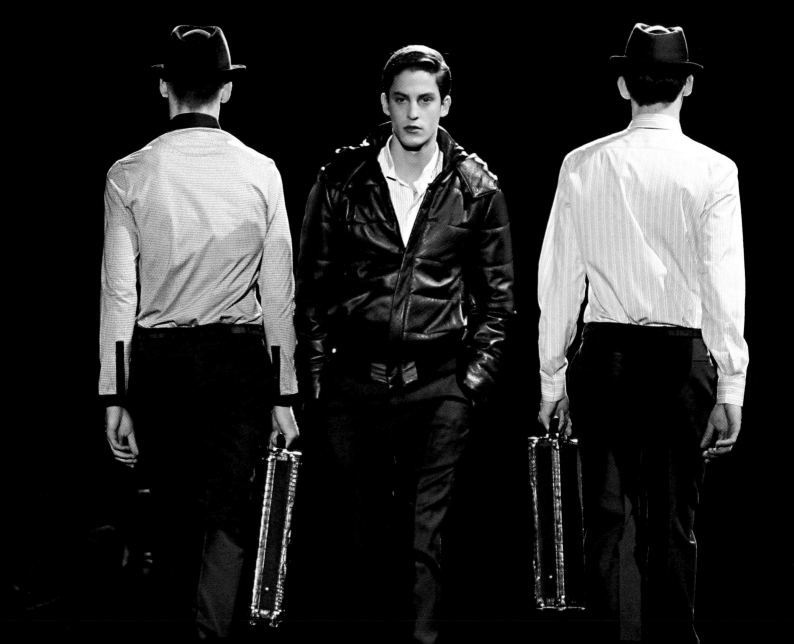

B for buckle, b for belt,
b for bag—B. Fendi!

Amanda Harlech, photographer and muse

In fashion, it is the details that really catch the eye!
Detail from the FENDI Spring/Summer 2006 women's collection
at Milan Fashion Week.

1 2 3 4 5 6 7 8 9 10 11 12 13 14 15 16 17 18 19 20 21 22 23 24 25 26 27 28 29 30

NOVEMBER

I am in the fashion business but I feel when
I design I'm in the business of trying to figure
out what people want and why they want it.
One of the main reasons that I do work in
the fashion industry is because I'm intrigued
about why people choose certain clothes
to reflect their mood.

Stella McCartney

The Rich and Beautiful and Important and Right People—at a fashion show
they always sit in the front row. Many fathers of fashion designers don't end
up there—proud papa Paul McCartney is an exception.
Spring/Summer 1999 ready-to-wear collection show by STELLA MCCARTNEY for
CHLOE. Among the audience are her father Paul McCartney (with tie) and
Simply Red singer Mick Hucknall (with sunglasses). Paris, 1998.

1 2 3 4 5 6 7 8 9 10 11 12 13 14 **15** 16 17 18 19 20 21 22 23 24 25 26 27 28 29 30

NOVEMBER

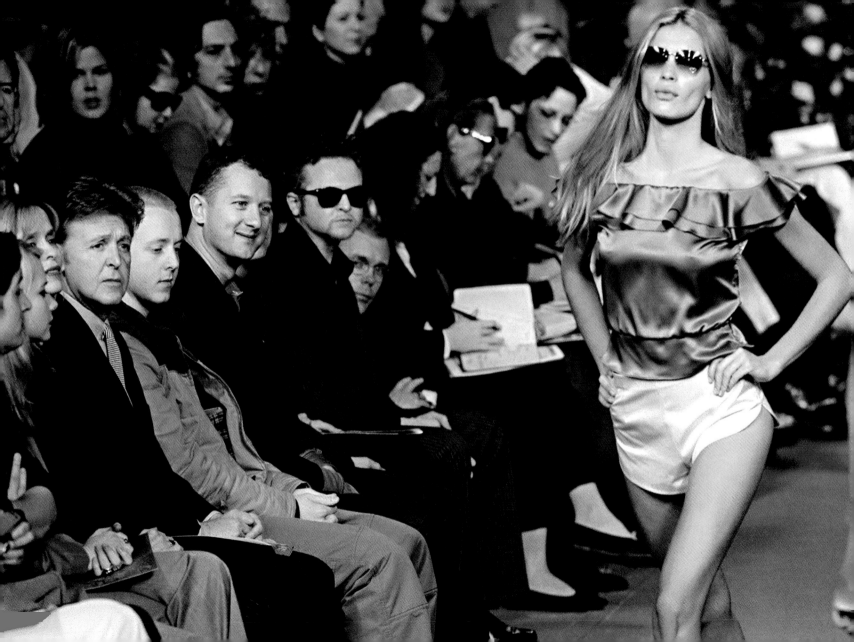

It was the bias cut—discovered by
Vionnet—that made freedom of
expression in clothing possible.

Issey Miyake

For flowing robes—with or without flounces—fashion designers find their
inspiration in antiquity, as well as in Symbolism and Art Nouveau.
An haute couture creation of Lebanese designer ABED MAHFOUZ for the
Fall/Winter 2007/08 collection, presented at Italian Fashion Week in Rome.

1 2 3 4 5 6 7 8 9 10 11 12 13 14 15 16 17 18 19 20 21 22 23 24 25 26 27 28 29 30

NOVEMBER

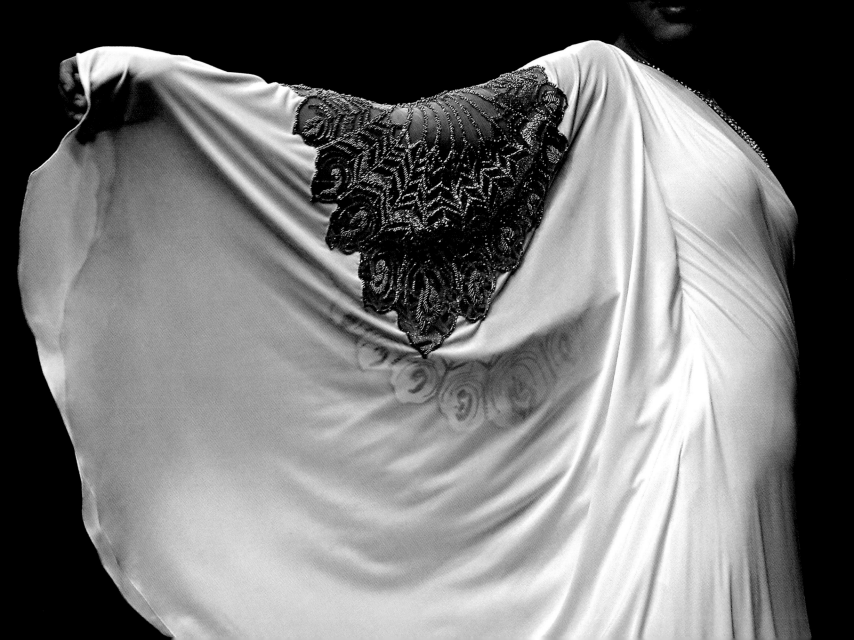

Red is the great clarifier—bright, cleansing, and revealing. It makes all other colors beautiful. I can't imagine becoming bored with red—it would be like becoming bored with the person you love.

Diana Vreeland

John Rocha's red creation has a story behind it. Historically, the wide-cut harem pants were an invention of the landsknechts and were supposedly first seen in 1553 in the camp of the Elector of Saxony. It is not too difficult to guess why the pockets of such baggy pants were known as "thieves' pockets." A creation by JOHN ROCHA from the Fall/Winter 2006/07 collection at London Fashion Week.

1 2 3 4 5 6 7 8 9 10 11 12 13 14 15 16 **17** 18 19 20 21 22 23 24 25 26 27 28 29 30

NOVEMBER

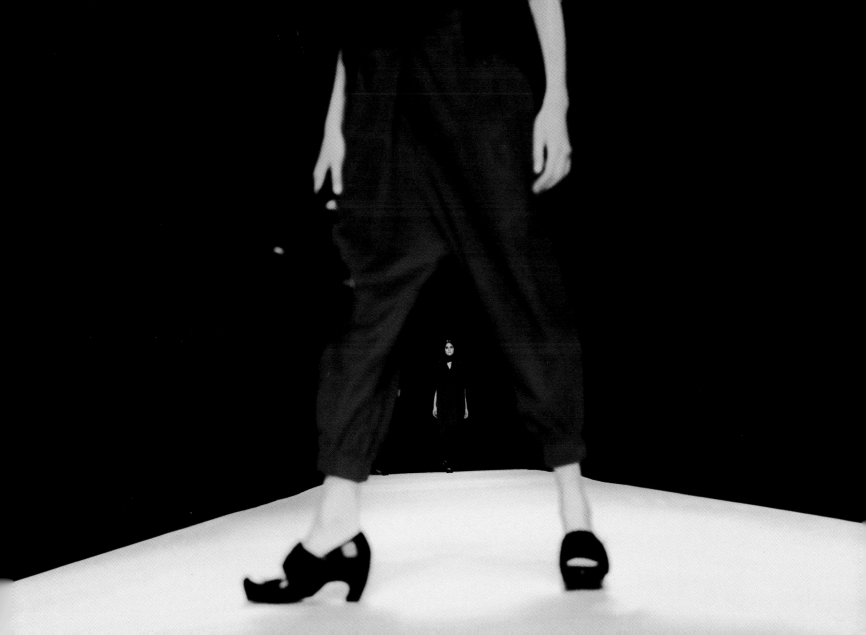

If you look at any great fashion photograph out of context, it will tell you just as much about what's going on in the world as a headline in *The New York Times*.

Anna Wintour

True fashion is for the most part not seen on the catwalk. It will be found sitting and standing in the audience. The guests in the front row are all dressed up. But the others, the hard-working photographers? They wear jeans and a T-shirt or polo shirt. Actually, real fashion looks rather different than on the catwalk.
All eyes are on the skimpy outfit by UNGARO during the ready-to-wear Spring/Summer 2006 fashion show in Paris.

1 2 3 4 5 6 7 8 9 10 11 12 13 14 15 16 17 18 19 20 21 22 23 24 25 26 27 28 29 30

NOVEMBER

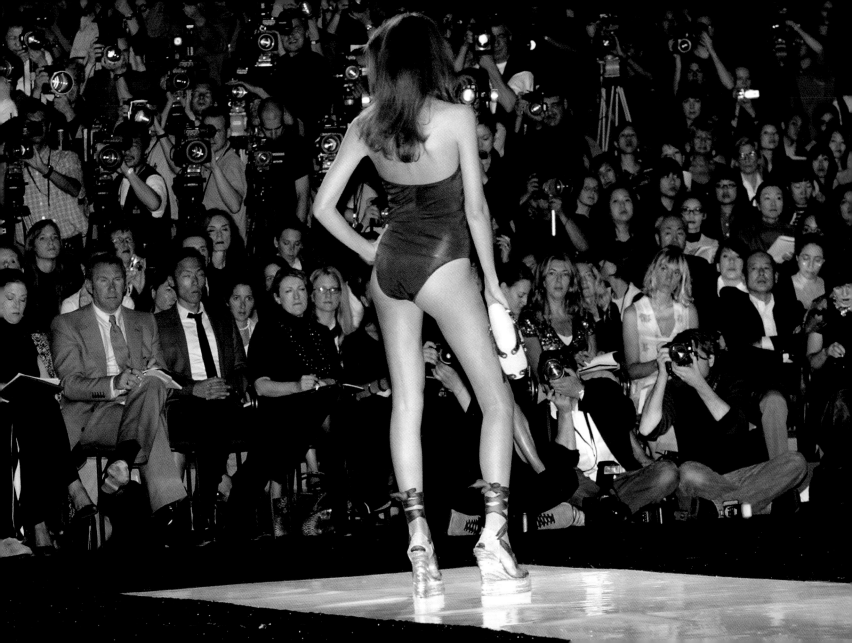

Just like the silhouette of a car needs
to be changed periodically so as not
to lose its power of attraction, in the
Western world the female body is also
reshaped from time to time.

Bernard Rudofsky

A creation whose sophisticated ruffles recall the calyx of a flower—or did
Hussein Chalayan's model emerge from the cocoon of her fashion maestro?
A voluminous dress—a design from the Spring/Summer 2000 collection by
HUSSEIN CHALAYAN at London Fashion Week.

1 2 3 4 5 6 7 8 9 10 11 12 13 14 15 16 17 18 19 20 21 22 23 24 25 26 27 28 29 30

NOVEMBER

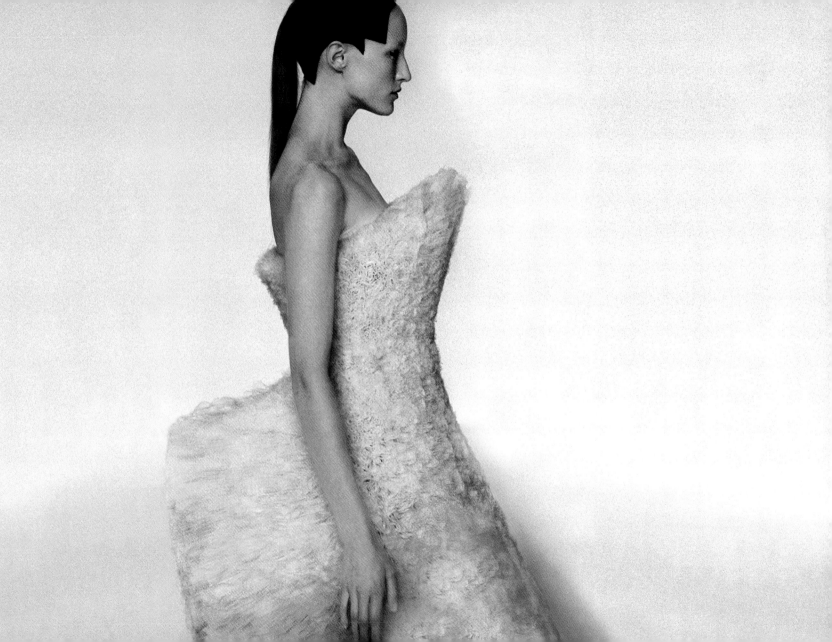

I can go all over the world with just three outfits: a blue blazer and gray flannel pants, a gray flannel suit, and black tie.

Pierre Cardin

The working class East End of London? Impoverished landed gentry? No, by 1962 the fashion designer Pierre Cardin (b. 1922, Venice), who worked for Paquin and Schiaparelli, and designed film costumes for Cocteau, was already in the fast lane of the fashion world. His look was always innovative; in 1958 he created the first unisex line, and because Cardin is a brilliant businessman, he is thought to be the fashion designer who holds the most licenses worldwide.

Past or present? Four models wearing the latest fall collection from PIERRE CARDIN, 1962.

1 2 3 4 5 6 7 8 9 10 11 12 13 14 15 16 17 18 19 20 21 22 23 24 25 26 27 28 29 30

NOVEMBER

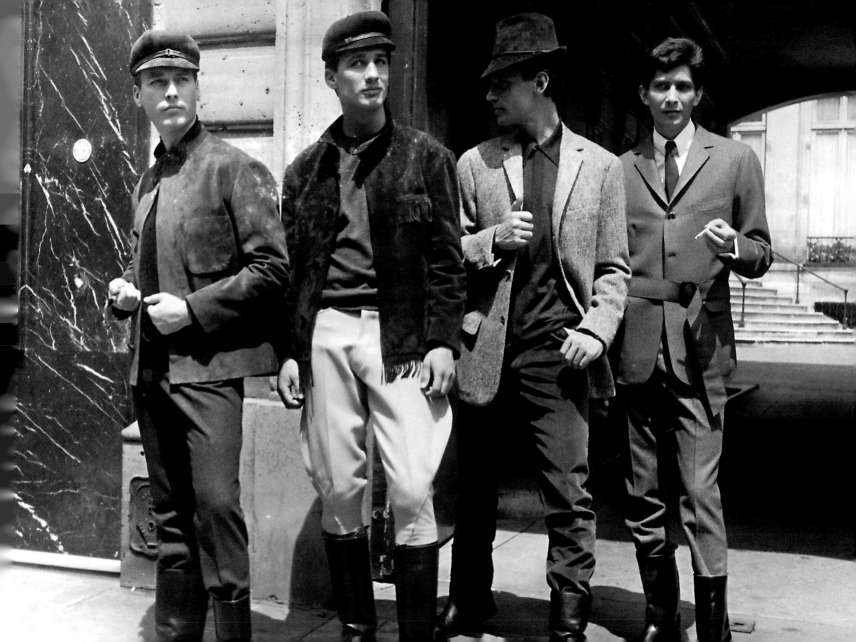

A woman's dress should be like
a barbed-wire fence: serving its
purpose without obstructing the view.

Sophia Loren

Brocade was especially popular among the Italian aristocracy of the fifteenth century, the early Renaissance. The fabric is very heavy because of the metal threads woven into the silk. The glamorous effect of the material has been retained to this day—as has its weight.
Model wearing a gold brocade evening dress, undated.

1 2 3 4 5 6 7 8 9 10 11 12 13 14 15 16 17 18 19 20 21 22 23 24 25 26 27 28 29 30

NOVEMBER

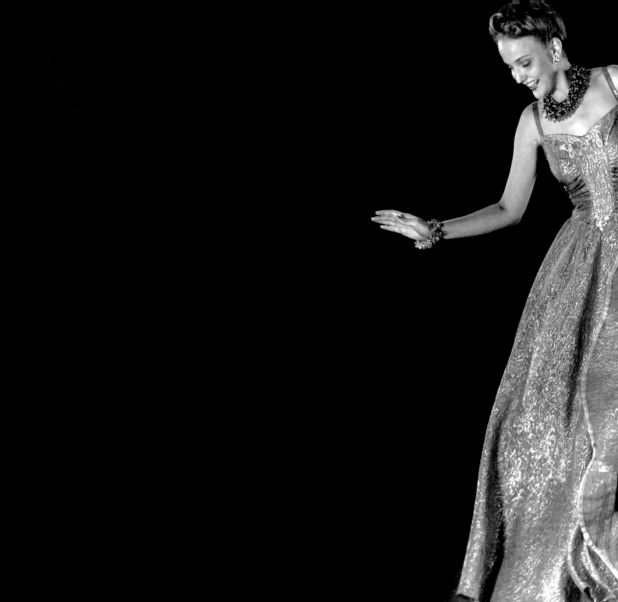

I prefer couture clothes because they are better-made, the way clothes should be. It's the difference between a brick house and a pre-fabricated hut. Couture is things as they should be: farmyard chickens instead of battery hens, real tea instead of instant powder.

Inès de la Fressange

The worship of the individual takes place in the atelier. Down on your knees, down on your knees and pray, pray to the goddess. Later, the masses will also worship the idol—not kneeling but purchasing.
A woman's second skin—designer RANDOLPH DUKE assists with the fitting of a tight evening dress on a model.

1 2 3 4 5 6 7 8 9 10 11 12 13 14 15 16 17 18 19 20 21 22 23 24 25 26 27 28 29 30

NOVEMBER

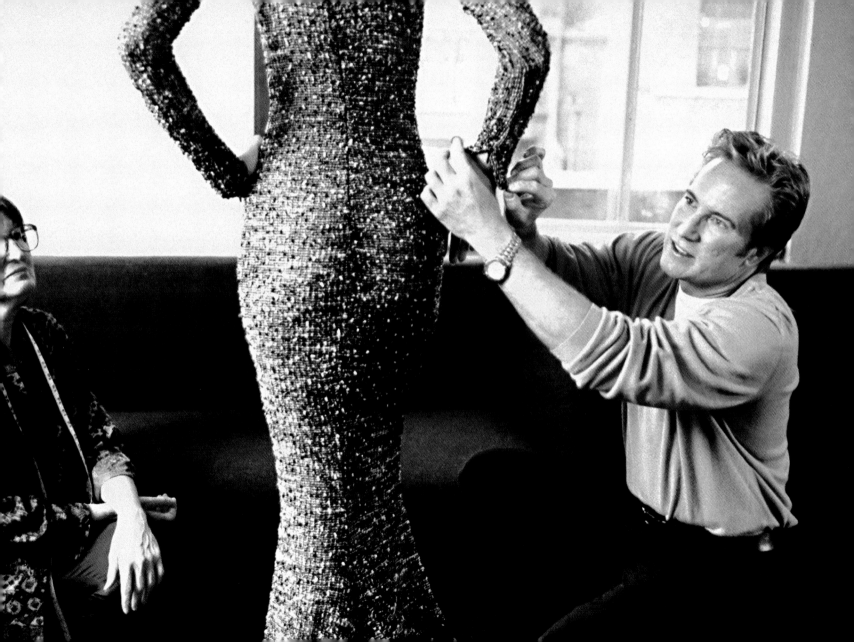

A good model can advance
fashion by ten years.

Yves Saint Laurent

In earlier times, actresses were also models. Today, models try their luck as actresses.
LAUREN HUTTON, actress and supermodel, in a sleeveless dress, 1974.

1 2 3 4 5 6 7 8 9 10 11 12 13 14 15 16 17 18 19 20 21 22 **23** 24 25 26 27 28 29 30

NOVEMBER

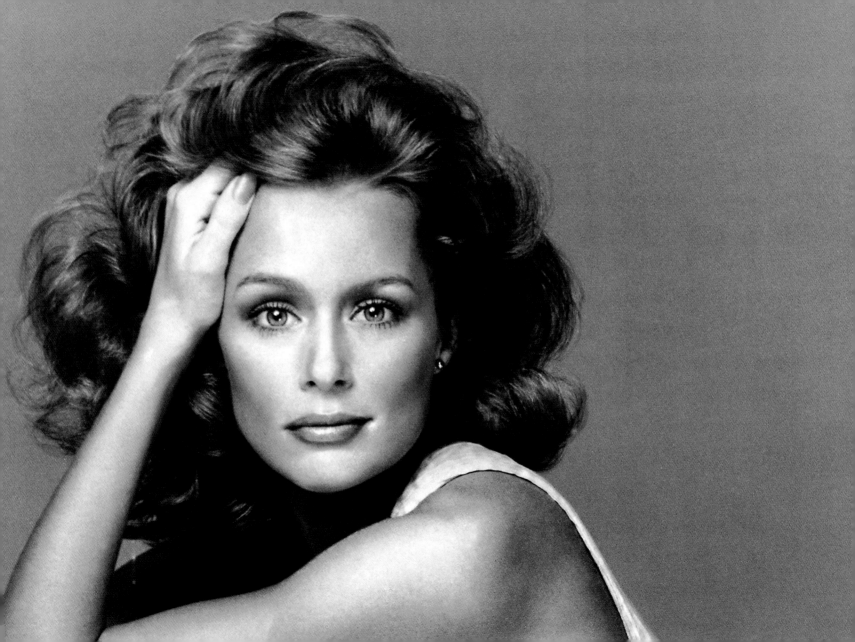

Call it fashion, costume, or dress, what
we wear and how we decorate ourselves
tells the world who we are, even in less-
than-fashionable circumstances.

Valerie Mendes

The Turkish fashion designer Rifat Ozbek aims to make the Pollini label famous
again, frequently borrowing from ethnic styles and oriental motifs.
Models in designs by RIFAT OZBEK for POLLINI, Spring/Summer 2007 women's
collections in Milan.

1 2 3 4 5 6 7 8 9 10 11 12 13 14 15 16 17 18 19 20 21 22 23 24 25 26 27 28 29 30

NOVEMBER

Everything today betrays a great
weakness: people just want uniforms
that satisfy some deep-seated need for
security. That proves that today's people
are of little depth: nothing is less realistic
than feeling reassured by a uniform.

Ann Demeulemeester

The look created by Belgian star designer Ann Demeulemeester is invariably
shaggy, eccentric, and consciously un-erotic. And here the designer remains
true to her reputation. She prefers dark, beige, and earthy tones. A sensuous
world of opulence and glamour, of color and magnificence, is not
Demeulemeester's style.
Outfits by ANN DEMEULEMEESTER, Spring/Summer 2008 men's collection in Paris.

1 2 3 4 5 6 7 8 9 10 11 12 13 14 15 16 17 18 19 20 21 22 23 24 25 26 27 28 29 30

NOVEMBER

Only the minute and the future are interesting in fashion—it exists to be destroyed. If everybody did everything with respect, you'd go nowhere.

Karl Lagerfeld

The British pop singer Lily Allen (b. 1985) sang background for Robbie Williams before embarking on her solo career. Allen's methodical and clever provocation has earned her titles such as "sexiest woman" and "worst-dressed." PR like that guaranteed her solo career, and the label "Lily Loves" was launched using her name. Sneakers now bear the pop label and have become a part of pop culture. The method—transience.

Presentation of shoes from LILY ALLEN's "Lily Loves" collection, London, 2007.

1 2 3 4 5 6 7 8 9 10 11 12 13 14 15 16 17 18 19 20 21 22 23 24 25 26 27 28 29 30

NOVEMBER

Don't you know that a man being rich is like a girl being pretty? You wouldn't marry a girl just because she's pretty, but my goodness, doesn't it help?

Marilyn Monroe in *Gentlemen Prefer Blondes*

Goddess and golden angel! Fashion's "big white gown" can only be surpassed by the "great golden gown" of Hollywood's Dream Factory. The ever changing, gently flowing fabric has a very special quality that makes it reflect the spotlights, producing a particularly sensuous and erotic, not to say lively, impression.
MARILYN MONROE in her famous gold lamé gown by BILL TRAVILLA for the 1953 movie *Gentlemen Prefer Blondes*.

1 2 3 4 5 6 7 8 9 10 11 12 13 14 15 16 17 18 19 20 21 22 23 24 25 26 27 28 29 30

NOVEMBER

I like fashion you can't see.

Giorgio Armani

How stylish. How typically Armani. Unadorned and simple—and therefore simply elegant.

Simple and elegant—designs by EMPORIO ARMANI from the Fall/Winter 2005/06 collection at Milan Fashion Week.

1 2 3 4 5 6 7 8 9 10 11 12 13 14 15 16 17 18 19 20 21 22 23 24 25 26 27 28 29 30

NOVEMBER

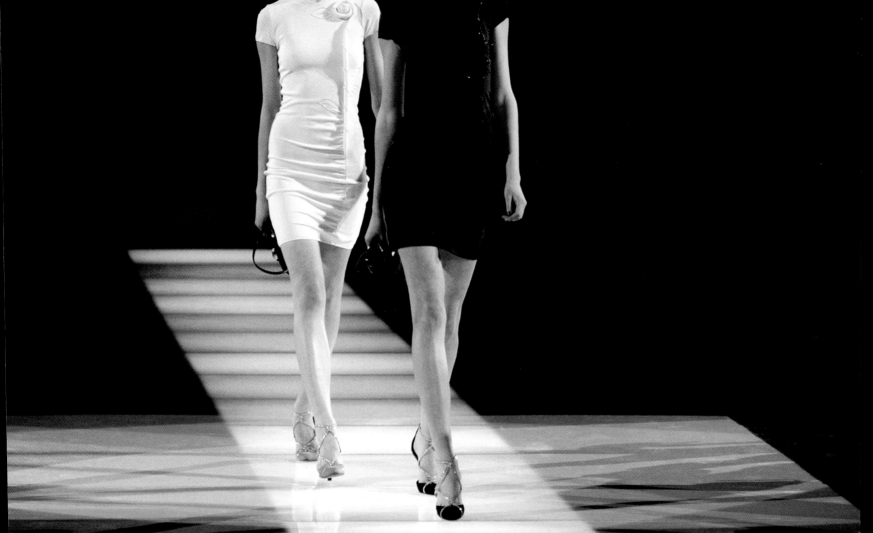

The only real elegance is in the mind;
if you've got that, the rest really comes
from it.

Diana Vreeland

The long glove is definitely part of a glamorous outfit and therefore an essential part of any *grande entrée*. Its highly erotic appeal in combination with a woman's bare arms should not be underestimated—long gloves give a lady poise, cover the inside of the elbow and the elbow itself, and suggest that Madame only touches things (and people) from a safe distance.
Glove designed by CORNELIA JAMES and worn by the Queen, March 1996.

1 2 3 4 5 6 7 8 9 10 11 12 13 14 15 16 17 18 19 20 21 22 23 24 25 26 27 28 29 30

NOVEMBER

People who go to my fashion shows
kinda go to a rock concert.

Anna Sui

The umbrella is all too often reduced to its mere function and underestimated as an everyday accessory that accentuates the effect of an outfit. Designer Anna Sui proves that that could be a mistake.

A creation by ANNA SUI, presented at Mercedes-Benz Fashion Week in New York, 2007.

1 2 3 4 5 6 7 8 9 10 11 12 13 14 15 16 17 18 19 20 21 22 23 24 25 26 27 28 29 30

NOVEMBER

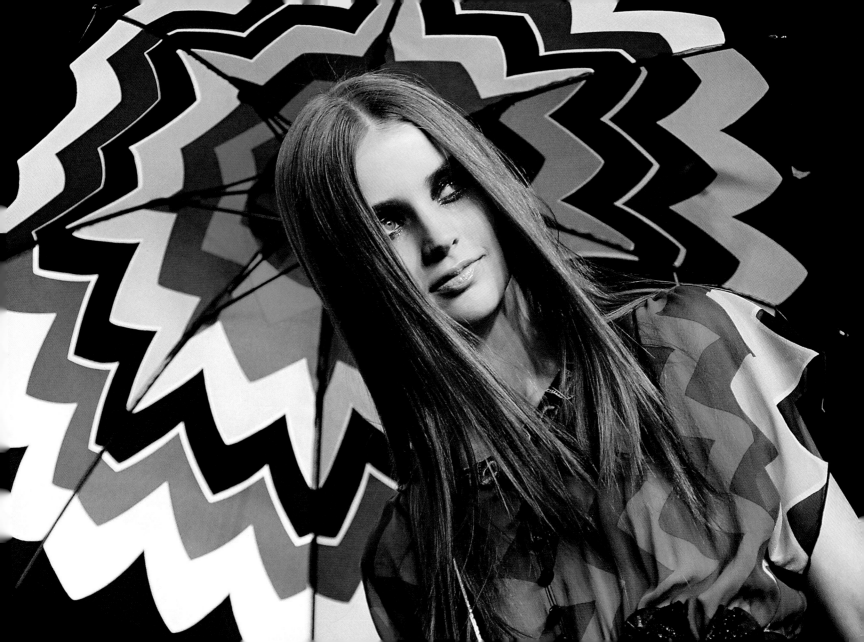

I think for health and for happiness
colors are much better.

Agatha Ruiz de la Prada

Sight or insight? That is the question here. Maybe Frank Sinatra had the answer: "A woman doesn't make a fool of a man; she just sits there and watches how he makes a fool of himself." And then she laughs—as here—with all her heart.
A model displays an outfit by Spanish designer AGATHA RUIZ DE LA PRADA as part of her Spring/Summer 2007 collection at Madrid Fashion Week.

1 2 3 4 5 6 7 8 9 10 11 12 13 14 15 16 17 18 19 20 21 22 23 24 25 26 27 28 29 30 31

DECEMBER

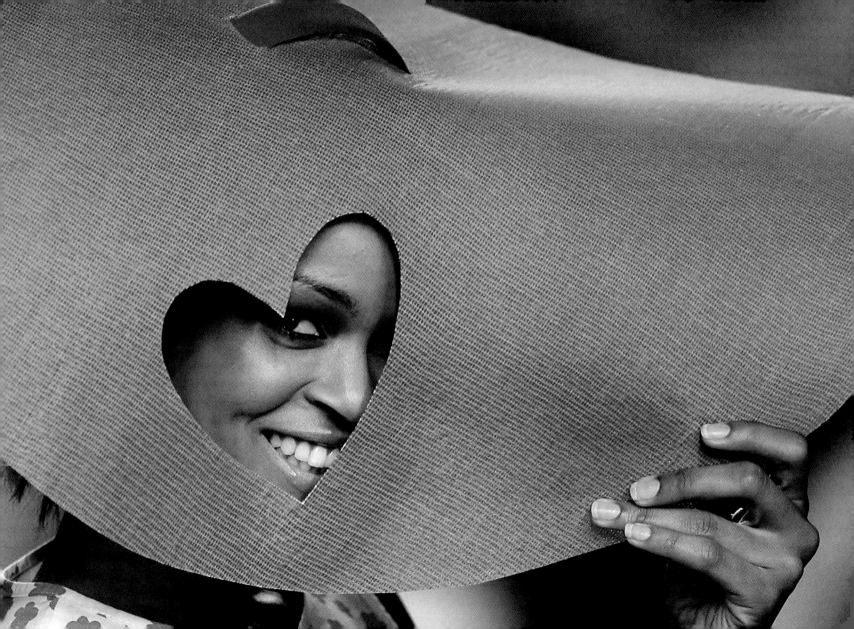

Gucci. The word speaks volumes.
It stands for elegance, sex, desire, limits.

Bridget Foley

Gucci-mania reigns. It's hard to believe, but twenty years ago the label with the five letters, G.U.C.C.I., was as good as dead, and the company was bankrupt. But then "he" came along—Tom Ford. He achieved what Marc Jacobs did at Louis Vuitton—a cult label. It was not achieved by mere virtue of the casual elegance that all Gucci designs now radiate. It was achieved (as it often is in the fashion world) above all through a rigorous strategy in PR, advertising, and marketing.

Buttons on a GUCCI jacket on display at a GUCCI shop window in London, 2002.

1 2 3 4 5 6 7 8 9 10 11 12 13 14 15 16 17 18 19 20 21 22 23 24 25 26 27 28 29 30 31

DECEMBER

What is the difference between elegant, new, edgy, and *branché*?

Oscar de la Renta

An elegant Spanish shoulder-warmer—the bolero was originally part of the torero's costume. Since the 1930s and 1950s it has often appeared over summer, cocktail, and ball dresses as an elaborately ornamented short "Figaro jacket."
A model wears a design by OSCAR DE LA RENTA at the Fall 2007 collection show in New York.

1 2 **3** 4 5 6 7 8 9 10 11 12 13 14 15 16 17 18 19 20 21 22 23 24 25 26 27 28 29 30 31

DECEMBER

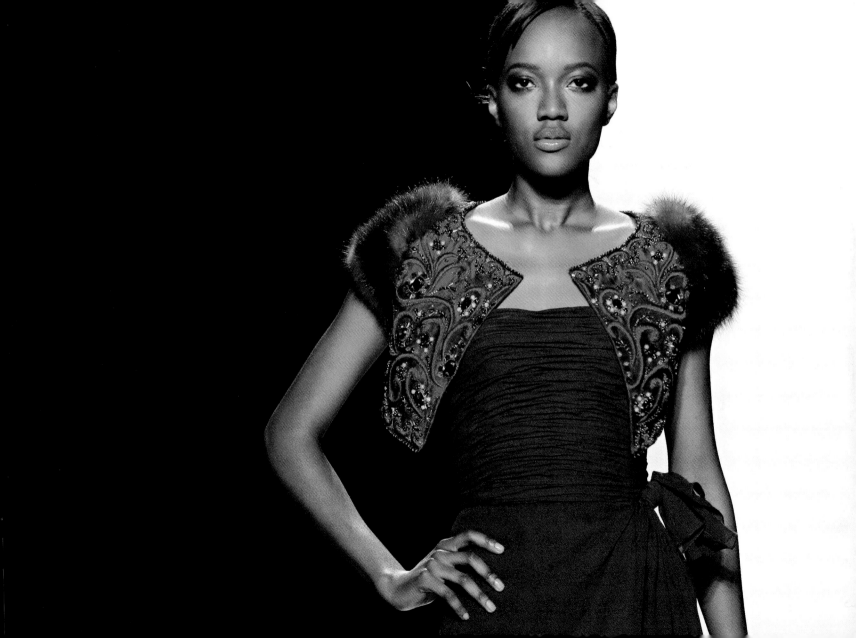

You have to have a strong style even
if there are people who like it or who
don't like it.

Agatha Ruiz de la Prada

Without a dressmaker's model, known as a "stockman," you can't get far in
fashion. The doll has to try on and put up with every crazy innovation, every
preliminary design.
Spanish designer AGATHA RUIZ DE LA PRADA in her studio in Madrid,
September 2004.

1 2 3 4 5 6 7 8 9 10 11 12 13 14 15 16 17 18 19 20 21 22 23 24 25 26 27 28 29 30 31

DECEMBER

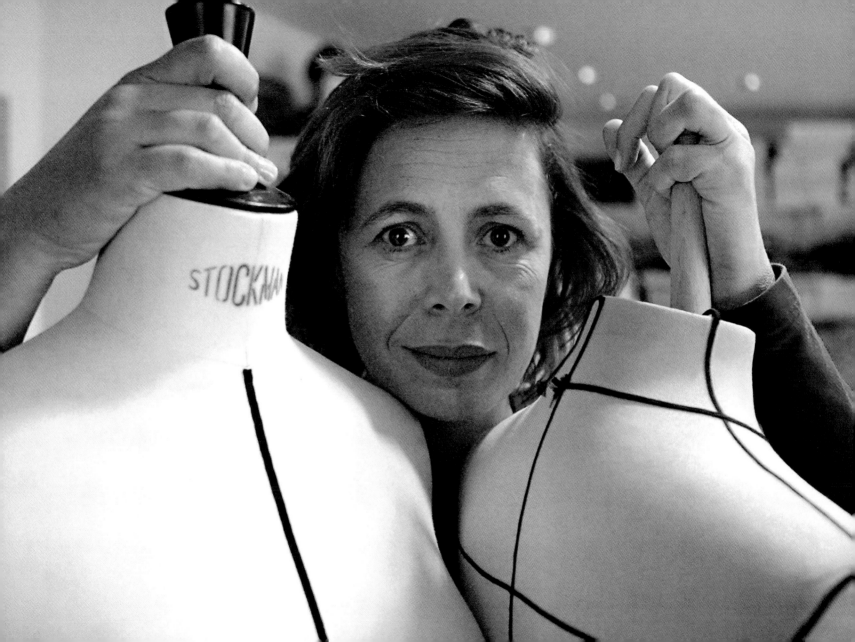

No Future / No Future / No Future for you
No Future / No Future / No Future for me

Sex Pistols, *God Save The Queen*

Chic-er shock! It is especially exhausting to want to be "not" fashionable, to rebel against the fashion establishment, simply to refuse to join in—the result of such efforts is usually a new fashion, or rather a new style. Punk proves it—the shock became chic.

A group of punks colonize a street corner in England with a can of beer, 1983.

1 2 3 4 **5** 6 7 8 9 10 11 12 13 14 15 16 17 18 19 20 21 22 23 24 25 26 27 28 29 30 31

DECEMBER

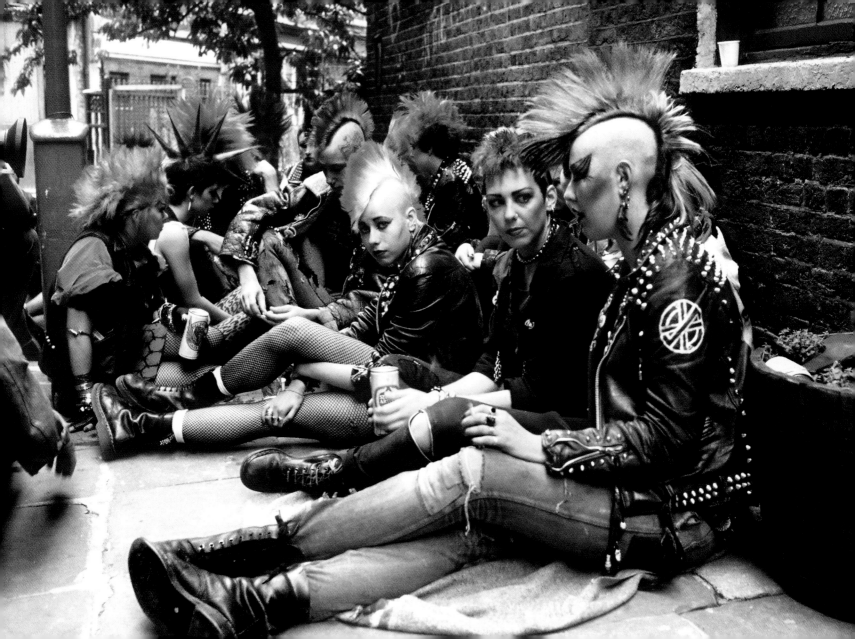

The difference between fashion and
what people normally wear is that fashion
is what I do and what people normally
wear is just consumerism.

Vivienne Westwood

The great British designer Vivienne Westwood perfectly understands how to
present herself—and how to attract attention. Stylistically she seems to stand
halfway between punk and pomp—but always with both feet planted firmly
on the ground.
The shoes of British designer VIVIENNE WESTWOOD, seen during her arrival at a
charity event in Vienna, 2007.

1 2 3 4 5 6 7 8 9 10 11 12 13 14 15 16 17 18 19 20 21 22 23 24 25 26 27 28 29 30 31

DECEMBER

Glamour is a part of us and we want
to be dandy. We want to shock and
be outrageous, instantly.

Freddie Mercury

Despite the facial expression, the lady doesn't dare to use the one-finger sign.
Or does the sign she is making stand for victory? After all, fashion is victorious.
A model poses in a creation from the ZANDRA RHODES Fall/Winter 2003/04
collection show during London Fashion Week.

1 2 3 4 5 6 7 8 9 10 11 12 13 14 15 16 17 18 19 20 21 22 23 24 25 26 27 28 29 30 31

DECEMBER

Do you know her story? How the restless young wife of Peter Pulitzer began selling orange juice out of a tiny storefront in Palm Beach and dressed in shifts made from fabric at Woolworth's to hide the stains? It was the early 1960s, and the Kennedys were in town, and even Jackie wore a Lilly.

Penelope Green, *The New York Times*, 2004

The designer Lilly Pulitzer (real name Lilian Lee McKim) was born in New York in 1931. The severe cut of her creations represented the typical American style of the 1960s—simple, sporting, and yet sophisticated. It was just the style of First Lady Jacqueline Kennedy, who was therefore one of the first among the famous faces of the United States who took to wearing Pulitzer's collections.

Standing at the bottom of a swimming pool, a young woman models a LILLY PULITZER shift dress, 1964.

8

1 2 3 4 5 6 7 8 9 10 11 12 13 14 15 16 17 18 19 20 21 22 23 24 25 26 27 28 29 30 31

DECEMBER

Imagination gives form to dreams.

Edgard Varèse

Fashion is always also applied Surrealism.
A model wearing false eyelashes, made from fake flower petals and real hair,
by EYLURE, 1969.

1 2 3 4 5 6 7 8 9 10 11 12 13 14 15 16 17 18 19 20 21 22 23 24 25 26 27 28 29 30 31

DECEMBER

I think that I'm in love with what
I am doing.

Sonia Rykiel

Designer Sonia Rykiel, born in Paris in 1930, is also known as the "Queen of Knits,"
becoming famous during the 1970s for her luxurious knitwear collections.
To this day, stripes and knitwear remain the trademark of the fashion designer,
who is also a writer.
French fashion designer SONIA RYKIEL walks down the catwalk after her
Fall/Winter 2002/03 ready-to-wear collection show in Paris.

1 2 3 4 5 6 7 8 9 10 11 12 13 14 15 16 17 18 19 20 21 22 23 24 25 26 27 28 29 30 31

DECEMBER

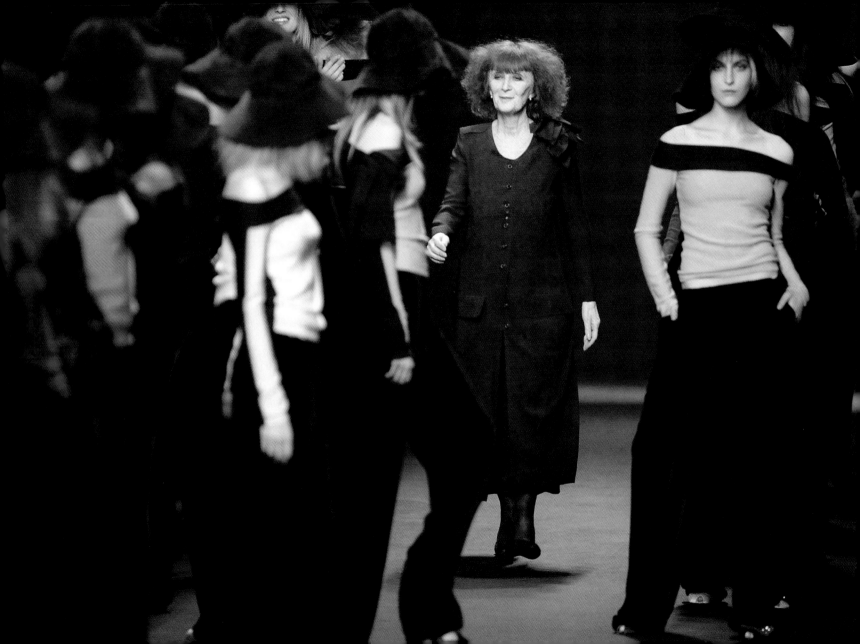

I am convinced—yes, we have done something in fashion.

Rosita Missoni

Zig-zag knitwear in strong but subtle color combinations is typical Missoni. Ottavio Missoni (b. 1921) is one of Italy's great (quiet) fashion designers. However, his fine, knitted fashion experienced its heyday during the 1970s. A model poses in a colorful outfit by MISSONI on pillows covered in Missoni fabric, 1975.

1 2 3 4 5 6 7 8 9 10 **11** 12 13 14 15 16 17 18 19 20 21 22 23 24 25 26 27 28 29 30 31

DECEMBER

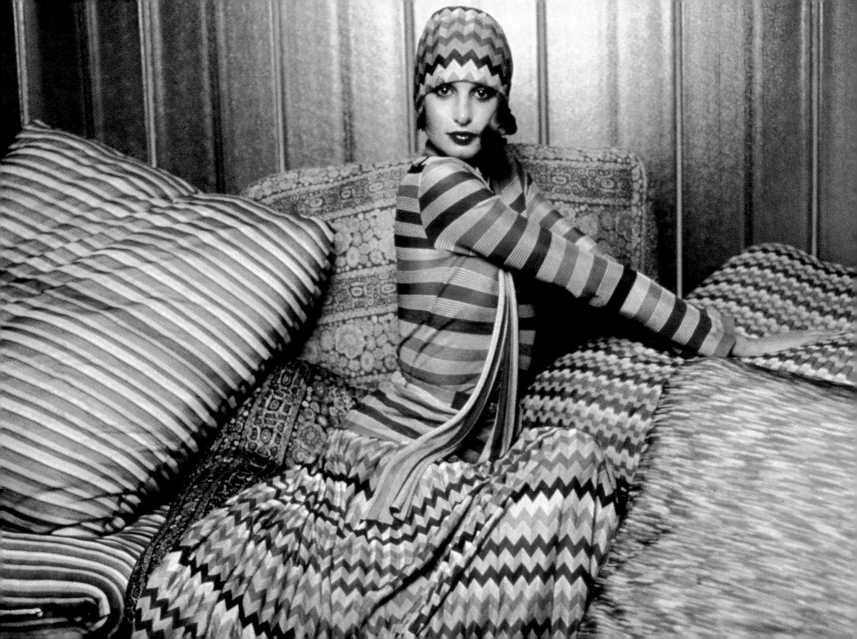

Perhaps there are more beautiful times;
but this one is ours.

Jean-Paul Sartre

There are no doubt higher heels… However, because the ladies putting their best foot forward in this photo almost always only show one shoe and one leg, the overall concept of the picture acquires a scurrilous undertone.
A group of women trot out their winkle-picker stilettos.

1 2 3 4 5 6 7 8 9 10 11 **12** 13 14 15 16 17 18 19 20 21 22 23 24 25 26 27 28 29 30 31

DECEMBER

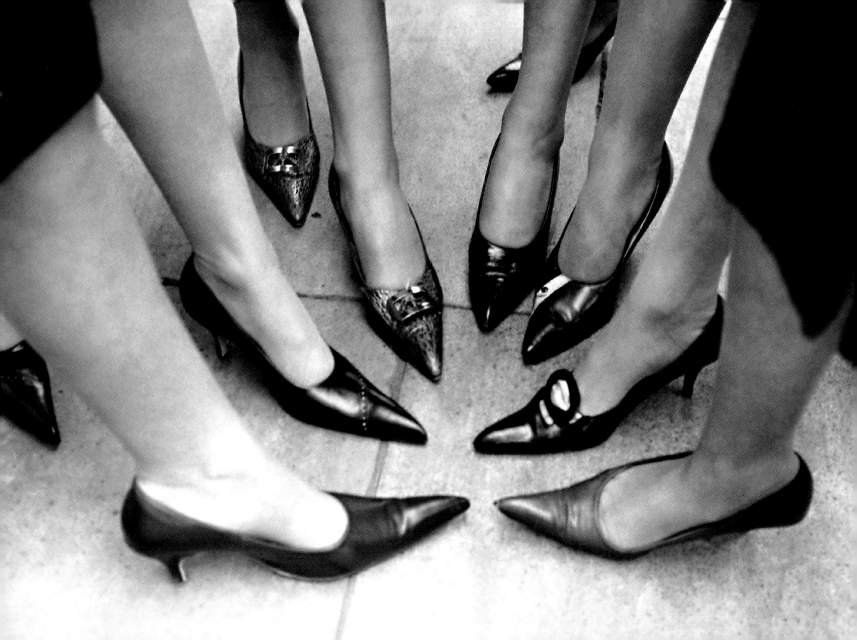

The thing I'm most interested in is
continuity. I've always worked hard
at not being today's flavor.

Paul Smith

Paul Smith, the British creator of the slightly asymmetric men's shirt collar, basically produces cheerful everyday streetwear rather than serious or sad fashion. So why aren't the models smiling?
Models walk down the catwalk during the PAUL SMITH fashion show as part of the Paris Menswear Fall/Winter 2006/07.

1 2 3 4 5 6 7 8 9 10 11 12 13 14 15 16 17 18 19 20 21 22 23 24 25 26 27 28 29 30 31

DECEMBER

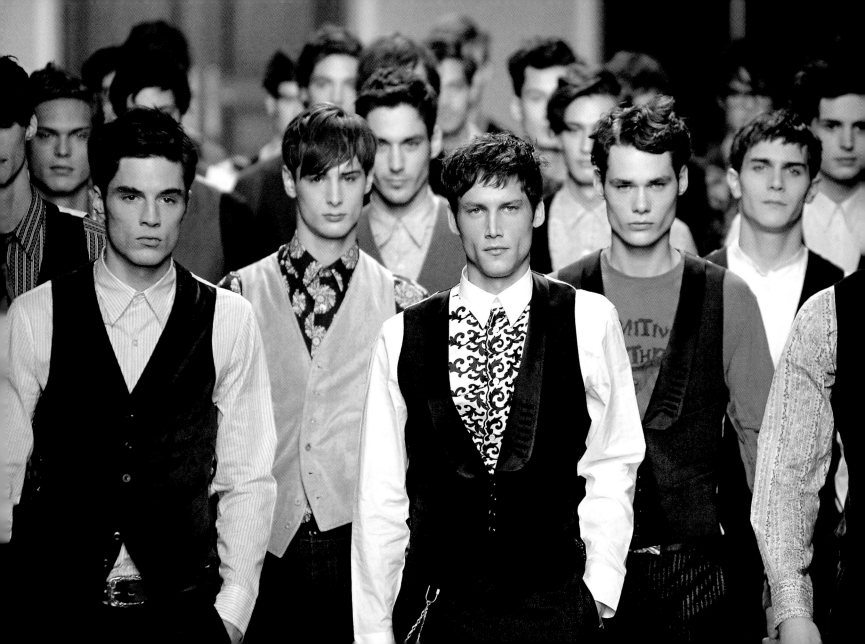

I don't know if it's a challenge—I'm just interested in trying to provoke people.

Jeremy Scott

The clown-like collar proves it. Jeremy Scott, from the state of Missouri, USA, is famous for unusual designs not afraid of dwelling on comic or witty aspects. He perfectly understands how to use these humorous effects in his collections, which is why Scott is a favorite designer of stars like Cameron Diaz, Christina Aguilera, Kylie Minogue, and Madonna.

Models present outfits by JEREMY SCOTT at the Fall 2002 fashion show during Mercedes-Benz Fashion Week at Bryant Park, New York.

1 2 3 4 5 6 7 8 9 10 11 12 13 **14** 15 16 17 18 19 20 21 22 23 24 25 26 27 28 29 30 31

DECEMBER

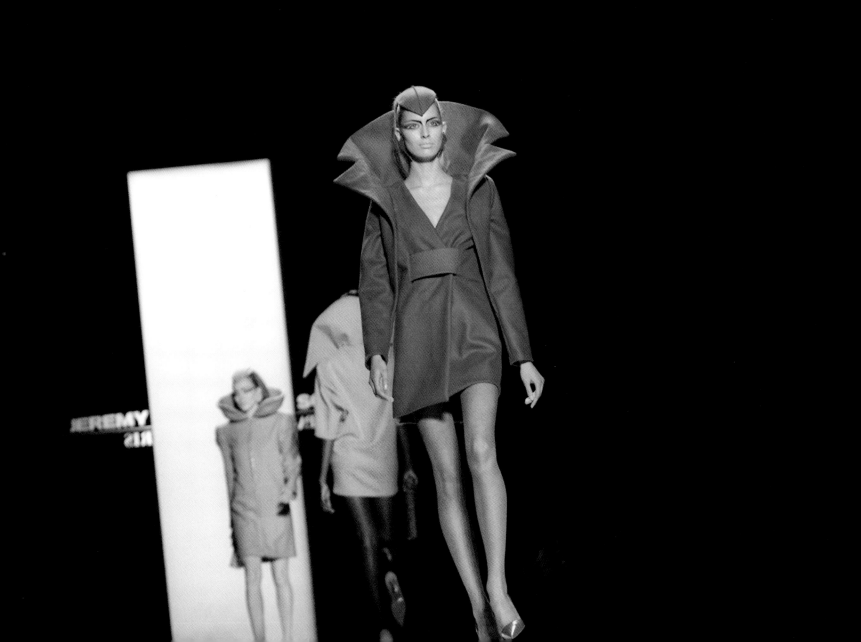

I am part of my past,
but I look to the future.

Issey Miyake

A collar designed down to the last detail—even the black hairpins on the lacquer cap fulfill an optical function. Without them, the harmony of the overall composition would be lost.

1 2 3 4 5 6 7 8 9 10 11 12 13 14 **15** 16 17 18 19 20 21 22 23 24 25 26 27 28 29 30 31

DECEMBER

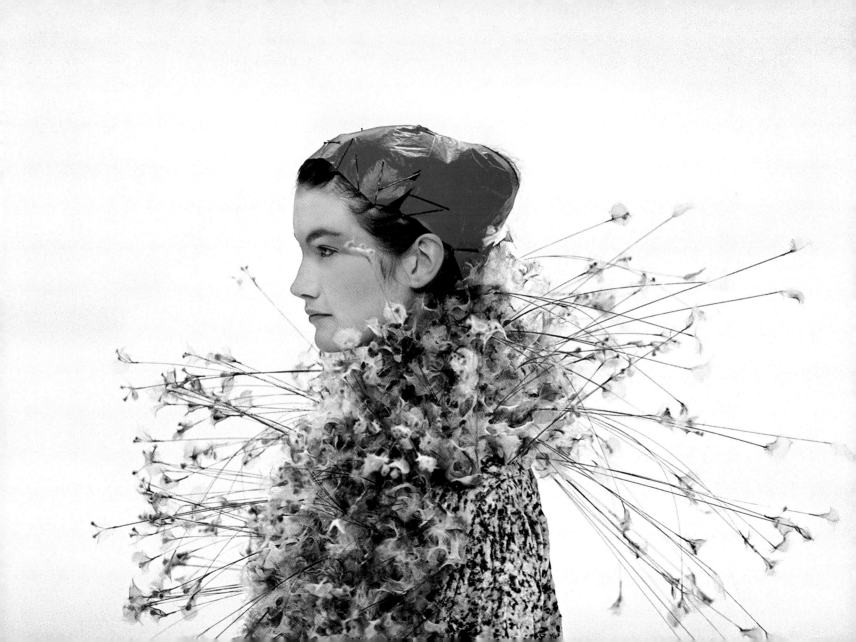

The Queen has been pilloried for years for her lack of style, but whatever you think of it, this is style.

Jasper Conran

Milliners like those in England seem to ensure, among other things, that the horses are not distracted from their race by the hairdos and head coverings of the female spectators.
Portrait of FREDERICK FOX, awarded the Royal Warrant as one of the Queen's favorite milliners, with many of his hats in London, 1993.

1 2 3 4 5 6 7 8 9 10 11 12 13 14 15 **16** 17 18 19 20 21 22 23 24 25 26 27 28 29 30 31

DECEMBER

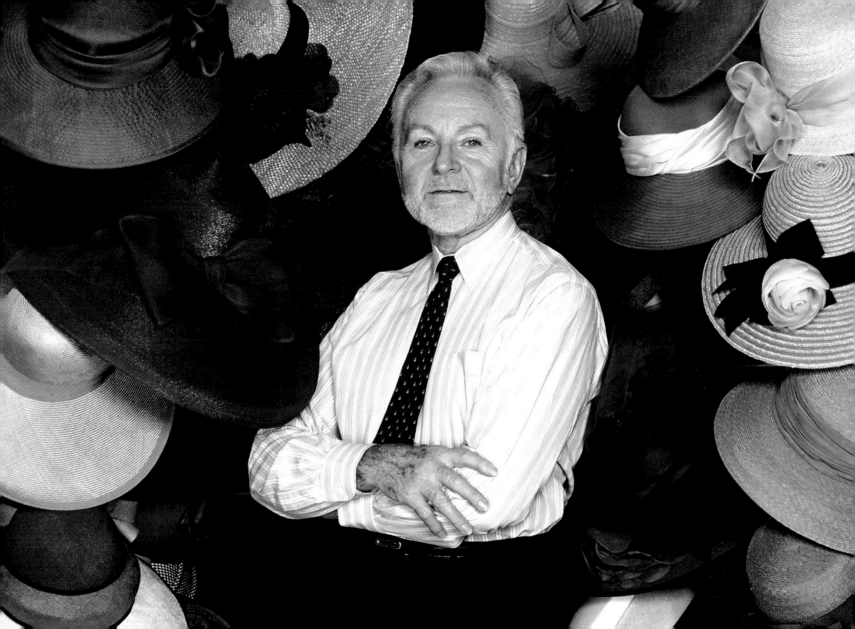

Women need to learn to arouse
men's curiosity for that which they
already know.

Coco Chanel

Young fashion designers work hard on this quotation by the great Coco Chanel,
as we can see again and again, especially at the avant-garde fashion shows.
A model displays a creation for the Fall/Winter 2006/07 collection of London-
based label KISA during London Fashion Week.

1 2 3 4 5 6 7 8 9 10 11 12 13 14 15 16 **17** 18 19 20 21 22 23 24 25 26 27 28 29 30 31

DECEMBER

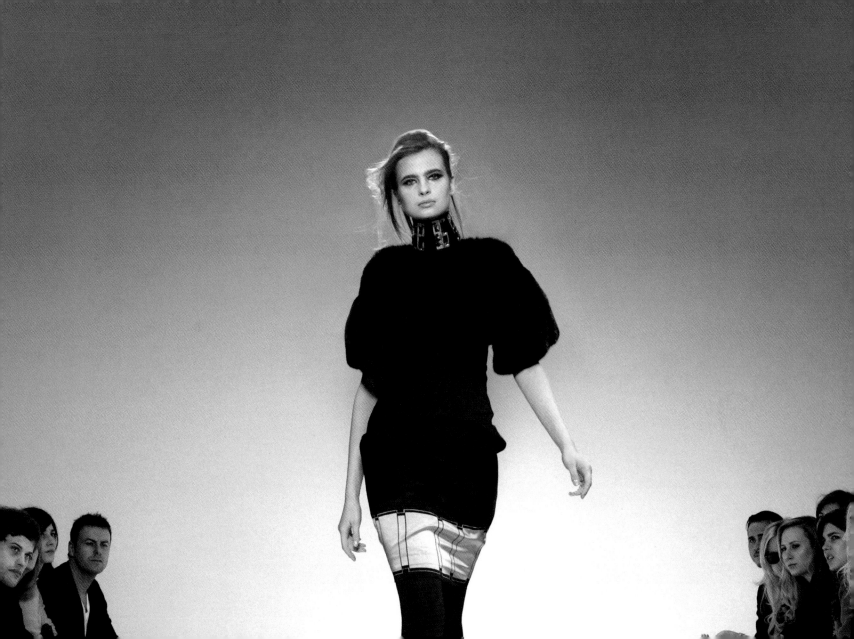

She's not too scary, she's almost in reach but she's not in reach. She's the kind of girl you wish lived next door, but she's never going to.

David Bailey

The British photographer David Bailey captured in images like no other his era's sex appeal. That was why he left such a decisive mark on the fashion photography of the 1970s. Before then it had been stiff, statuesque, and aristocratic. Bailey demonstrated his own preference for fetishism and latex in the series *Miss David Bailey*—a declaration of love to his wife.
British supermodel JEAN SHRIMPTON (b. 1942) wearing a short-sleeved dress and stockings, ca. 1970.

1 2 3 4 5 6 7 8 9 10 11 12 13 14 15 16 17 **18** 19 20 21 22 23 24 25 26 27 28 29 30 31

DECEMBER

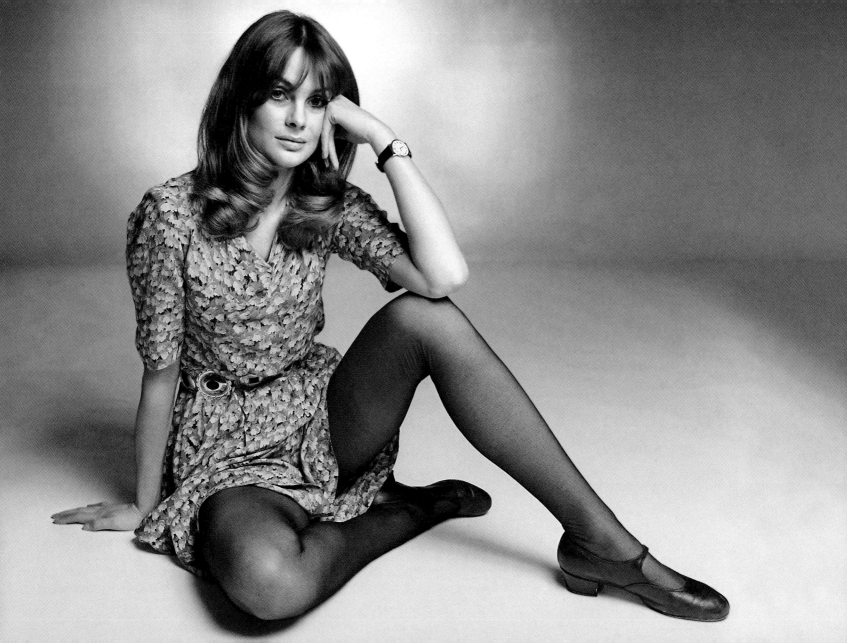

In the last few years I have come to understand the value of fashion. I always felt guilty about being interested in it, but now I can say that it's creative work and it relates to the world, and people buy it because it means something to them beyond the logo.

Miuccia Prada

Fashion boutiques are the temples of the modern age. The items on display, statically arranged as in a museum or an Egyptian tomb, are supposed to arouse feelings of awe, lying on shelves and in vitrines ready to be worshiped. The glass front door at the PRADA store on Rodeo Drive reveals the greenish decor within, Beverly Hills, Los Angeles, 2002.

1 2 3 4 5 6 7 8 9 10 11 12 13 14 15 16 17 18 19 20 21 22 23 24 25 26 27 28 29 30 31

DECEMBER

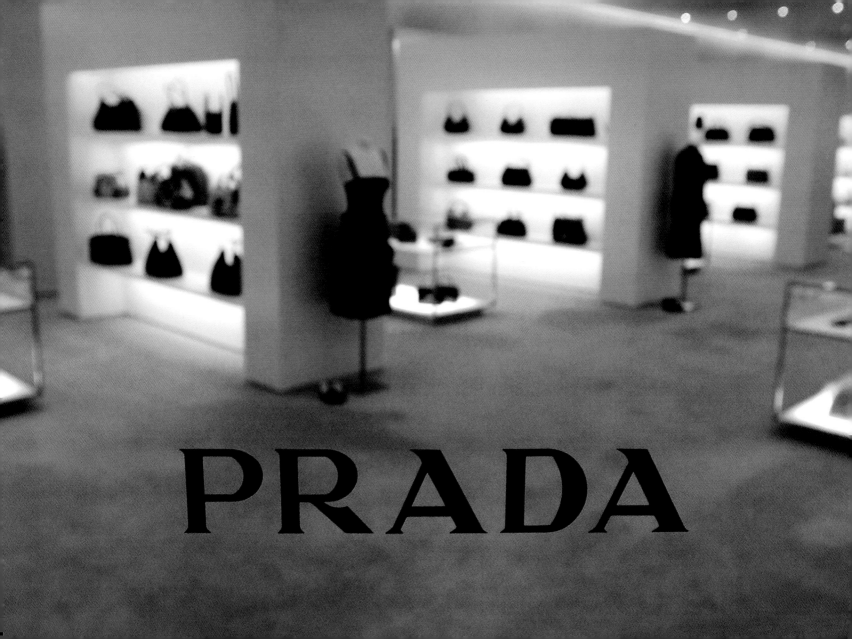

For me, elegance is not to pass unnoticed but to get to the very soul of what one is.

Christian Lacroix

An eye catcher, but why? Because a silk dress under water has a completely different effect on the observer than a rubber wetsuit—yes, we would even bet that it is usually worn out of the water and that its wearer knows precisely when and where she would wear what.
Underwater view of a young woman wrapped in silk.

1 2 3 4 5 6 7 8 9 10 11 12 13 14 15 16 17 18 19 20 21 22 23 24 25 26 27 28 29 30 31

DECEMBER

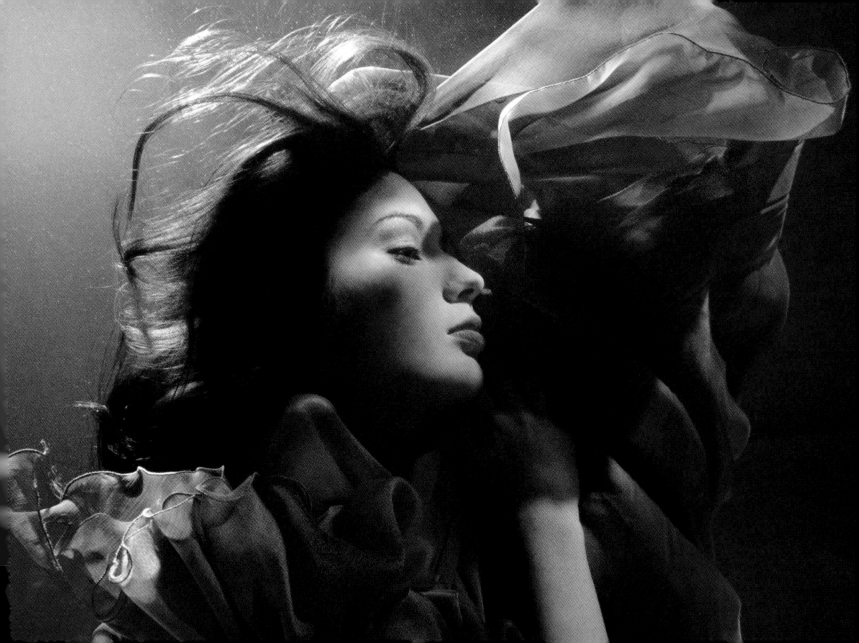

A well cut dress suits every woman.
Period!

Coco Chanel

The pleated collar gives the evening dress a theatrical appearance. There is hardly a fashion designer who would create a collection without it.
A model displays a creation by Italian designer RENATO BALESTRA during his Fall/Winter 2007/08 haute couture collection show in Palazzo Valentini as part of Rome Fashion Week.

1 2 3 4 5 6 7 8 9 10 11 12 13 14 15 16 17 18 19 20 21 22 23 24 25 26 27 28 29 30 31

DECEMBER

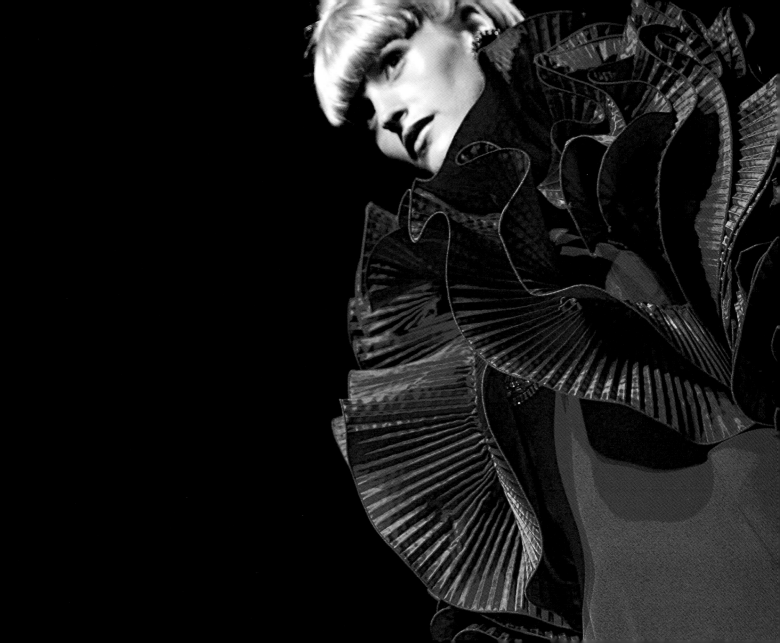

With quality, one is always successful.
The question is whether one can be
successful without quality.

Hanns Joachim Friedrichs

Sewed-on instructions for success. How to become the next CEO? During the 1970s, the creative fashion designer Perry Ellis drew attention to himself with his sportswear. When Ellis died in 1986 at the age of only 46, he was one of the first famous AIDS victims in the U.S.—and in the world of fashion.
Close-up of a label, backstage at the PERRY ELLIS Fall 2007 show during Mercedes-Benz Fashion Week in New York.

1 2 3 4 5 6 7 8 9 10 11 12 13 14 15 16 17 18 19 20 21 22 23 24 25 26 27 28 29 30 31

DECEMBER

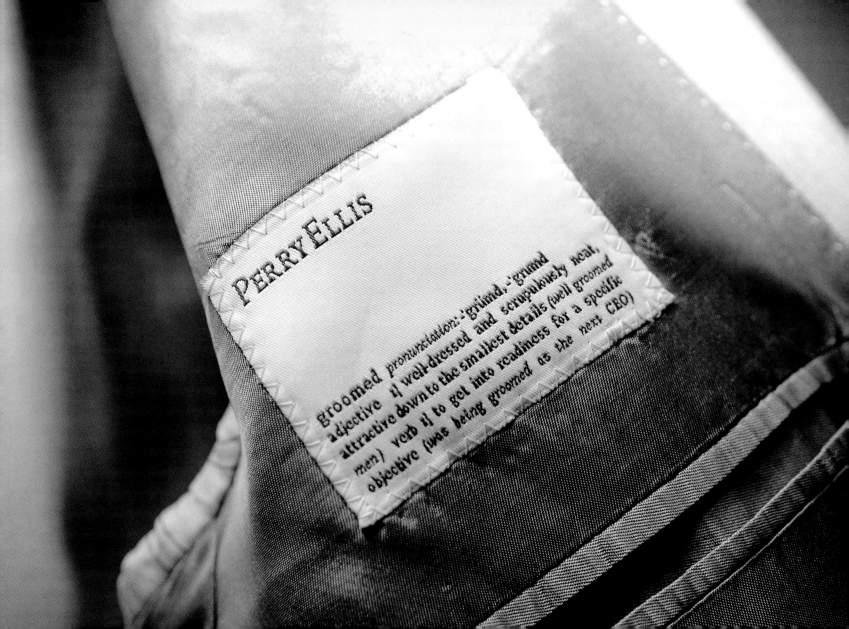

First find out who you are,
and then dress accordingly.

Epictetus

As early as 1800, elegant ladies covered their *décolleté* with feather shawls known as boas, after the giant snake. The reasons had more to do with coquetry than with a desire to keep out the cold. The feather boa is still very much a part of the overall look of ball gowns and evening dresses today. The glamorous woman would be reluctant to manage without this sensuous, attractive accessory that all too often recalls the operetta.

A model wearing large rhinestone earrings and bracelets blows on a red feather boa, 1950.

1 2 3 4 5 6 7 8 9 10 11 12 13 14 15 16 17 18 19 20 21 22 **23** 24 25 26 27 28 29 30 31

DECEMBER

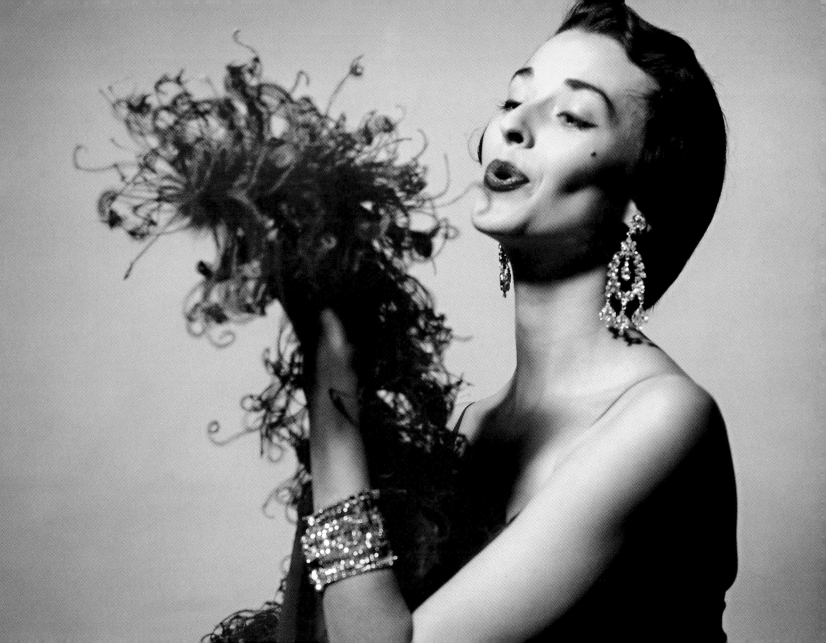

My philosophy: keep it simple!

Narcisco Rodriguez

"Thy magic reunites those whom stern custom has parted." Set to music by Beethoven, Friedrich Schiller's *Ode to Joy* expressly declares custom—fashion—as separatist and divisive. On the catwalk in this photo it certainly does divide the audience—which, for its part, surely has differing views about this creation by designer Rodriguez.

A model walks the runway at the NARCISCO RODRIGUEZ Fall 2005 show during Olympus Fashion Week, New York.

1 2 3 4 5 6 7 8 9 10 11 12 13 14 15 16 17 18 19 20 21 22 23 **24** 25 26 27 28 29 30 31

DECEMBER

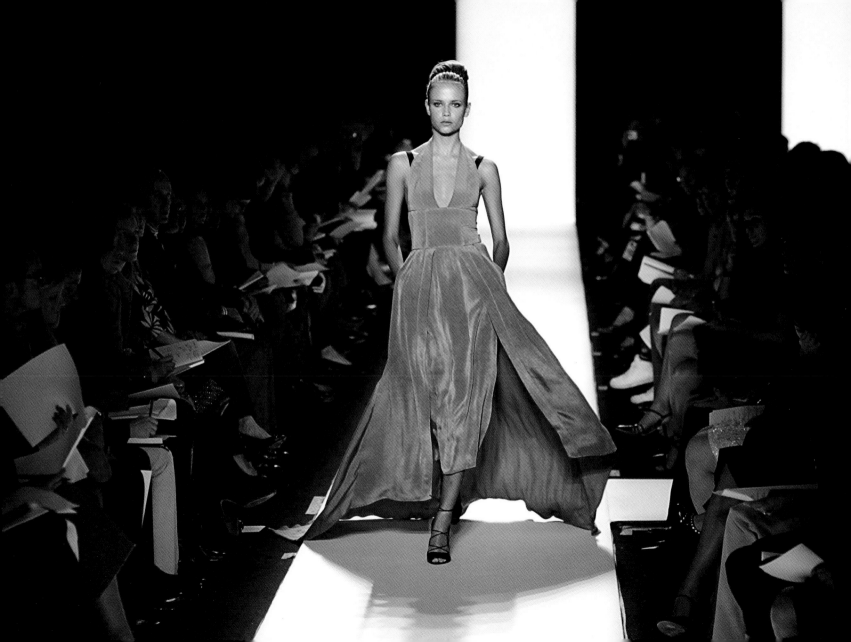

Fashion is, for me, the opposite of
a uniform. It beautifies, but at the
same time must respect singularities.

Dries van Noten

The fashion designer demands not only the model's body, but also her head.
In quite different ways however.
Headshot of a model presenting a creation by Belgian designer DRIES VAN NOTEN
during the Spring/Summer 2006 ready-to-wear collections in Paris.

1 2 3 4 5 6 7 8 9 10 11 12 13 14 15 16 17 18 19 20 21 22 23 24 25 26 27 28 29 30 31

DECEMBER

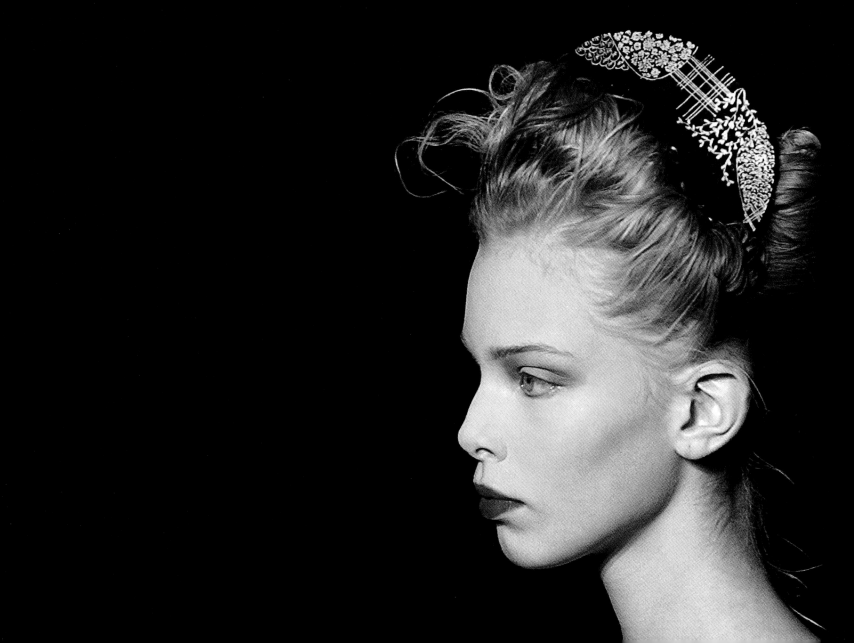

Jewelry shouldn't make one look wealthy, but adorn one. This is why I have always liked to wear fake jewelry.

Coco Chanel

Flawless—and therefore superior to the human soul.
A diamond belonging to actress ELIZABETH TAYLOR, bought from CARTIER, 1969.

1 2 3 4 5 6 7 8 9 10 11 12 13 14 15 16 17 18 19 20 21 22 23 24 25 26 27 28 29 30 31

DECEMBER

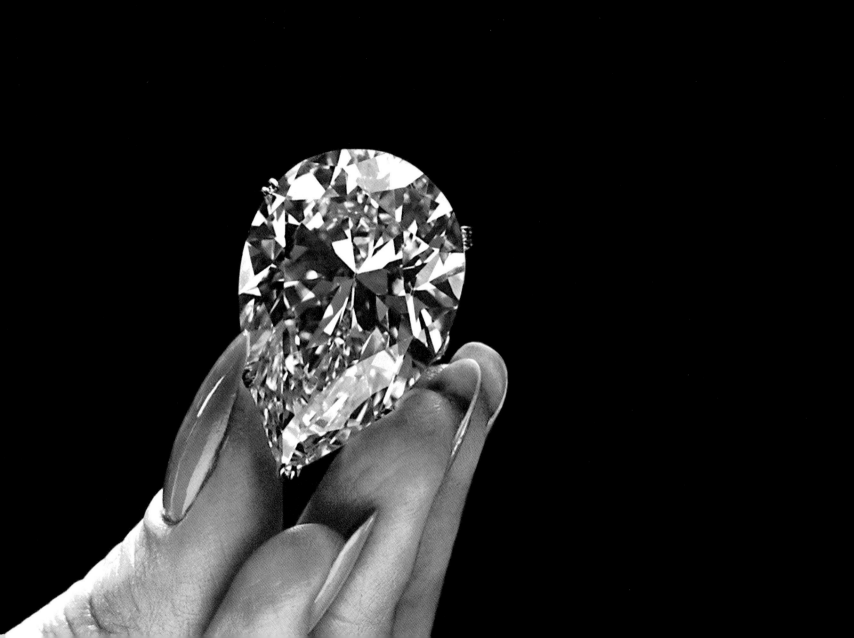

Men are freer in the way they dress now.
The rigid suit is gone forever.

Paul Smith

Which man will wear this shirt? The flamenco dancer or the ice skater?
During a fashion show no one poses questions like this one.
A model wears a creation by Italian designer GIANFRANCO FERRÉ during the
Fall/Winter 2006/07 men's collection at Milan Fashion Week.

1 2 3 4 5 6 7 8 9 10 11 12 13 14 15 16 17 18 19 20 21 22 23 24 25 26 **27** 28 29 30 31

DECEMBER

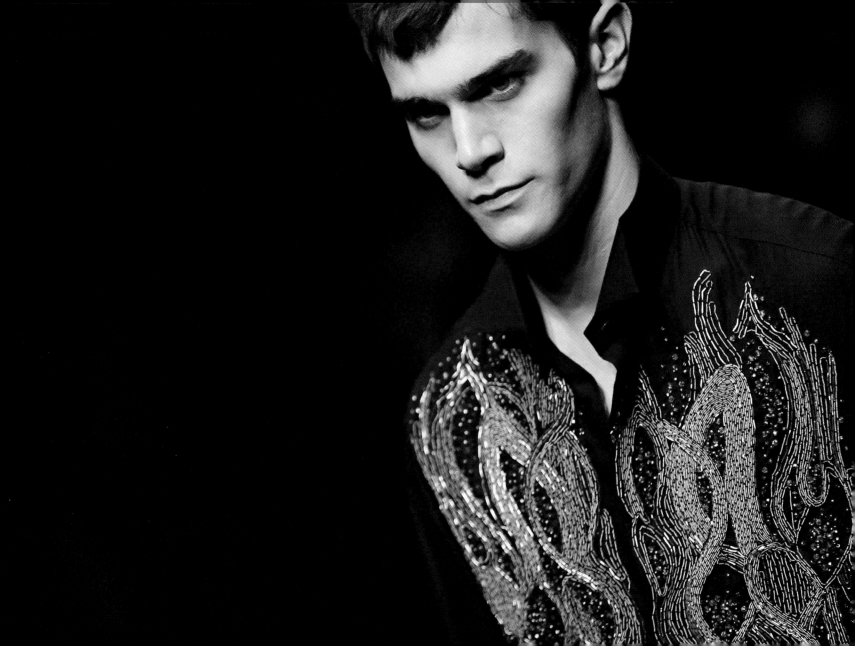

There were times when a handbag
was fitting if it blended in decently
with the overall look.

Katrin Kruse, *Die Zeit*, 2005

I shop, therefore I am.
A model carries a gold handbag by Lebanese designer ELIE SAAB during
the Spring/Summer 2007 fashion show as part of Paris Fashion Week.

1 2 3 4 5 6 7 8 9 10 11 12 13 14 15 16 17 18 19 20 21 22 23 24 25 26 27 28 29 30 31

DECEMBER

Women's lives have changed, but their desire for beauty has not.

Dries van Noten

In the 1950s, the neck and brow were free of hair, making heads seem long and narrow, and contributing to the distortion of proportions. Those who could afford it wore their hair pinned up—elegantly and tightly styled—with a saucy hat.
The jeweled Stay Put cocktail hat, perched on a woman's head at a reckless angle, 1953.

1 2 3 4 5 6 7 8 9 10 11 12 13 14 15 16 17 18 19 20 21 22 23 24 25 26 27 28 **29** 30 31

DECEMBER

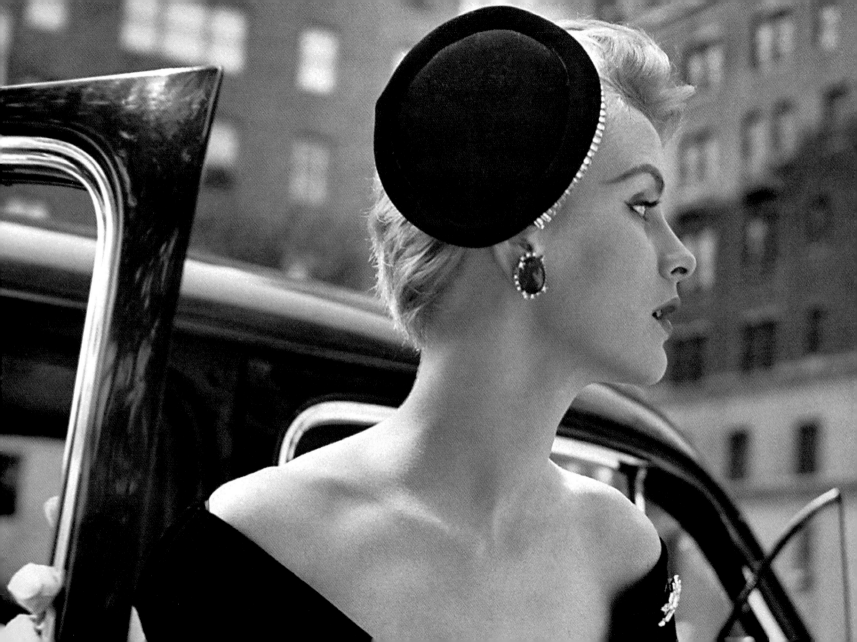

I grew up with wearing button-down shirts and badly-cut chinos, knowing that one day I wanted to change the way that these classics were made.

Tommy Hilfiger

Thomas Jacob Hilfiger (b. 1952), famous worldwide as Tommy Hilfiger, is a U.S. fashion designer with Swiss ancestors. Hilfiger began his career in the fashion world at the age of 26 with a chain of ten fashion boutiques in New York. Since then, the brilliant businessman and well-known designer has invested heavily in advertising and PR. Today, Hilfiger's fashion mega-empire has an annual turnover of 400 million dollars—mostly with "casual looks," in other words, comfortable street and sportswear, but also with licenses for perfumes and accessories.
A model displays a creation from U.S. fashion designer TOMMY HILFIGER during the 2008 Mercedes-Benz Fashion Week in New York.

1 2 3 4 5 6 7 8 9 10 11 12 13 14 15 16 17 18 19 20 21 22 23 24 25 26 27 28 29 30 31

DECEMBER

I wanted to mix extreme sophistication
with something more primitive.

Emanuel Ungaro

Emanuel Ungaro (b. 1933) is a true *homme à femmes* of the fashion scene.
Regardless of the current fashion, this designer from the South of France with
Italian roots has never abandoned his elegant, glamorous style. Ungaro has
always had a weakness for colors and light, airy fabrics. And so it is typical of
this great designer that he creates a pyrotechnic display of color using frills,
feathers, and appliqué—not only on New Year's Eve.
A model presents a feathery design by EMANUEL UNGARO during the
Fall/Winter 2000/01 haute couture show in Paris.

1 2 3 4 5 6 7 8 9 10 11 12 13 14 15 16 17 18 19 20 21 22 23 24 25 26 27 28 29 30 31

DECEMBER

Index

Photo Credits